THE SIDES OF THE SEA

CARIBBEAN
STUDIES
SERIES

Anton L. Allahar and Natasha Barnes
Series Editors

The *Sides* of the *Sea*

Caribbean Women Writing Diaspora

Johanna X. K. Garvey

University Press of Mississippi / Jackson

The University Press of Mississippi is the scholarly publishing agency of
the Mississippi Institutions of Higher Learning: Alcorn State University,
Delta State University, Jackson State University, Mississippi State University,
Mississippi University for Women, Mississippi Valley State University,
University of Mississippi, and University of Southern Mississippi.

www.upress.state.ms.us

The University Press of Mississippi is a member
of the Association of University Presses.

Copyright © 2024 by University Press of Mississippi
All rights reserved
Manufactured in the United States of America

∞

Library of Congress Cataloging-in-Publication Data

Names: Garvey, Johanna X. K., author.
Title: The sides of the sea : Caribbean women writing diaspora /
Johanna X. K. Garvey.
Other titles: Caribbean studies series (Jackson, Miss.)
Description: Jackson : University Press of Mississippi, 2024.
| Series: Caribbean studies series |
Includes bibliographical references and index.
Identifiers: LCCN 2024024189 (print) | LCCN 2024024190 (ebook) |
ISBN 9781496850706 (hardback) | ISBN 9781496850713 (trade paperback) |
ISBN 9781496850720 (epub) | ISBN 9781496850737 (epub) |
ISBN 9781496850744 (pdf) | ISBN 9781496850751 (pdf)
Subjects: LCSH: Caribbean literature—Women authors—History and criticism.
| Women authors, Caribbean. | Women and literature—Caribbean Area—History. |
Caribbean fiction—Women authors. | Group identity in literature. |
Gender identity in literature. | Caribbean Area—In literature. |
West Indies—In literature.
Classification: LCC PN849.C3 G37 2024 (print) | LCC PN849.C3 (ebook) |
DDC 809/.8928709729—dc23/eng/20240627
LC record available at https://lccn.loc.gov/2024024189
LC ebook record available at https://lccn.loc.gov/2024024190

British Library Cataloging-in-Publication Data available

In memory of my parents

*Justine Spring Garvey (1922–2018) and
James Emmett Garvey (1917–1995)*

CONTENTS

Acknowledgments . ix

Introduction
The Caribbean Atlantic: Trauma, Relation, Resistance. 3

Part One: Plumbing the Depths

Chapter 1
Watery Webs Weave Stories:
Unblocking the Salt Roads in Marshall, Cliff, and Hopkinson 23

Chapter 2
Oceanic Ossuaries: Caribbean Women Reading the Bones 43

Part Two: Voicing the Wounds

Chapter 3
Words to Heal the Wounds: Amnesia, Madness, and Silence as Testimony in Haitian Women's Fiction . 71

Chapter 4
"I Hear the Voice":
Performing the African Diaspora in Brodber and Hurston 92

Part Three: Unsettling Borders

Chapter 5
Mapping the Body: Caribbean Migrations in Tessa McWatt's Fiction. 115

Chapter 6
Caribbean Boundary Crossings:
Undoing the Violence of Borders in Santos-Febres and Lara 144

Conclusion
Beyond the Door: Journeys to the Free . 176

Notes . 193
Works Cited . 217
Index . 235

ACKNOWLEDGMENTS

I extend my deep gratitude to anonymous readers and to those at University Press of Mississippi who have supported and guided *The Sides of the Sea* to publication. They include Katie Keene, Lisa McMurtray, Valerie Jones, Kerri Jordan, Mary Heath, Jennifer Mixon, Cassie Winship, and all others who worked behind the scenes.

This book has evolved over the course of many years and I am grateful to all those who have contributed to that evolution. It began in an independent study with Julia M. Petitfrere, herself a native of Barbados and writer extraordinaire, who has inspired this project and whose friendship I treasure. Students over the years at Fairfield University, particularly in my seminar on Caribbean Women Writers, have further contributed to the development of the ideas explored in this study. I thank them all, in particular Alan Peláez López.

I presented various versions of the chapters at conferences and thank the organizers and participants: the Collegium for African American Research (CAAR); the Caribbean Studies Association (CSA); the Caribbean Philosophical Association (CPA); CECAB, a Caribbean Studies conference in Brazil (Salvador, São José); MESEA, Multi-Ethnic Studies of Europe and the Americas; the Haitian Studies Association (HSA); the Modern Language Association (MLA); the American Literature Association (ALA); the Caribbean Unbound conferences in Lugano, Switzerland; and the Caribbean Migrations, Negotiating Borders conference in Toronto. I thank Patrick B. Miller for introducing me to CAAR many years ago and for his enthusiastic support of this project over many years.

Chapter 1 grew from a paper I presented at the first of those conferences, CAAR in Tenerife, Spain, and published in the volume *Black Imagination and the Middle Passage* (eds. Diedrich, Gates, and Pederson, Oxford UP, 1999). The current chapter is a very different discussion of representations of the Middle Passage, but in a sense this whole book originated in the conferences organized by CAAR. I am grateful to colleagues who have shared this journey over the years, including Caroline Brown, Irline François, Marie-Hélène LaForest, Angelita Reyes, Robert McCormick, Sarah Waisvisz, Alan

Rice, Newtona "Tina" Johnson, Violet Johnson, Maria Diedrich, Justine Tally, John Hawley, and many more.

At Fairfield University, I am grateful for support from the English Department, the College of Arts and Sciences, and the Humanities Institute, and from my current and former colleagues, including Elizabeth Hohl, Rose Rodrigues, Maggie Wills, Emily Orlando, Peter Bayers, Nels Pearson, Elizabeth Petrino, Kris Sealey, Yohuru Williams, Diane Menagh, Susan Tomlinson, and the late Ben Halm, as well as Ben's daughter Kai Willow Halm. I also thank colleagues in the Humanities Institute Seminar who read a version of chapter 2 and offered helpful critique: Gwendolyn Alphonso, Cecelia Bucki, Sara Díaz, and Katherine Schwab. I also thank the librarians at Fairfield who have provided invaluable assistance, particularly John Cayer, Interlibrary Loan Specialist, DiMenna-Nyselius Library.

Family and friends have also provided encouragement over the years. I thank Kathryn Beaumont, Suzanne Beaumont, Ken O'Neill, Steve Kenney (whose death in December 2022 came as a devastating loss), Mary Tyson, Cynthia Taylor, June Schutt, Susan Mainero, Mo Sila, Lena Syssoeva, and many more. And I especially thank my sister, Michaela Garvey Hayes. I am deeply grateful for her wisdom and kindness, and her constant support and friendship.

THE SIDES OF THE SEA

Introduction

THE CARIBBEAN ATLANTIC

Trauma, Relation, Resistance

I.

"All beginning in water, all ending in water. Turquoise, aquamarine, deep green, deep blue, ink blue, navy, blue-black cerulean water" (Brand, *A Map to the Door of No Return* 6). Dionne Brand claims the waters of the Atlantic Ocean as origin and death, in a multiplicity of shades and as a powerful force of nature. "The ocean and the planet it weeps around, these are the only powers I truly respect" (Brand, *Map* 171). She also balances an endless grief with a deeply rooted respect for the spaces of trauma and relation formed by the Caribbean Atlantic.[1] The two bodies of water meet in places like the coast of Trinidad and Tobago, where Brand grew up, and in locations throughout the archipelago that Antonio Benítez-Rojo has termed "the repeating island." Brand's *A Map to the Door of No Return*, which I elsewhere refer to as an "autobiocartography" of the African Diaspora, repeatedly dwells in oceanic spaces. These aquatic and submarine roots and routes lie at the center of her oeuvre and of Caribbean writing more broadly—from Édouard Glissant and Kamau Brathwaite to the authors included in *The Sides of the Sea*.

Brand's meditations on spatial movement and fluidity, as well as on fragmentation and relation, frequently invoke the Door of No Return and the ossuaries at the bottom of the sea. She states, "I am, we are, in the Diaspora, bodies occupied, emptied and occupied. If we return to the door it is to retrieve what was left, to look at it—even if it is an old sack. Threadbare with

time, empty of meaning itself" (*Map* 94). Her mapping of the Caribbean Atlantic provides an initial framework for this study, as it also resonates with Glissant's philosophy of Relation and Brathwaite's tidalectics.[2] Increasingly, theories of the Caribbean expand to include both the waters and the multiple shores they touch, shaping an archipelagic approach to literature and cultural studies.[3] Glissant states: "The volcano's waters streamed through the tormented geography of these ocean depths, between the islands, and maybe they linked in one huge body of Water one continent to the other, the Guyanas to Ucatan, across this trajectory of craters placed one by one through the islands, on these shuddering heights where the earth questions the earth" (Glissant, *Tout-Monde* 224). Such a vision informs this study of Caribbean women writers whose works engage with experiences across a spectrum of languages and locations, of cultures and histories, yet who also are part of this "tormented geography." As Craig Santos Perez observes, "[N]*o island is an island* because islands exist in dynamic relationship to a larger archipelago and ocean" (98, original italics). This study aims to explore that expansive cartography of relations through a sustained discussion of fifteen authors, from eight countries (as well as the US), of African descent, writing in English, French, and Spanish.

Glissant's concept of Relation, which evolved over the course of his oeuvre, rests in part on the rhizomatic qualities of Caribbean experience. Instead of the single root and unitary identity that European colonialism sought to impose, Glissant posits a rooted multiplicity that he also terms *creolisation*. The "tormented geography" in and out of which Caribbean women write is an archipelagic combination of islands and the waters that define them. They also connect the seas and might appear as stepping stones through the Caribbean Atlantic, bridging those spaces and linking them to the continental Americas. Llenín-Figueroa explains Glissant's concept of the archipelagic: "Relation is an archipelagic, coastal poetics; it is walking along the edge of land and sea, where the 'line' between 'sand and soil' is 'buried.' It emerges from the lived experience of Caribbean peoples: the submerged histories whose markers are the 'chains and balls gone green,' which also inaugurate the transformation from 'land-beyond to land-in-itself'" (97). The paths traced in the texts I discuss illustrate the "dynamic relationship" that shapes Caribbean rootedness, based in both fragmentation and connection, a Relation informed by the archipelagic.[4]

The authors discussed in *The Sides of the Sea* draw upon the complex histories of the Caribbean to enact the "pattern of fragmented Diversity" that marks our present era (Glissant, *Caribbean Discourse* 97). In his study *Against Race*, Paul Gilroy argues that diaspora identities "are creolized, synthesized, hybridized, and chronically impure cultural forms, particularly if they were once rooted in the complexity of rationalized terror and racialized reason"

(129). While he moves toward a theory of relational cultures and culture as Relation that may appear utopian, it is crucial to pause at the roots—the traumas of history that underlie the Caribbean experience. "Roots mark the commonality of errantry and exile, for in both instances roots are lacking. [...] [R]hizomatic thought is the principle behind what I [Glissant] call the Poetics of Relation, in which each and every identity is extended through a relationship with the Other" (Glissant, *Poetics of Relation* 11). Three aspects of Glissant's poetics apply to the ways that Caribbean women writers "pull the sides of the sea together" in their fiction and poetry. First, as Glissant explains, the rhizomatic is both rootedness and multiplicity in Relation. For this study, both specificity of context—location, culture, language, and so forth—and connection through the experiences of colonialism and enslavement, as well as resistance to those forms of oppression, distinguish *and* link the texts. "A spiral retelling, then, is the movement out to the multiple from this economy of the One, but it is rhizomatic in the sense of producing a rootedness in the world" (Hantel 111). *The Sides of the Sea* aims to create a version of this spiraling through the analysis of a range of texts that together embody the rhizomatic nature of Caribbean women's writing from locations throughout the archipelago.

A second element in Glissant's thought is attention to place and space that informs his emphasis on geomorphism, a "model of thinking [...] through which geography and geology transcend the very humanity they are integrating in their poetics" (Mardorossian 991). Mardorossian further explains, "Nature becomes an active, shaping force as testified by [Glissant's] emphasis on the sea rather than the human subject as 'ce qui importe'" (992). And thirdly, Glissant stresses the importance of what he terms "Diversity": "In Glissant's terms, 'the Caribbean Sea does not enclose; it is an open sea. It does not impose one culture, it radiates diversity'" (DeLoughrey, "Routes and Roots," 170). The authors discussed in *The Sides of the Sea* excavate the depths of the Caribbean Atlantic, illustrating Walcott's statement that "the sea is history," revealing the pain and trauma at the core of the Middle Passage and enslavement even as they also embrace the waters as a matrix.[5]

Glissant's concept of Relation is marked by the sea and the boats that brought people through the Middle Passage. He argues that this world of wounding or trauma is chaotic in an unexpected way: "We were circling around the thought of Chaos, sensing that the way Chaos itself goes around is the opposite of what is ordinarily understood by 'chaotic' and that it opens onto a new phenomenon: Relation, or totality in evolution, whose order is continually in flux and whose disorder one can imagine forever" (*PR* 133). He underscores the active quality of this form of chaos: "Passivity plays no part in Relation. Every time an individual or community attempts to define

its place in it, even if this place is disputed, it helps to blow the usual way of thinking off course, driving out the now weary rules of former classicisms" (*PR* 137). As Glissant explains in the first section of *Poetics of Relation*, "The Open Boat," what originated in the ships moving through the Atlantic Triangle is a new form of Relation that connects those of the African Diaspora and resists linearity and colonial binaries. From that "Abyss," as he terms the trauma of the diaspora, comes a shared experience: "Relation is not made up of things that are foreign but of shared knowledge. This experience of the abyss can now be said to be the best element of exchange" (*PR* 8). And the Caribbean Atlantic is the matrix of that experience, as is the archipelago washed by both bodies of water.

Similar to Glissant, Kamau Brathwaite develops theories that focus on the sea, in particular his concept of tidalectics. Elizabeth DeLoughrey states: "By excavating what Kamau Brathwaite refers to as those 'alter/native' signifiers of history that are not overdetermined by the Euclidean grids of the plantocracy, we open up the possibility of rediscovering the past in the continual 'tidalectic' between the Caribbean land and sea" (DeLoughrey, "Routes and Roots" 163). She continues: "To engage island tidalectics is to historicize the process by which discourses of rootedness are naturalized in national soil, and to establish a series of external relationships through transoceanic routes and flows" (164).[6] This study explores those routes and flows, as well as the consequences of historical processes rooted in European imperialism and the Atlantic Triangle Trade, what Brathwaite has referred to as the "African Atlantic" (DeLoughrey, "Routes and Roots" 161). "It [Brathwaite's work in the 1970s] refocused our attention on the submarine (because repressed) unity of Caribbean culture: 'our problem is how to study the fragments/whole'" (Scott 6). The sea, the waters, and the islands form a collective rootedness that is both scattered and interconnected.

Concomitantly, I argue that tidalectics also includes resistance to violence and oppression, in a claiming of space/place and in giving voice through narrative. Llenín-Figueroa connects Glissant to Brathwaite: "Like the sea, which both 'limits and opens,' like Brathwaite's tidalectics [. . .], Relation names an understanding of the centuries-old encounters in the Caribbean archipelagos on the basis of a never-ending spiral with neither definitive, rooted origins nor definitive, rooted endings" (98). She further states: "[R]ather than the sea represented as a featureless image in our hegemonic maps, Relation names a sea saturated with histories whose traces, however, the sea is recalcitrant to yield by means of any conventional 'historical' register that we may be accustomed to" (99). The authors discussed in this study explore a different kind of archive and give voice to what has been silenced by history as written by the colonizers. Together, the texts illustrate Relation that moves across borders and transgresses "norms" imposed by imperial forces.

II.

Until the late twentieth century the Middle Passage remained one of the most horrific memories in US history and concomitantly in African American literature, but also the most unspoken. In seeking literary representations, one could turn to writers from the Caribbean, however, and find numerous poems and novels engaged in re-membering this global event.[7] That is, these texts explore memory, create monuments, and invoke those lost or erased in official narratives. They evoke the multiple meanings of "The Wake," as explored by Christina Sharpe: death, funeral; celebration; awakening; "woke," resistant.[8] The history of what I term the Caribbean Atlantic extends and develops not only from the slave trade itself but also from the ensuing colonialism, enslavement, and plantation system in the Americas (see, for instance, Benítez-Rojo).[9] I situate the Caribbean at the center of that network of experiences stemming from traumas individual and collective, historical and cultural, a nexus that includes gender and sexuality as well as concepts of race as a means of identification. "For the Africans who lived through the experience of deportation to the Americas, confronting the unknown with neither preparation nor challenge was no doubt petrifying" (Glissant, *PR* 5). The founding nightmare of the triangle trade has perpetuated itself in a myriad forms across the centuries, in circles of violence that reach all "sides of the sea" (Brodber) and that rely on heteropatriarchal definitions of relation. The resulting genealogies—and the emphasis placed on legitimacy as well as bloodlines—often participate in the repetition of trauma and the accompanying amnesia that can prevent resistance from taking hold. As many of the writers in this study suggest, however, resistance can succeed and also initiate a process of healing.

Over the past four decades, women writers from the Caribbean have excavated the painful memories, putting words to trauma and beginning the difficult process of analysis called for by Erna Brodber in her novel *Louisiana*, as well as by the other authors from a wide range of nations and backgrounds whom I include in this study. Examining the present situation—both local and global—and its relation to legacies of the past, these authors illustrate not only the complicated routes and roots traced through the Caribbean, linked to Africa, Britain, China, Europe, India, the US, and Canada, but also the potential of this site for transformation in how we conceive of both identity and Relation.[10] The primary focus is on fiction, but I also include book-length poems in the study. The following authors form the core group whose work I analyze: Paule Marshall (Brooklyn and Barbados); Michelle Cliff (Jamaica); Nalo Hopkinson (Jamaica, as well as Guyana and Trinidad); Dionne Brand (Trinidad); Marie-Elena John (Dominica and Antigua); M. NourbeSe Philip (Trinidad); Marie-Célie Agnant (Haiti); Jan J. Dominique (Haiti); Myriam A. J. Chancy (Haiti); Erna Brodber

(Jamaica); Zora Neale Hurston (US); Tessa McWatt (Guyana and Barbados); Mayra Santos-Febres (Puerto Rico); Ana-Maurine Lara (Dominican Republic); Nicole Dennis-Benn (Jamaica). Complicating categories of identification, they show us paths out of and beyond the binarisms embedded in colonialism and its ongoing aftermath. As their texts re-member moments and sites of trauma, beginning with the Middle Passage, they embark on new passages both across old routes and in other directions that stretch beyond an "African Atlantic" and "Black Diaspora" to a more complex understanding of how to "pull the sides of the sea together" (Brodber) in the twenty-first century.

The texts under consideration in *The Sides of the Sea* continually remind readers that the story begins in and invokes the waters. In Lucille Clifton's poem "blessing the boats," a narrative voice addresses those forced onto ships making the crossing through the Middle Passage: "may the tide / that is entering even now / the lip of our understanding / carry you out / beyond the face of fear / may you kiss / the wind then turn from it / certain that it will / love your back may you / open your eyes to water / water waving forever / and may you in your innocence / sail through this to that" (82). Paradoxically, the waters that touch the sides of the Caribbean Atlantic perform both the severing and the connecting of "this" and "that," the space that is shaped by and comes after the Door of No Return. The writers who navigate and excavate the depths chart new territories and create a new kind of cartography. In *A Map to the Door of No Return*, Brand states: "To travel without a map, to travel without a way. They did, long ago. That misdirection became the way. After the Door of No Return, a map was only a set of impossibilities, a set of changing locations" (*Map* 224). Yet the works under discussion together offer a contemporary set of possibilities, as well as performing a re-membering that claims the seas as a way to excavate and claim the trauma.[11]

The Caribbean Atlantic becomes a *lieu de mémoire*, Pierre Nora's term for a site "between memory and history," one imbued with meaning and serving as an archive, though not necessarily of specific events, notable people, or singular moments. One aspect of such a site is its metaphorical nature. Though Nora references many figures and instances from French history, he does not mention France's colonies, nor does he include the slave trade and enslavement as aspects of the history that calls for *lieux de mémoire* in the present (late twentieth century) context of his writing. Nevertheless, the Caribbean Atlantic as sea/ocean, as watery depths and archipelagic birthplace of what is referred to as globalization, performs the functions of the site of memory Nora describes. The desire for—indeed the necessity of—such a repository of history and memory might be seen as a

response to the multiple traumas of the Atlantic World evidenced in Caribbean history and literature.[12]

While we can define trauma as the experience of an event that immediately and radically shifts one's view of the world, that disrupts the world-as-one-knows-it, we must also recognize the connections between trauma and history, moving from the personal to the shared experience. A key element on both the individual and the collective levels is memory. Cathy Caruth observes that "[t]he historical power of the trauma is not just that the experience is repeated after its forgetting, but that it is only in and through its inherent forgetting that it is first experienced at all" (*Unclaimed Experience* 17). Further, she explains, "[H]istory, like trauma, is never simply one's own," but instead, "history is precisely the way we are implicated in each other's traumas" (24). Such is the history explored from multiple, intersecting angles in contemporary Caribbean fiction, born of spaces that themselves hold the traces of the slave trade. As Achille Mbembe says, the slave ship led to a necropolitical geography: "an oceanic death/prison-scape, wherein the border separating life and death became virtually indecipherable" (Childs 279).[13] The sea itself often serves in these texts not only as catalyst but also as repository for the memories of the Middle Passage.

In *Praisesong for the Widow*, Paule Marshall illustrates how travel to the Caribbean for someone of West Indian heritage conjures visions of the slave ships and necessitates a movement through dis-ease to memory and re-connection. And as the narrator of her earlier novel *The Chosen Place, the Timeless People* says of the Atlantic, "What, whom did it mourn? Why did it continue the wake all this time, shamelessly filling the air with the indecent wailing of a hired mute?" (267). Christina Sharpe examines the term "wake" in her study of "Blackness and Being": "In the wake, the past that is not past reappears, always, to rupture the present" (9). The water is funereal, celebratory, conscious, both an awakening and a re-memory. In trauma, again as discussed by Caruth, not only do we see a repetition compulsion but we also hear a voice, "a voice that is paradoxically released *through the wound*" (2, original emphasis). In her re-membering of the diaspora, Michelle Cliff transports us to the horrific waterways that both separate and link continents and countries in the Caribbean Atlantic: "There were no ship tracks, no oceanic ruts where they'd plowed [...]. The ocean closed its books, darkness revealing nothing.... Underneath, underneath right now, the painting came to life. The stunning fish, the brown limbs, the chain...." (*Free Enterprise* 209, 210). The text itself performs a witnessing crucial not only to unearthing trauma but also to initiating a process of healing. In the case of the Caribbean Atlantic, the sea itself becomes the wound through which authors voice ongoing trauma.

III.

Brand states that "[t]he sea was its own country, its own sovereignty" (*Map* 7), and also says that "[i]t can wash away blood and heal wounds" (*Map* 10). In novels such as Agnant's *The Book of Emma*, McWatt's *Out of My Skin*, and Brodber's *Louisiana*, female protagonists bring the wounds to center stage and expose the traumas at their core. This process of re-membering not only delves into archives left hidden but also voices the pain, sometimes passed down through generations, sometimes shared among a collective like the seamen whose stories Brodber's Ella listens to and records on note cards. As Kali Tal notes, in a discussion of trauma,

> Bearing witness is an aggressive act. It is born out of a refusal to bow to outside pressures to revise or to repress experience, a decision to embrace conflict rather than conformity, to endure a lifetime of anger and pain rather than to submit to the seductive pull of revision and repression. Its goal is change. [. . .] If survivors retain a control over the interpretation of their trauma, they can sometimes force a shift in the social and political culture. (7)

Agnant's Emma speaks the history of Haitian women, from the first ancestor stolen from Africa and her grieving mother left behind on the shore, to the descendants raped and suicidal, to Emma herself researching in the archives and determined not to be silenced by those in power. In McWatt's first novel, Daphne discovers her heritage in journals written by the insane man who was both her grandfather and her father, including them in her own narrative before burying the notebooks in order to effect a transformation.

As Carole Boyce Davies notes, "Caribbean ocean spaces cover the unfathomable existences, unknown except by the daring, but nevertheless, still with their own palpable existences and histories" ("Carnivalised" 346). The authors discussed here illustrate the damage done by colonialism, racism, and enslavement, systems grounded in a belief in the dichotomy Man/other, as analyzed by Sylvia Wynter.[14] They evoke the madness that results from trauma, the violence done to women, and the effects on the Black female body in particular.[15] Through forms of Relation, Caribbean women writers imagine ways to resist the "dis place" -ments effected by colonialism and systems of enslavement, established and perpetrated by the plantation system. For instance, M. NourbeSe Philip explores "space inner and outer" from the perspective of Black women: "Space and place—the public space—must be read and interpreted from the point of view of the space between the legs and, in particular, from the perspective of how safe the space between the legs is or will be" (*A Genealogy of Resistance* 76). She continues: "'*Dis place*':

the result of the linking of the inner space between the legs with the other place leading to 'dis placement.' '*Dis place*'—the space between. The legs. For the Black woman 'dis placed' to and in the New World, the inner space between the legs would also mutate into '*dis place*'—the fulcrum of the New World plantation" (76, original italics). While Paul Gilroy's Black Atlantic does not rely on kinship as a central part of its genealogy, and his study for the most part excludes the experiences of women as transatlantic voyagers, authors such as Marie-Célie Agnant, Erna Brodber, Tessa McWatt, and Marie-Elena John perform a transgressive gendering of diasporan identifications with Black women—and the ocean—at the center of the narrative.[16] In these narratives, we witness a movement towards what Huggan describes as "an acceptance of diversity reflected in the interpretation of the map, not as a means of spatial confinement or systematic organization, but as a medium of spatial perception which allows for the reformulation of links both within and between cultures" (125). Individually and collectively, Caribbean women writers occupy the "Demonic Ground" that Wynter discusses in her landmark essay "Beyond Miranda's Meanings," in which she calls for new voices to speak and write from spaces of resistance.

Wynter's theories provide further grounding for *The Sides of the Sea*, spanning from her early article "Novel and History, Plot and Plantation," to a recent conversation with Katherine McKittrick that opens a collection of essays focused on Wynter's work. She states in the 1971 essay that the Caribbean is "the classic plantation area," and adds: "We are all, without exception still 'enchanted,' imprisoned, deformed and schizophrenic in its bewitched reality" ("Novel and History" 95). She further argues that the plot system, by which the enslaved could grow food on land allocated to them by plantation owners, "was like the novel form in literature terms, the focus of resistance to the market system and market values" (99). The "enchantment" refers to the dichotomy Man/other imposed by colonial powers through the Americas, according to which Europeans began "to invent, label, and institutionalize the indigenous peoples of the Americas as well as the transported enslaved Black Africans as the physical referent of the projected irrational/subrational Human Other to its civic-humanist, rational self-conception. The West would therefore remain unable, from then on, to conceive of an Other to what it calls human—an Other, therefore, to its correlated postulates of power, truth, freedom" (Wynter, "Unsettling" 281–82). In her work, Wynter exposes the racism at the heart of the colonial project and aims to unsettle the tenets of that sociogenic model. While there is disagreement about whether one can term Wynter a "feminist" or see gender as a central part of her arguments, we see a model of resistance in her vision of a new definition of the Human that would move beyond binaries and hierarchies.

That vision resonates with the ways that the authors included in this study challenge the norms of what Katherine McKittrick terms "plantation logic."

These writers shape what McKittrick describes as an oppositional geography and a "poetics that envisions a decolonial future" ("Plantation Futures" 5). In *Demonic Grounds*, McKittrick discusses geographies of domination and Black women's geographies that contest those imperial mappings: "the interplay between geographies of domination (such as transatlantic slavery and racial-sexual displacement) and black women's geographies (such as their knowledges, negotiations, and experiences)" (x). She continues: "Geography, then, materially and discursively extends to cover three-dimensional spaces and places, the physical landscape and infrastructures, geographic imaginations, the practice of mapping, exploring, and seeing, and social relations in and across space" (xiii). Demonic grounds are the spaces produced by the plantation, the madness and trauma of those spaces, but also Black spaces (xiv). In and from these grounds, Black women (and I would add Indo-Caribbean women) articulate the effects of domination, expressing their resistance through spoken and written words.

McKittrick connects the theories of Wynter with Glissant's "poetics of landscape" to discuss geography and genealogy in these spaces. "[T]here are genealogical connections between dispossession, transparent space, and black subjectivities" (*DG* xxi). The narratives produced by Caribbean women writers participate in a "naming of place" that Glissant sees as "also a process of self-assertion and humanization, a naming of inevitable black geographic presence" (xxii). Ultimately, McKittrick argues as follows: "The poetics of landscape allow black women to critique the boundaries of transatlantic slavery, rewrite national narratives, respatialize feminism, and develop new pathways across traditional geographic arrangements; [. . . thus] positioning black women as geographic subjects who provide spatial clues as to how more humanly workable geographies might be imagined" (xxiii). In putting authors into an extended dialogue across the archipelagic spaces of the Caribbean Atlantic, this study aims to illustrate what those genealogies and geographies look like in the narratives shaped by women writers.

M. NourbeSe Philip's title *A Genealogy of Resistance* expresses a vision that resonates for *The Sides of the Sea*, replacing genealogies structured by singular root systems with a pattern of Relation grounded in resistance. Philip explains her project: "And I am speaking, giving an account. An enumeration of a genealogy of the Atlantic: a genealogy of bodies. Of ghosts. Of the silenced. Whose voices can still be heard. If you listen closely enough. Of resistance: a genealogy. I would rather be a free woman in my grave. Than a slave" (23). This form may resemble an "antigenealogy," as conceived of by Deleuze and Guattari, "which is not simply an inversion of existing hierarchies. Rather an antigenealogy resists the organizing principles that shape the stable paradigms ordering human culture" (Rohrbach 483). As Philip's words suggest, instead of the conventional image of a tree, or even the rhizome, perhaps the ocean itself offers a more useful

way to perceive an as-yet unformed vision of identity, watery spaces through which these characters trace their histories—elsewhere and otherwise. It is also an archipelagic vision, the Caribbean Atlantic a space of water and islands: "To love! The island is to resist. To love! Is to resist. [...] And so those of the *Maafa* continue. To love! To resist. Creating genealogies of resistance" (*GoR* 29). Philip explains that the word *Maafa* is Swahili for disaster or terrible occurrence: the traumas and lasting wounds of the Middle Passage, the plantation, and the "logic" of those spaces as perpetuated in contemporary sites and structures.[17]

IV.

The connections in the archipelagic spaces of the Caribbean Atlantic disrupt plantation logic and the Man/other binary, as they cross boundaries, dissolve borders, and shape decolonial thinking. "It is a genealogy whose resistance lies in Silence/s. And words. In gaps. And synapses. In discovery. Surprising always in the correspondences and connections" (Philip, *GoR* 28). These spaces become sites of transgression that contest the "enchanting discourse" of colonial and neocolonial structures based in racism and herteronormativity. In *Philosophie de la Relation*, Glissant encourages us to "reconnaître la différence (les différents) comme l'élément premier de la Relation (dans le monde). Le différent, et non pas l'identique, est la particule élémentaire du tissu du vivant, ou de la toile tramée des cultures" (29). This emphasis on difference as the central element in Relation corresponds to Glissant's vision of the Caribbean: "the Caribbean Sea is the sea that 'diffracts.' Since 1492, it has been a preface to the continent . . . a place of passage, of transience rather than exclusion, an archipelago-like reality, which does not imply the intense entrenchment of a self-sufficient thinking . . . but of relativity . . . It does not tend toward the One, but opens out onto diversity" (qtd. in Murdoch 876). Instead of the "One" or unitary identity imposed by European colonization, which attempts to repress and eliminate an "other" (even while depending on that "other" for self-definition), the archipelagic spaces foster passage, difference, and fluidity. Glissant further states: "[La Relation] ne confond pas des identiques, elle distingue entre des différents, pour mieux les accorder. Les différents font poussière des ostracismes et des racismes et de leur monogonies. Dans la Relation, ce qui relie est d'abord cette suite des rapports entre les différences, à la rencontre les unes des autres" (72). Relation thus defined has the potential to dissolve hierarchies and oppression, Glissant argues. And the waters, the archipelagic spaces, serve as roots and routes for this process. As Bonfiglio observes in discussing Glissant, the sea is a gateway to interrelation, independence, and freedom (155).

Sexuality provides powerful examples of difference in Relation, specifically genders and sexualities that resist heteropatriarchy and transgress established norms (and official laws in some locations). While not all chapters of *The Sides of the Sea* engage what might be termed "queer livity" (Smith 2017), transgressive sexuality is a central focus of this study. In her landmark essay "Black Atlantic, Queer Atlantic," Omise'eke Natasha Tinsley discusses "erotic resistance" in the Middle Passage, using Brand's fiction to explicate her argument. Tinsley is one of several scholars whose work informs this section of my book, in which I discuss Spanish-speaking authors whose characters resist gender binaries and/or heteronormative rules as they express their queer identities and desires (gay, lesbian, trans, or otherwise gender-nonconforming). These versions of difference in Relation contest colonial imperatives and their legacies to form transgressive and resistant genealogies.[18]

Michel-Rolph Trouillot's landmark study of power and ways history is produced engages with "the cycle of silences" in that production (26). As Mimi Sheller argues, "One of the greatest silences in Caribbean historiography is the invisibility of queer subjectivities" (3).[19] I situate *The Sides of the Sea* in the expanding scholarship on what Sheller terms "erotic agency" in the Caribbean, works by Thomas Glave, Rinaldo Walcott, Rosamond King, Tinsley, the contributors to *Sex and the Citizen* (edited by Faith Smith), and more. Mayra Santos-Febres and Ana-Maurine Lara, writing out of different cultural and historical contexts and exploring different forms of erotic agency in their fiction, illustrate the ways that silence operates and how transgressive sexualities break those silences.

While Sheller's study focuses on citizenship, albeit challenges to normative definitions of the Caribbean citizen, characters in novels by Lara, Santos-Febres, and others move across borders and create Relation that is more fluid, or boundary-resistant, one might say.[20] I argue that what Sheller envisions is made manifest in these texts: "[we can] begin to see how embodied agents may find ways to engage in transgressive, disruptive, or redemptive performances," she states (18). While these acts of resistance meet serious challenges, they are part of the gathering Thomas Glave invokes, one that is potentially without borders or boundary: "No end, like the sea: that sea from which this all began. Its water still stretches a broad, restless belly out to the sky [. . .]. Quite soon the moon, lumbering up over those hills in the east, will have something to say about all this. But for now, over all that glistening water and beneath it, gathered voices are rising" (10). This study aims to listen to those voices as they repeatedly, forcefully, insistently break the silence.[21]

The revolutionary is located in memory itself, as all of these authors insist, weaving together the dysfunction and violence perpetrated by colonial systems and binarisms with the struggle to re-member differently, to follow passages of return and begin a difficult but necessary analysis. In a discussion of home,

Carole Boyce Davies states: "Writing home means communicating with home. But it also means finding ways to express the conflicted meanings of home in the experience of the formerly colonized. It also demands a continual rewriting of the boundaries of what constitutes home" (129). That continual process of vision and re-vision informs Caribbean women's fiction set in places such as New York City, which "talk back" to island homes and also to the powers that colonized those sites. Resistance and revolution move outward in waves or tidalectic flows from Caribbean locations to North America, and from cities like New York they also follow tides that return to the Caribbean Atlantic and challenge inherited structures that seek to maintain oppression.

OVERVIEW OF THE CHAPTERS

Part One: Plumbing the Depths

Chapter 1, "Watery Webs Weave Stories: Unblocking the Salt Roads in Marshall, Cliff, and Hopkinson," examines representations of the Middle Passage and its ongoing legacies in Paule Marshall's *The Chosen Place, the Timeless People* (1969), Michelle Cliff's *Free Enterprise* (1993), and Nalo Hopkinson's *The Salt Roads* (2003). Cliff depicts the slave trade as "free enterprise" that has little to do with freedom and everything do to with the economic, political, and cultural institutions of the United States, a commodity culture at the center of the country's history. Perhaps the most telling image she selects as vehicle of witnessing and re-membering is an aesthetic representation, Turner's famous painting of the *Zong*, a ship from which traders threw captured Africans overboard in order to collect insurance money on their "cargo." In *The Salt Roads*, Hopkinson explores the Middle Passage and diasporic identities through a multi-layered narrative set in eighteenth-century Saint-Domingue (now Haiti), nineteenth-century Paris, Alexandria and Jerusalem in the fourth century CE, and in the mind and body of an African ancestress (and contemporary *loa*), Ezili. These three texts perform the witnessing crucial not only to unearthing trauma but also to initiating a process of healing.

In chapter 2, "Oceanic Ossuaries: Caribbean Women Reading the Bones," three texts by Caribbean women serve as testimony and detection, excavations of bones that trace histories of the Atlantic World from the Middle Passage, through the Caribbean, to what Brand calls a contemporary "ossification of the world." Beginning with the originary globalization of the triangle trade, in *Zong!* (2008), NourbeSe Philip performs what she calls an "exagua," to seek in "the bone beds of the sea" the buried history, to mourn and also to express the inexpressible. In this book-length poem, bones

occupy an underwater grave, leaving no traces for the present. In language captured from the brief record of the British court case, Philip names the 150 Africans thrown overboard to claim insurance for lost property and gives voice to those buried in the sea. Meanwhile, the novel *Unburnable* (2006), by Marie-Elena John, uncovers a history of (in)justice that haunts a forest of skeletons in Dominica, the formal archive destroyed, leaving a tangle of false testimony and justice miscarried. Brand's book-length poem *Ossuaries* (2010) charts the fragmentation and commodification of the contemporary moment, intertwining the narrative of a Black woman living underground after her participation in 1970s resistance movement with a larger evocation of "this big world, our ossuary." Employing language and narrative to undo the legal record and to let the bones speak, these texts offer a foundation— the speaking bones reestablishing Relation—on which to build a new house for Caribbean Studies in the twenty-first century.

Part Two: Voicing the Wounds

Chapter 3, "Words to Heal the Wounds: Amnesia, Madness, and Silence as Testimony in Haitian Women's Fiction," discusses contemporary novels by Haitian women, texts that ground themselves in a larger historical and cultural context as they also explore the relation between past and present, both in Haiti and in Dyaspora. As Marie-Célie Agnant states when discussing her novel *Le livre d'Emma* (2008), "folie = 'langue-cri' pour dire la révolte et le désarroi engendré par le poids du passé, de la mémoire, et de ses résonances sur le présent." ("madness = 'tongue-cry' to speak the revolt and disarray produced by the weight of the past, of memory, and of its echoes in the present" (Ghinelli 148, my translation). Thus, while silence and madness might appear to be a negation of language, instead they become a refusal of the colonizer and an affirmation of the individual (woman) who resists on behalf of female generations before her as well as for herself and her offspring. In Agnant's novel, as in Jan J. Dominique's *Mémoire d'une amnésique* (2004), the narrative is told through multiple perspectives and voices, such that forgetting becomes instead an act of constructing memory syncretically and relationally.

A witnessing "I" that shifts identity throughout these and Myriam Chancy's *The Scorpion's Claw* (2005) provides testimony both personal and collective, challenging official history even as this creative process shapes a new national identity located firmly in female experience and women's voices. The titles of both Agnant's and Dominique's novels underscore the role of writing as testifying, the production of histories from stories both personal and national. The role of exile in this specific "dyaspora" is also explored, as these Haitian authors write from the remove of Canada or the US. Haunted by the Middle Passage

and a history scarred by colonialism and then the neocolonial presence of the US in Haiti from 1915 to the present, postearthquake, these narratives are also guided by the ancestors and by figures such as the Métrès Dlo and Ezili/Erzulie.

Chapter 4, "'I Hear the Voice': Performing the African Diaspora in Brodber and Hurston," explores the connections between ethnographic fiction and fictional ethnography, as well as music and vodun/voodoo, widening the scope of my study to include a dialogue between a contemporary Jamaican author and a central figure of the Harlem Renaissance. In what becomes a multi-vocal production, we discern what Glissant has termed "transversality," as multiple paths form a "dazzling convergence of here and elsewhere" (*Caribbean Discourse* 100). These texts, Erna Brodber's *Louisiana* (1994) and a work with which it clearly engages in dialogue, Zora Neale Hurston's *Mules and Men* (1935), can be read together as bookends: two different yet complementary approaches to re-membering the diaspora and voicing it in complex narratives. Though Brodber, a sociologist from Jamaica, writes a fictive narrative while Hurston compiles a collection of folk tales and voodoo embedded within her own narrative of anthropological research, both texts underscore the centrality of performance to their creation—and to the creation of a diasporic identity. In a dialogic process of constructing a collective identity rooted in the experiences of those of African descent, both authors examine different kinds of performativity—authentic, inauthentic—as well as the motivating factors in such an endeavor. Louisiana, in particular New Orleans, offers a site well-suited to the syncretism that marks both texts. Individually and (especially) collectively, these texts frame the larger experience of diaspora and "pull the sides of the sea together" (Brodber 148).

Part Three: Unsettling Borders

Chapter 5, "Mapping the Body: Caribbean Migrations in Tessa McWatt's Fiction," examines the ways that Caribbean migrations are innovatively depicted in three novels by Tessa McWatt, fiction in which interlocking concerns with Relation and geography are reflected in and on bodies that have traced paths throughout the Caribbean, North America, and England. McWatt's narratives weave together her native Guyana, Barbados, London, and locations in Canada—most often Toronto but also Montreal. Her fiction explores family histories, often filled with violence and loss, and the means by which a character pieces together an identity from the fragments of maps carried within traveling bodies. Each text uses a heuristic device—the moon's cycles, music, food—to structure the journeys of characters seeking to fill in the gaps created by a combination of colonialism in the Caribbean and subsequent migrations of Caribbean subjects. Through her mapping of Caribbean migrations, McWatt

explores the intersections of family and geography, of bodies and memory, of Caribbean relations and locations of the self.

In *Out of My Skin* (1998), the protagonist Daphne negotiates multiple paths of Relation, as she searches for her biological family in contemporary Canada, reads the journal of her maternal grandfather who went insane in Guyana, and becomes tangentially involved in events surrounding the standoff at Oka between indigenous peoples and the Canadian government. *Dragons Cry* (2000) traces Relation across and between bodies in Guyana, Barbados, and Canada, with gestures towards both the US and England. And *This Body* (2004) connects a present-moment London with both Toronto and Guyana in the protagonist's past, as borders blur and geographical spaces bleed into one another. In all three novels, the characters concern themselves with issues surrounding fragmented genealogies—violent loss, suicide, childlessness, adoption—their bodies carrying traces of Caribbean history both personal and communal. The paths that McWatt maps move from excavation and burial of the past, to personal mourning and forgiveness, to both a return "home" and an outward movement in the creation of new relations and an acceptance of "this body" as the key site of identity and healing.

Chapter 6, "Caribbean Boundary Crossings: Undoing the Violence of Borders in Santos-Febres and Lara," analyzes how Mayra Santos-Febres and Ana-Maurine Lara explore "being Caribbean" in narratives that both illustrate and challenge the violence born of borders, whether those of nation, of race/ethnicity, of class, of gender and sexuality, of faith, or of language. In *Sirena Selena vestida de pena* (2000) and *Erzulie's Skirt* (2006), respectively, Santos-Febres and Lara employ the figures of La Sirena, La Mar, and Erzulie to invoke multiple passages across the Caribbean, beginning with the Middle Passage and continuing through contemporary travel into, out of, and especially within the geographical and cultural spaces termed "Caribbean." Exposing and disrupting binarisms, both texts demonstrate the damage wrought by adherence to prescribed boundaries, illustrate the subversive potential of queer identities, and suggest the healing that such nonnormative affiliations can initiate in a queer un-doing of borders.

Santos-Febres's *Sirena Selena* defies the boundaries of conventional categories of masculine and feminine, even as the characters travel between Puerto Rico and the Dominican Republic, dreaming of New York City as magical destination and of an elsewhere unconfined by national borders. In an airplane above the Caribbean Sea, the transgender performer Martha and her new "daughter," Sirena Selena, experience a liminal safety, in contrast to the threats posed by passports, taxes, customs, barriers, and accompanying physical assault and violence. In their "wanton Caribbean," we encounter a dizzying slippage of nouns, names, and pronouns, watching the fluid performances of these *transformistas*. In the

face of danger, loss, rape and other traumas, La Sirena is the singing voice that offers stories, connects the seemingly disparate, and suggests a potential healing.

In *Erzulie's Skirt*, Lara interweaves the narrative of a long-term relationship between Haitian Miriam and her Dominican lover Micaela, with dream sequences linking their lives in the Caribbean to roots in Africa, the Middle Passage, and enslavement. We witness the violence of borders, including that of the Massacre River between Haiti and the Dominican Republic, and of another middle passage when the women unwittingly pay for a boat trip that takes them not to a better life in New York, but into the hell of sex trafficking in Puerto Rico. Erzulie and La Sirène, *loas* of the sea, counter the trauma of this contemporary passage and offer spiritual power to survive the extended violence of sex slavery. The queer desire of the two *brujas* (so perceived by their neighbors when they escape and resettle in the Dominican Republic) challenges the brutal impulses to impose heteronormative boundaries and to force Relation into rigid categories. In both texts, younger individuals represent a next generation who will continue the twinned processes of transgression and healing and offer a vision of queer diasporas that may undo the violence of borders.

I return to Glissant, whose words reverberate throughout this introduction. In exploring histories and identities that initially appear fragmented and dispersed, he says, Caribbean writers can discover a subterranean unity: "We are the roots of a cross-cultural relationship" (*CD* 67). Islands and sea form an archipelagic Relation: "Caribbean insularity emerges not as parochial, fixed, and self-enclosed but rather as a crucial component of a terraqueous planet whose land- and water-spaces are connected by a fundamentally archipelagic logic. The island becomes a rim opening onto the sea, in a rhythm and tension between movement and settlement, plantation colony and ship, island and mainland, land and water" (Stephens 12). The authors discussed in *The Sides of the Sea*, whose texts explore the Caribbean Atlantic, together shape an understanding of this "terraqueous planet."[22]

They also claim both the seas and the islands, these archipelagic spaces of the Caribbean Atlantic, and counter the damage that Aimé Césaire describes in his *Notebook of a return to my native land*: "Islands / that are scars upon water / islands that are evidence of wounds / crumbled islands / islands that are waste paper torn up and strewn / upon the water / islands that are broken blades driven into the / flaming sword of / the sun" (qtd. in Wynter, "The Pope Must Have Been Drunk" 34). The inspiration for the title of this study, Erna Brodber's novel *Louisiana*, provides images of the legacies of trauma but also the potential for creative revelation and ongoing

revolution. As Brodber's narrator states, analysis serves as the key step in a process that can embrace both trauma and resistance and perhaps lead to revolutionary new visions of Relation: "People's memory of events close in time to them, is poor. Poorer still if it is a painful memory. They don't want to remember. The failure [. . .] is just so painful and difficult to handle. It inhibits analysis. And putting words on things means analysis. People share post analysis. They file things away until their emotions can handle them" (*Louisiana* 149). The female characters in this novel are shown as agents of connection, "wanting to pull the sides of the sea together, wanting to sew them little islands together and tack them onto New Orleans" (148), and Louisiana herself performs both an exorcism and a curing—a version of *myal*—going back to the place of pain and allowing the sufferer to reexperience the circumstances and then move in new directions. That practice of potential healing resonates throughout this study of women writing diaspora across the Caribbean Atlantic.

Part One
Plumbing the *Depths*

Chapter 1

WATERY WEBS WEAVE STORIES

Unblocking the Salt Roads in Marshall, Cliff, and Hopkinson

I.

A silent, fugitive chasm, the Middle Passage stands as the originary trauma of the modern world, in the Caribbean, in the US, and throughout the Americas. A crossing through the Door of No Return and a passing from one identity to another, the Middle Passage informs diasporic experience, testifying to the birth of both people and places, creating new temporal and spatial relationships. Édouard Glissant expresses this process of loss and (re)birth: "'Je te salue, vieil Océan!' You still preserve on your crests the silent boat of our births, your chasms are our own unconscious, furrowed with fugitive memories. Then you lay out these new shores, where we hook our tar-streaked wounds, our reddened mouths and stifled outcries" (*Poetics of Relation* 7).[1] While partial records of the horrific journey exist, for instance in Olaudah Equiano's narrative and in the logs of ship captains, for decades it remained "unspeakable, unspoken" in poetry and fiction.[2] Robert Hayden's landmark poem "Middle Passage" (1945) broke this silence, but only more recently have other writers begun to imagine and re-member—that is, to capture the fugitive memories, to invoke those lost to the sea, to point to the ongoing legacies of the triangle trade, and thus to give voice to wounds, shape new relations, and initiate a potential healing.[3] "**Each time, the aether shows me more stories. Seas breathing deep in their waters, carrying**

ships on their backs. Whole histories, of people, of places. [. . .] **I splash in joined tributaries of lives, watery webs that connect each one's story to each**" (Hopkinson, *The Salt Roads* 212, 213, bold in original).[4] In speculative fiction such as Nalo Hopkinson's *The Salt Roads*, they also begin to imagine a path to futurity.

Though one can travel to the west coast of Africa and visit the Door of No Return, both that space and the passages to which it led do not exist as presence so much as gaping cavity. Dionne Brand provides an extended meditation on this conundrum:

> The door exists as an absence. A thing in fact which we do not know about, a place we do not know. Yet it exists as the ground we walk. Every gesture our bodies make somehow gestures towards this door. What interests me primarily is probing the Door of No Return as consciousness. The door casts a haunting spell on personal and collective consciousness in the Diaspora. (*A Map to the Door of No Return* 25)

The Door, framing the ships and ocean onto which it opened, occupies a paradoxical space of endings and beginnings, absence and embodiment, ghosts and lived experience in the "New World" shaped by colonialism and capitalism. Invoking Yemaya, the African goddess of the sea, Brand further states: "The ocean and the planet it weeps around, these are the only powers I truly respect" (*Map* 171).[5] The Caribbean lies at the center of the Middle Passage, defined by and defining that experience and the identities, relations, and cultures that it spawned.[6] Boats become bellies in an awe-full birthing. Jonathan Smith describes this paradoxical consciousness: "the captives—blacks, Africans, Negroes, etc.—must have understood this catastrophic journey as both a final and an *originary* (and originating) moment" (74, original emphasis). He also poses powerful (if rhetorical) questions about identity: "the most telling analysis of race must attend to issues of space, geography, mapping, and positioning. [. . .] After all, what is it that brought and bound black people together in the first place? Was it not the fact that we were literally *bound* together and forced, despite any differences, to share the same confining dark spaces?" (63, original emphasis). In this chapter, I argue that for writers from the Caribbean, a reclaiming of the seas is crucial in the process of envisioning Caribbeanness and developing a diasporic consciousness.

In representing and re-membering the Middle Passage, writers such as Paule Marshall, Michelle Cliff, and particularly Nalo Hopkinson address the blockages, the lack, the absences, and what Glissant terms the "Abyss."[7] He invokes the sea as one of the three experiences of this abyss faced by those torn from Africa and shipped to the Americas:

Whenever a fleet of ships gave chase to slave ships, it was easiest just to lighten the boat by throwing cargo overboard, weighing it down with balls and chains. These underwater signposts mark the course between the Gold Coast and the Leeward Islands. Navigating the green splendor of the sea [. . .] still brings to mind, coming to light like seaweed, these lowest depths, these deeps with their punctuation of scarcely corroded balls and chains. (*Poetics of Relation* 6)

Marshall's novel depicts the carnivalesque performances that reenact the passage in the stomping of chained feet and lamenting voices, while Cliff incorporates Turner's painting of a slave ship sailing over waters where chained limbs are attacked by sharks. Marshall and Cliff provide stepping stones that suggest new paths, exploring archives and seeking connections both spatial and temporal. Hopkinson takes readers into the abyss itself, the "salt roads" and their cancerous blockages. Representing and re-membering the Middle Passage in depth, her novel *The Salt Roads* addresses the blockages, the lack, and the absences, looking to Relation to shape new stories in diaspora and to envision Black futures.[8]

In her meditation on the Door of No Return, Brand distinguishes between migrations, which "suggest intentions or purposes. Some choice and, if not choice, decisions," and the departures of those taken from Africa: "But the sense of return in the Door of No Return is one of irrecoverable loss of those very things which make returning possible. [. . .] The door signifies the historical moment which colours all moments in the Diaspora" (24).[9] In *Free Enterprise* (1993), Cliff envisions US history as inextricably entangled with that of Africa and of the Caribbean. In *The Chosen Place, the Timeless People* (1969), Marshall's fictive Bourne Island figures this intersection of places, identities, and stories: approaching from the air, a traveler remarks its location in the West Indies, off to the east of the other islands, washed by the Atlantic ocean as well as the Caribbean Sea, the furthest edge or "bourn" of the Americas, facing in multiple directions. It is both cusp and meeting point, of Africa, Europe, and the Americas, as well as of memory and forgetting, loss, death, and rebirth.[10] In *The Salt Roads* (2003), Hopkinson interweaves the stories of women in Saint-Domingue (later Haiti), France, and Egypt with the voice of the African deity Ezili, while also underscoring the extreme difficulty of re-membering and connecting those blocked memories. Ultimately, Hopkinson offers an Afrofuturist narrative to pull the sides of the sea together in the wake of the Middle Passage.

Although Marshall refers repeatedly to the Middle Passage and the concomitant experiences of enslavement, she roots the narrative in a single island at a specific moment in the twentieth century.[11] On the Atlantic side of Bourne Island, the water is dangerous, the reefs threatening, "with a sound like that of the combined voices of the drowned raised in a loud unceasing lament—all those,

the nine million and more it is said, who in their enforced exile, their Diaspora, had gone down between this point and the homeland lying out of sight to the east. This sea mourned them" (106). Cliff experiments more with time and space, creating a multidimensional confrontation with the slave trade, the systems of colonialism and capitalism that undergirded the Atlantic World, and the lasting legacies of those violent institutions. While Marshall's text primarily gives *voice* to the Middle Passage, Cliff's novel turns to *embodiment* in its imagining of ocean crossings. In *The Salt Roads*, Hopkinson both re-members bodies and records voices in her speculative rendering of the experiences, drawing even closer geographically and temporally to the Middle Passage, as her characters contend with the blockages it formed.[12] Born in Jamaica, spending her childhood in her father's home country Guyana, as well as in Jamaica and Barbados, then the US, subsequently transplanted to Toronto for thirty-five years, then returning to the US, Hopkinson is ideally situated to perform these crossings.[13] To re-member the African Diaspora and the passages that created it may necessitate a fundamental experience of displacement, a questioning of "home" and of "family."[14] As Hopkinson makes particularly clear, that process also requires a direct confrontation with the cancerous blockages inherent in the Salt Roads.

II.

Written over fifty years ago, Paule Marshall's *The Chosen Place, the Timeless People* explores memory and identity, time, space, and place, topics that also inform more recent texts about the African Diaspora and its roots/routes in the Middle Passage and enslavement. The semichaos of Merle Kinbona's room, containing "memorabilia" of many lifetimes, reflects the time-laden quality of the fictive Bourne Island, a place "where one not only felt that other time existing intact, still alive, a palpable presence beneath the everyday reality, but saw it as well at every turn, often without realizing it. Bournehills [. . .] might have been selected as the repository of the history which reached beyond it to include the hemisphere north and south" (402). A repository, however, suggests that the history is easily accessible and legible, while as Brand argues and these fictional engagements with the Middle Passage illustrate, blockages form toxic impediments. Marshall's novel begins the kind of archival exploration and excavation that Saidiya Hartman brilliantly performs in her own creative investigations of enslavement, the Atlantic Triangle, and figures such as "Venus."[15]

Marshall's narrative posits the leader of a slave revolt, Cuffee Ned, as a medium through whom the characters and the text itself give voice to the repressed of the Middle Passage. Cuffee Ned is referred to as "both seer and shaman to the people, the intermediary between them and the ancient gods" (284). The

workers in the cane factory on present-day Bourne Island, descendants of the enslaved, repeat the abyssal experiences of their ancestors: "the disembodied look to the men at work there, who never failed to call to mind ghosts confined to the dark hold of a ship set on some interminable voyage" (221).[16] The factory replicates the plantation, itself an iteration of the slave ship. In her study of the slave trade, Sowande Mustakeem argues that "the Middle Passage comprised a violently unregulated process critically foundational to the institution of bondage that interlinked slaving voyages and plantation societies" (3). Marshall captures the way Bourne Island's present has been shaped not only by enslavement but by the Atlantic crossing itself. In yet another reference to the Middle Passage, when the Bournehills residents march at Carnival with their float representing Cuffee Ned's act of resistance, their feet make an "awesome sound":

> It conjured up in the bright sunlight dark alien images of legions marching bound together over a vast tract, iron fitted into dank stone walls, chains—like those to an anchor—rattling in the deep holds of ships, and exile in an unknown inhospitable land—an exile bitter and irreversible in which all memory of the former life and of the self as it had once been had been destroyed. (282)

Marshall, one of the first contemporary writers to directly evoke the Middle Passage, shows how difficult a reverse passage proves to be, an example of the "inner anxiety" of the text (Gikandi 177, 179) and the book's double vision (DeLamotte). Yet the final image of this crowd suggests that Cuffee Ned's story provides connection to the past but also the power to challenge its ongoing legacies of oppression and exploitation. "And more than ever now that dark human overflow [. . .] resembled a river made turbulent by the spring thaw and rising rapidly—a river that if heed wasn't taken and provision made would soon burst the walls and levees built to contain it and rushing forth in one dark powerful wave bring everything in its path crashing down" (Marshall 289–90). This image of waters bursting forth suggests the possibility of breaking through the blockages of trauma to allow for both destruction and reconnection, as will be called for by Hopkinson's characters. In Marshall's text, this tumultuous river inspired by Cuffee Ned does indeed bring down walls, specifically for the two main female characters, Merle Kinbona and Harriet Shippen.

Marshall comments on creating the character Harriet, whose family—the Shippens—made their money in the slave trade: "An in-depth study of just how these American families were very directly involved—not only the men [. . .]— but also how the women from respectable families of the North [. . .] had their side trade in slaves" (Pettis, "MELUS" 125). Through Harriet, Marshall reminds her audience of how the deep roots of enslavement in the Northeast affected

and implicated white women in the institutions steeped in anti-Blackness and racist practices. The sea surrounding Bourne Island serves as a voice for the nine million and more dispossessed, victims of an enterprise based in capitalism and commodity exchange. In *Slavery at Sea*, Mustakeem underscores the centrality of water to the "manufacturing" of enslaved bodies:

> With the body being the primary portal to recount a global slaving past, water here takes on equal and even greater importance as an axis and looming bridge between worlds and a depository of dreams, planned routes, and most of all littered and dead bodies no longer deemed worthy of preservation. All of this shows the integral relationship of people and the sea that many easily miss through disparate and thus separate histories, historiographies, and ongoing discourses in studies of slave trade, shipping, and maritime culture. (185)

That Harriet Shippen eventually commits suicide in the waters surrounding Bourne Island underscores the toxic, lethal nature of that entire undertaking.[17]

If Cuffee Ned is the link to the past of enslavement and resistance, and Harriet perpetuates the damages of commerce and colonialism, Merle connects communities on Bourne Island and also its antagonistic "motherlands," England and Africa.[18] In placing a Black woman at the center of the text, Marshall offers an early version of what Sylvia Wynter discusses as the coming-to-voice of "Caliban's Woman," who was omitted from the historical narrative by both colonizers and colonized. Wynter discusses what she terms "demonic ground": "This terrain, when fully occupied, will be that of a new science of human discourse, of human 'life' beyond the 'master discourse' of our governing 'privileged text,' and its sub/version. Beyond Miranda's meanings" ("Beyond" 366). Merle's most salient trait is her incessant *talk*, a refusal to be silenced, which Hopkinson's Ezili will amplify exponentially.[19] Merle's personal history also reflects the violent relations wrought by colonialism, as well as the difficulties of moving beyond categories that rely on colonial paradigms grounded in heteropatriarchy and racism. The daughter of a white British landowner and one of the Black women employed on his estate, witness to that woman's murder by the man's white wife, Merle embodies a history of sexual exploitation and racialized violence. Not knowing her mother, Merle was initially raised by her father and sent to university in England, where her experiences led to a mental and emotional breakdown that continues to haunt and destabilize her. According to Merle, she was traumatized by a sexual liaison with a white British woman that replicated the relationship between "owner" and enslaved. The text describes this transgressive sexuality as "rotten," for instance in Merle's

acceptance of money from this unnamed woman even after her subsequent marriage to an African man, Ketu. In talking about how Ketu found out, divorced her, and took full custody of their daughter, Merle cries out: "It was as if an old wound deep at her center that had never completely healed, but had, at least, remained dormant over the years, quiescent, had suddenly begun to lance her again" (334). While the "wound" may refer to her pain at being rejected by Ketu and separated from her daughter, it also signifies a queer form of loss and grieving.

Merle gives every indication of sharing her husband's disgust at female same-sex intimacy, as she recalls how he looked at her, as if "I stood for the worst that could happen to those of us who came to places like England and allowed ourselves to be corrupted" (334). Marshall's depiction of this lesbianism has drawn sharp criticism for its homophobia, and it does reinforce heteronormative attitudes.[20] Though *The Chosen Place, the Timeless People* does not silence "transgressive sexuality," as do many Caribbean-centered texts of the twentieth century, the novel follows a familiar pattern: "same-sex desire is always located outside the Third World subject as a corrupting force to be reckoned with" (Keizer 92).[21] This legacy of colonialism prevents Marshall's novel from stretching as far as it might otherwise towards a decolonizing vision for the Caribbean, "a culture that can reach across the sea and the colonial histories dividing the islands and recognize other insurgent histories—Haiti's, Cuba's—as its own" (Keizer 96). In expressing those cultural patterns and testifying to the multiple traumas, Merle opens old wounds and demonstrates the need for a further and more intentional excavation of the watery depths.

At the end, the narrative gestures towards a reverse passage, a journey to Uganda, where Merle hopes to be reunited with her daughter. After divesting herself of material possessions and personal practices inherited from the tangled colonial history of Bourne Island, she will travel south to Trinidad, then to Brazil, where the city of Recife reaches out into the Atlantic toward Africa, "as though yearning to be joined to it as it had surely been in the beginning" (471). Yet, in keeping with the novel's "double movement" (Gikandi 173), the final vision undercuts such a notion of return. Pyre Hill appears to burn still, a conflagration unextinguished over the centuries, and the road swelling with rain threatens to "take a walk" (472), to become an impassable river. Though Merle seeks her lost daughter, that quest in itself cannot undo the blockages or heal the larger wound. "Very few family stories, few personal stories have survived among the millions of descendants of the trade. Africa is therefore a place strictly of the imagination—what is imagined therefore is a gauzy, elliptical, generalized, vague narrative of a place" (Brand, *Map* 25). The challenge to re-member and to address what Hopkinson's Ezili calls a cancerous growth continues into the later twentieth century and the twenty-first.[22]

III.

Michelle Cliff has said of Caribbeanness that "the Caribbean doesn't exist as an entity; it exists all over the world. It started in diaspora and it continues in diaspora" (Schwartz, "Interview" 597). *Free Enterprise* seeks to uncover lost versions of history—the official one is "a cheat"—but it refuses to accept the possibility of going back.[23] This refusal resonates with Brand's words challenging any notion of the African Diaspora as an experience of migration: "There is a sense of return in migrations—a sense of continuities, remembered homes [. . .]. But the sense in the Door of No Return is one of irrecoverable losses of those very things which make returning possible. A place to return to, a way of being, familiar sights or sounds, familiar smells, a welcome perhaps, but a place, welcome or not" (*Map* 24). Brand discusses the Door as "consciousness," always connected to a history that both defines and eludes the Black diasporic subject and that makes Black experience in the Americas a "haunting." She also states: "The door signifies the historical moment which colours all moments in the Diaspora. [. . .] The door exists as an absence. A thing in fact which we do not know about, a place we do not know" (*Map* 25).[24] In *Free Enterprise*, Cliff turns her own historical sensibilities into a kaleidoscopic lens that illuminates shards, fragments, and also connections and Relation born of the Middle Passage.

One historical figure Cliff includes is Mary Ellen Pleasant, a Black woman who became an entrepreneur in nineteenth-century San Francisco and who played a role in John Brown's attempt to free enslaved people in Virginia.[25] In an imagined conversation between these two, Cliff appears to reject a return to "roots":

> "Neither will it do us any good, as some have suggested, as my own, exhausted father did, to take a boat back to Africa in search of home, as if a reverse passage can reverse history. The time has passed for all of that. We are no longer African. We are New World people, and we built this blasted country from the ground up. *We are part of its future*, its fortunes.
> We belong in the here and now." (150–51, emphasis added)

Nevertheless, while *Free Enterprise* refuses to make that return voyage, the narrative does travel in time and space to connect the US to the Caribbean, centering on the catastrophe of the Middle Passage. The text repeatedly approaches the blockages, exhibiting a version of what Brand refers to as an "existential dilemma": "To the descendants of the nineteenth-century Indian and African Diaspora, a nervous temporariness is our existential dilemma, our descent quicker, our decay faster, our existence far more tenuous: the routine of life is continually upheaved by colonial troublings. *We have no ancestry except the black water and the Door of No Return. They signify space and not land*" (*Map*

65, emphasis added). The black water is the space of birth, what Glissant terms the abyss, containing past, present, and future.

Conversations between Mary Ellen Pleasant and another Black woman, Annie Christmas, serve as scaffolding for the narrative, both characters with roots in the Caribbean. While Annie lives near the Mississippi, in a house at the "edge," her thoughts focus on her earlier years growing up in Jamaica, in a family of *gens inconnus*, or those with light skin who belonged to the "better class" (8).[26] Having fled the island to escape the ways that environment colonized her mind, Annie thinks constantly of Jamaica, while also claiming her "placelessness" (19). Mary Ellen, meanwhile, recalls her father who ran contraband: Africans runagate, rebels whom he protected and delivered to Martha's Vineyard and from there to a maroon community on the US mainland. Her mother, Quasheba, lived in the Sea Islands and worshipped Yemaya, mother of the seas, whose anger she explained to her daughter: "Too many of her children are at the bottom of the sea," she told Mary Ellen (126). Similar to Annie, who cannot return home, Mary Ellen decides that Yemaya and other African gods are "helpless," just "beautiful stories": "Against the endless canvas of sails, the passing of cargo, the genius for detail, this pretty picture was powerless" (128). Such a dismissive assessment contrasts to the central role the goddess Ezili plays in *The Salt Roads*, just as the buried queer relations in Cliff's novel and the homophobia in Marshall's are challenged and replaced in the radical visioning of Black female embodiment and sexuality in Hopkinson's novel.

While Marshall invokes performances of both the Middle Passage and resistance in *The Chosen Place, the Timeless People*, Cliff turns to an aesthetic evocation of the Salt Roads, specifically to a painting by J. M. W. Turner that was originally titled *Slavers Throwing Overboard the Dead and Dying: Typhoon Coming On* (1840). The depiction is based on an actual ship, the *Zong*, and a case in which traders threw captured Africans overboard to collect insurance money in a perverted concept of investment.[27] In a mise en abyme that incorporates the painting into the novel's plot, Mary Ellen Pleasant wonders to herself about the financial backing of the ship and then examines the artwork itself, which shows arms and a leg, severed and bearing chains, sinking in the waves alongside bright fish: "I was grateful that the artist [Turner] had portrayed it thus, indicating the horror of the thing aslant. By these few members, and a reminder of their confinement" (73). Like Marshall, Cliff chooses to retell "aslant," not returning to the Middle Passage itself but to its representations and ramifications in the nineteenth and twentieth centuries. The blockage remains in place despite the partial opening provided by the inclusion of Turner's painting. I argue that Glissant's invocation of and to the chains-gone-green underwater, which weaves through his explanation of the Abyss, offers a more direct engagement with the Middle Passage, which Hopkinson explores further in *The Salt Roads*.[28]

Nevertheless, Cliff is focusing attention on the Middle Passage at a moment (the 1990s) when it was largely ignored by contemporary novelists and poets.

Another kind of invisibility, shaped by white denial of racism past and present, is illustrated in Cliff's character Alice Hooper, the new owner of the painting in 1874. In a letter to Mary Ellen Pleasant, Alice expresses confusion and regret at not speaking up against the trades both in and of the artwork that she has just purchased. A multilayered palimpsest is grounded in the colonial ideology of Man/other, as theorized by Wynter, Alice owning a painting that represents and thus "owns" the traffic in humans that supported and informed the Atlantic World and capitalism. Yet, at the thought of her own complicity in enslavement, Alice represses guilt: "The whole thing could become a game. For if I cut every link to every enterprise which might have supported the traffic in human souls—sold every piece of stock in every maritime company, for example—I would still have to reckon with the mills, the question of property in and of itself" (78). Cliff directs awareness to what has only become more glaringly clear in the almost three decades since *Free Enterprise* was published: the United States is irrevocably built on enslavement; once one traces the paths backward, not even as far as Africa but simply to the nineteenth century, complicity is rampant, willed ignorance its support.[29] Cliff's Alice Hooper pronounces beliefs that remain prevalent in the twenty-first century, when she writes to Mary Ellen that her desire to have the latter explain the painting to a dinner gathering of white folks was due to "a sense of you as someone all too familiar with the horrors of slavery and the Middle Passage. [. . .] I was prevailing on you to educate us. To be our authority" (78). The Turner painting hangs in a museum in Boston, aesthetic testimony that requires contextualization and storytelling such as Cliff's novel begins to provide, in order to break "the silence" (65), unblock the Salt Roads, and address this originary wound in the Atlantic World.[30]

A silent exchange between Pleasant and Malcolm X adds an Afrofuturist note to Cliff's novel, imagining a world in which the nineteenth-century entrepreneur meets a twentieth-century revolutionary: "Why didn't I know you? About you? My point exactly" (142). Mary Ellen stands at a temporal and spatial juncture, thinking back to her mother and maternal grandmother in the Sea Islands, who watched the traffic from the Guinea coast, and looking ahead almost a century to another radical leader. Yet Cliff never takes the characters back to Africa, only to an aesthetic representation of the horrific waterways, their archive of the trade in human beings. A final sequence in *Free Enterprise*, situated on a boat off the eastern seaboard of the US, interweaves threads of diasporic experience: "The ocean was impassive. There were no ship tracks, no oceanic ruts where they'd plowed, like the ruts across the High Plains, High Desert [. . .]" (209). It continues:

The ocean closed its books, darkness revealing nothing. [. . .] Underneath, underneath right now the painting came to life. The stunning fish, the brown limbs, the chain. In the darkness, in the silence at the bottom, bones comminuted into sand, midden becoming hourglass. Here and there a gold guinea shone, the coin minted fresh for the Trade, surface impressed by an African elephant. [. . .] She felt everyone behind her. In the here and now. (210)

These Salt Roads, with their oceanic ossuaries, littered with and by the exchange of capitalism, are spaces of both absence and presence. "The one door transformed us into bodies emptied of being, bodies emptied of self-interpretation, into which new interpretations could be placed. Phantom, chimera, vision, Ellison's invisibility" (Brand, *Map* 93). Cliff's text is a palimpsestic invocation of the Middle Passage, though one remembered "hardly," barely, and with difficulty.

IV.

In *The Salt Roads*, Nalo Hopkinson centers the narrative in the sea and in Black women's bodies, signaled linguistically by the French word *mer* inscribed into the protagonists' names—Mer, Lemer, Meritet—as the voices of four first-person narrators re-member the Middle Passage and the surrounding, ongoing legacies of that originary trauma. This text begins with a pregnancy and then the stillbirth of a boy, in the colony Saint-Domingue that will become Haiti. In *Poetics of Relation*, Glissant connects the terror of the Middle Passage to the experience of the womb:

> What is terrifying partakes of the abyss, three times linked to the unknown. First, the time you fell into the belly of the boat [which] dissolves you, precipitates you into a nonworld from which you cry out. This boat is a womb, a womb abyss. [. . .] [A]lthough you are alone in this suffering, you share in the unknown with others whom you have yet to know. *This boat is your womb, a matrix, and yet it expels you. This boat pregnant with as many dead as living under sentence of death.* (6, emphasis added)

Hopkinson includes characters with direct experience of the ocean crossing, specifically "Auntie" Mer and others enslaved or marooning in eighteenth-century Saint-Domingue. The sections narrated in Mer's voice offer stories that unblock the Middle Passage; the interwoven sections told by Jeanne Duval (Lemer), the "mulatta" mistress of poet Charles Baudelaire, and by the enslaved Egyptian prostitute Thais (Meritet) extend the textual relations temporally and

geographically. A fourth female voice, that of the African deity Ezili merged with Lasirèn, *lwa* of all the waters, offers a guiding first-person narration as she voyages through fluid elements and inhabits the bodies and consciousnesses of the other three women. Ezili is a variation on Erzulie, also referred to in Haitian vodun as Erzulie Freda: "She is associated with the Virgin Mary in Catholic theology for her purity and role as mother of the world" (Chancy, "Exiles and Resistance" 280). As Maya Deren writes, "She is the divinity of the dream, and it is in the very nature of dream to begin where reality ends and to spin it forward in space, as the spider spins and sends forward its own thread" (qtd. in Chancy 287–88).[31]

Such a description fits the voice of Hopkinson's Ezili, a reflexive presence that participates in the narrative as it also constructs the fictional text: "**Each time, the aether shows me more stories. Seas, breathing deep in their waters, carrying ships on their backs. Whole histories, of people, of places**" (212). "**I splash in joined tributaries of lives, watery webs that connect each one's story to each**" (213). As the braided stories unfold, this "I" moves from birth through infancy to toddler stage, grounding herself in Black female embodiment. The passages spoken by Ezili/Lasirèn invoke the seas traversed in the Middle Passage, an awe-full matrix that severed roots and soldered relations in the Americas. Connecting the slave ship to its legacies on the plantation and in contemporary forms of racialized violence, Mustakeem states:

> [T]he slave ship experience served as the first historical iteration in the mass detention of black people—shackling, surveillance, disciplining of bodies, stripping of freedom, guarding of contained property, exploit of labor and laborers, dangled freedom, and the ever present threat of fatal aggression. As such, this history of racialized terror and confinement of black people with uninhibited economic potential and exploit in carceral spaces found its deepest roots in the bowels of slavery at sea. (190)

Hopkinson participates in the process of breaking the silences, as her vision of Ezili inhabits the bodies of Black women across centuries and listens to their experiences. In discussing Glissant's poetics in the context of trauma, John Drabinsky states: "Trauma is about the dead, surely, but it is also *for* the living as a relation to the dead, as obligated to the dead with unbearable imperatives, and so always charged with the duties of beginning again with a new, renewed history" (294, original emphasis). In Hopkinson's narrative, the waters contain the webs of stories that can unblock the Salt Roads, and a goddess born of those spaces serves as the conduit. "The religious ritual across North and South America and the archipelago of being inhabited by the gods, goddesses, and spirits of Africa may be another method of way-finding" (Brand, *Map* 44). In a narrative that

gives voice to the wounds in a re-membering of the originary trauma and its legacies, the sea witnesses not only death but also birth, and serves as locus for Caribbean diasporic subjectivity and relation.[32]

One question raised by *The Salt Roads* is whether speculative fiction offers an effective means of not only representing but directly addressing the Middle Passage. In interviews, Hopkinson has commented on her use of fabulist fiction:

> [T]he experience of slavery is a huge cancer in the collective consciousness of African people all over the diaspora. The ripple effects of it [. . .] still continue, and they touch the past, the present, and the future. [. . .] Speculative fiction allows me to experiment with the effects of that cancerous blot, to shrink it by setting my worlds far in the future (science fiction) or to metonymize it so that I can explore the paradigms it's created (fantasy). (Rutledge 592)

Hopkinson has also commented on her use of language in novels and short stories, connecting the multiple layers of expression (such as forms of creole) to Caribbean experience.[33] Rejecting binaries, like many Caribbean writers she emphasizes multiplicity as well as hybridity and collage (Batty 177). In *The Salt Roads*, through the voices and personae of Mer, Lemer, Meritet, and Ezili/Lasirèn, she vividly recreates that multivocality and locates its origins in the watery depths of the Middle Passage. In one interview, she states: "For people from diasporic cultures there's more than a doubled consciousness. It's occupying multiple overlapping identities simultaneously. [. . .] There is no solid ground beneath us; we shift constantly to stay in one place. [. . .] [W]e're struggling to find modes of expression that convey how we've had to become polyglot, not only in multiple lexicons but in multiple identities" (Rutledge 599). That multiplicity informs *The Salt Roads*, which intertwines the stories of Black women in the Caribbean, in Europe, and in North Africa over more than two millennia.

Temporally and geographically, the sections focused on Jeanne Duval in nineteenth-century Paris and Thais in Alexandria, 345 CE, frame the central story of Mer, the three woven together by the voice of the waters. Slavery in ancient Egypt—both men and women sold into brothels, for instance—and sexual slavery in modern France stand in a continuum with the enslavement suffered in Saint-Domingue before the Haitian Revolution.[34] Made seriously ill by her lover, the poet Charles Baudelaire, who passes on his syphilis and then deserts her, Jeanne/Lemer is turned into a cripple who struggles with poverty, is rescued by a hard-working butcher, and is released from her rotting, cancerous body only in death. "**As she leaves the world of flesh, the fading chant of sorrow that comes is one bittersweet woman's wet death rattle. [. . .] As Jeanne's awareness melts, like foam dissolves back into the**

sea, I wish I could melt with her" (366). The descriptions of Lemer's physical suffering suggest that by the mid-nineteenth century, the cancer has spread throughout the world to such a degree that no healing or cure seems possible. Ezili, who has worked to address the blockage caused by that fatal growth, is both liberated and defeated by Lemer's death: "But I am free! [. . .]. **I will have no more dampness about me, no more water, no more salt tears or piss or blood; no more flesh. [. . .] I soar on, fleeing the world I have failed**" (366). In Lemer's story and death, Ezili would appear to have conceded defeat, to have relinquished her quest to unblock the Salt Roads and to heal the world from the wounds of colonialism and enslavement.

The scenes in Paris interweave with those in Alexandria, where the young prostitute Thais or Meritet runs away by boat to Jerusalem, not realizing she is pregnant. On the floor of the Church of the Sepulcher—a site formerly occupied by a temple to Venus—she has a sudden miscarriage. Passages inserted into the novel from Catholic texts about Saint Mary of Egypt connect Meritet (little Mer) with this "dusky" saint, and layer stories and births in a revisioning of official, institutional history. The voice of Ezili suggests that the loss of Meritet's baby prevents another tragedy: "**The slave Thais would have borne a girl, to be raised in a whorehouse as another slave girl. Another African body borne away on the waves**" (305). Each time she is pulled into one of these female bodies, especially Lemer's and Meritet's, Ezili encounters slime and foulness, desiring freedom: "**I need to learn the world that is my birthright, to go from baby steps to sure ones, to fly**" (154). Those words reiterate the concept of birth that reverberates throughout Hopkinson's novel, even though some pregnancies end in death. Meritet both grieves the loss of her baby and envisions a future with many births: "I had carried that child in the blood of my belly, like a ship on the sea. I had made it a home, even though I hadn't known it was there. [. . .] There will be other children in the world. Not my fault! My soul leapt with joy" (386–87). Though neither Lemer nor Meritet resists completely or achieves a lasting liberation, their voices join that of Mer. With Ezili as the connective presence, together they create a narrative that re-members the Middle Passage and its legacies.

The novel's title refers to the repressed or "blocked" oceanic passages that have become "cancerous," as well as to the trauma at the core of those "salt roads." As Mer fishes on a moonlit night in Saint-Domingue, she has a momentous meeting with Lasirèn, her "water mother," who appears to her as a mermaid and speaks directly of the Salt Roads. Telling Mer she must fix a problem, the "lwa, this Power of all the waters," explains: "The sea roads [. . . are] drying up. [. . .] The sea in the minds of my Ginen. The sea roads, the salt roads. And the sweet ones, too; the rivers. Can't follow them to their sources any more. I land up in the same foul, stagnant swamp every time"

(65). The challenge posed by Hopkinson's Lasirèn, indeed by the text as a whole, is how to unblock and re-member, to clear the muck and foulness from the water roads, to reclaim the sea.[35] She leaves Mer a talisman, a small glass whale, and the charge to understand why a sea engulfs the minds of the Ginen. Further, the "foul swamp" or blockage is described by Ezili as a cancer that keeps spreading, metastasizing. This description resonates with Audre Lorde's argument in *The Cancer Journals* (as paraphrased by Zakiyyah Iman Jackson), "that carcinogenesis is a feedback loop encompassing biological, psychological, environmental, and cultural agencies and, therefore, neither a matter of individualized disease nor inferior biology but rather a somaticization of politics, and, by politics, I [Jackson] mean war" (43).[36] Hopkinson's Ezili, with the three central female characters whose experiences she voices, addresses this systemic, global "loop" originating in the Atlantic slave trade.

To initiate this process of unblocking, the text invokes female deities associated with the ocean, who interweave in a syncretic movement between Africa and the Caribbean. Mer remembers the boat filled with African people speaking different languages and devoted to different gods, who blended their faiths as they also invented new words. For instance, as she and her friend/lover Tipingee assist in the delivery of another woman's baby, Mer recalls that "Tipi was Akan, but on the ship, as we learned each other's speech, I would tell her stories of the power of Aziri, how she wouldn't let us drown. Tipi had adopted Aziri to herself" (26). The deities protect and also connect the women in queer relationship, illustrating Omise'eke Natasha Tinsley's argument: "The brown-skinned, fluid-bodied experiences now called *blackness* and *queerness* surfaced in intercontinental, maritime contacts hundreds of years ago: in the seventeenth century, in the Atlantic ocean. You see, the black Atlantic has always been the queer Atlantic" (Tinsley, "Black Atlantic" 91). I will return to queer Relation, as embodied by Mer and Tipingee, as challenge to the heteronormative violence of the plantation and colonial ideology. In the present time of the narrative, Aziri merges with Ezili, as well as with Mami Wata, River Mumma, and Lasirèn. This composite entity speaks in bold-faced words throughout the novel and identifies with each of these female water deities: "**many goddesses with many worshippers, ruling in lands on the other side of a great, salty ocean,**" but "**now we are one, all squeezed together, many necks in one coffle**" (44). Repeatedly, this voice connects the horror and fatality of the Middle Passage to a terrible, powerful birth out of the matrix of the ship's belly:

> **I'm born from mourning and sorrow and three women's tearful voices** [when the baby is stillborn]. **I'm born from countless journeys tight in the bellies of ships. Born from hope vibrant and hope destroyed. Born of bitter experience.** [. . .]

> It's when my body hits the water, cold flow welling up in a crash to engulf me, that I begin to become. I'm sinking down in silver-blue wetness bigger than a universe. I open my mouth to scream, but get cold water inside. Drowning! (40)

This "beginning to become" in the process of drowning illustrates the paradox of the Middle Passage, a deadly and trackless path through the seas *and* the irrevocable birthing of the Caribbean.

The Middle Passage haunts as an ongoing nightmare, surfacing in dreams, stories, and memory. Hopkinson's first-person narrator comments on Jeanne Duval's dreams of water, for instance: "**Poor Jeanne dreams almost nightly of my watery, salty birth in drowning water, chained**" (153). Glissant argues that "[i]n actual fact the abyss is a tautology: the entire ocean, the entire sea gently collapsing in the end into the pleasures of sand, make one vast beginning, but a beginning whose time is marked by these balls and chains gone green" (*PR* 6). Hopkinson gives voice to this matrix that contains both salty grave and anguished birth.[37] In an interview, Hopkinson invokes Black futures: "If black people can imagine our futures, imagine—among other things—cultures in which we aren't alienated, then we can begin to see our way clear to creating them" (Rutledge 593). Subversion is not sufficient. Black futurism imagines beyond the ship's belly, even as that matrix remains the center and origin.[38]

The concomitant challenge is to achieve true liberation, as Mer grasps late in the book. Still wondering why Lasirèn's sea roads are blocked, Mer's mind is "only running on how to clear Lasirèn's roads of power so that she and the gods might use them to set us free" (309). Throughout the sections set in Saint-Domingue, resistance to enslavement and the plantation system takes multiple, increasingly violent forms as the Ginen struggle to be free. Memory offers one powerful means, as the shape-shifting Makandal tells the enslaved: "Remember what we are, remember our names. We Mandingue, we Ashanti, we Congo, we Ibo, we Allada people," he says, encouraging them to chant these names and inciting them to destroy the plantations and their owners (105). Remembering preserves origins, but it also does not recognize that those he addresses are now Caribbean, diasporic people. While Makandal sets in motion plots to poison the imported water supplies and set fire to the estates, Mer's antagonistic encounters with him suggest that other paths might offer more lasting success and freedom.[39]

Plantation owners may be poisoned and their homes burned, but the system itself survives and replicates itself. Colonialism demands—and relies upon—heterosexual normativity. Effective resistance may lie with challenges to the patriarchal assumptions rooted in heteronormative relations. Marshall's novel flirts with this possibility but then reinforces the norm by labeling as deviant Merle's lesbian affair in London. Cliff gestures towards same-sex attraction

and desire, most obviously in the character Clover, but also mutes the power of such relations.[40] Hopkinson, however, indicates that such bonds can serve as the core of meaningful resistance and radical change, as well as affording a means to "unblock" the sea roads in the minds of the Ginen. Female same-sex relationships sustain both Mer and Jeanne/Lemer—with Tipingee and Lise, respectively; bonds between the young prostitutes in sections devoted to Thais/Meritet provide similar sustenance for female characters.

Heterosexual relations, especially those forced on Black women or coerced from them, participate in the systems of oppression and injustice established by the slave trade. On the other hand, women's bonds among themselves are depicted as not only supportive but potentially liberating, perhaps most clearly in the traumatic birth of the guiding "I." As this voice continually reminds us, her birth began with the pain of three women in Saint-Domingue, when Georgine lost her baby, and Mer and Tipingee buried its body at the riverside. The voice invokes the Middle Passage as the core site of trauma and equates that space with the blocked sea roads:

> **There are other places I can go in the spherical world, but they all end up there, at the blockage. I cannot get by it. Its taste is foul. It reeks of grief and horror. I gather my forces—I am much more able now—and throw myself at it, hoping to break through. Instead I land in it, and it is vile; corruption creeping into every sense. Spitting, gagging, I fight myself free, but I am back where I started. This cancer, it blocks my freeflowing world. Forces it to move in only one direction. I must, must clear it. (293)**

The initial injunction to Mer, to clear the Salt Roads, expresses the necessity of attacking this cancer head-on instead of allowing its malignancy to spread further. To do so means to reclaim the sea and to value the identities born of the Middle Passage. It also means to repudiate the patterns of relation that perpetuate rather than dismantle the systems established by colonialism. The way to address the trauma, to remove the cancer, is to nurture Caribbean, diasporic relations among women. Mer's greatest enemy is not a white plantation owner but the most powerful of the Ginen men, Makandal, who has invested in the colonizers' ideologies.

Makandal's methods include attacks not only on those in power but also on any Ginen who do not agree with him, especially Mer herself. Ironically, he will die a gruesome death by fire, burned alive as punishment and warning to others who would rebel against their enslavement. The meetings that he conducts in darkness in the cabins resemble the crowded spaces in the hold of a slave ship, human bodies tightly packed and treated as commodities. And

when he emerges from a prison to face death, he looks as if he has come from one of the ships, soiled, bruised, broken. Before his imprisonment, he faces off against Mer, each one possessed by a *lwa*—her water to his fire. The cancerous poison of colonialism and the Man/other dichotomy has so devoured him that the spirit in his body (Ogu) uses a machete to cut out Mer's tongue: "**With that axe slash, the river, the mighty rolling river that is one Ginen story crashes full tilt into a dam. Its waters boil, angry; and go nowhere. That story is stopped dead in its bed**" (331).[41] The long-term, loving, sexual relationship between Mer and Tipingee serves as the potential antidote to this violent and cancerous blockage—a disease born of the Middle Passage and passed on in relations that replicate hierarchies informed by racism, colonialism, misogyny, and heteronormativity. They occupy "demonic ground," in Wynter's formulation, from which they might think relation otherwise.[42]

The ship gave birth to this friendship, as the two women shared their different languages and invented a hybrid faith, as well as means to communicate. Tinsley's pathbreaking article on the Black queer Atlantic provides a context for this friendship: "During the Middle Passage, as colonial chronicles, oral tradition, and anthropological studies tell us, captive African women created erotic bonds with women in the sex-segregated holds [. . .]. In doing so, they resisted the commodification of their bought and sold bodies by *feeling* and *feeling for* their co-occupants on these ships" ("Black Atlantic" 192, original emphasis). Though Tipi has a "husband," Patrice, who spends most of his time in maroonage rather than with her on the plantation, the relationship between her and Mer is depicted as deeper and longer-lasting, curative and liberating. While they cannot manage to save Georgine's baby, they are midwives to a healing consciousness embodied in the "I" that shapes the entire narrative. That they are also partners to each other, emotionally and sexually, underscores the importance of relations that "queer" conventional roles and resist the authority of both plantation and patriarchy. The silencing of Mer's tongue by Ogu/Makandal parallels the female genital mutilation that she suffered as a child in her African homeland. And Lasirèn is unable to help her: "**I feel Mer's hand tighten around the knot of me. Glass me. No body, no colour. I didn't help her that night when Ogu cut her. I can't help them, any of them. I am no use. I will leave her limbs under her own control**" (345). Mer last appears in the narrative with Tipi, who has chosen to stay with her on the plantations to assist the enslaved rather than accompany Patrice back to the maroons. They are again helping a woman in childbirth, a repetition-with-a-difference of trauma as matrix for relation. This time, instead of a dead male infant, a baby girl is born strong and healthy, and the voice of the spirit-narrator foresees her role in liberation:

> Dédée Bazile, they will call you Défilée when you and I march with the Haitian soldiers of the revolution, urging them to keep moving. They will call you mad after your brothers are massacred and grief makes you wild. They will call you sane again when you collect the torn pieces of the body of the black Emperor Dessalines who made the flag of the land he called Ayiti, as the original Taino inhabitants had named it. Dédée Bazile, they will obey you when you demand that Dessalines be buried. (376)

In a narrative that swims through time and space as it enters bodies with sea salt beneath the skin (119), this voice conjures future resistance from the birthing performed by the three women.

Resistance is also enacted through aesthetic expression, as Mer embroiders the deities on banners: "With the thread, I paint pictures on the clothes: Lasirèn, Ezili, Ogu, Kouzin Aka. All the lwas. And the Lady too; Mother Mary," whom she paints with a baby girl, not a boy (369). "She's pale, the Lady; a sang-melé. Pale and white since she comes from the other world beneath the waters. That makes sense. [. . .] I know her real name. Ah, my Ezili Frèda" (369–70). This syncretism offers both preservation and adaptation, in a shared project of unblocking the Salt Roads, re-membering the Middle Passage and claiming the seas. Mer's banners recall a small piece of fabric preserved by Cliff's Annie Christmas, the depiction of a lion with a rifle that was part of a commemorative tapestry never completed: "The patch was discolored, with traces of mildew at the edge. The places where it has been folded over on itself were indelible lines by now, crevices obscuring the original message. Only with imagination could you draw it at all" (*Free Enterprise* 19). *The Salt Roads* posits that a cure lies not in revisiting or trying to reconnect with a lost history, which like the image on Annie's fabric is obscured.

Rather, use the trauma to claim the present and envision the future—or multiple futures simultaneously. In contrast to Annie's faded patch of fabric, Mer's creations are vibrant. Hopkinson's narrative pauses to include a visionary moment as antidote to the unrelenting traumas experienced by her female protagonists. Ezili/Lasirèn explains:

> They are me, these women. They are the ones who taught me to see; *I* taught me to see. They, we, are the ones healing the Ginen story, fighting to destroy that cancerous trade in shiploads of African bodies that ever demands to be fed more sugar, more rum, more Nubian gold. [. . .] *"We can lance that chancre,"* we say. [. . .] I, we, rise, flow out of ebb, tread the wet roads of tears, of blood, of salt, break like waves into our infinite selves, and dash into battle. (305)

Hopkinson addresses the originary dis-ease of the Middle Passage and Atlantic slave trade, emphasizing the importance of storytelling in any process of healing. Cliff's Annie suggests the extreme difficulty of remembering, when she comments on the tapestry that did not materialize: "Our historical moment was lost, so our tragedy is dissembled. Oh, it exists piece by piece. Some pieces have been buried with those who passed on. Some are forgotten, misplaced" (192). Through the voices of the sea goddess, Hopkinson suggests that resistance and healing are not only possible but already happening. The final words from the voice of Ezili/Lasirèn emphasize this vision of Relation in the face of trauma and annihilation: "**We are all here, all the powers of the Ginen live for all the centuries that they have been in existence, and we all fight. We change when change is needed. We are a little different in each place that the Ginen have come to rest, and any one of us is already many powers. No cancer can fell us all, no blight cover us completely**" (387). Instead of the fragmentation and loss expressed by Cliff's Annie Christmas, *The Salt Roads* invokes Ezili to connect the "watery webs" of stories of African diasporic peoples, to create "joined tributaries of lives" (213) that can fight and defeat the cancers born of the Middle Passage.[43]

Hopkinson thus pulls the sides of the sea together, in a narrative that extends and deepens the attention paid to the Middle Passage in Marshall's and Cliff's novels. All three texts demonstrate that the Caribbean Atlantic forms the center of that bringing to voice of the Atlantic slave trade itself and the ongoing trauma that it perpetrated. The next chapter dives into the oceanic spaces that Ezili and the women in *The Salt Roads* aimed to unblock, to free of the cancerous products of colonialism and enslavement. In particular, chapter 2 explores the *Zong* case through M. NourbeSe Philip's book-length poem named for the ship, as well as the ossuaries that contain bones of the African Diaspora, as explored by Dionne Brand and Marie-Elena John. And chapter 3 returns to Haiti, discussing fiction by three contemporary Haitian women whose works invoke the seas and the *lwas*, who continue the process of addressing silences, resistance, and healing.

Chapter 2

OCEANIC OSSUARIES

Caribbean Women Reading the Bones

I.

"'Give me the bones,' I say to the silence that is so often what history presents to us. And again, because that space of memory and of the archive where you come up against their inherent limitations can become a sphere of craziness, the bones actually ground you" (Saunders, "Defending" 69). In her "Notanda" following the book-length poem *Zong!*, M. NourbeSe Philip reflects on the process of writing this text that employs the language of a court case to perform an impossible voicing of the Africans murdered for insurance money in the 1780s.[1] Coining the term "exaqua" as the oceanic parallel to digging up a body from its earthly grave, Philip describes her effort to find the bones, to retrieve the lost souls from both a nonexistent watery grave and the legal case that served as a formal burial of the event. The bones speak from undersea, the names of the dead un-sea-ed, the unseen thus spoken though the story cannot be told, as the poet strives to unlock the legal archive. This chapter circles back through the Salt Roads and Caribbean Atlantic spaces re-membered by Paule Marshall, Michelle Cliff, and Nalo Hopkinson (discussed in chapter 1), focusing in this iteration on the ossuaries at the heart of the circum-Atlantic World.

In his book-length poem *Omeros*, Derek Walcott calls upon the Caribbean Atlantic bones as both sea and mother: "*O* was the conch-shell's invocation, *mer* was / both mother and sea in our Antillean patois, / *os*, a grey bone, and the white surf as it crashes // and spreads its sibilant collar on a lace shore"

(Walcott 14). While Philip's *Zong!* (2008) invokes the *os* or bone to reconstruct what cannot be recuperated, Marie-Elena John's *Unburnable* (2006) seeks on one level to excavate another (fictional) miscarriage of justice by deciphering the story of mysterious skeletons in a hilltop forest in Dominica. Moving from the oceanic passages to an island defined by the sea and sheltering a community of New World Africans who attempt to preserve customs that survived the Middle Passage, this text also challenges the misreadings perpetuated in popular song and personal trauma, all of which cover up the bones that reveal a larger truth. Spreading outward from the heart of the Atlantic—to Algiers, Cuba, Canada, the Northeast US—as well as diving into the waters, Dionne Brand's book-length poem *Ossuaries* (2010) offers a twenty-first-century bonescape that extends relation globally even as it dissects contemporary legacies of the Atlantic trade that has defined and marked modernity, starting in the 1500s. Taken together, these three recent texts allow us to enter a "Bone Court," where we listen to Caribbean women reading (for) the bones, an aesthetic testimony that constructs oceanic ossuaries and asks for justice, freedom, healing.[2]

Gerald Vizenor offers the concept of a Bone Court as a means for the remains of Native peoples in the US to recover their rights, in the face of grave robbing and museum displays that continue a (neo) colonial disrespect for the bones of Indigenous groups. He states: "The rights of bones are neither absolute nor abolished at death; bone rights are abstract, secular, and understood here in narrative and constitutional legal theories. [. . .] [T]hese rights are based on the premise that human rights continue at death" (63). While the issues are different for those Vizenor defends, who were buried formally and then later dug up and displayed in museums as well as used for scientific research, than for New World Africans lost in the Middle Passage, their bones never recovered from the oceanic depths and properly buried, the concept of Bone Courts still provides a way to read the bones in the three texts discussed in this chapter. "The rights we hold over our bodies and organs at death are the same rights we must hold over our bones and ashes," Vizenor asserts (63). John's novel and the book-length poems by Philip and Brand all work with narrative involving legal cases and court procedures to give voice to the invisible, unforgettable bones of the circum-Atlantic World. Vizenor emphasizes the role of narrative in his own argument for Bone Courts: "the proposal for bone rights is a post-modern language game with theories on narration and legal philosophies to direct the discourse. Narrative theories augment the proposition that bones have the right to be represented and heard in court; moreover, tribal bones would become their own narrators and confront their oppressor in a language game, in a legal forum—the proper person, mode, and perspective in a narrative mediation" (64). In the three texts examined here, we move through textual ossuaries where the bones both speak and serve as legible traces, such that we resuscitate buried

histories that deconstruct the official archives and replace them with narratives that seek justice through knowledge and/as aesthetic practice.

Contemplating her feat of "exaqua" enacted for those murdered in the *Zong* catastrophe, Philip says, "It's ironic, isn't it, to think that the very sea that took the lives of those Africans now performs the task of reconstituting those dried facts—the water in the ocean has filled this case with all of the bodies, all of the stories of those bodies that were squeezed out of this case to arrive at this two-page report" (Saunders, "Defending" 66).[3] The poem *Zong!* emerges from the alphabet letters that slowly offer a fragmented word: "water." Constructed from the actual language of the existing record of the legal case *Gregson v. Gilbert* (1783), which Philip breaks open, splinters, sunders, then solders into astonishing swirls, leaps, and falls of letters on the page, the text gradually fleshes out the catastrophe, its chaos, confusion, and violence, as well as its multirelational trajectories. The first section, "*Os*," consists of individual poems, each titled "*Zong!*" plus a number, from one to twenty-six. In this section, the words "*os*" and "bone" do not appear at all, though we read the poems as each embodying or voicing the Africans. Those souls have ghostly presence as names at the bottom of each page of this first section, forming a counter-discourse to the numbering that reflects and refracts the language of ships' logs that counted Africans and/as commodities, ignoring and denying their humanity. In her notebook charting the process of writing the poem, Philip says of this naming, "*The Africans on board the* Zong *must be named. They will be ghostly footnotes floating below the text—'underwater . . . a place of consequence' // Idea at the heart of the footnotes in general is acknowledgement—someone was here before—in* Zong! *footnote equals the footprint. // Footprints of the African on board the* Zong" ("Notanda" 200, original italics). Moreover, the cover of *Zong!* includes the words "As told to the author by Setaey Adamu Boateng." Philip has explained that this invented name credits a female African as coauthor, incorporating ancestral voices and presence, a creative and visionary way of unblocking the Salt Roads.[4]

Within the pages of *Zong!*, language both proliferates and disintegrates, repetition and arrangement balanced with and against chaos, witnessing the failure of ethics and of communication. Meaning takes shape as if rising to the sea's surface, then dissolves, re-forms, in shifting, fluid movements across, down, and through the spaces of the page: the form thus forces the eye to read differently. Philip's poem is not so much a writing in or from the margins as a scripting of the open spaces of a blank page. The reader receives orthographical messages in this reading of the bones. Scanning the lines, we perform a bone scan, looking beneath the ocean's surfaces seeking the bones' inner depths as well as the voices to proffer their testimony, to piece together the story that Philip insists cannot be told. This manner of telling and reading reenacts the narratives at the heart of the circum-Atlantic World.

That "Zong" captures "Song" as well as "Zorg" or "Sorrow," the original Dutch name for the ship that became mistakenly transcribed with an "N," underscores the contradictions and erasures inherent in what Philip calls "the currency of globalization."[5]

Widening the lens, Philip connects our contemporary situation with the Atlantic trade, the Middle Passage, and the *Zong*:

> And so much of what we are living with today is linked to that first experience of globalization where the currency of globalization was the black body. Black bodies could be taken anywhere in the world, at any point in time, sans passport, sans visa. That was the currency of globalization then and I don't think we have had a reckoning on that yet. And this is why we keep recycling and returning to these moments, to which we will continue to return until (if ever) and unless we come to some kind of reckoning. (Saunders, "Defending" 76)[6]

These three texts urge us to join the three authors in reading the bones, hearing their testimony, and initiating that reckoning as a mutual and relational project. The bones give a structure to the oceanic world, the circum-Atlantic as mapped and re-membered in these works. The sea contains the bones, the roads, the histories, and the skeletons of memory, in a multilayered hauntology.[7] The authors "exaqua" the *os* and place them in ossuaries that provide a scaffolding for the testimonies offered in fiction and poetry, a witnessing that seeks justice, voicing what cannot and must be told. They become underwaterwriters, as opposed to the underwriters who considered Black bodies commodities and insurable property. Rescripting concepts of value, the authors aim for the "subversion and resistance" that Philip envisions as the possible outcome of what I am terming oceanic "Bone Courts" (adapting the phrase coined by Gerald Vizenor, as discussed above).

II.

In *Zong!*, the bones take multiple forms, while they also multiply as the poem moves from *Os*, to sections titled *Sal*, *Ventus*, *Ratio*, and *Ferrum*, to conclude with the section "*Ębora*," meaning "underwater spirits" in Yoruba. The actual victims of the Middle Passage lie in *agua*, unseen, unburied, while they appear obliquely in the record of the court case and float hauntingly through the pages of the poem. Finally, in an affective, relational synchronicity, they structure our own bodies—as Ian Baucom would likely argue, we are all the *Zong*. In her essay "In the Matter of Memory," Philip says,

> When thinking of the cataclysmic events around the enslavement of Africans in the New World, there exist no similar markers—and certainly not on the same scale—of these historical events, or of the memories generated by them. How then does memory function in the virtual absence of these markers? More particularly the body then becomes increasingly implicated in the materializing of memory. [. . .] Memory, I suggest, is to be found in the interstices, the silences, the half said, the stories that are passed on, the markers of absence. (23)

Taking a cue from Walcott, we can invoke (call "*O*" to) a Sea-Bone muse that is also a Sea-Mother, birthing modernity, with whom Morrison's Beloved stands in direct kinship: both are stories "not to pass on."[8]

An ossuary serves as a repository for bones, a cemetery minus burial, an archive of the human body and its earthly passage. Philip creates an alternative archive—not an antiarchive but a counter-cartography of modernity: catastrography, writing the catastrophe of the Atlantic slave trade and Middle Passage. The sea births the bone with great struggle and pain, a difficult, repeated passage to which the reader bears witness. "*Zong! # 17*" offers one such attempt to listen for and record the testimony.

> there was
> the this
> the that
> the frenzy
> leaky seas &
> casks
> negroes of no belonging
> on board
> no rest
> came the rains
> came the negroes
> came the perils
> came the owners
> master and mariners
> the this
> the that
> the frenzy
> came the insurance of water
> water of good only
>
> came water sufficient

> that was truth
> & seas of mortality
> question the now
> the this
> the that
> the frenzy
>
>
> not unwisely
> _____
> Ayoka Faluyi Owolabi Oni Sowole Mudiwa (29–30)

The argument presented in court by Collingwood, the captain of the *Zong*, claimed that the ship had too little drinking water and too many ill on board for everyone to survive until reaching Jamaica, and thus the throwing overboard of Africans was a "necessity" to preserve the crew and the rest of the "cargo."[9] Into that argument, a specious and blind *ratio*, the lines insert other meanings, alternative readings.

The Africans' uprootedness, their homeless state in the ship's belly and on the ocean, echoes in "no belonging," even as that phrase also challenges the idea that people can belong, like objects, to human "owners." Another set of lines juxtaposes and equates "perils" and "owners," illuminating the dangerous and destructive aspects of such an identification (human owner of humans). What *is* "truth"? The "&" indicates that murder in the "seas of mortality" is the un(der)written, underwater truth. And the "footprints" lie beneath the command to "question the now [. . .] not unwisely." Just as each poem within "*Os*" opens like a puzzle to fit bone to bone, name to soul, reconstructing a skeletal narrative, so the twenty-six poems gradually flesh out a haunting truth, asking readers to reckon *now* into the accounting, as well. As Philip says, the next four sections are "the flesh," while the twenty-six poems of the opening section "are the bones" ("Notanda" 200). Furthermore, the twenty-six poems, the "*Os*," share the number of letters in the alphabet, such that the language of bones lies at the center of this narrative not-being-told. Philip states: "*The alphabet is the universe of language — all the sounds contained in each alphabet of letters and each letter a fragment — of the whole // a link between the dynamic of the text containing everything and the fundamental flaw that led to Africans being taken*" ("Notanda" 200, original italics). In similar fashion, the twenty-six poems of "*Os*" contain the bones of the narrative, just as they reveal the footprints of the Africans in the names located at the bottom margin of each page. Such is Philip's "poetics of fragmentation" ("Notanda" 202), which is kin to a poetics of Relation as developed by Glissant: using the alphabet of

the court case, she breaks apart while also reflecting and reckoning with the fatal flaw at the center of the circum-Atlantic system.

After the *Sal, Ventus,* and *Ratio* of the catastrophic acts of throwing 132 Africans overboard, and justifying those murderous acts by the flawed logic of commodity capitalism and insurance regulations, based on the "necessity" that the law might recognize as valid, *Zong!* moves to iron, "*Ferrum*." This section has two epigraphs, from the Bible and from St. Augustine, the first taken from Ezekial: "*There was a noise and behold, a shaking . . . and the bones came together, bone to bone . . . the sinews and flesh came upon them . . . and the skin covered them above . . . and the breath came into them . . . and they lived, and stood upon their feet*" (126, original italics). Here, ironically, the words "bone" and "*os*" flood the text, while they are absent in "*Os*" and appear infrequently in the second, third, and fourth sections:

```
              me i                      sing song
 for ògún el          son of                       iron come bring
                              our mask s
      let the play begin we          each act the part
                        in murder what           will they
                   how               do they the bones
      say what          cannot be give            voice to
               a tale one            tale their tale
                   how bone be
                                     come sand be
      come the tale             that can           not be
                   told in this     tale the tao

                                                      (127)
```

Calling on Ògún, the Yoruba deity of iron, the poet invites readers into a theater of murder, willing the bones to speak and tell the unspeakable tale, to show how humans died and their bones sank into the sands at the bottom of the Atlantic Ocean. Then performing what I am calling a bone-scan, the eye/I of Philip's text asks us to scan the water for

```
                    bo           nes to           e bon
   e he       el b       one l           eg bo
       ne hi       p bo        ne ha              nd b
   one a      rm bon
       e no           se bo            ne e
                   ar b           one fin          g
```

 er bon e hea
 d bo ne bon
 e bone all is bo ne wha t be t

(137)

In the disjointed pace of reading and deciphering the fragments of bone, the shattered skeletons of the murdered souls, the lines perform a disarticulation of individual bones, a linguistic fragmentation that mirrors the dissolution of bodies, souls, stories in the Atlantic depths. Yet, the eye works to rearticulate the bones, to see a toe, a heel, a leg, a hand, an arm, and more bones emerge from the scattering beneath the sands. These lines *exaqua* the Africans, a gasping struggle to bring to the surface the ghostly absence and fill it in with alphabet signs that trace the descent and now ascension of the *Zong*'s victims. This process resembles the reassemblage that Walcott describes in *What the Twilight Says*: "This gathering of broken pieces is the care and pain of the Antilles. . . . Antillean art is this restoration of our shattered histories, our shards of vocabulary, our archipelago becoming a synonym for pieces broken off from the original continent" (qtd. in Baugh 12).[10] In *Zong!*, words both form and flesh the bones, providing an account(ing), despite the fact that an inventory is impossible, that one cannot count the bones. The conundrum, the inherent contradiction, arises repeatedly in the poem and in Philip's commentary on the text: "But there are no words, there is no language for it. The closest I came to it was in that last book, 'Ferrum,' where language disintegrates and degrades into sounds expressing that which cannot be expressed" (Saunders, "Defending" 74).

Philip's strategy is to voice the act and the concomitant trauma by using the legal archive to unlock its own secrets, employing its own words to shape a testimony to the murders of captive Africans. Of the law, she says that " you have to explode it from inside, and connect it to its origins, its buried past" (Saunders, "Defending" 67). This blowing apart of the law is a complementary, reverse process to a reassemblage of fragments, as Philip dismantles the master's house. Philip is eminently suited to such dismantling, as she attended law school and practiced law for seven years before turning to writing.[11] Her career as a lawyer gives her an astute understanding of how the law works, as well as ideas of how to break open the legal archive. Ceaselessly drawn to the originary trauma, the oceanic wound, listening for the sounds emanating from its depths and scanning for bones, the poem drowns its audience in water. The sea is *mai, mère, mer, mar ema* and *mater, madre, omi o ab wa ma e*, water. The maternal references resonate with Hopkinson's naming of her protagonists—Mer, Lemer, and Meritet. Origins lie in the sea, the birthplace of the *Zong* catastrophe, those watery spaces where modernity takes shape,

both sinking to the bottom and washing ashore in the circum-Atlantic World. Underwater, Philip has been told, noise or sound does not cease: "I have often since wondered whether the sounds of those murdered Africans continue to resound and echo underwater. In the bone beds of the sea" ("Notanda" 203). Though one might argue that Philip is still using the "master's tools," I see her rather as creating a new language to tell the story in those resonating sounds of silence underwater. In one interview, she claims that it is a new language, especially in the final section, "*Ferrum*," what she calls "my very own language" (Saunders, "Defending" 71). Again, the bones are the alphabet that she rescues from oblivion, which become the scaffolding for this (not)telling.

If the poem performs a court case, even as it takes apart the record of that legal action, is a verdict reached? Can the performance accomplish a reckoning? In terms of a trial, we might consider who is the witness and whose testimony we encounter in the pages of *Zong!* According to Derrida (as explicated by Bauman), *the* type of ethical actor in history, the witness, is "if not exclusively then crucially Atlantic in its provenance; crucially if not exclusively haunted by the specter of the trans-Atlantic slave trade" (Baucom 33). The ocean—what I am terming the Caribbean Atlantic throughout this study—is the stage for the trial enacted by Philip's poem and the space from which the witnesses emerge.

Countering a narrative of universality or generalization, *Zong!* performs errantry, as explained by Glissant, who identifies the ocean as the second abyss into which Africans fell when enslaved—the first being the belly of the boat: "This boat is your womb, a matrix, and yet it expels you. This boat: pregnant with as many dead as living under sentence of death" (*Poetics of Relation* 6).[12] Those like the 132 Africans thrown or forced to jump overboard from the *Zong* perish in the sea, but their bones become seeds that give birth to modernity, as well as to Philip's aesthetic challenge to the foundations of that edifice that is built on the Atlantic slave trade. "In actual fact the abyss is a tautology: the entire ocean, the entire sea gently collapsing in the end into the pleasures of the sand, make one vast beginning whose time is marked by these balls and chains gone green" (Glissant, *Poetics of Relation* 6). He says of what he terms "Action of Diversity": "Rearticulated in such a network the former sacred power of filiation would not be the exclusive player; the resolution of elements in dissolution here would be relayed by the aggregation of things that are scattered" (55).[13] This concept of relation can apply to *Zong!*—the work it performs to *exaqua* the bones using the words of *Gregson v. Gilbert* and to shape a new language that is not the master's tools. Though Philip appears to use the language of a system based in the belief that humans could be bought, insured, sold, jettisoned, exchanged, and otherwise treated as commodities with monetary value, in finding the bones she devises new instruments.[14] "The tale of errantry is the tale of Relation" (Glissant, *Poetics of Relation* 18). The

repeating bones in Philip's poem in a sense resemble Benítez-Rojo's repeating islands, with relation as a unifying principle. From the abyss of the Caribbean Atlantic, Philip creates a unique performance of Relation that explores and perhaps begins to heal the wound.[15]

Another way to view the achievement of *Zong!* is to consider the poet as obeah woman, reaching into the waters (as Ma Kilman in Walcott's *Omeros* turns to Africa) for the language with which to perform her healing arts.[16] What the poem "aggregates" (to echo Glissant) are multiple, relational narratives, one of an African family split apart (Wale, Sade, and Ade, the father, mother, and son), another of a white male European crew member who cannot bear the insanity of the murdering. This latter is also a writer, penning a letter to a woman, Ruth, back in England, which includes the lines "par se the t / ruth in m urder in s / in [...]" (165–66).[17] He is then asked by Wale to write a note from him to Sade. The African husband and father eats the note, then leaps overboard; the European male witness/writer can continue no longer, and he follows Wale into the sea, concluding "*Ferrum.*" Discussing the white male character who stubbornly inserted himself into the narrative, despite her efforts not to write his voice, Philip states: "the risk—of contamination—lies in piecing together the story that cannot be told. And since we have to work to complete the events, we all become implicated in, if not contaminated by, this activity" (198). Thus, again, we observe Relation: "Other" (205) in/as the white male crew member.

Philip says her organizing principle in *Zong!* became *relational*—the text interacting with the space around it on the page ("Notanda" 207). She also comments on what her poem achieves in its interaction with the original legal document: "*Gregson v. Gilbert* becomes a representation of the fugal state of amnesia, serving as a mechanism for erasure and alienation. Further, in my fragmenting the text and re-writing it through *Zong!*, or rather over it, thereby essentially erasing it, the original text becomes a fugal palimpsest through which *Zong!* is allowed to heal the original text of its fugal amnesia" ("Notanda" 204).[18] She terms it a "recombinant antinarrative" (204). From different yet interconnected perspectives and locations, both John's novel and Brand's poem, along with *Zong!*, illustrate this concept of relation. Glissant says, "relation is not about forgetting but about living on within the abysmal" (Baucom 332). Throughout *Zong!*, including the final section "Ebora" or underwater spirits (Yoruba), Philip puts the original case on trial. Note what Philip says about the printer, overwriting the beginning of each section, erasing, palimpsestic. Within it, we see the sea and the writer of truth: "Seas there is o /[...] / i am writer / over for truth from / visions & mortality" (176). In her commentary on the poem, Philip says she is both censor and magician (199), with a dual power of and over language. She can block/not say *and*

transform/retell differently. This kind of power resonates with the *magistrat/magie* of Matilda in *Unburnable*. Bones do not burn or dissolve—they are the traces, the signs along the Salt Roads, the evidence *and* the witnesses.

III.

Marie-Elena John's novel *Unburnable*, set primarily in Dominica, offers intertwined case studies embedded in a detective story that explores Caribbean archives and exhumes bones, as the protagonist sifts through evidence testifying to traumas born of the Middle Passage and Atlantic slavery. The circum-Atlantic takes shape differently than in *Zong!*, the narrative unfolding not in water but on an island defined by the sea. Yet, as John Gillis argues, "Atlantic islands and mainlands are not internally coherent, clearly bounded things, but interdependent parts of a larger world that includes coasts and hinterlands, as well as all that lies in between the shores of Western Europe, West Africa, and the Americas" (3). As such, Dominica participates, as do the other islands of the Caribbean archipelago, in the abysmal experience of relation that marks the circum-Atlantic World. Another way to approach the island is to see it as a phantom of the slave ship—another repository of oceanic ossuaries resulting from the mass murder of New World Africans. Living with and within the legacies of the abyss, as adumbrated by Glissant, the characters of *Unburnable* inherit a rhizomatic space and are the product of the mixing or creolization identified by Glissant as Caribbeanness. This island "paradise" is not an Eden—rather, it deconstructs colonial and neocolonial images of Caribbean sites. Moreover, we can read these spaces through the lens of African traces such as scarification and masking and through the *chanté-mas* that record events orally. In a space marked by violence and haunted by skeletons left unburied in a hilltop forest, where popular *chanté-mas* lyrics pass on stories of murder and punishment, how do we find the bones and how do they come to voice? What truths can they speak from archives that resist revelation of forgotten, erased, or unrecorded events? The storyline emphasizes what Glissant terms Relation identity (as opposed to Root identity), illustrating his concepts of *métissage*, fluidity, and submarine networks.[19] The forest, resting place of countless skeletons as well as the buried bones of a thousand more Maroons, mirrors the ocean's depths, each space where the bones lie, unreachable yet demanding to be read. At the present time of the narrative (2003), the bridge to their village Noah has fallen into such disrepair that it is impassable.

The complicated plot of John's novel centers on Lillian Baptiste, who works in Washington, DC, for a global women's rights organization, after her college years at Columbia University. Sent at the age of fourteen from Dominica to the

US, in her adoptive mother's attempt to protect the girl from family history and to heal her multiple traumas, Lillian has suffered nightmares for years and built what she calls a "firewall" to prevent visions and voices from consuming her. This psychological barrier is reinforced by a talisman in the form of cufflinks originally intended as a gift to her long-term "friend" Teddy, which Lillian has instead kept for herself. They are engraved with a design in Twi: "[it] was called *Hye won Hye*; in English, 'that which does not burn' [. . .]. It was a symbol of the permanence of the human soul" (7). As an adult, still suffering from those hauntings, Lillian decides it is time to return to Dominica and uncover the truth about her maternal grandmother Matilda's death by hanging: Was Matilda guilty of murder? The narrative moves back and forth between present-day Lillian and Teddy, who together journey to Dominica, and the backstory of her prostitute mother Iris, daughter of Obeah-woman Matilda. The tangled relations in the past confounded class and color lines and led to the death of Iris's upper-class lover, John Baptiste, in a *masquerade* face-off involving huge African masks and ritualized behavior. In the process of exhumation that the text enacts, readers participate in opening the archives and reading the bones, though the narrative never confronts the actual skeletons directly. In a nutshell, Lillian's story is "one in which history was recorded in *chanté-mas* songs, a history centered around a village on a mountaintop where unburied bones were found in a forest; a history that included Flying Masquerades and a man who suddenly dropped dead; about a violent rape and a middle-aged crazy woman making a baby with her dead lover's young son" (195). As in *Zong!*, here through recuperated oral histories, we hear the bones' voices and unpack layers of court cases, trials, judgments, and punishments—all deeply inflected by the Middle Passage and colonial systems of law and enslavement, as well as by traces of African customs in the Americas.

Lillian herself is circum-Atlantic, in that her maternal grandparents were an African woman (Matilda) and a Carib man (Simon), and her father (Winston) was a light-skinned member of the elite in Dominica (later revealed to be the son of John Baptiste by his wife), i.e., of European and African descent.[20] According to Glissant, the Caribbean is "a sea that explodes the scattered lands in an arc. A sea that diffracts" (*PR* 33). In *Unburnable*, we trace the abyss beyond the Middle Passage of *Zong!* to the Relation it birthed and the repeating waves of trauma it perpetuates into the present. In Lillian's narrative, we can read a set of bones that offer evidence of the effects of living in and with the legacies of the abyss, as we also experience the imperative to re-member: forgetting is not an option. In order to remember, however, one must find and expose the skeletons, as well as understand their stories. This process parallels the unblocking of the Salt Roads in Hopkinson, as well as the impetus in both Marshall and Cliff to excavate the Middle Passage and to discern its ramifications in the present.

Lillian seeks archival evidence to prove that Matilda was not guilty of murder. What is murder and what is justice? *Unburnable* complicates those questions.

The archives most immediately available to Lillian growing up in Dominica with her adoptive mother Icilma and that woman's husband Winston Baptiste opened up through the often lewd songs or *chanté-mas* that told her family's history. One song, titled "Bottle of Coke," relates the gruesome torture perpetrated on Iris by John Baptiste's mother-in-law, while another tells of "Matilda swinging." Lillian overhears the latter sung by her schoolmates, and "it all came together for her," knowledge replacing innocence (228). One of the girls, pressed by Lillian, reveals that "[Matilda] is your murdering Obeahwoman grandmother," and as Lillian forces more explanations, she "got a précis of her history, with names and dates and as much detail as time allowed" (229). That new self-knowledge leads to her attempted suicide on her mother's grave, but later to her determined interrogation of the bones, in this case, the truth about Matilda's hanging, a pursuit of justice.[21]

While Lillian is drawn to oral history as legitimate and necessary archive, the scholar Teddy seeks written records, trusting more in "Western" knowledge and even giving credence to racist views of African belief systems and behaviors. Thus, he turns to court archives, only to find that those covering the crucial years of Matilda's trial in the late 1940s were destroyed by Hurricane David in 1979. "We file documents by year. Every piece of paper for those years—blown away. Or destroyed by the rain," the archivist tells Teddy and Lillian. "There would be nothing in any archive to help them" (235), and nobody from the trial appears to be alive in 2003 (235–36). The official record of the charges against Matilda, of any testimony either against her or in her defense, any written material to read and decipher: all is gone. In the *Zong* case, historical documents (though brief and filled with lacunae) do exist, so that Philip could dismantle those official words in her construction of *Zong!* In the fictional case that John creates in *Unburnable*, the contemporary protagonist must seek information in oral records and similar traces indebted to African traditions, not only the *chanté-mas*, but also scarification, masking, and relational systems of justice. This process of reading the bones involves testimony and witnessing that are remembered and reenacted by two characters present during the period of the trial.

In opposition to the epistemic paradigm of eyewitnesses in the New World that continued into the nineteenth century and that still holds weight for some theorists and philosophers, a premodern form of testimony better serves as model for witnessing in colonial through contemporary contexts, as Andrea Frisch explains. This argument offers a template by which to read the trial of Matilda, the verdict of "guilty," and her subsequent death by hanging. "In order to be eligible to give testimony, a folklaw witness had to be recognized as a legitimate deponent in the eyes of his community" (Frisch 43). Lillian

first recalls that Mary-Alice, the white woman who is her godmother, was a character witness of Matilda during the trial: "I was asked to give my opinion of whether she was a decent person or not," Mary-Alice tells Lillian (217). A former nun, Mary-Alice married the African-descended Bird and settled in Dominica; a white woman still imbued with Catholic beliefs, she was horrified at Matilda's acquiescence in her daughter Iris's position as teenage mistress to John Baptiste. Two different views of women's roles emerge in the heated argument between Mary-Alice and Matilda, the former seeing Iris as being prostituted to a wealthy mulatto man about to marry someone of his own class, the latter considering Iris safe and provided for as the "outside" woman. This confrontation between the two women ends with Matilda baring her breasts, slapping them across the white woman's face, and giving a speech, "in which the mountain woman used a kind of Creole that one did not hear normally, the complex Creole of someone who never spoke English, a rich Creole that did not call on support from thrown-in English words but was nonetheless completely comprehensible" (222). The act and the language counter Mary-Alice's familiar paradigms for female behavior; this one encounter determined how as "character witness" she spoke of Matilda in the trial.

Mary-Alice rationalizes her testimony based on her perception of Matilda as transgressive Other and guilty in that Otherness, a perception that is both "eyewitness" and "character" witness. That those in charge of the trial turn to Mary-Alice in the first place and then accept her testimony as valid indicates the addressee's standpoint, rooted in racism and colonial attitudes towards both women and Africans. Mary-Alice herself and those who validate her assessment of Matilda conform to the Man/other dichotomous ideology critiqued by Sylvia Wynter.[22] Though Mary-Alice maintains that her words did not condemn Matilda, that the latter confessed to killing the people whose skeletons were found in the forest, her testimony clearly confirmed the beliefs of those in power: "what I said was that I found her to be morally corrupt" (218). Folklaw testimony here breaks down for Matilda, because the person serving as character witness does not recognize her own relation to the accused. Rather, Mary-Alice judges the Other based on an oppositional, hierarchical, and inherently racist sense of self and other, and of community itself. The testimony becomes "impossible" due to Mary-Alice's "failure to know" (Frisch 52); that is, she is a character witness who does not have direct knowledge of Matilda's character. To the contrary, she turns to her impressions of one encounter, in which she was rebutted and shamed, as the basis for her assessment of Matilda's character. Hers is the one report of the trial that Lillian receives from someone actually present and participating, and it offers clues to the nature of that system of justice suffered by the New World African woman.[23]

Two legal systems and sets of cultural beliefs clash, two ways of judging and punishing, as do two sets of words: Mary-Alice's and Simon's. "In order to function as a witness—and thus, as a member of an ethical community—the folklaw witness must understand that he owes his very existence to others" (Frisch 51). Such a witness is Simon, the Carib husband of Matilda, who shared and then abused her obeah powers, and whom she thus banished from Dominica. While Mary-Alice spoke against Matilda, hardly in solidarity with her, Simon returned by canoe from Guyana in order to offer his testimony that might save her life.[24] When he stands outside the court, not permitted entrance, and yells as loudly as he can, he is speaking in ethical relation to Matilda. "Folklaw testimony does not provide knowledge or understanding of an event; rather, it enacts an ethical relation of solidarity with a person" (Frisch 51–52). Such, I argue, is the informal testimony proffered by Simon: "It was in the name of love, a futile attempt to save her life" (271). While Mary-Alice sees Black female breasts and sexuality that threatens her conception of womanhood, as well as Obeah practices that challenge her Catholicism, Simon sees a Black woman who was "*magistrat*," a judge for her people. Despite that spontaneous, relational testimony, and despite the fact that Matilda's confession was false, forced, and based on testimony that misread her, she is judged guilty of multiple murders: John Baptiste, who dies of a heart attack in the wake of a battle between two masked groups; dozens of people whose skeletons the police discover in the forest at Noah. Both charges illustrate the problems of epistemic witnessing: "As long as we persist in thinking of testimony primarily as knowledge, and especially as complete and certain knowledge, we will run up against some version of the unspeakable (predicated on the notion of the unknowable)" (Frisch 52). The unspeakable and the unknowable lie in the two sets of bones at the heart of both Noah and the narrative itself.

As we read these bones and place them in the larger context of the circum-Atlantic and of New World Africans, again Glissant's concept of Relation reverberates: "relation is not about forgetting but about living on within the abyss" (Baucom 332). Like *Zong!*, *Unburnable* juxtaposes ways to remember events, dismantles the official record, explores alternative systems of justice, and asks how we come to a reckoning for the abyss. "The debt to the other is never paid in full, but persists as an infinite obligation" (Frisch 51). This text illustrates the abysmal, the ongoing violence and death, destruction and annihilation that Relation experiences as "the unconscious memory of the abyss" (Glissant, *PR* 7). Ultimately, it also attains "knowledge of the Whole, greater from having been at the abyss and freeing knowledge of Relation with the Whole" (*PR* 8). The bones remain and testify, as Lillian gradually uncovers the skeletal narrative that acquits Matilda and frees her granddaughter.

As testifying is performative, so, too, were the actions that constitute the core event in this reading of the bones: a *masquerade* enacted by those wearing African masks as they confronted the man responsible for Iris's broken bones and tortured body. A year after Iris was beaten and raped by Mrs. Richard (mother of John Baptiste's wife Cecile), aided by her servants, a *bande mauvaise* in wire masks faces off against a band wearing wooden masks that more closely replicate those used in African *masquerades*. A visiting anthropologist provides exposition to convey to readers the underlying meaning: "they're wearing masks from all over the west coast. Nigeria, Sierra Leone, the Gold Coast, Liberia . . . " (134). John Baptiste, a member of the first group, reacts in terror to the sight of the advancing wooden masks, which Mrs. Richard dismisses as "ugly" and "old-time," because of their Africanness (138). "It was a masquerade that only came out to direct strong magic against those who had broken the law, perpetrated a taboo" (140). This band descends from their hilltop village, Noah, bringing traditions more closely linked to Africa into direct battle with the belief system of those who have been multiply colonized—by the French, by the Catholic Church, and by the British. As the observing visitor notes to himself, they are "people who, although so obviously African, were yet and still not African at all" (139). Matilda's act of revenge incites the events that trace a path to two sets of bones in the forest surrounding Noah, as well as to Matilda's death by hanging. As the lead masked figure—later identified as a woman, more specifically as Matilda—whirls madly around John Baptiste, observers feel the enormous power unleashed, and Baptiste is ultimately terrified to death. "[T]he thing looked as if it would jump up into the very sky. It raged against the three sets of rope noosed around its head and torso, tethered to the street only by the effort of three struggling masked beings with whips" (140).[25] This dreadful mask is "so powerful that it came out only in times of deepest crisis" (142). Though the official cause of Baptiste's death is a heart attack, those in power and the legal system that supports them, all based in colonial rule, perceive Matilda as a Black woman who has transgressed and who must be punished.[26]

Matilda's hilltop village is revealed as an African-based, women-centered community descended from maroons, its actual name "Noir." This hidden space manifests the "demonic grounds" theorized by Katherine McKittrick and serves as a challenge to anti-Blackness (especially directed at the Black female body) and necropower.[27] In the rush to pursue and capture Matilda, the police invaded Noah, albeit first suffering a deadly attack by farmers armed with hoes. Misinterpreting the movements of the "country people" as a welcome dance performed with their farming implements, the police were viciously attacked as the people of Noir tried to prevent them from capturing Matilda. "It is good enough to know oneself to be superior, something else entirely when the inferior confirm the fact with a show of their adulation. Such acknowledgment of one's cemented

place in the scheme of things must be an intoxicant. Nothing else could account for the failure of the police to properly interpret what was taking place" (152). Indeed, the whole narrative is constructed on such performative clashes, a continuing cycle of violence born in the abyss; the text becomes its own *chanté-mas*, marked by repetition, repercussion, and an attempt at recuperation.[28]

Matilda is revealed to be not only a powerful obeah woman but also the "*magistrat*," the judge who determined the outcomes of legal cases and enforced punishment for those found guilty. This part of the story emerges in another form of oral history, as the assistant archivist, Sylvie, tells Teddy what she heard from her grandfather, who himself overheard details when working as servant to the governor: the police had found a village inhabited by dark-skinned people ("*noir-noir-noir*") who were celebrating with drums, masks, costumes, and dancing, whose homes gave evidence of animist religious practices and polygamy, and who thus must be exterminated, in the view of the Catholic police. Further horror-struck by the sight of dozens of skeletons in the forest, the first set of bones, the police attempted to destroy the village and to murder the inhabitants, as well as capturing Matilda. They also falsified the evidence in claiming to have found only eleven skeletons, a number that they agreed would be more believable to those in Roseau. "Through the hanging vines and ferns and orchids, the police had seen them all, so many of them, some sitting with their backs supported against the deep green of moss-covered tree trunks, some lazily lounging on the forest bed, some reclined on their sides, others spread-eagle on their backs, gazing up at the canopy" (266). These bones belong to those on whom Matilda had imposed the death penalty, who were then poisoned and left in the forest as punishment. The court mistakenly read them as murdered by her, through "*magie*" or obeah, just as she was judged to have killed John Baptiste, though she did not touch him. Like *Zong!*, John's text undoes a colonial-based system of justice and claims humanity for those considered "other" to its "Man" or "Human."

Noir, or "Up There," is physically and geographically the opposite of the sea bottom, but both hold the bones and serve as ossuaries. The bones in the forest speak to a different legal system, one deriving from African practices, which a colonized mindset cannot fathom or appreciate, and thus attacks in an attempt to erase it. The second set of skeletons provides yet another key to how we are to read the bones in *Unburnable*: those thousands from Noir who leaped to evade the police and were buried with proper ritual by a few who remained for that purpose.

> [T]hey had all jumped, all except the few who remained behind to prevent an abomination [. . .]. A few of the people of Noir had voluntarily postponed their homecoming to give the thousand bodies down in the still-uncharted forest a proper interment befitting their noble lives and

glorious deaths, and then they had quietly waited out their time, undetected except by Father Okeke's African eyes, with only their beautiful scars to mark them as holy. (288)

The leapers landed in another manifestation of the abyss, yet in that action, they also sent their spirits home. On one level, their fall is parallel to that of enslaved Africans from the *Zong*, and they resemble the ghosts of the *Zong* that Philip captures in the pages of her poem.[29] They are also the Ancestors' voices that Lillian hears as she approaches Noir—or its remnants: "they were real voices, and Lillian now knew who they were and why they were calling her" (290). Her desire to reach Noir and to hear the ancestors, the Maroons who "had jumped to their heaven, as people were wont to do when enslavement was not an option" (291), indicates the importance of witnessing the actual spaces and listening to the voices of the bones.

This last information has come from another witness in this version of a Bone Court: Mary-Alice's husband, Bird. One of the last of a group of families in Roseau who supported and aided the maroons, Bird has performed silence, remaining quiet about what happened, in an oath sworn to those who buried the bones. Through him and the African priest (Father Okeke), we can read the African traces in scarification on the old people from Noah: their "identity cards" (241). Dominica has a peak named Diablotin, for a bird supposed to be extinct, but not, and thus similar to the Caribs and the maroons (267). Simon is the Carib who journeyed by canoe to return for Matilda's trial and to serve as witness to her innocence, to her position as *magistrat*—Judge. Calling himself Diablotin, he attempted to testify, but was refused entrance: "A half-naked Carib, stinking, sweating, sunburned, hair all tangled up, shouting like a crazy man outside the courthouse? Remember it was a closed trial. He couldn't even get in" (267). He was not chosen to serve as "character witness," in direct contrast to Mary-Alice, the white former nun who is judged worthy to serve in that capacity. Shouting in Creole outside the courtroom, he tells the judge that Matilda was not capable of murder, that she herself was a judge. Though he was not heard at the time by those in control of the court, nevertheless his reading persists—he can now speak the truth of the murder of Matilda, as the old man named Bird tells Teddy the true story of what happened and of Matilda's innocence. In court, she "only said that she was responsible for the dead in the forest" (272), not that she had killed them.

Lillian has inherited this history, a legacy of bones, as she belongs to the abyss: space of destruction and trauma, yet also of wholeness—unity in Relation. Her desire to reach the ancestors at Noir, to hear them and to commit suicide, intensifies in the final pages of the narrative. She seeks her own *chantémas*: "Let them sing on her—she wanted her own song, it was her birthright.

A *chanté-mas* to guarantee her place in history, alongside her grandmother and her mother" (291). She imagines drowning herself in a river, like a "*Mama Glo*, the West African *Mami Wata*, the seductive, long-haired deity" (291), a deity of the sea like Yemaya, or like Ezili who guides Hopkinson's narrative. Another option would be to jump, like the maroons, flying into a union with the ancestors. Yet the text leaves the question open, as John herself has stated in interviews, so that Lillian's death is not certain, only her connection with the voices and her final embrace of her family's story.[30] The bones signify Africa in the heart of the Caribbean, a group of New World Africans at the center of the circum-Atlantic, a woman-centered community that resists colonial systems. This Bone Court concluded, the audience is left with the story: "the listener or reader is *essential* to the survivor's speech, and this because speech and the representational or interpretive and normative frameworks it implicitly articulates are essentially social or intersubjective" (Trezise 59, original emphasis). Or in Adorno's ethical bind, "the very difficulty of hearing is what makes listening itself an obligation" (Trezise 60). As Philip listens to and transcribes Boateng, her coauthor, John underscores the necessity of listening to the voices that bring the bones to the surface, exaquaing them from oceanic ossuaries.

IV.

Dionne Brand invites readers into contemporary oceanic *Ossuaries*, through a text in which bones pile up in a "museum of spectacles" that explodes in the final lines. With the first-person narrator, we enter chamber after chamber of "Branded bones" (36), words that bear the mark of the poet's accounting. Evoking bones and the bodies for which they provide the scaffolding, the poet reads contemporary struggles interwoven with legacies of the past that appear in fragments, as she creates an aesthetics of disintegration for a world needing redemption: "our ossuary" (82). With the narrative persona, "I," we excavate oceanic depths as well as urban hiding places, witnessing twentieth-century flight and pursuit that replicate the experiences of runaway slaves. We read of violence inflicted on human bodies that causes skin and muscle to disintegrate, as does the paper on which the lines have been written in an attempt to capture that process and to represent the bones. The poem also serves as a court case, inflected by the ocean, ships, and repeated drowning. It echoes the *Zong* incident obliquely while surrounding those ghostly presences with the detritus of centuries scarred by the slave trade and circum-Atlantic violence. Rather than mourning or elegy, however, the text seethes with explosive energy as the "I" narrator challenges the audience with visceral images of slaughterhouse, prison, and museum—spaces filled with the bones that offer evidence of

violence done to human bodies. Glissant's concept of the Abyss resonates with Brand's vision in *Ossuaries*: "For though this experience made you, original victim floating toward the sea's abysses, an exception, it became something shared and made us, the descendants, one people among others. People do not live on exception. Relation is not made up of things that are foreign but of shared knowledge. This experience of the abyss can now be said to be the best element of exchange" (*PR* 8). Moving beyond the spaces of the Atlantic and Caribbean, taking a planetary perspective, Brand's poem questions, however, the potential for a wholeness of Relation. Like Glissant, Brand turns to poetry as a way to share and tame knowledge: "We cry our cry of poetry. Our boats are open, and we sail them for everyone" (Glissant, *PR* 9).

The poem is structured as a dialogue between two voices, in fifteen "ossuaries" that alternate between the poet's "I" and a figure named Yasmine, a young Black woman involved in revolutionary activities in the 1970s who has gone into hiding in upstate New York and then escaped to Canada. The text is not conversational, but contrapuntal: "there are certain synergies between the two, or so, narrators . . . so it's Yasmine and some consciousness and a movement toward a unified voice, but still keeping a kind of magnetic—mis-attraction between the two. The other voice is both very old and ancient, but very new" (Brand, qtd. in Nolan, n.p.). In the odd-numbered sections, the narrator is our guide through the ossuaries of our contemporary world, filled with the toxic remnants of circum-Atlantic history and anchored in the bones of New World Africans. "Ossuary I" opens with the image of prisons, incarceration not in a physical cell but in a life of "every square metre of air so toxic with violence" (10), permeated by a vicious racism encountered in offices, on trains and walkways, in words and glances, and especially at night, such that the narrative persona says that "restraining metals / covered my heart," "tanks rolled into my life, grenades took root / in my uterus, I was sickly each morning, so dearly" (11). The legacy of the Abyss leaves the Black female body imprisoned and under attack in a society that directs violence at "others," a vision of illness and despair that intensifies in this first section of the poem.[31]

"Ossuary I" also traces the horrific experiences of Saartjie Baartman (without naming her), whose adult life was shaped and destroyed by scientific racism, her path leading from birth in 1789 in South Africa, to capture by Europeans, then imprisonment and exploitation in England, to further dehumanizing display in France, death in 1815 in Paris, with a final, belated homecoming for her bones in 2002.[32] Beginning in "dreams full of prisons," this first section of *Ossuaries* connects "I" to the young woman whose body became an object of both "entertainment" and "study" in the nineteenth century: "when the jailers went home and the spectators drifted / away and the scientists finished their work / like a bad dog chained to an empty gas station, / for blue blue nights, / I

got worse and worse, so troubling // I would fall dead like a specimen, / at the anthropometric spectacles / on the Champ de Mars, the Jardin d'Acclimatation // the mobile addresses of the autopsy fields" (13). Speaking for and as Saartjie, comparing her own experiences to Baartman's life in Europe, the narrator establishes Relation with the African woman and revisits the ways that the Black female body was (dis)regarded and abused. No place is home, as Brand earlier illustrates in *Land to Light On* (a text that ends with a woman in a prison cell, circling endlessly): "I don't want no fucking country, here / or there and all the way back, I don't like it, none of it, / easy as that. I'm giving up on land to light on, and why not" (48). Saartjie Baartman did return home, however, her bones laid to rest in the land from which she was stolen.[33] In *Ossuaries* (as in *Zong!* and in *Unburnable*), the text performs that laying to rest, even while reminding us that the contemporary moment emerges from, is indebted to, and remains complicit in the modernity birthed by the Atlantic Trade. Brand's poem presents a court case—a Bone Court in writing—sometimes described by the narrator as an unsent letter to her past self: "petitions, I gave here, I gave there, I allowed, / of course here's my innocence" (48). This persona has haunted courthouses and brought suit numerable times, in a global trajectory across and around the Atlantic World.[34]

On the micro-level of the poem, we listen to the voice of Yasmine—in the shadow of 9/11, which opens her first "Ossuary," as she watches the news and pieces together where the attacks have occurred. She embodies resistance and its failure, in her life of revolutionary dreams, a botched bank robbery, flight, hiding, movement through the cities of the northern US, and finally escape to Canada. Her narrative engages Atlantic World history, especially in North America, and raises questions of whether freedom is possible in these spaces in the twenty-first century. Similar to the dichotomy of prison and anchor, the abyss as ongoing enslavement and/or liberation in Relation, the narrative of Yasmine's adult life questions whether she is trapped or free. "One of the motifs of the book is these bone chambers where one can, hopefully, lose that freight [the impossibility of the past]—or be trapped by that freight. Or, just observe it" (Brand, qtd. in Nolan, n.p.). Brand says that Yasmine is no longer engaged, but rather observing: "But, I don't think she has a way of engaging anymore because there is not merely death, but there are actually bones, of her existence and of the culture she has come from. And the culture that she comes from doesn't know that it's boney, but she observes it as bones" (qtd. in Nolan, n.p.). What holds one in place can become a ball and chain: how can one discover not a prison cell but supportive structure in the bones? Instead of refuse, can they be marrow and sustenance? Yasmine does become free, escaping to Canada, but she does so with a fake passport, essentially false papers, and then works in a mind-numbing job killing chickens in a factory,

chained to a kind of butchery. The poem questions how to free oneself from the chains, how to use tools other than those of the master.

Each section of *Ossuaries* works as a Bone Court, the ossuary a space in which the bones speak and demand justice. Saartjie Baartman provides an iconic case, one that connects Africans to the Indigenous people on whose behalf Vizenor argues. Her remains were saved and displayed, like those of the Native peoples on show in museums, whereas victims of the Middle Passage sank to the sea bottom (if not eaten by sharks). As Vizenor also argues, narrative is crucial to this demand for human rights. Brand's poem pushes to an edge, incorporating Yasmine's story and the "conversation" between "I" and Yasmine, which creates enough of a story to make a case, to seek and demand justice. Yasmine represents a stage in the process of becoming aware, both personally and collectively, of witnessing and testifying, a reckoning that resonates with that in *Zong!* and in *Unburnable*. Along with Saartjie Baartman and the narrative persona, Yasmine is poisoned by cultural toxicity, and healing is left under suspension, even as the "I" voice turns repeatedly to the law for retribution. These three Black women form a triptych, seeking a return, a home, reading and embracing oceanic ossuaries.

As in Philip, the ritual involves language itself as that potential home, centering the return in the waters, the abyss that forms and shapes relation for New World Africans. Glissant describes this way of knowing: "Not just a specific knowledge, appetite, suffering, and delight of one particular people, not only that, but knowledge of the whole, greater from having been at the abyss and freeing knowledge of Relation within the Whole" (*PR* 8). The poet reads the bones, which speak, as skeletons become words that both nourish the ghosts and present a Bone-Court case. Near the end of *She Tries Her Tongue, Her Silence Softly Breaks*, Philip invokes bones: "The emptied *skull* a gourd / Filled / With the potions of determine / That compel the split in bridge / Between speech and magic / Force and word" (98, emphasis added). She continues the invocation of the body's boney scaffolding as source of music and song, the ribcage becoming a harp, other bones a flute. The bones both inspire and participate in a transformation: " . . . Silence / *Song word speech*" (98, emphasis added). The bones become the word, moving from silence into voice, acting as witnesses. Creating ossuaries, Brand (like Philip and John) faces the challenge to make them live even while they express loss and embody the unspeakable, what cannot be seen or known.

Traces reside in the bones, which these three texts reassemble in words. Language and aesthetics become the resources in *Zong!*, while in *Unburnable* all that seems available to Lillian is a return to the ancestors, joining the bones on the hillside as her spirit takes flight. Can language reintegrate the bodies, recuperate what has been lost? As both Philip and Brand note, paper turns to

dust, as does skin. Philip writes in "Testimony Stoops to Mother Tongue": "Hold we to the centre of remembrance / that forgets the never that severs / word from source / and never forgets the *witness* / of broken utterances that passed / before and now / breaks the culture of silence / in the ordeal of *testimony*; / in the history of circles / each point lies / along the circumference / diameter or radius / each word creates a centre / circumscribed by memory ... and history / waits at rest always / still at the centre" (*She Tries Her Tongue* 96, emphasis added). Like Philip and John, Brand offers a text that forms these words into oceanic ossuaries that serve as contemporary Bone Courts for the Atlantic World.

Throughout her oeuvre, Brand has studied the diaspora with its originary Door of No Return and has traced the paths of diasporic subjects to cities across the globe.[35] In *Ossuaries*, the ocean floods cities, giving a view from underwater: "I loved and lived, as I said, for a time, / looking up from water like sea shells, / I arrived where the sonorous oceans took me" (31). As "I" re-members the Middle Passage and inhabits cities, ships surface in urban surroundings and her body often fills with salt water: "my coastal limbs carrying shells and seaweeds // the full ocean in my mouth, oh I longed, longed / for the deepest suicidal blue waters, I craved the seas, / where what was on earth could not scar me" (35). Yet the seas also hold scars of trauma, evidenced in the bones at the bottom, haunting the present with knowledge of the Triangle's past.[36] Thus, the ocean fills the narrator's mouth both as memory of those deaths and as the bones to read: "what it is to lie down in water each night // to feel the mouth full like drowning" (104). In Brand's *Land to Light On*, when the speaking voice says, "I am giving up land to light on," she remembers: "The ocean as always [is] pulling you towards its bone" (45). That persona also claims the ocean as her land: "your land is a forced march on the bottom / of the Sargasso, your way tangled in life" (44). This space is a mass grave of ships, as also of Africans: ghosts, phantom limbs, and numberless bones. It recalls Hopkinson's description of a cancerous blockage to the Salt Roads, as well as the underwater writing in *Zong!* Through the central narrative voice, we discern traces of the past, a ghostly script rewritten in layers, palimpsestic.

The sea floods and saturates cities, particularly in Yasmine's sections, so that they sometimes appear to lie underwater and become themselves oceanic ossuaries.[37] As the Atlantic Triangle built cities in Europe and North America, in Brand's poem the cities through which Yasmine journeys and in which she hides cannot escape their connection to salt water. In *No Language Is Neutral*, Brand writes, "I have tried to imagine a sea not / bleeding" (34), yet the bones speak another story, of violence, illness, injury, and death. Where indeed is "land to light on"? The city and/as ocean becomes a syncretic space, both terrestrial and aquatic. Can it offer or create Relation, as a space/place? Yasmine's narrative most often shows us a Black woman alone, navigating the watery

urban territories of New York State, Havana, and an unnamed Canadian city. In the earlier text, Brand draws together images that expand further in *Ossuaries*, pieces of a history both oceanic and metropolitan. Of the ocean, she writes, "you see it without its history of harm, without / its damage, or everywhere you walk on the earth there's harm, / everywhere resounds. This is the only way you will know / the names of cities, not charmed or overwhelmed, all you see is / museums of harm and metros full" (45), in places like Paris, Amsterdam, Zeebrugge, and Kinshasa. *Ossuaries* keeps moving, as Yasmine changes cities over the course of several decades, and "I" moves across oceanic spaces as she guides us through the fifteen ossuaries. The interwoven narratives are haunted by history: the Door of No Return, the Middle Passage, rebellions, the *Zong* and similar incidents, plantation slavery, flight, the Law, disease, and death. Bone remains, and at its heart, the marrow, and the poet's voice that makes the bones speak: "me hunting for slave castles with a / pencil for explosives" (*Land to Light On* 75). We see skeletons of ships and bones of the Middle Passage. Africans and the Middle Passage have become *absorbed* (not like the hidden and buried traces that Lillian must uncover in *Unburnable*).

When the narrator evokes the other shore and homecoming, she immediately tries to refute a return passage or a resuscitation of the Middle Passage: "this boat should remain out there / will remain out here, ghosting in its watery solitude, praying / never to make shore" (86). Yet Yasmine's narrative contains numerous elements that echo and repeat a history rooted in and continuing the legacies of enslavement in the Americas, as well as repeatedly linking the sea and the city. Disoriented by all of the safe houses in upstate New York and recalling her stay in Havana, she is "a body at sea" in "Ossuary II," which takes place in part on September 11, 2001. The first lines of this section point to the repetitive, haunted aspects of her story: "to undo, to undo and undo and undo this infinitive / of arrears, their fissile mornings, / their fragile, fragile symmetries of gain and loss" (21). When "Ossuary IV" flashes back to 1977, in Albany, Algiers, and Cairo (all cities in New York), she lives with a boyfriend and listens to music as an antibody to the toxins in her culture, her skull itself an ossuary (45). Her made-by-hand genealogy includes Engels, Bird, Claudia Jones, Monk, Rosa Luxemburg, and Coltrane, and she is caught in a "drenched net / a blue crab angling and articulating // sideways" in a city she cannot name: "which city now, / which city's electric grid of currents, / which city's calculus of right and left angles // which city's tendons of streets, identical, / which city's domestic things" (55). This merging of city and sea occurs strikingly in "Ossuary VII," which takes place in Havana: "she glimpsed below the obdurate seduction of Atlantic // and island shore" (63–64), where "the urban sea washed anxiety from her" (65). One night she walks out into the Caribbean Sea, where coral meets cartilage, bone touches air. The poem's lines here reflect and enact yet another form of the "exaqua" process theorized by Philip.

Brand reads the bones of contemporary struggle and the legacies of the past in a palimpsest that is both aesthetic creation and evocation of disintegration. Gradually, Yasmine's sections lead to the moment when she and other Black revolutionaries attempt to rob a bank in Albany, which becomes a dividing line in her life, as the four of them escape in a rusted-out car, pursued by the police. In Utica, she experiences phantom limbs and crosses a river, "and so she will enter an earlier time, / contrive to change the river's course, / the forensic circumstances of her own" (93). She wonders, "are we still slaves in this old city?" Disintegration happens in a surreal manner, their bodies seeming ready to come apart, imagining that "here their bones erupt like skeleton over skeleton" (100), in their fear of capture and desire to reach freedom. In this section the echoes of slavery are most salient, the fugitives' future uncertain, even as it replicates that of forebears: "and, look, anyway, they're all composed in bony anchors / at the feet, they'll escape or they won't, / those are eternal cops behind them, glacial and planetary" (102). With references to passes, borders, rivers, pursuit by cops, and the general state of being "anchored" in their bones, Yasmine's story demonstrates the intractable qualities of racism and violence in North American cities.[38]

Yasmine's final "ossuary" (numbered XIV) takes place in April, when she crosses the Niagara River, using the passport of a dead white woman (which resembles a slave's forged pass). References to just-blooming apple trees remind one of the paths to freedom taken by those escaping from South to North, who would know to follow the unfolding of spring moving in the same direction.[39] Yasmine crosses the border into Canada: "she steps into another country, another / constellation of bodies, / her compass reset to what reckonings" (120). Working at the Maple Leaf chicken farm (its name echoing the national symbol), she must kill the birds and cut out the parts, a form of labor not much removed from that performed by her enslaved ancestors. Just as the ocean has flooded cities, erasing distinctions between water and land, so do Yasmine's experiences illustrate the permeability and meaninglessness of borders or boundaries, of separation of then and now. Her story leaves off with redemption (and freedom) still out of reach. The poem questions how to free oneself from the history that keeps one chained. How do we explode the "museum" and release its boney contents? This revolutionary vision parallels Philip's breaking open and exploding the archive, dismantling the legal document and reading the bones.

In *Land to Light On*, Brand writes a "history of the body," from water through bone, saying that "all that has happened since is too painful / too unimaginable" (34), yet, like Philip and John, she continues to write that unspeakable, to read the bones and give them voice. What does one do with knowledge? The narrator poses that question at the beginning of "Ossuary XV": "they ask sometimes, who could have lived / each day, / who could have lived each day

knowing" (122). *Ossuaries* faces the unimaginable and refracts it in language that keeps slipping, creating and obliterating, fitfully stopping and starting again. Rather than "giving up" on land, *Ossuaries* provides a way to mark the harm, re-member it, aestheticize that history, and then both inhabit and walk out of the bone-spaces. These bones are exhumed, *exaquaed*, such that Atlantic World history is stripped bare by the poet, down to the bones, like the chickens that Yasmine butchers. The challenge is to make the bones speak, to find the boney language that testifies, witnesses, *exaquas*, and then builds the oceanic ossuaries, while returning the bones to a home. They then can nourish future generations, as an anchoring instead of an imprisonment.

Relation emerges from the Abyss and regenerates.[40] Dionne Brand's words capture this process of connection and return: "'shipping out' / who could not see this like the passage's continuum, / the upsided down-ness, the cramp, the eyes compressed // to diamonds, / as if we could exhume ourselves from these mass graves, / of ships, newly dressed // if we could return through this war, any war, / as if it were we who needed redemption, / instead of this big world, our ossuary" (*Ossuaries* 81–82). *Zong!* seeks redemption, as *Unburnable* seeks truth and knowledge. Brand's *Ossuaries* seeks a new way to engage with others, a new way of relating and a new understanding of relation. All three texts discussed in this chapter underscore the desire for connection, via memory, history, and the present "boney" (and bone-strewn) moment. Together, they plot an arc of the African Diaspora, centered in the Abyss theorized by Glissant: the ocean of the Middle Passage, an island in the Caribbean Sea, and global trajectories outward from that initial passage and landing, linking North American cities to the Atlantic in oceanic ossuaries. These repositories, the texts, are aesthetic responses to the layers of memory underlying modernity's history and informing its narratives. Brand stands at the most contemporary of these moments and expresses the oxymoronic attitude of hopeful despair, calm rage, wise resistance, even as she also testifies to a disbelief in the efficacy of language to address the centuries-long crimes against New World Africans.

Part Two
Voicing the *Wounds*

Chapter 3

WORDS TO HEAL THE WOUNDS

Amnesia, Madness, and Silence as Testimony
in Haitian Women's Fiction

Contemporary novels by Haitian women explore the relation between past and present, both in Haiti and in Dyaspora, grounding the narratives in a larger historical and cultural context that reaches back to the Middle Passage. Discussing her novel *Le Livre d'Emma* (*The Book of Emma*, 2001), Marie-Célie Agnant states: "folie = 'langue-cri' pour dire la révolte et le désarroi engendré par le poids du passé, de la mémoire, et de ses résonances sur le présent" (Ghinelli 148).[1] While silence and madness might appear to be a negation of language, instead they become a refusal of the colonizer and an affirmation of the individual woman who resists on behalf of female generations before her, as well as for herself and her offspring.[2] In Agnant's novel, as in Jan J. Dominique's *Mémoire d'une amnésique* (*Memoir of an Amnesiac*, 1984), the narrative is told through multiple perspectives and voices, such that forgetting becomes instead an act of constructing memory syncretically and relationally. A witnessing "I" that shifts identity throughout these two novels, as also in texts by Myriam J. A. Chancy, provides testimony both personal and collective, challenging official history even as this creative process shapes a new national identity located firmly in female experience and women's voices. The titles of both Agnant's and Dominique's novels underscore the role of writing as testifying, the production of histories from stories individual and national. All three authors explore the experience of exile in Dyaspora, both Agnant and Dominique writing from the remove of Montreal, while Chancy has migrated among locations in Canada and the US. Haunted by the Middle Passage and a history scarred by colonialism and

then the neocolonial presence of the US in Haiti from 1915 to the present, postearthquake, and deeply scarred by the Duvalier years, these narratives are also guided by the ancestors and by figures such as the *Métrès Dlo* and *Ezili/Erzulie*. They resonate even more forcefully in the aftermath of the assassination of President Moïse and another devastating earthquake.

Silence haunts Haitian women in both written and oral narratives, a legacy of the country's tumultuous past and overtly patriarchal institutions.[3] Thus, many authors and critics laud Marie Vieux-Chauvet as the pathbreaking novelist who brought both female experience and endemic violence to the forefront in her triptych *Amour, Colère, Folie* (*Love, Anger, Madness*, 1968). Set during the early twentieth century but clearly reflecting elements of the Duvalier years (1957–1986), the three novels explode with the emotions of their titles as they document the horrors faced by men and especially women under a dictatorship maintained by terror and atrocities. The author herself confronted pressure to silence her voice, including the resistance of her immediate family who feared reprisals, thus not publishing the works in Haiti and fleeing into exile in the US for the last years of her life.[4]

Contemporary writers follow in the steps of this foremother, depicting Haitian women as the repositories and recorders of national history: a female-bodied history, shared across generations of women, birthed by the protagonists who testify and who witness, generating narratives that express "the autobiographical experience of the whole country" (Dominique 291). These texts employ multiple perspectives and narrators to relate a composite story of Haiti, focused on Black female experience. And they also involve the writing process: Flore, the interpreter, retells Emma's story, reconstructing it from the sessions she tape-records; Paul/Lili writes the memoir whose pages alternate with the first-person narratives of those she remembers and with whom she interacts, both in Haiti and in Montréal; Chancy's protagonist Josèphe (*The Scorpion's Claw*, 2005) uses her typewriter to capture the stories told by her grandmother, as well as those of the familial spirits who haunt her writing space. As Chancy has argued, "it becomes necessary to define the novelistic literary tradition of Haitian women as one that transgresses nationalistic ideologies and reformulates nation and identity through the lives of personal and communal exile" (*Framing Silence* 10). All of these voices offer testimony or serve as witnesses in Dyaspora as the texts exhume the legacies of the slave ships and Middle Passage, the recurrent violence against women, and the ongoing effects of patriarchal institutions. Similar to the ossuaries exhumed (and exaquaed) by Philip, John, and Brand, these novels invoke both a sinking into and a rising from the waters, as Haitian women birth themselves and a nation-vision.

I.

Le Livre d'Emma is both the book that Emma Bratte writes as her doctoral dissertation—rejected by her professors and thus officially silenced—and the narrative produced by Flore, the interpreter assigned to listen to Emma and decipher the mystery surrounding her seeming murder of her baby, Lola. Emma's studies in Bordeaux arose from her desire to learn and know her own (and Haiti's) history, born on the slave ships in the Middle Passage. As Glissant says, "It seems to me that I have always known [the sea], the route and dumping-ground of the slave traders, depths of the unconscious, or a pit of suffering" (qtd. in Miller 341). Like NourbeSe Philip, Marie-Elena John, and Dionne Brand (discussed in chapter 2), Glissant is haunted by the slave trade, especially the image of people thrown overboard alive; his words resonate with Philip's *Zong!*, and they also offer a frame through which to embark on an analysis of Agnant's novel. When Emma was leaving Haiti to study in France, she thought of similar incidents: "I thought about the boats, about all those ships that the slave traders had sunk with thousands of slaves chained in their holds. They sank the ships to avoid being caught, to avoid paying a fine, when laws had finally been adopted to try to prohibit slavery. But it was too late" (191). Incarcerated in a mental hospital in Montreal, accused of infanticide, Emma refuses to speak French and insists on using Creole, a language that her doctors cannot comprehend—thus, the need for Flore's interpretive skills.[5] The latter's "I" frames the narrative as she meets with Emma in a building that faces a river, a location that evokes generations of trauma: water is the repository of the past that haunts her and the element in which she will eventually commit suicide, as did a maternal ancestor to escape her enslavement in Haiti.

From an external perspective similar to that of the colonizers, Emma's preoccupation with the ocean may appear obsessive and mad. Summarizing his pages of notes on Emma's words, the psychiatrist Dr. MacLeod tells Flore, "It's only about blueness: the blue of the sky, the blue of the sea, the blue of black people's skin, and about the madness which is supposed to have come over in the holds of the slave ships" (10). That dismissive attitude is challenged throughout the narrative by Emma's own story and by the words passed down to her from maternal forebears, such as her grandmother's cousin, Mattie. That surrogate mother talked to Emma of her home as a "cursed land": "this water that has washed it since the day it was born, this water, with its blue, so blue, hides centuries of blood vomited from the holds of the slave ships, blood from all the blacks that were thrown overboard" (139–40). Emma's story, which includes the tales of generations of women from whom she is descended, back to an enslaved African ancestor Kilima, serves as a return of the repressed for

Flore. Through Emma, the other woman confronts and digests the forgotten history; Haiti thus haunts her in visceral form.[6] Flore tells her audience near the beginning that she is being consumed by Emma's voice and words:

> I am no longer the person whose knowledge and sensitivity help others solve their communication problems, but rather the person who doesn't know, who no longer knows, her own place in the world. [. . .] Little by little, I abandon my role; I become a part of Emma; I embrace Emma's destiny. During that fourth session, it felt like my spirit left the room and went off drifting on the river along with Emma. (21)

As witness to the unfolding story of trauma, Flore experiences the raggedness and gaps that inform the eruption of fragmented memory as Emma speaks.[7]

The layers of quotation in *The Book of Emma*, as offered to readers by Flore ("I"), reflect the nature of this retelling. All of the female protagonists become both narrator and witness, going back to the voice of Malayika in Africa who mourns the loss of her daughter, and the self-silenced voice of that daughter, Kilima, who swallows her tongue rather than take a new name and adopt the language of the slave master.[8] The narrative that Emma and Flore mutually construct is thus a shared telling that stretches back across generations as it brings repeated violence and wounding to the surface. Flore provides the cultural context lacking in the Canadian doctors and non-Haitians in general, so that the narrative can take form. And she may one day make a (return) journey to Emma's home, Grand-Lagon (on an island off of Haiti's coast). All of the women become *Métrès Dlo* through this telling—not by suicide, which is the personal release for some but which does not constitute healing.

At both start and end of the narrative, a male figure connects Flore to Emma, initially the doctor, later Emma's former lover, Nickolas Zankoffi. When first mentioning Nickolas to Flore, Dr. MacLeod tells her that the spelling of the last name may be incorrect. If we substitute an "S" for the "Z" and slightly change the last syllable, we arrive at "Sankofa," the Akan word meaning "It is not wrong to go back for that which you have forgotten." For Emma, that return is to Guinée or the African home, while for Flore it *may* be to Haiti. Like Emma, Nickolas is a carrier of the past; the father of Lola, though he did not take on his paternal role and duties, he cannot kill either past or future, but rather serves as a catalyst for Flore's rebirth.[9] For some, like Emma, the weight of the past is unbearable and suicide seems the only option; for others, like Flore, ignorance of the history is transformed into knowledge and then action. Speaking of his film "Sankofa," Haile Gerima says, "*Cra* is a belief in spirits, a belief that people who have died but are not yet settled roam the village, trying to find a living body to enter, to go back into the living world to repent their crimes or avenge injustices done to

them." (103). The exchanges between Emma and Flore, and Emma and Nickolas, participate in a version of this return of the dead. The relationship between the two women illustrates this belief in a soul not yet "settled" inhabiting that of a witness who can listen and then pass on the truth. Mattie tells the young Emma, "When [women's] body is thought of as road dust to be spit on, [. . .] when all that happens to us, when our eyes cannot hold back our tears, well then, yes, our soul leaves us, it is carried off in our tears, it is washed away like sediment in a storm. Then we walk about like zombies, with madness in our eyes and in our guts" (162). The multiple souls born of Kilima—Emma, Rosa, Emma, Rosa, Fifie and Grazie, and Emma—tell interlocking, echoing stories of trauma suffered by Black female subjects and of the corporeal memories that they have passed down through those generations.

The story begins with African women violently separated, and then repeatedly shows women torn asunder by forced labor, rape, and torture in the Americas: "The voice of her [Kilima's] mother, screaming on the shore, while the slave ship cuts through the water, tearing open the limpid blue of the ocean" (164). As Christopher Miller argues, in the slave trade, the European traders did not venture into the African interior and the African traders did not cross the Atlantic, so only the captive Africans (like Kilima) crossed the boundary of the shore in Africa. "They alone would see the full reality of two worlds. They would ultimately tie those worlds together" (Miller 41, citing Eltis 154).[10] They suffered the originary trauma and then repeated violence, as illustrated in the experiences of Kilima and her descendants. "As soon as the boats docked, hardly had the chains been removed from their feet, then the blacks, both men and women, were sent to the fields. And there, whites, blacks, less-white whites and less-black blacks, all threw themselves on the night-colored women, unbidden, as though they were drawing water from the river to quench their thirst" (167). That repeated, embodied memory is buried at Emma's core and must rise to the surface in her testimony to Flore.[11]

Emma finds a room of her own in exile, a space in which to experience silence, madness, amnesia, and from which to begin her testimony to Flore. As will the texts by Dominique and Chancy, her narrative serves as a mouth through which the traumas pour out, in disconnected, tumultuous, multilayered streams: the wounds speak. Violence against women, perpetrated primarily by men but often with female complicity, crimsons the waters that flow in the multiple voices telling the stories.[12] For Emma, the pivotal betrayal was perpetrated by her mother, who took her to undergo ceremonies performed by yet another woman, most likely female genital mutilation. During those three days, Emma tells Flore, "I was robbed of a lot of my memories. Ablation, extraction, excision. The dictionary contains only a few terms to designate loss and destruction" (111). A writerly, narrative "I" struggles both to understand

and to express the unspeakable that must be spoken, an oral history of Black women, relation, secrets, and silence. As Roberta Culbertson explains, discussing trauma, "the experience that dissolved as it occurred is nevertheless present in its components; the knitting together of these comprises the body's psychic healing quite literally, the reweaving of body, mind, and cultural context from a point of unraveling or rupture" (174). Emma relates to Flore that she told her great-aunt Mattie, "we prefer silence as a way of *pretending to have forgotten.* [. . .] we are there like witnesses and we feel smothered by shame. Then we try to find the pieces that escape us [. . .]. These are things for which there are no words" (188, emphasis added). Just as Emma pretends not to know French, though when she slips accidentally into that language she speaks perfectly, she uses silence as *pretense* of forgetting. In fact, that choice of silence initiates the reclaiming of experience and the act of testifying.[13]

Testimony requires a witness as truth is revealed. Flore intuitively understands her role, as she accepts the job of listening to and interpreting Emma's words: "The one thing influencing me, I think, is the idea that there is a veil covering the lives of black women, those with blue skin as well as those with 'inside-out-skin,' as Emma describes me. Something tells me that by listening to Emma, I will be able to help tear away that veil" (47). The oral tales passed down to Emma led her to write a thesis on the route of the slave ships, a manuscript rejected by her advisors in Bordeaux and thus by the French academy, a muting that has driven her into madness, silence, and perhaps the murder of her newborn girl, Lola. To the social worker initially assigned to her "case," Emma "repeated over and over again that the colonialists of Bordeaux wouldn't destroy her!" (17) The newspaper reports of Lola's death perform a further erasure of Emma's story: "One particular reporter, who didn't know the history or the geographical location of the island Emma comes from," compares her town to "the lepers' quarters in Calcutta," while a photo caption reads, "Black Woman Sacrifices Her Child . . . A Voodoo Act?" (18). Ironically, the stories emerge from behind this veil of silence, into Flore's ears, into her tape recorder, and ultimately onto the pages of *her* manuscript—*The Book of Emma*—which challenges, subverts, and replaces the sensationalist and ignorant misreadings.[14]

Emma's talk—a narrative formed from wounds—seems "mad" to outsiders like the doctor and the police because it is nonlinear and repetitive, returning continually to the originary trauma of the slave ships, recuperating but not able on her own to turn those memories into a coherent story. "It is in the holds that everything was written," she tells Flore, "in the folds of the sea, in the wind gorged on salt, and in that smell of blood" (146). The doctor refers to "your culture" when telling Flore that "It's up to you to discover what's wrong" (46). Indeed, Emma does require a witness who shares and comprehends Haitian history and culture. Narrative emerges from trauma, as trauma becomes narrative:

"wounding exposes the root of the problematic nexus of the cultural and the experiential, the biological and the social, in the memory of violence, making it clear that violence is about pain and wounding and dissolution, and that *communication about it happens between the poles of body and culture*, themselves wrapped in the meanings created or destroyed in the moment of harm" (Culbertson 173, emphasis added). Kilima, the African woman stolen into slavery and shipped to Saint-Domingue, loses her cultural context, represented by her mother Malayika (whose name means "guardian angel") and by her adoptive mother Cécile, who is brutally punished for trying to save Kilima from rape and branding. Without that context into which to insert her story, Kilima first refuses to speak and then turns to the only option she sees, the ocean. Perceived as crazy on the plantation, in her not-speaking she initiates a silence that will be passed down, woman to woman, perpetuating the trauma until Mattie unfolds the pages of her "book" for her great-niece. "Living with Mattie was like living in a big book, a book that she constructed each day, page after page, and in which I discovered the arabesques and the meanderings of human souls" (136). That book, these stories, fill Emma's body and overflow her consciousness, so that in Haiti she cannot survive or even begin to speak and heal.

Like her female forebears, Emma found no available context in Haiti, given first her mother's betrayal, then the increasing violence of the Tontons Macoutes.[15] "Armed with guns, their faces concealed behind their balaclavas, they plow across the country. [. . .] '[I]n order to nourish the kids, the women are learning to live on their backs, under the boots of the men in black.' I am delighted to be so scrawny, puny, with such dark skin. Behind their dark glasses, the men in black don't see me." (92) Nor did she find a context in which to be visible and heard in France, when she produced a formal scholarly narrative of the slave trade, because her supposed interlocutors, the members of the university faculty, refused to validate her written words. She needs Flore to listen and to move past the seeming madness, into a joint venture of healing: "With her eyes closed, as though to soften the words she was pronouncing, Emma talked, and as her voice rolled on, her body emptied itself of these images thrust up from the depths of an ancient memory, words extracted from archives buried in her entrails" (146). Speaking thus participates in a process of potential healing.[16]

The three Haitian authors discussed in this chapter compose texts that reflect on the necessity and impossibility of remembering traumatic histories, finding the words with which to express them, and doing the hard, painful work of testifying—each book a manifestation of that process and also its product or results. The "dirty waters" (Emma's words) surrounding Haiti hold the stories: as Emma says of the ocean, if it "could only talk" (191). The wound, the trauma, speaks due to the courage with which Emma employs silence and amnesia in order to testify (as will Lili and Josèphe). Emma tells Flore: "Mattie also said that we needed

to constantly hunt down the obscenity that suffering carries with it. Alas, this obscenity, it seems to me, too often encircles us, strips us of what can be so precious and so human, transforms us into filthy vultures, *obliges us to put our entire hand into the wound*" (168, emphasis added). As will Dominique's narrator Lili and the writer Josèphe in Chancy's novel, Emma performs for her witness, acting out the numerous parts, taking on multiple identities. Flore states: "I feel like I am watching a play, a theatrical production, where Emma plays all the roles, for she gets up and attempts to mimic the characters with big, energetic movements" (171).

The communal narration evolving in Emma's hospital room as she testifies to Flore performs an ironic marronage: silent to authorities, mad according to their diagnoses and judgments, Emma escapes those borders and with Flore constructs an elsewhere of words that challenge and subvert plantation logic.[17] Emma may tell Flore that "[b]y confining me here, they have really managed to steal my soul" (190), but in actuality she embeds her soul in Flore. "[Emma's last words] made their way into me. I feel them, like living things that swell, burst into a thousand little pains, gather in the pit of my stomach. Sometimes they settle near my heart" (193). That Emma takes "the route of the big boats" by walking into the river, her soul making the return trip, leaves Flore initially lost, "like in a shipwreck," "falling, falling, sliding, capsizing, and dying" (203). Yet, turning to Nickolas Zankoffi and making love with him, Flore both revives and has a vision of Emma at her side. Together, they have unsilenced the trauma and released it into *The Book of Emma*—a narrative of and in process: "an active and continuous denial and reassertion of memory, in a slow process of building a story of loss and recovery, of placing body and mind in a cultural narrative that recognizes certain things as truth, and *the body's language as always in need of translation*" (Culbertson 190, emphasis added).[18]

Agnant raises the issue of healing: can the testimony of silence, amnesia, or madness indeed serve to cure the wounds of history? Emma has expressed despair in the face of rejection—she only desired to write "this book that, whenever it was opened, would never ever be closed. [. . .] How many centuries will it take to close up these wounds?" (192). Of course, Emma and her baby girl Lola are both dead when we read the final lines of the novel, but Emma's book does survive, held in our hands. Flore says at the end that "Emma is bringing me into the world; she is reinventing my birth. She is there to lead her last fight and to defeat destiny, through me" (204). Emma has taken the only path that signifies a return for her, but it is not the manner of return for her witness, Flore. Though we leave her in bed with Nickolas, hearing the voice of Emma telling her to be a woman first, then a Black woman, Flore may travel to Grand-Lagon, a necessary return of the Haitian woman to the site of trauma, as Emma passes on through the blue waters.[19] Each path offers a reclamation of self and a resistance to the forces that have perpetrated and perpetuated the violence.

II.

While any trip Flore might take to Haiti remains unwritten, beyond the boundaries of the narrative, Dominique's protagonist Paul/Lili both re-members her homeland and contemplates from multiple angles the *Retour* that she eventually undertakes at the end of the book. The silence and amnesia Paul/Lili experiences, both in Haiti and in exile in Montréal, result from violence she has witnessed and suffered, which are rooted in patriarchy past and present. Her narrative—the text she produces and to which we act as witnesses—does not ground itself in the Middle Passage or enslavement, that longer history of trauma. Rather, she is haunted by the more recent violence of the US occupation, neocolonialism, and the Duvalier years, starting with the passed-on story of American soldiers arriving in Port-au-Prince in 1915, when her father was a young boy. "Why choose the infamous mark of their presence to begin her tale of hatred?" (23). The Americans are the initial "bogeyman," "oppressive, intrusive and so visible" (22), terrifying the six-year-old and ignoring a female witness to their invasion. Taking over the streets of the capital, "the boots could care less about this country. The boots know nothing. They have been sent, they have been given orders, they have embarked in giant boats" (24). Like automatons, the Americans enforce without questioning the commands they receive and show no curiosity or interest in learning about the country they have come to occupy. These figures of power and authority prefigure those who will serve an enforcers for the Duvaliers, François or "Papa Doc" and his son Jean-Claude, "Baby Doc."[20]

Writing later, in her room in Montréal, Lili remembers a composite, symbolic image: "the men in black, the man symbol, the man logical construction of a long line of other men in black even if they wore all the colors of the prism" (59). Tellingly, both Emma and Paul/Lili are haunted by the "men in black," who appeared suddenly and then proliferated around them when they were still girls. Paul/Lili remembers encountering one of them as she walked to school each morning, recalling the fear and hatred she felt, and how she imagined having a magical ability to make him afraid of her and to turn him into a small snake. When this man, André, visits her family one evening, she suffers a rough slap from her father when she looks the wrong way at the Tonton Macoute: "You looked at him with such contempt," her father tries to explain. "I saw you dead. [. . .] I saw in a flash that you looked at a bogeyman that way. He was killing you. You had to be protected" (66). Thus, Lili learns to hide and to silence her "true self," to protect herself by self-censoring.[21]

She links this scene in her narrative to another incident from childhood when she watches a gun battle in the street outside her school, and yet another in which she climbs to the roof of that school and witnesses Duvalier's armed henchmen flying low over the roofs in a helicopter: moments of exposure and

vulnerability. Watching men shoot at each other in the street, Lili is protected by one of them who tries to prevent her from seeing the fallen dead bodies. "The horror of this impression [as the men shoot]. [. . .] A few seconds, or minutes (in real time) or hours (of anguish) and it is silence, more terrifying than the previous noise" (88–89). Her reaction, however, is not to forget but to recall in detail, as she writes the patchwork narrative of her memoir. She also reconstructs the memory of coming face-to-face with the armed men flying over her school's roof, even as gunmen lie on a balcony across the street. This moment is marked by silence, just as Lili's father silenced her gaze of hatred. "She will know later. She should never have known. She will know later that she will never be able to forget. She did not suspect that the sounds of the bullets would lodge themselves so deeply in her memory" (91). Like a wounded body, her memory is riddled with psychic shrapnel.

In the face of endemic violence, Lili (like Emma) will struggle with silence and amnesia, the effects of severe trauma; she, too, slowly constructs a narrative that performs and speaks the wounds. Memories of violence are often perceived as madness, just as dissociation, nightmares, numbness, and silence all "are seen as pathological detachments from the real, rather than as remembered flights into the super-real, which is, of course, what they are" (Culbertson 188). Lili grapples with fear, gaps, silence, and nightmares as she employs memory to reconstruct the story. Frequently, she refers to her father, Paul, as her main reader, but that name also serves as self-reference, a doubling of audience. "*I feel I must write it, finish it, but it's a total blank. I need to write this book.* [. . .] *the Country is the abscissa, the Text is the axis*" (25, original italics). Lili also struggles to reach her "true being," fighting a gag: "*Yes, I am gagged: I gag myself; I would like to, I want to remove this gag but it is holding on tightly, I feel it ensnaring my fingers the same way it often stops my mouth*" (26, original italics). Wanting both to remove this impediment and to control the words she fears will emerge without that blockage, Lili describes the excruciating process of (re)telling that will conquer silence.

Her anguished process of voicing silence results in part from the state of exile. As Lili hears "*Silence all around!*" in the middle of repeated nightmares, she senses that the answers no longer "*arrive from elsewhere, coming from an indeterminate place*" (120), but that instead the communication is blocked. She recalls a dream of "*forced exile*" out of an unbearable place, leaving her "*like a captive in the midst of all this perfection*" (120, original italics). An image of drawers recurs, holding both memories and texts—those she has been writing. "*And so among other texts, I know I can find a forgotten story that I just recognized, upon waking up: my nightmares written beforehand. Have I already lived these hallucinations?*" (121, original italics). Boundaries blur, so that all seems hallucinatory. One of the nightmares involves her childhood room back in Haiti,

at night, a man leaning over her; this haunting vision connects in memory not only to the terrifying men in black, but also to a semiburied scene of rape in New York: "*It was a rape, Eli, even though it didn't leave any physical marks. He used my dreams, spoke about our rage, he took the right to want my body because of our shared madness.* [. . .] *he heard none of her screams, he understood nothing about her mute suffering, because he only looked at her breasts, only wanted to experience her sex*" (241, original italics). To compound the shame and anger, the man's pregnant wife was sleeping in the room next door as he raped Lili, an act of violence and multiple betrayals.[22] In her retelling, the memory turns into yet another nightmare, of pain, running, fleeing, and silencing. The rape narrative also performs a doubling, as Lili is first "I" and then "she," the splitting or dissociation that forms a self-protection in the moment of trauma. For Lili, as for Emma, the exile or elsewhere of Montréal provides a room in which to hear and remember, a borrowed space that ironically serves as one both of *refus* and of testimony.[23] In writing, she will sift and sort, using her hands to take control.

Lili writes a text that enacts a fitful, stuttering, screaming process of giving birth, via language and multiple selves, a coming-to-the-surface that is not precisely amnesiac but rather a constant remembering and reclaiming. In writing about her story of "Steve," for instance, she offers a description that also applies more broadly to the entire text: "I told you about him pell-mell, zigzagging through memories still burning, scars still sensitive, making it difficult to lay myself bare" (154). Dominique's text overflows with names, as the figures in Paul/Lili's mind multiply rapidly and relentlessly, both family and friends, as do the "men in black" who populate her childhood memories. She serves as both the testifier (like Emma) and the witness who turns that testimony into a narrative (as does Flore). "How does one recall events accurately? Is it so important to go on with the story? This young woman, writing a long time after, is striving for precision. Which one? That of dates and events lived in her own truth across the genesis of history? A long time after, can the events be retraced in their entirety?" (89–90). The desire for control punctuates this telling; Lili needs to establish "truth" of and for the self, in the face of the ruptures and gaps that are the aftermath of trauma.

While Dominique titles her book the memoir of an amnesiac, in fact Paul/Lili remembers constantly and writes that process of reclaiming, of refusing the gag of silence that imprisons her. Whereas Emma knows that the story originates in the waters of the Middle Passage, the "I" writing *Memoir of an Amnesiac* does not know where to begin her narrative. Paul—named for her father, by mistake—reflects on the need to tell all the stories in her head and invokes her unborn daughter, Maya, as the recipient of the shreds of memories she has stored in an internal chest of drawers. She practices writing, not yet knowing how to perform that act: "*Until such time, I store the sentences*

I discover, an archivist, a usurer, I keep the story" (77, original italics). Just as Emma's stories told to Flore work backward from her mother and aunt to earlier female forebears, Lili thinks back through mothers, both biological and surrogate, including a vision of her own mother giving birth to her: "*I can still hear the scream of the one whose muscles expelled me into the world of men, it stayed on my lips and my mouth is still open*" (84, original italics). Her silence embraces and then releases that scream, in a contrapuntal expression of both oppression and liberation, potentially of healing. As Lili writes, "*I am too many to wear the gag, to keep the gag. One silence bogs me down, like the bars encircling an island imprison me for ever*" (85, original italics). As did Emma, Lili flees Haiti, headed for North America instead of France; both eventually land in Montréal, in spaces from which they begin to testify.

For Lili, that process involves stutters and false starts, as well as an actual miscarriage that mirrors the dead ends she sometimes encounters as she struggles to create her text. She mentions the loss of her fetus indirectly, in a letter to her close friend Liza, explaining a lapse in correspondence: "I lost my baby. Hospital, pain . . . [. . .] I will try to tell" (252). In Agnant's novel, Emma tells Flore in a final phone call that due to the curse of the boats, "the flesh of your own flesh transforms itself into a fanged beast and eats you up from within. That's why Lola needed to die" (199). Unlike Emma, who is haunted by the memory of the Middle Passage and has perhaps murdered her daughter before killing herself, Lili envisions a future daughter's survival. "The daughter of mine, I will bear her for those who will not be able to have any; and if I can't I will bring her into the world pulling her out of the wombs of a thousand women to celebrate the new day" (265). Lili births a narrative populated by many others, speaking for a nation, as a Haitian woman.[24]

The narrative becomes a multilayered performance—replicating oral testimony, and bringing memories to the surface, even while embracing silence and amnesia as part of that process. "I scream my silence in order to learn how to speak and I am still nurturing incoherent words" (94). On some occasions, the protagonist takes on different roles and personae, as when Paul/Lili presents herself to her father's assistant as "Patricia," a false identity behind which she makes phone calls and sets up dates that she then breaks.[25] The fact of her split or double name also underscores this shifting of identity and adopting of masks as ways of exploring the various truths of her self. Once in Canada, Lili becomes a conduit for the many people she encounters, as well as those she remembers back in Haiti; she writes plays in which she divides herself up into the characters and scripts sections of her memoir as imagined scenes between others in her life. As Emma sees herself as the "horse" ridden by Kilima, Cécile, Béa, and other female ancestors, Lili becomes the mouth or wound through which trauma speaks.[26]

As Emma had wondered if a cure would ever be possible, Lili questions the power of her writing: "Seated at the table, I attempt, through the written words, to heal my pain, knowing that once expressed, when the pain flowing through my fingers will have caused them to shake, I will be able to try and stand back in order to recover my sanity" (229). The question of return has haunted Lili throughout her twelve years in exile. As she thinks of her book, "the autobiographical experience of the whole country," she also thinks of her daughter-to-come. In the final paragraph of the book, she takes these pages with her to Haiti. As in *The Book of Emma*, the question of healing is placed in suspension at the end of Dominique's novel, offering the potential for that process to emerge from the pages in our hands.

III.

Chancy's novel *The Scorpion's Claw*, while centered in the semiautobiographical character Josèphe, employs multiple narrative perspectives to excavate the history of Haiti in the twentieth century, based in female generations of an extended family and grounded in the deeper history reaching back to an era precontact and to the arrival of Europeans and Africans on the island of Quisqueya/Hispaniola. Haiti lies at the center of the Atlantic World in Chancy's fiction, the ocean signifying both death and return, women's bodies emerging from the depths and reentering the waters cyclically. To stay stuck in such repeated patterns, however, perpetuates the trauma; instead, the sea must become a matrix in and through which to heal. Vision and madness mark the female characters in her later novel *The Loneliness of Angels* (2010), sea goddesses who appear as a woman in blue rising from the ocean and calling like sirens to multiple generations of women on shore, linked by the *Métrès Dlo*. How can one listen without being drawn into the depths and death? This narrative suggests that rather than succumb to the pull of destructive memories and repetitive patterns of trauma, a woman can work with that energy to envision a shift, a healing, a "rainbow sign after the floods, the unreturning dove sent to let me know that some new day is coming" (248). Women thus birth selves and nation, so that water is not a space of drowning but one of vital energy. Standing on the shore, resisting the urge to walk into the water to join the floating woman she observes, the protagonist Catherine experiences a cosmic shift:

> And then I feel something, a churning from the deep, rising from below, a dull throb as if some entity is trying to come up through the concrete and into my body. I open my eyes and look out to sea. *Whatever it is is coming from out there.* [. . .] I peer out across the dark blue vastness and

feel the power beneath the waves. I feel the surge again, rising up through my feet all the way to the top of my head [. . .]. The crown of my skull tingles oddly. (246, emphasis added)

The woman in the water holds on to the decayed beam of an old jetty, a submerged, ruined structure, as she floats and sends this silent power to Catherine. The vision is not one of suicide or of drowning Africans, but rather of a spiritual communication to the present-day woman on shore, who may see the rainbow and begin to make something new, to heal the wounds through words.[27]

This possibility appears forcefully in the character Josèphe, focal point of Chancy's earlier novel *The Scorpion's Claw*. In this text, the ancestral mother, Mami Céleste, speaks of one who will "write the secrets of our lost memory" (157) with the sea as her primary source. In counterpoint to Emma's suicide and the meandering, streaming flow of *Mémoire*, this novel offers a female protagonist more in control of the narrative—the testimonies it provides—perhaps because she has a guide to spiritual roots, as well as to her own and Haiti's past. In the final section of the novel, Josèphe sits at her desk and receives as visitants, one by one, the family members she has brought to life:

I listen to the sound of metal keys biting into the soft, thin paper on which I am typing the final words of Désirée's story. [. . .] Nothing is quite as I wanted to say it, but there it all is, sheets of paper thrown to the floor, piece after piece. I pull out the page still stuck against the roller of the typewriter, stare at the black letters still glistening with ink. Should it matter that my memories are borrowed? (180)

When Mami Céleste appears in this scene, she notes the written pages but comments that the typewriter cannot replace the tongue: her tongue kept her alive, she tells Josèphe, as she witnessed "every imaginable desecration" over the centuries. "It is hard for you to see this, I know. But I saw it all. It was my tongue which allowed me to tell others what I'd seen each time I came back" (185). Unlike Emma's ancestor Kilima, who swallowed her tongue in a refusal to communicate with the colonizers, and Emma who will not engage with the doctor, Céleste chooses to voice the atrocities and passes them on to a female descendant who will transfer them to the written page. The text performs a double voicing in this scene, reporting spoken stories via the machine's keys and the quoted inner monologue of the writer-protagonist. As in Agnant's novel, the story originates in the waters surrounding the island of Quisqueya/Hispaniola, a relation that births Haiti and its history from 1492 to 1991 (when *The Scorpion's Claw* concludes), dates that coincide with the four lifetimes of Mami Céleste.

Chancy's novel narrates Haitian history and Dyaspora through the relations among members of one extended family, focusing on three generations: those whose childhoods were marked by the US invasion and occupation of Haiti 1915–1934; their offspring, particularly Josèphe's uncle Léo, who becomes a *macoute* during Duvalier's presidency; the generation entering their twenties as "Baby" Doc is forced into exile and a people's movement grows in opposition to those who perpetuate Duvalierism in the later 1980s. The narrative concludes in 1991, the year Aristide first became President, though it does not refer to him or depict that election. For all of the characters, a central question concerns home: where is it and how does one know oneself? The roots lie in the ocean and an island in a "time beyond memory" (8). A seeming paradise, a "rare pearl [...] cradled in the aquamarine blue waters of the ocean which lay playful as a child against soft sandy beaches" (8), this place is actually a utopia, a no-place or nowhere. "Beyond memory there is only that place where we yearn to return, but which can only evade us since it has never truly been" (8). When the narrative invokes this timeless, unattainable place, it performs both longing and a refusal of nostalgia, expressing the desire for a site of true freedom, an always lost or disappeared homesite of belonging. Carmel (Josèphe's grandmother) and Céleste, two of the mistresses of the patriarch Gustave, both offer visions of this prelapsarian island, glimpses of an existence that Haitian history has buried under centuries of violence, exploitation, abuse, and suffering. As Josèphe's "cousin" Désirée asks in an unsent letter, "*Was there ever a time when we were free?*" (142, original italics). That question haunts the narrative and resonates with the history that Emma excavated in Bordeaux and that Lili witnesses during the Duvalier dictatorship.

For women, this history means ongoing nightmares of abuse, oppression, loss, and rape: unending circles of violence. Josèphe's story reveals the individual experience of that larger endemic pathology of colonial and patriarchal institutions. Now living in Canada, where her parents fled to escape Duvalier in the early 1970s, she evinces ongoing effects of trauma as a survivor of rape—attacked by her "cousin" Eric when she was a young girl. That trauma rises more insistently to the surface as the narrative proceeds.[28] Unlike Emma's Book, in which rape of Black women figures repeatedly beginning with Kilima's story, and also different from the muted reference Lili makes to her rape, Josèphe gradually faces hers directly and graphically. It comes to represent the widespread, institutionalized sexual abuse of women under Duvalier. The narrative itself enacts the process of testifying and witnessing crucial to a survivor's healing.

While silence may be the initial response, in both victim and those near her, that reaction ultimately perpetuates the illness rather than diagnosing and healing it. Carmel knew Josèphe had been harmed, but said nothing when the girl came home, "walking like a small bird that has been brought down from the blue skies

with a sharp stone. [...] Someone has turned her from a free, open child to one who is afraid, closed, unhappy" (16). In this first, oblique reference to the rape, Carmel chastises herself for not speaking to her granddaughter: "Why have I not taught them [the girls] to love themselves, to nurture their bodies and their minds like *douces*? I carry this around like the scar on my stomach" (16). Fear, particularly of the *macoutes*, silences women so that they fail to protect younger generations, girls who then suffer the ongoing effects of trauma into adulthood.

Such is the case for Josèphe, who has been silenced by the rape and the rapist's threat to kill her if she tells: "there is something lodged in my throat, keeping me from speaking" (44). She cannot tell Désirée what has happened and received no support from Carmel, suffering a double or multiple death of the soul. She attempts to use Catholicism—"sacrifice and devotion"—to erase Eric, and then turns to the ocean, a space of safety. That respite is brief, however, as she is called back to land and feels the scorching sand on her feet: "For a long time, all I feel is pain and wonder why I put myself on solid ground, a disruption between the meeting of sea and sky, the endless stretch of blue hope whispering to me from behind" (47). Land—Haiti— betrays Josèphe, as the rape steals her body and spirit, and women around her provide no protection of comfort. The water offers a "blue hope" that slips away, ephemeral, interrupted, deferred.

Another surfacing memory symbolically enacts the shattering of self that trauma causes. Dared by Alphonse and Désirée to steal a rose from the mambo Mlle. Dominique (Mami Céleste), whom they perceive as a crazy woman, Josèphe instead discovers a kind, generous woman who readily picks and hands the flower to her. That gift, like the girl herself later, meets the destructive impulses of Eric: "I pull it out along with the mirror [from her small purse]. I watch in horror as the mirror falls to the concrete, face down, and breaks into a thousand slivers. [...] Eric takes the flower and plucks away the petals, letting them glide on the air until they reach our shoes. In the glass fragments, my face is reflected in a thousand separate pieces" (70). That splintering of her reflection, like the tearing apart of the "hiding princess" (as Mlle. Dominique called the rose), anticipates the brutal rape Eric commits three years or so later, when he is eighteen and Josèphe is nine or ten. Both the purse and the mirror are decorated with a mermaid, a version of the *Métrès Dlo*: "The mermaid's head is on the back of the mirror, smiling, so you can pretend that she is you on one side and that there is someone else looking back at you from the silvered side of the mirror" (67). The mermaid serves first as a double for the young girl, a talisman watching and protecting her; in the shattering, the mermaid also doubles for Josèphe, showing the lack of safety females face in a culture of terror and rape. The two moments bleed into each other as the narrative follows the twisting, halting paths of her memory, and the wounds speak hidden truths.

As in Agnant's and Dominique's novels, trauma involves violence both individual and cultural, perpetrated and enforced institutionally by Duvalier and his henchmen. Culbertson explains the term "violation" in ways that illuminate the violence witnessed by women in all of these texts: "the experience of violation, violence from which there is no escape or recourse because one's body and one's repertoire of responses are quite simply overpowered from the outset, poses a central existential dilemma precisely because it is different, involving not a contesting of hierarchy or power but its full, primary assertion, and the threatened, even actual, dissolution of the self in the midst of it" (171). The *macoutes*, depicted as tenebrous men in dark glasses, boots, and denim, populate the stories of all central characters in *The Scorpion's Claw*, as they also fill both Emma's and Lili's memories of Haiti. They signify a lack of freedom, a source of torture, pain, and death, especially for women and girls, but also for men like Delphi, who resists in the name of the people. As he flees the *macoutes* who pursue him, Delphi arrives at the sea: "There is hope here, in the water that has taken in its womb the blood of the fallen, swept away the bloated corpses of the vanquished, waiting for us, standing dumb on the shores, to come to terms with all its whisperings" (80). Unable to escape, soon to be murdered by Eric, Delphi yet has faith in his *mambo* mother Céleste and in the future of a Haiti of "one people. *Libéré*" (82). Josèphe tells his story as part of her coming-to-voice through writing, revealing the brutality of the *macoutes* through the actions of Léo and Eric. Before that voicing, however, she experiences silence as a response to violence, a muteness and inability to write that provides a flood of memories the space to rise and inhabit her consciousness. Her need for stillness began when images of the Duvaliers (Jean-Claude and Michèle) leaving Haiti in 1986 filled television screens: "It was the beginning of my need for silence, for utter stillness. And yet, it seems to me now that it was then that all the memories began to flood my body like a fever" (25). She stopped writing when witnessing another event televised from Haiti—Eric being attacked and literally torn apart by a raging crowd, who suspected him of being a "member of the notorious secret police, the Tons-Tons Mack-oots" (26). Josèphe says that at that moment, "I chose silence: there are stories I can never tell. Letters I will never write home" (26), and yet the narrative itself is that "writing home," a telling of secrets and testimony that can both open and then begin to heal the wounds.[29]

While Josèphe cannot yet perform that self-liberation, Désirée pens letters that further illustrate the ways trauma remains inscribed on the body and gradually becomes legible, thus available to be read and then written as testimony. In one unsent letter to Josèphe, she in fact predicts the inescapability of that process, telling her "cousin" that she will feel a weight in her bones that will not be age. "It will be the weight of your mind and the caches of memory trapped there like small animals gnawing themselves out of

rusty traps. Like those small creatures, you will writhe in pain and wish that memories had never been made to haunt and torture you so" (141). Similar to the pieces of broken glass that Céleste seeks to find buried in her garden, as well as to the slivers of mermaid mirror and petals of a rose, secrets and lost memories can cause amnesia or madness. Mami Céleste—who would not lose her tongue—recognizes and underscores the necessity of voice as she tells of the birth of a girl child who "would write the secrets of our lost memory" (157). This arrival is announced by conch shells and the child is described as a manifestation both of Africa and of the diaspora. The sea thus represents both hope and reconnection, while the narrative reminds us of the extremely tenuous nature of such a vision.

The water imagery also marks a scene of sex between Josèphe and her Canadian boyfriend Georges, years later, but the remembered rape again interrupts that vision of safety and contentment, such that Eric "replaces" the lover and she reexperiences the pain and wounding. Like both Emma and Lili, Josèphe turns to words as therapy and cleansing: "It is then that I begin to write these pages, deep into the night, filling piece after piece of scrap paper with my memories, as distant and unclean as they are. [. . .] It is like vomiting up a virus that has weakened your muscles and clouded the sharp, clear pattern of your thoughts. It is like freeing some part of me too long mute" (33). Repetition and muteness cede to expression and testimony, similar to the flood of stories that Emma received from Mattie and relates to Flore, and Flore to us, and also paralleling Lili's anguished, screaming narrative as she releases the gag that has bound her in silence. When memories begin to surface, as Culbertson notes, that process of recall indeed resembles a powerful rush of water: "Once the flow has begun, they become difficult to stop, as if the self wished to reconstitute itself according to a biological scheme akin to the healing of wounds, or as if it had to rid itself of toxic energy, and could only do so through its passing out of the body in the same form in which it entered" (175–76). The emission of toxins describes the image Josèphe employs, a purging through the written word that revisits the trauma in order to excise it from the body and consciousness. She performs on the individual level the unblocking of trauma sought by the female characters in Hopkinson's *The Salt Roads* on a communal and even global level.

Unlike Emma, who succumbs to the pain and madness, Josèphe has models of resistance as well as spiritual support, in Mami Céleste, Carmel, and Erzulie. She inherits a belief in vodun from her grandmother, who attended ceremonies with her own father. "It is here that I learned to pray Metrès Ezili rather than to her twin image, the Virgin Marie" (15). Carmel passed that knowledge on to Céleste: "It is from her that I learn of Ezili and the secrets of *voudou*," memories of Carmel's childhood shared with the younger woman (132). And Céleste repeatedly appears as a *mambo*, claiming that identity that others despise: "Not

to surrender to grief, I initiate myself in one of the voudou cults I have come to know; I want to become a priestess of this land" (135). In turning to the land, to Haïti Chérie, Céleste offers an example of how to incorporate knowledge of the past into a process of remembering trauma and shaping it into a narrative.[30] Josèphe gradually learns to do so, though at first she cannot face her own pain: "I haven't realized yet that one can't rush into the future without having looked the past in the face. I know that facing the past would be like holding up a mirror to myself and seeing the pain hidden there, behind the skin still recovering from the scars of adolescence" (31). The text enacts a re-creation of self and past—multiple selves revealing their individual and collective wounds.

Throughout, Céleste and Carmel remind the younger generation to remember ancestors and to claim Haiti as a space of healing. Mami Céleste's dates or lives span four eras: 1400–1490, precontact; 1784–1800, the birth of the Revolution; 1934–1976, from the end of US occupation to "Papa Doc" Duvalier's death; 1979–1991, from Delphi's death to the demise of Carmel. Each cycle invokes both death and rebirth, the hope for change constantly renewed, in spite of despair, pain, loss. In route to a rally he has organized, as Delphi pauses at the shore in his flight from the *macoutes*, he calls his mother over the sea and her name echoes back to him: "My *mambo* mother is somewhere out there, painting placards, braiding hair, securing buttons on scraggly shirts. My *mambo* mother, whom so many despised, accused of ill-doing, was, in truth, working quietly to make life better for others" (80). Her presence, as illustrated in the garden scene where she offers Josèphe a rose that Eric promptly tears apart, provides an anchor or touchstone, one largely missing for Paul/Lili, except remotely in her friendships with women and also largely unavailable for Emma. Granted, Emma grew up with Mattie's storytelling, a talking book of Haitian women's history, but that body of narratives and narrative of the Black female body weighs Emma down more than it sustains her once her thesis is rejected and she enters the psychiatric hospital. Nevertheless, similar to Flore's book of Emma and Lili/Paul's memoir, the narrative Josèphe produces, fitfully, disjointedly, reflects a shared spirit of persistence and survival in the face of ongoing violence and terror. As Mami Céleste explains at the end of her section, those who continue to fight against oppression in Haiti survive much as their ancestors did:

> All this because some of our foreparents were brought to this land in chains and it was decided then that this land could never be freely ours, that we would have to buy it back with our work and our sorrow. And this is what we have been doing all these many years, ever since the day of Independence, which came much too late. [. . .] We keep alive the ways of our homelands, which so many of us have begun to forget. We resist. We subsist. We recreate ourselves in the name of the ancestors. (139)

She describes a nurturing strength necessary to both testifying and witnessing. In writing her own story, Josèphe also writes the larger story of Haiti, merging hers with remnants of what has come before.

Women's communication frames *The Scorpion's Claw*, from Carmel's prefatory section to Josèphe's typewriting in the final pages. Carmel cannot phone her granddaughter in Canada due to fears of "the clicking on the line and the murmurs of breathing telling you that you are not alone. [. . .] But this silence keeps me from having to tell her how things have gone from bad to worse, from poverty to chaos, from hope to anarchy" (18). Instead, she sends both thoughts and notes, as well as photos and other "pieces of myself and the life I wish she could have here" (17), objects that can provide mininarratives of family and nation. Meanwhile, Désirée writes lengthy letters to Josèphe detailing her decision to leave the comfort of family and join an underground resistance movement. Part of that experience involves moving from an abusive relationship with Charles, who is actually a *macoute* aligned with Léo, to an intimate partnership with a woman, Affiba.[31] Female generations perform a passing on that provides a framework into which Josèphe can slowly insert her own story: trauma narrative requires a cultural context, and the other women create that for Josèphe, whose self and world have remained shattered, a state compounded by exile from Haiti. The key to their old room that Désirée wishes to send to her cousin so she will return with it one day helps to unlock the memories that the typewriter keys will impress on paper. Women are crucial to this process, as Flore's role in Emma's narrative has already made clear; they are like the mermaid, helping to mirror the individual's experience (in their role as witnesses). "So the final construction gives back the self—dissolved before, somewhat like a watercolor wash, in the midst of threat and the survival strategy of leaving the body—establishing the outlines of the new self as contiguous with the body seen in the mirror now" (Culbertson 190).

One such mirror appears in a story told by Mami Céleste to those in the underground, as part of her memory of an African presence in Haiti centuries earlier: the girl child who would "write the secrets of our lost memory" (157). As Céleste reveals when she appears to Josèphe at her typewriter, "you were the child in the story I told your cousin and the others. Ezili works in strange ways, doesn't she?" (185). This linking of Josèphe to the story-child connects her not only to Haiti but also to Africa and the diaspora. In the tale, she is born in Haiti speaking "the tongue of the forgotten, the tongue of their African foreparents. In her they would see the magic of a land they only knew in their dreams, only began to feel in their bones when they took part in the ritual dances which brought them closer to the ancestors" (158). This child tells stories until she becomes ill, her tongue swells, and she loses her

voice. The cure lies in her stories: as her mother and then the other villagers tell her these tales, they "acquired her memory" and she regains her own self. Similarly, Josèphe needs others to share in her process of re-membering the trauma and beginning to voice it. "Telling, in short, is a process of disembodying memory, demystifying it, a process which can only begin after memories have been re-membered and the mystical touched by a buried self seeking its own healing" (Culbertson 179). The larger narrative—the text we read—comprises multiple "borrowed" memories, as Josèphe says, but at its core lies the one that she has buried, the shattering trauma of rape, which she must recover and then reconstruct as narrative. "To return fully to the self as socially defined, to establish a relationship again with the world, the survivor must tell what happened. This is the function of narrative. The task then is to render body memories tellable, which means to order and arrange them in the form of a story, linking emotion with event, event with event, and so on" (Culbertson 179). It is when faced with the prospect of becoming a mother that Josèphe realizes the imperative: she must write to reclaim her own self.

Her reaction to Georges's desire to have a child with her recalls Emma's belief that Lola must die, in that Josèphe rejects the possibility of bringing a child into a world she sees shadowed by death. She cannot give life because hers has been taken away, one further sign that rape can mean a death of the self. Rather than committing suicide, however, she decides to face the past and to write. "I need time to gather my thoughts one by one, like pieces of broken glass to be taken out of harm's way, to write it all down for myself, for Alphonse and Désirée, and for those who have brought us to this point," as she sits at the typewriter and remembers Mlle. Dominique in her garden (72). Instead of a child, she creates a manuscript, a mirror in which to see both her own reflection and those of the souls sharing her path.

As the spirits depart after visiting her apartment in Canada, Josèphe knows she must return home, specifically to find Désirée: "Just like Grandmother, her name is engraved on my heart and I must find her again, before it is too late. I need to hear her story in her own words, from her own tongue" (186). Thus, she is in route at the end, on a plane as it takes off for her return journey—Winnipeg, Miami, Port-au-Prince. The written narrative cycles back to the oral—the speaking tongue—as Josèphe, like Emma, Flore, and Lili, uses amnesia, madness, and silence as testimony in a process of reclaiming the self. The novel's final words state the goal of this shared journey: to find out "the measure of our loss" (188). Each woman's path takes her from exile on a return voyage home, to Haiti or to Guinée, charting loss and pain, but using words to heal the wounds and create a Haitian women's narrative.

Chapter 4

"I HEAR THE VOICE"

Performing the African Diaspora in Brodber and Hurston

I.

In an article on what she calls her "head-hurting fiction," Erna Brodber discusses the process of writing each of her novels, stating that "*Louisiana* was the sound of singing of unseen people" ("Me and My" 124). The text's focus on voice and oral transmission of stories resonates with Marie-Célie Agnant's Emma performing for Flore, passing on the layers of Haitian women's history and traumas.[1] As seen throughout this study, voices from the Caribbean have become central participants in the dialogue of Africans in the Americas and vividly demonstrate the collective nature of diasporic history and creativity.[2] In this multivocal production, we can discern what Édouard Glissant has termed "transversality," as multiple paths form a "dazzling convergence of here and elsewhere" (*Caribbean Discourse* 117). The preceding chapters have explored the processes of re-membering the African Diaspora in texts that experiment with voice, narrative, and textual production. Taken together, they illustrate Glissant's concepts of the "dazzling convergence" in the Caribbean Atlantic. And a single text can offer narratives of identity as community endeavor, emphasizing the performative nature of such a gathering and weaving together of tales—what Glissant might refer to as an "organized manifestation of diversity" (*CD* 100).[3]

Two such texts, Erna Brodber's *Louisiana* (1994) and a work with which it clearly engages in dialogue, Zora Neale Hurston's *Mules and Men* (1935), can be read together as unique but complementary approaches to re-membering

the diaspora and voicing its complex narratives.[4] Though Brodber, a sociologist from Jamaica, writes a fictive narrative while Hurston compiles a collection of folk tales and voodoo[5] embedded in her own narrative of anthropological research, both texts underscore the centrality of performance to their creation—and to the creation of a diasporic identity. In a dialogic process of constructing a collective identity rooted in the experiences of those of African descent, both authors examine performativity, as well as the motivating factors in such an endeavor. Individually and (especially) collectively, these texts frame the larger experience of diaspora, "pulling the sides of the sea together" (*Louisiana* 148).[6] They also recall the performances in Agnant's novel as Emma tells her family history and Flore records those narratives.

In exploring histories and identities that initially appear partial, disconnected, and dispersed, Caribbean writers can discover a subterranean unity: "We are the roots of a cross-cultural relationship" (Glissant, *CD* 67). Another way of explaining this relationship is in terms of a "pattern of fragmented diversity" (*CD* 97), focused on accepted differences, a cluster of narratives, and a process of becoming. In its narrative structure, its polyphonic mapping of space and time, and its intertwining of music, madness, and memory to deal with a history of trauma, Brodber's novel *Louisiana* offers a unique rendering of the interconnections among African Americans and Afro-Caribbeans. This contemporary text is a fictive version of the collection of WPA oral histories—a "tale of cooperative action" among Ella, an anthropology student at Columbia University sent to Louisiana to gather materials, her primary "source," Mrs. Sue Ann King/Anna/Mammy, and the voice of Anna's young friend Lowly or Louise, who came from Jamaica to the US and eventually returned home to work as a nurse. As in Hurston's *Mules and Men*, this information-gathering is initially resisted by its "subjects," until Ella's mainstream scholarly approach is decentered and replaced by the psychic powers of Louise, Anna, and Ella as their spiritual daughter, Louisiana. As in her earlier novels, Brodber employs the spiritual realm to connect parts of the African Diaspora, especially in the Americas. Carolyn Cooper's comments on spirit possession shed light on the exchange that occurs in Brodber's text: "Spirit possession, that ecstatic moment of displacement central to the religious practices of Africans in the diaspora, literally embodies the transmission of cultural values across the Middle Passage. As metaphor spirit possession doubly signifies both the dislocation and rearticulation of Afro-Centric culture in the Americas; divine possession mirrors its subversive other—zombification—that diabolical ownership of the enslaved in the material world" ("'Something'" 64).[7] Brodber will explore these possibilities through the interactions between her protagonist Ella-Louisiana and the many spirits whose voices she comes to hear and record.

The story is a community production in numerous ways, a text that has arrived years later at the office of a fictional women's press, after being

organized into a sequence by Ella's husband Reuben, the African son of a European missionary. These four characters form the kind of transversality that Glissant describes as a fruitful way to conceive of the African Diaspora: Jamaican immigrant Louise meets southern-born Anna in Chicago—one of the destinations of the Great Migration. Jamaican-born Ella meets Europeanized Reuben in Harlem, and in the environs of New Orleans she converses with the spirits of the two older women, first on the tape recorder intended for her scholarly study. Then, as "Louisiana," she herself becomes the recording machine. Discourses—like names and identities—proliferate in this communal history project. Binaries are complicated: doubling becomes multiplicity. What has been ruptured and fragmented ultimately undergoes a healing process that makes the living dead not zombies but participants in a cross-cultural, shared, ongoing history: "the anthropology of the dead? Celestial ethnography? Crazy" (61).[8] We witness a passing on of the lifeline from the dead-but-speaking Anna and Louise to the living Ella and the results of this collaboration: Ella's use of *myalism* as a psychic in New Orleans; the incorporation of music as diasporic performance; and the possibility of an identity beyond nationalism.

The character Ella recalls the Zora of *Mules and Men*, Hurston's first-person narrator who journeys back to the South as an ethnographer, to collect the tales that surrounded her growing up in the all-Black town of Eatonville, Florida. Zora begins as both insider (her childhood in the town and familiarity with its denizens) and outsider (her education in the North and long absence), reestablishes herself as a member of this community, but then must negotiate her way into a mining camp in Loughman, Florida, and ultimately flees the hostility of other women. Ella, on the other hand, is gradually accepted into more than one group in Louisiana and becomes the central conduit for diasporic voices. *Louisiana* also performs cross-cultural voyages linking Jamaica and the southern US, similar to the Atlantic crossings traced not only in Hurston's collection of folk tales and hoodoo, but also in *Tell My Horse*, about her travels in Jamaica and Haiti. John Carlos Rowe argues that in these two works, Hurston "attempts to uncover the secret continuity of West African, Caribbean, rural U.S., and urban U.S. cultures for African Americans. Hurston's journey also retraces one of the principal routes traveled by Africans from West Africa to the Western Hemisphere," including the Middle Passage and slavery in the West Indies (256–57). While in Hurston's texts a single narrator encounters a wide range of characters and listens to their stories (in the South and in the Caribbean), Brodber's narrative emerges from interwoven voices, telling their stories of several generations in locales in Jamaica, Louisiana (both rural and urban), Chicago, and New York City, with connections to both Africa and Europe.[9]

II.

To better appreciate the multiple levels on which Brodber's novel succeeds, I first turn to Hurston, whose two "anthropological" texts have drawn conflicting assessments, one of critics' main concerns being genre itself: are they autobiographical, or ethnographic, neither, both? An overview of the responses to these two texts proves useful in establishing an approach to *Louisiana* that centers silences, voice, and relation. As Lynn Domina observes, in "Hurston's oeuvre, the generic distinctions between ethnography and autobiography are suspect" (197).[10] A number of critics comment on how Hurston's approach complicates ethnographic techniques and offers a challenge to dominant modes of thinking. For instance, Kamala Visweswaran reads Hurston's "tendency to blur genres and to rely on first-person narration both as 'experimental' and as an early example of feminist ethnographic work," and continues: "In Hurston's ethnography, community is seen not merely as an object to be externally described, but as a realm intimately inhabitable" (33). This description not only claims Hurston as feminist (especially in the emphasis on community), but also supports the argument that she succeeds at blurring the distinction between outsider and insider.[11]

In contrast, Samira Kawash judges Hurston "risky" and "profoundly suspicious of recovery, origins, community, and identity, the very terms that have defined her most recent canonization. In place of the secure stability and certainty offered by historical narrative, ancestral inheritance, or indissoluble identity, Hurston constantly and consistently chooses another path" (168). In a slightly different vein, Graciela Hernández points to the effects of Hurston's positioning of self both within and outside of what passes for a scholarly study: "Hurston's ethnographies demonstrate that self-reflexivity, in and of itself, does not necessarily ameliorate disparate power relations. Rather, Hurston shows the potential for the self-reflexive mode to unmask the asymmetrical relationships that exist between researchers and the communities they study." The result, Hernández states, is ambiguity, "as Hurston participates in the institutionalization of anthropology while she simultaneously undermines a project that deems the ethnography a final repository of knowledge" (151). Brian Carr and Tova Cooper argue along similar lines about Hurston's self-positioning within *Mules and Men*, concluding as follows: "what Hurston's *Mules and Men* pulls off is a symptomatic exposure of the anxieties internal to the modernist critical project: that it could maintain distance, operate definitively against commodity forms, ensure its critical effectivity, and resist the inevitability of appropriation. [. . .] Hurston brings [these anxieties] into critical view—a move that we are hard pressed to find undertaken with the same fervor now, even in our so-called postmodern era" (306). And finally, in an article on *Mules and Men* subtitled "Toward the Death of the Ethnographer," John Dorst provocatively suggests that

"the elided text of *Mules and Men* reveals that ultimately even to go there is not *really* to know there. We see in this text a disruption of identity rather than a closure, the necessary result of the radical inauthenticity that is the eternal and inescapable scandal and dilemma of participant-observation fieldwork" (311). Through her first-person narrator, "Zora," Hurston *appears* to offer a representation of the ethnographer at work, as well as a compilation of her research; at the same time, however, the performative aspects of the narrative and its resemblance to fiction refuse to meet readers' expectations connected to ethnography.[12]

The tensions raised by Hurston's critics reside not only in generic differences between ethnography, fiction, and autobiography, but between orality and textuality, between speaking voices and the textual recording of those voices. Rather than dismiss the product (*Mules and Men*) for its failure to adhere to a single, recognizable genre, or than disparage Hurston's incorporation of connective narrative into a collection of folklore, we can better appreciate her achievement when studying the text in its social, cultural, and political contexts. Deborah Gordon comments on Hurston's experimental style as "occasioned by intense political and cultural projects" (150). Instead of adhering to the dictates of the dominant culture and the academic mainstream, Hurston has found—or indeed created—a unique balance between orality and written word, a combination that might help move us beyond binaries and rigid categories, in a challenge to the status quo, particularly involving racial identifications and social arrangements. I argue that she offers an illustration of the transition that Glissant observes when he discusses Caribbean literature of several decades later, a transition occurring "from the written to the oral. I am not far from believing that the written is the universalizing influence of Sameness, whereas the oral would be the organized manifestation of Diversity" (*CD* 100). Nalo Hopkinson's Ezili, who speaks from within the bodies and lives of Black women across centuries, M. Nourbe Se Philip's lines that break open the archives and give voice to the victims of the *Zong*, Emma's stories that Flore records in her Book of Emma: all participate in this oral practice of manifesting Diversity in diaspora. Hurston and Brodber illustrate further variations on this performative manifestation.

Commenting on her careful self-positioning when she returned to Florida to undertake the ethnography that set a foundation for *Mules and Men*, Hurston wrote: "I needed my Barnard education to help me see my people as they really are. But I found that it did not do to be too detached as I stepped aside to study them. I had to go back, dress as they did, talk as they did, live their life, so that I could get into my stories the worlds that I knew as a child" (qtd. in Hemenway 215). She demonstrates a keen awareness of the benefits of her studies in anthropology, though here and elsewhere, one must also question the sincerity of her appreciation for her mentors and "benefactors," as well as of the trickiness of identifying as both community member and researcher.[13]

In the book itself, readers can follow the development of Hurston's narrative persona, Zora, the outsider/insider who must contrive ways into the group she wishes to study.[14] Familiar with the tales she had heard from infancy, she could not see her culture as the "tight chemise" she wore until leaving Eatonville; only in college in New York could she "see myself like somebody else and stand off and look at my garment" (*Mules* 1). Her clothing now understood to be a costume, her identity multiplied or diversified, the ensuing narrative is best considered through the lens of the performative.[15]

The first stage of the journey back does present unexpected obstacles, because although her home community recognizes and accepts Zora as one of them, they resist her role as story collector. Explaining to the group on the store porch that she wants to collect the old tales they share, she is met by incredulity and even labeled a liar herself: "Zora, don't you come here and tell de biggest lie first thing. Who you reckon want to read all them old-time tales" (8). She must focus self-consciously on the act of storytelling as lying, a performance that she learns to perfect herself as well as to appreciate in her "informants." She must also participate in their rituals—putting her toe out from behind a sheet in a mating game, drinking strong liquor, gathering on the porch to share "lies," and lying herself when questioned about her interest in the stories.[16] Zora's actions and interactions present a mise en abyme of role-playing and signifying, an individual performance of the Black Diaspora in the US.[17]

In *Mules and Men*, Hurston makes a move outward, from her childhood hometown of Eatonville to a less familiar locale in Florida and later to New Orleans (as will Brodber's Ella). As Zora gradually moves into the community of workers in Polk County, Florida, they provide a plethora of tales for her to record. Throughout this section of the book, Hurston plays the role of "Sis Cat," a doubling of narrator and material. The stories themselves offer commentaries on Blackness and whiteness, on slavery and its legacies, on gender relations, as well as making connections to the Middle Passage and through that history back to Africa.[18] The folk hero John appears frequently in these tales, standing up to Ole Massa, offering a model of Black resistance to white oppression. In one story, John figures as "de first colored man what was brought to dis country" (79), a man too smart to get beaten, who uses languages to his advantage, with freedom his goal.[19] Throughout these chapters, as Hurston interweaves the tales with the narrative of Zora's interaction with the workers' community, storytelling captures the traumatic experiences of slavery (and its contemporary equivalent in the camps) and offers a powerful, healing response to those traumas.

The text and its narrator, Zora the ethnographer/participant, engage in a similar layering of meaning and identity, a slippery enterprise that becomes fraught with danger for the female persona. In the concluding vignette about "Sis Cat," we see the cat learn a lesson not to put manners before hunger, to eat

the rat first and then wash up. The final words of the book reveal that this is Zora's own tactic: "I'm sitting here like Sis Cat, washing my face and usin' my manners" (246). David Boxwell sees this ending as a "creatively affirmative act of self-mythification," as Hurston inserts herself into one of the tales she is retelling, one that is about female empowerment and wit.[20] But ironically, in the sections about Polk County, the adversary turns out also to be female, as Zora learns not to be too familiar with the men and not to challenge another woman's authority and power. Finding herself in the middle of a fight between the women, Zora "lie[s] to keep the peace" (151), finds her life threatened by Lucy, and ultimately departs, reclaiming the identity she initially shed, leaving Polk County and her tale-gathering behind her. "I was in the car in a second and in high just too quick. Jim and Slim helped me throw my bags into the car and I saw the sun rising as I approached Crescent City" (179). This moment confirms the near-impossibility of maintaining a dual position, of an outsider gaining lasting status as insider.

Zora's flight, in the automobile that initially signified her otherness in this group, reasserts a critique of mainstream ethnography, and of the dominant culture itself, with "Zora" as its purported representative. Furthermore, as its multiple uses of first-person underscore, *Mules and Men* is Zora's tale as much as it is a sustained version of ethnography. As Wall comments,

> Anticipating the work of current-day anthropologists by several decades, Hurston in the 1930s both theorized about and put into practice the concept of performance. For Hurston, performance is, as Bauman defines it, "the enactment of the poetic function, the essence of spoken artistry." What becomes clear in *Mules and Men* is the extent to which the most highly regarded types of performance in Afro-American culture, storytelling and sermonizing, for example, are in the main the province of men. (56)

Zora, as character in this narrative, operates as an individual, her encounters and interactions with others, especially with women, proving largely adversarial (as with the folk-heroine Ella Wall, whose name Brodber's protagonist shares).[21] Zora must walk a risky path, trespassing in what was likely perceived a too-masculine manner on territory where she did not belong. Her position or role remains that of observer and her performances are carefully staged for the reader.

Zora takes on a new role in the second part of *Mules and Men*, "Hoodoo," which follows her initiation into voodoo and performances as healer. Headed toward Louisiana, Zora states: "New Orleans is now and has ever been the hoodoo capital of America. Great names in rites that vie with those of Hayti in deeds that keep alive the powers of Africa" (183). As Jessie Mulira notes, the "most dominant and intact African survival in the black diaspora has proved

to be the religion of voodoo" (36); moreover, in "New Orleans *vodu* survives as a conglomeration of various African rituals, beliefs, and practices" (64). Hurston marks her text with an image of the new identity she will perform: a drawing of her naked body on a bed, a lightning bolt traced across her back: "With ceremony Turner painted the lightning symbol down my back from my right shoulder to my left hip. This was to be my sign forever. The Great One was to speak to me in storms" (200). These chapters follow Zora's training with various figures in the New Orleans area and offer examples of the rituals she observes and learns to practice. She takes a liminal position, on the border or threshold, moving between outsider ignorance and insider knowledge, and showing her audience how to read the performances.[22]

Hurston's description of hoodoo/voodoo in this text, as well as of zombies, stands in contrast to the ways that Brodber's Ella engages with spirits of the diaspora as well as with healing.[23] Zora operates as an individual, as did well-known practitioners of obeah such as Marie Laveau and her nephew/disciple Luke Turner. Voodoo is a solitary practice, as opposed to the more communal aspects of *myal* (as seen in all of Brodber's novels). In the subsequent ethnographic text, *Tell My Horse*, in the section on Haiti, Hurston retells and discusses tales of duppies, the dead who haunt the living and who must be driven back into the grave. Similarly, she dwells on tales of zombification, and includes a photograph of a woman "zombie."

> Here in the shadow of the Empire State Building, death and the graveyard are final. It is such a positive end that we use it as a measure of nothingness and eternity. We have the quick and the dead. But in Haiti there is the quick, the dead, and then there are Zombies. This is the way Zombies are spoken of: They are the bodies without souls. The living dead. Once they were dead, and after that they were called back to life again. (179)

Later in this chapter on Zombies, Hurston notes that those appearing as zombies have actually taken a drug: the emphasis rests, thus, on the physical, not the spiritual, with what might be considered a ruse at the heart of the zombified state.[24]

III.

Brodber's Ella Townsend, in her interactions with Anna, Louise, and others who have passed, as well as with the living who suffer from trauma, will move in a different direction: for her, the souls are not zombies or duppies who terrify the living, but become voices who recreate their stories, bring the past into the present in a process of healing, and also offer means to resist oppression in its

myriad forms. Or as a character says in Brodber's first novel, *Jane and Louisa Will Soon Come Home*, "the voice belongs to the family group dead and alive. We walk by their leave, for planted in the soil, we must walk over them to get where we are going" (12). In the "Hoodoo" section of *Mules and Men*, as in *Tell My Horse*, the emphasis is less on curing or healing, more on the curses and fears associated with the practice of voodoo. And Zora frames the text, her marked body serving as initial illustration and her final appearance as Sis Cat closing the text. Nevertheless, the related practices of voodoo and *myal*, like obeah, *santería*, *candumblé*, are forms of resistance to a dominant culture and its official, sanctioned religious institutions.[25] And in turning to a "confidence trickster" named Marie, Ella/Louisiana (like Zora) pays tribute to the foremother of "voodoo" in the US and signals the centrality of New Orleans to diasporic culture.[26]

From the angle of a trained sociologist, Brodber also explores questions surrounding the collection of ethnographic material, the relationship between the "scholar" and her "subjects," and the degree of truth or authenticity one can expect from such an endeavor.[27] In her article "Fiction in the Scientific Process," Brodber discusses the genesis of her first novel, evolving from her habit of writing before commencing fieldwork, as well as from her desire to find a method not solely "objective." In the 1970s, in the midst of movements by Black people and by women, she says,

> my particular pain was settling into my own country after living in areas defined as racist and having here to deal with what I now know to be prejudice against blacks in a country of blacks. The enemy was a ghost that talked through black faces. It was maddening, and to keep my sanity I talked on paper, reviewing from time to time what I had written before. I was now keeping my nonacademic writing for therapeutic purposes. (165)

In *Louisiana*, Brodber engages questions of the oral and the written, as in her previous two novels, which show a particular concern for the deleterious consequences of colonialism and the need for healing via communal efforts.

In her first novel, *Jane and Louisa Will Soon Come Home* (1980), she explores female sexuality and shame, caused by attitudes that perceive womanhood as a threat to girls and a burden to adult female subjects. In this novel, intended as a case study for her students, Brodber intertwines Jamaica, England, and the United States, showing that these spaces and cultures are entangled, not discrete.[28] The protagonist, Nellie, moves from girlhood to maturity uncomfortable in her body and fearing her own sexuality: "Shame. You feel shame and you see your mother's face and you hear her scream and you feel the snail what she see making for your mouth. [...] A big woman running from a snail

and you run. But you can't run! How can you? You want to be a woman; now you have a man, you'll be like everybody else. You're normal now! Vomit and bear it" (28). Trained as a doctor in the US and practicing in Philadelphia, Nellie becomes profoundly alienated and psychically dis-eased, in need of a cleansing process to counter the illness caused by racism and the legacies of colonialism. Hearing white people talking about her and other "Negroes," she feels a huge lump in her throat: "But that lump is anger. Research labs now link repressed anger with cancer and the cancer must out with a surgeon's knife" (32). One recalls Hopkinson's Ezili, who struggles with the cancerous blockage of the Salt Roads and encourages the female characters to seek ways to unblock and to heal those wounds. In Brodber's first novel, as in all the texts discussed in this book, the primary healing requires *relation*, as Nellie first has to "go eena kumbla"—a calabash-like protection and talisman against pain, danger, uncertainty. "It makes no demands of you, it cares not one whit for you. [...] It is a round seamless calabash that protects you without caring. [...] And inside is soft carpeted foam, like the womb and with an oxygen tent. Safe, protective time capsule" (123). She cannot remain in this cocoon, however, but instead must experience reconnection in order to recover.[29]

Brodber also illustrates the damaging effects of education on the colonial subject, in particular the dangerous and destructive aspects of a white British educational system for Afro-Jamaicans. A prime example occurs in her second novel, *Myal*, in which the young Jamaican Ella (not the same character as in the later novel, but clearly her precursor in Brodber's creative imagination) first appears as a schoolgirl reciting a poem by Kipling. Memorizing and internalizing colonial stereotypes, molding her mind to fit imperial norms, the light-skinned Ella (of "mixed race") illustrates the profound damage done to a young woman who passively digests the "master's" written texts, until she finds herself transplanted to the US after marriage to an Anglo-American. Significantly, Ella "passes" as white when she goes through US Immigration, and then accepts her husband's reinvention of her as "full Irish" (42–43). Encouraged by him to tell stories of her homeland and discovering in that oral narration the depth and humanity of those she had dismissed and abandoned, Ella must then confront the results. Specifically, her husband Selwyn has produced a "coon show," in which she can recognize the outlines of friends and family, buried under the weight of a racist imagination:

> Everyone of them Grove Town people whom Ella had known was there. Like an old army boot, they were polished, wet, polished again and burnished. The black of their skins shone on stage, relieved only by the white of their eyes and the white of the chalk around their mouths.

Everybody's hair was in plaits and stood on end and everybody's clothes were the strips of cloth she had told him Ole African wore. (83)

Selwyn has created a travesty of what Ole African represents: traces and remnants, memory resurfacing and stories to be completed, the voice and spirit of an African past. Moreover, he has made the stage character Ella white-skinned and blond-haired, and turned her into the object of desire for the rest of the cast. This experience of seeing her memories and stories of Jamaica turned into a minstrel show sends Ella into a mute madness and mysterious illness that swells her stomach and has her talking to multiple selves.

From the beginning, the novel has emphasized the need for a cure, a confrontation with not only Ella's illness but also the larger damage done by colonialism. As Mass Cyrus says, "This pain, confusion and destruction is what these new people bring to themselves and to this world" (3). Brought home to Jamaica, she must be cured in a communal endeavor in which all join battle (69), a vivid demonstration of *myal*, which counters the "coon show" or minstrelsy that Selwyn produced.[30] She then becomes a schoolteacher—one who will challenge the texts of the colonizers and offer her students a radical and liberating education instead. And she also dismantles the state of zombification, as discussed by those close to her:

> [A] phenomenon common in parts of Africa and in places like Haiti and Brazil [. . .]. People are separated from the parts of themselves that make them think and they are left as flesh only. Flesh that takes direction from someone. The thinking part of them is also used nefariously . . . "immorally" might be a better word. [. . .] In those societies there are persons trained to do the separation and insertion. The name under which they go would be translated as spirit thieves. (108)

The final vision is of Ella "short circuiting" creation and putting it back together again in a new way, using both written texts and oral narratives to open her students' eyes and wake their minds. As Mass Cyrus observes, "Curing the body is nothing. Touching the peace of those she must touch and those who must touch her is the hard part" (93). Colette Maximin concludes that *Myal* "reconciles voice with writing" (62), which applies as well to both *Mules and Men* and *Louisiana*, if in different ways and to different degrees.[31] Both Hurston and Brodber are performing orality in textual production: a contradiction or paradox, but one that works effectively to convey the fraught processes of recovering cultural memory and narrating collective history, as well as individual life stories. Moreover, this process resonates with the re-membering explored in the first three chapters of this study.

IV.

Similar to the fictionalized "Zora," the Ella of *Louisiana* must negotiate a path from external (mistrusted) observer to listener-participant, as Brodber explores the nature of diasporic identity, and the recuperation and representation of the histories and cultures of the African Diaspora. Herself a sociologist who has published extensively on women and children in the Caribbean, Brodber produces a counter-discourse in this fictional ethnography, as she first deploys Ella as the tool of mainstream scholarly research and then decenters that approach to replace it with the psychic powers of Louise, Anna, and their spiritual daughter Ella or "Louisiana," as she renames herself. Ella's initial attempts to get Mammy/Anna/Sue Anne to speak of her past and to record that storytelling are frustrated by the older woman's refusal to play the game, her insistence on dealing the cards her way and directing the script, in a game she calls "coon can." The alien intruder armed with her strange tape recorder, Ella is positioned as outsider, even as "white" perhaps, the initial antagonist to Mammy, who claims the "coon" identity and asserts her power as a Black person. Like Zora in Florida, Ella must become one of the performers as well as serving as the recorder of voices.[32] As the tape "pings" at the end of one side, Ella thinks to herself about the silences it has captured:

> not a thing to give to the white people. How would it look? This woman they say has important data to give; is important data; she has seen things; had done things; her story is crucial to the history of the struggle of the lower class negro that they want to write. I was chosen to do her. It was an honour. Because of my color, I could get her to talk.(21)

Gradually Ella must recognize that this is the wrong kind of search, an inauthentic performance and a mistaken view of Anna's significance, based on a false essentialism. She cannot pick through Anna's brain and put its contents into the black box; instead, she must learn to listen and to hear the multiple tellers of the tale, as well as participating herself in its unfolding.

The hybridity seen in Hurston's text, which is effective in exploring the paradoxical relationship between oral material and written rendering of those voices, takes on added complexity in Brodber's fictional ethnography. The concept of "orature," developed by Ngugi wa Thiong'o and employed in performance studies, "complicates the familiar dichotomy between speech and writing" (Roach 11) and can serve as a way to understand the hybrid nature of both Hurston's and Brodber's texts. As Joseph Roach explains, "[O]rature goes beyond a schematized opposition of literacy and orality as transcendent categories; rather, it acknowledges that these modes of communication have produced

one another interactively over time and that their historic operations may be usefully examined under the rubric of performance" (11–12). Furthermore, this concept applies to collective memory, which is what *Louisiana* ultimately performs. Readers are being instructed in methods of understanding diasporic identities and histories, just as Anna is mentoring Ella in research methods.

The novel opens with the key voices, first Louise's spirit talking to the yet-living Anna, speaking of death and singing a song that will become the signature of these two women and their connection to Ella: "It has no written score. Succeeding generations of us, on each of our occasions, have, like you, simply appointed their own tenor, their own alto, their own timing to descant and fill out gaps built into a score by those who wrote it" (9). This dialogic and ongoing process is reflected in the narrative structure of the novel itself, as the various characters enter into the telling and contribute to the piecing together of a "score" or history that spreads from north to south and back in the US, and from Jamaica to New Orleans to Harlem, from Chicago back to Louisiana, to Connecticut and to the Congo. As she replays and transcribes the one tape she has of their conversation after Sue Ann's sudden death, Ella discovers more and more voices and information on it, so that what she terms the "content of the reel" comes to encompass a collective memory of the global "real" of the African Diaspora. The text becomes a step-by-step reconstruction of Anna's story as Ella develops an analytical scheme to decipher it, using files of data; as spirits or disembodied voices, Anna adds to the reel and Louise goes over the transcripts, adding punctuation, explaining unfamiliar words, and telling her own story as well. And, as Ella's husband Reuben will say near the end after Louisiana's death and his final compilation of the manuscript, "It is the story of the conduit, the scribe as much as that of the actors" (165). This joint performance enacts the "convergence" of peoples and places that Glissant describes as the transversality of Caribbean discourse and identity—a description that expands to include the diaspora more generally. It also resonates with the convergences and collective (re)telling that other texts in this study illustrate: Ezili guiding the three women in *The Salt Roads*; the way that Philip gives voice to the bones (as do Brand and John); the conversations between Agnant's Emma and Flore; Josèphe's gathering and typing the stories of generations of Haitians, especially women.

As Louisiana, Brodber's protagonist demonstrates the need for "community connection" (O'Callaghan, "Play it Back" 64) expressed throughout these texts. We witness Ella become Louisiana, giving up her individuality to become the conduit. She also relinquishes biological motherhood, much as she wants a child, in order instead to "mother" the tape recorder: "It was this process [of speaking of the recorder as 'the ladies'] that finally led me to opening the recording machine gently and reverently as if I were cleaning my baby daughter's private region" (50). And then Louisiana will metaphorically birth

all of those whose voices pass through the "hole" that she comes to embody, re-membering the diaspora in a constructive process with women as allies.[33] Anna's death is the catalyst for this communal project of re-creation, a death followed by ceremonies that echo those performed at Louise's funeral in Jamaica. As Roach observes, "[T]he performances marking the rites of passage from life to death represent some of the most elaborately staged occasions on which fictions of identity, difference, and community come into play" (28). The layering of deaths, the repetitions of rituals of passing, serve in this text to initiate the transformation of Ella into Louisiana—she is the "egg" laid by Louise and Anna, and the passageway for the rebirth of an oceanic and diasporic cast of characters whose voices pass through her.

The clusters of parallel and echoing identities and narratives in *Louisiana* are mapped across space and time, as Brodber creates a truly polyphonic text. Late in the book, Ella offers a concise retelling of the life of Sue Ann, a linear and coherent history of the woman she was sent twenty years earlier to interview; she notes that gaps remain, but the transcript as it stands has value as a guide to future researchers—an ethnography (within the fiction) for contemporary scholars of the African Diaspora. Though offered in a different, hybridized genre, this embedded narrative might serve a function similar to that performed by the tales gathered in *Mules and Men*, as Hurston's compilation offered a foundation for the study of African American folklore. Ella goes on to make a transparent statement of one of the book's central arguments: "I don't think for instance that the nature or extent of the influence of black America on the Caribbean and vice versa has been explored as it should" (154). Ella herself—later Louisiana—is chosen to receive the stories and to translate them, in part because she already has a dual identity—her "two voices" as Mammy says, of Jamaica and Harlem. She is also sensitive to language, noting that some words "control large spaces" (43), sit over grated holes as if over a city's underground system of pipes. To her, words are like name plates, belonging to "another civilisation and the modern day had not unearthed the key to their location. They were rather like flaps on a letter box" (44). As she listens to the voices in her head and learns to cross over, she receives visions of another place, similar to St. Mary's, Louisiana, USA, a place that emerges as St. Mary's, Louisiana, Jamaica. In a sense, she resembles the *milieux de mémoire*, as construed by Pierre Nora, "real environments of memory" (7), as opposed to the *lieu de mémoire* or deliberately created site of memory. She enacts a passage that maps space and time on multiple, parallel planes, overlapping in the sort of subterranean unity Glissant invokes. "I had broken through that membrane and was in, ready and willing to be and see something else. Transform, change, focus Transform, change" (*Louisiana* 52). This passage occurs in a transfer of souls at Anna's death, as Ella takes over

the lifeline. Such proximity on the spiritual level, a connection between those from disparate locations in the African Diaspora, provides a dimension not fully explored in Hurston's text, even when "Zora" reappears as practitioner of hoodoo in New Orleans. At this point in *Louisiana*, after Mammy's physical death, Ella's role begins to shift more explicitly from the hapless researcher to the spiritualist Louisiana, who will initiate *myal* or healing for intersecting communities in both the US and the Caribbean.[34]

V.

Just as *Mules and Men* takes Zora to New Orleans, Brodber's Ella arrives in this city with Reuben, who seeks its music, and she finds Madame Marie as teacher and guide. As Roach notes, the "Africanization of Louisiana included the powerful forms of musical celebration, dance, storytelling, and ritual that developed in the interstices of European laws and religious institutions, creolizing them, as they creolized the African ones in turn" (59). New Orleans epitomizes this process of transfusion and creolization, marked by voodoo and jazz, Congo Square's musicians and Marie Laveau's followers. And as Anna's death has invoked lives and voices, "the dead seem to remain more closely present to the living in New Orleans than they do anywhere else" (Roach 15).[35] Established as a psychic in New Orleans, Ella wears a pendant with a hole in its center: "That hole, that passage is me. I am the link between the shores washed by the Caribbean sea, a hole, yet I am what joins your left hand to your right. I join the world of the living and the world of the spirits. I join the past with the present" (124). She then explains her new name as this conjunction of times and places, a new way of mapping African America: "Say Suzie Ana as Louise calls Mammy. Do you hear Louisiana there? Now say Lowly as Mammy calls Louise and follow that with Anna as Louise sometimes calls Mammy. Lowly-Anna. There's Louisiana again. [. . .] Or you could be Spanish and speak of those two venerable sisters as Louise y Anna. [. . .] I am Louisiana. [. . .] I give people their history" (124–25). Such a positioning and purpose recall Hurston's words early in *Mules and Men*: "Ah come to collect some old stories and tales [. . .]. They are a lot more valuable than you might think. We want to set them down before it's too late" (8). Zora's "We" is not the same as Louisiana's "I," however. The "We" of Zora's pronouncement aligns her with those who seek to create a *lieu de mémoire*: the archive, the collection, the staged memory. Except perhaps briefly in her initiation into voodoo, Zora does not act as the effigy or surrogate, as Ella does: "performed effigies—those fabricated from human bodies and the associations they evoke—provide communities with a method of perpetuating themselves through specially nominated mediums or

surrogates" (Roach 36). What Brodber's text performs—expanding on Hurston's vision in her creative ethnographies—is an environment of memory, a space of orature, a transversality, and a collective identity.[36]

Part of this performance occurs as Louisiana engages with the many seamen who come to New Orleans from the West Indies, listening to their songs and tapping into their life stories with her psychic powers. Again, a transversality emerges as she stores their many identities in her mind: "My head is a cardboard box of US and West Indian file cards, each beginning 'name, date of birth, place of birth.' [. . .] I am having a great deal of difficulty in separating my West Indians from my Americans. That is my problem; they seem quite able to make use of the history I hand them" (129). Glissant writes of the Caribbean's lived history as a "neurosis," in a passage that has crucial implications for Brodber's creative oeuvre as a whole, as well as for *Louisiana* more specifically:

> Would it be ridiculous to consider our lived history as a steadily advancing neurosis? To see the Slave Trade as a traumatic shock, our relocation (in the new land) as a repressive phase, slavery as the period of latency, "emancipation" in 1848 [for Martinique] as reactivation, our everyday fantasies as symptoms, and even our horror of "returning to those things of the past" as a possible manifestation of the neurotic's fear of his past? [. . .] History has its dimension of the unexplorable, at the edge of which we wander, our eyes wide open. (*CD* 65–66)

Indeed Louisiana (both character and text) performs a kind of therapy, serving as conduit and scribe for the myriad voices and histories that erupt from both sides of the sea. The oral becomes an organized manifestation of diversity, as envisioned by Glissant (*CD* 100). Ella listens to these sea voyagers, many from "the islands," who hear a song that stirs individual memories, and as her head becomes a giant card file, she allows them to relive painful pasts so that they can both return home and move forward. Her "prophetic vision of the past"—a seeming oxymoron—is integral to the group's ability to join in a communal voice, to remember as they sing, and in that joint performance also to create a new version of the familiar songs. And her immersion in the folk songs parallels her husband Reuben's intense enthusiasm for the jazz and blues permeating New Orleans.[37]

Music opens the novel, beginning a pattern that resounds throughout the text, as first Louise voices the songs heard at her own funeral in Jamaica, then Anna sings a tune her mother learned from her father, then we hear a refrain of a folk song—and Ella wonders if she is going mad, if she needs a psychiatrist. Meanwhile, Reuben has journeyed from Europe to the US, following Du Bois, to find himself in the South, surrounded by Black culture and jazz: he feels

he is being made anew, experiencing a rebirth. Reuben is neither African nor European, but a mix, like the music with which he comes to identify: jazz, both a new and a renewed form. And in New Orleans music helps to cure madness, to perform *myal*, as Reuben attends a language school for musicians and hones his playing, while Ella meets the seamen from the West Indies and the US and listens to their songs. As Joseph Murphy observes in his study of ceremonies of the African Diaspora, the "linkage of music and movement with the presence of the spirit, while neither an exclusively diasporan way of worship, nor inclusive of all black people, is a distinguishable, important tradition among a great variety of people of African descent in the Americas" (5). In Brodber's text, music offers a performance in which memory is crucial, a repetition with differences. At the outset, a song connects characters in death, its words sung at Anna's funeral just as it had been voiced at Louise's; gradually, just as time and space overlap and merge, so do life and death, as Ella performs a kind of therapy. The songs lead to stories, memories of home and family, the pain of loss, and then an emerging network, a shared culture or cultural amalgam. "I couldn't get the shared experience of those two sets of negroes from two different parts of the world out of my head. I couldn't get it out of my head that Lowly and Mammy had been buried to the strains of the same song—" (86). The men do engage in disputes over whose song they are singing, a territorial claim to ownership—each side insisting, "that's ours" (85). Yet, through the character of Ben, another Jamaican, Brodber illustrates her vision of connectedness.

Ella recognizes Ben's depth of hurt, the trauma of the past that he carries with him and expresses in song. She also directly shares in that pain, when the words of one tune bring on a fit that sends her home to Jamaica and initiates her prophesying, as she "sees" the men's stories on the file cards that will soon fill her mind. This moment resembles the ceremonial transformations described by Joseph Murphy: "The individual is brought to a symbolic death and rebirth in the classic pattern of separation from the old life, liminal transition between spirit and human worlds, and incorporation back into ordinary life with a new identity and vision. [. . .] The mark of this reborn self is the ability to 'see' simultaneously the spiritual and human worlds" (191). Ella says of Ben, "[m]y job was to help him re-live his painful past. He had to take it from there" (105). She thus performs both an exorcism and a healing, a version of *myal*, going back to the place of pain, allowing the sufferer to reexperience the trauma and then to move ahead. Each of Brodber's novels offers instances of this process, usually associated with Jamaica, for the individual suffering from pain or madness brought on by colonial forces. While Ella in *Myal* is cured through a communal effort on her behalf, in the previous novel *Jane and Louisa Will Soon Come Home*, the "Western"-trained doctor Nellie returns to Jamaica assimilated to cultural norms that silence and erase her. She gradually

must listen to the voices of ancestral figures and childhood friends—and of her heritage—in order to emerge from a zombified state. In *Louisiana*, Ella as myalist performs healing in a different manner, in that she is both an individual and a conduit for the much larger communal voice, rising out of the spiritual sufferings and longings of those on all sides of the sea.[38]

The traumas experienced by Louisiana's seamen are multiple, often involving love, abandonment, women left pregnant to cope on their own, men carrying guilt and sorrow with them. Ben's story offers a prime example: linked to a song he was playing, his pain results from his own abandonment of a young woman to whom he refused to commit himself, so that she sought an abortion and then was found dead. His betrayal and her tragic death have left him traumatized, sunk in pain and grief; Louisiana initiates his healing, a journey in which he returns to Jamaica and the root of his pain, to relive and then move on from that pivotal moment: "nothing but an exorcism can come for him from re-visiting the scene of his love and the sin that accompanied it" (124). And in this narrative in which all are interconnected, through Ben we see Ella also return to her home in Jamaica and her own trauma, her parents' abandonment of her as an infant, which became a repeated pattern as their determination to assimilate in the US meant that she, too, was expected to adopt their bourgeois values, to follow a path of "uplift" via a profession such as medicine. Instead, in rejecting the career that Nellie (in the earlier novel) mistakenly selects, Ella was essentially disowned by her status-seeking parents:

> I was an egg, for those two people held in me the potential for all kinds of things they hadn't done and like an egg if I fell I could break and splatter all over their faces. [. . .] This particular egg was to be a medical doctor [. . .]. To create the right environment for my hatching, they said was the reason for their hard, childless work and for their further hard work when I got into medical school. And what does the egg choose to do to those poor souls? Quit medical school after one year. (39)

Via Ben's communication with her, as he walks the island and rediscovers familiar sites, Ella can retrace her route back to Jamaica.

As Louisiana, she takes in others' pain, not only Ben's but also the multiple traumas of those whose stories she files away in her mind. The disputes over who owns the songs cease, as the two groups come to see their cross-cultural links and their fundamental solidarity: "The songs are equally ours now. [. . .] My clients, though they are as many natives as West Indians, don't argue about origins either" (129), because they have found a common chord (130). This shared voice resists a genealogy that would identify "pure" origins (as formulated by colonial/European ideas of "race" as well as gender and sexuality). Instead of a

preoccupation with purity, the seamen/musicians accept syncretism, a creolized culture that reflects Caribbean realities, putting the West Indies at the center of this world created by the Middle Passage—what Walcott termed that "amnesiac blow."[39] This understanding or "common chord" provides the necessary step to move from trauma to resistance to healing in the Caribbean Atlantic.

The process is not easy or rapid, however, as Louisiana explains when she considers the painful memories of Anna and Louise, experiences of racism and violence, in particular. Sometimes people fail to deal with the past, which may explain why Ella has been chosen to excavate Sue Ann's story and come to an understanding of the interconnected histories of the African Diaspora. "The failure as it apparently was in this case, is just so painful and difficult to handle. It inhibits analysis. And putting words on things means analysis. People share post analysis. They file things away until their emotions can deal with them" (149). This filing is precisely what Louisiana's psychic power, her therapy, opens up, allowing the myriad voices of the diaspora to express their buried traumas, to come together, and to heal. This voicing means empowerment, both individual and collective, and again Brodber illustrates via a song—words that internalize racist views of Black people, words that must be taken back and used as resistance, similar to the way that the folktales collected by Hurston often signify upon racial identities and talk back to the oppressors. As Anna, her husband Silas, and Louise discovered in the violent years surrounding World War I, the dominant society's assumption that "whiteness" is "best" is reflected in a tune about Black people wishing to turn their skin a lighter shade— "I'd rather be a whiteman / 'Stead of coon, coon, coon," it says (145). Lowly recalls Silas's explanation: "If you are afraid of what people call you, then they have power over you. They call you 'coon,' then call yourself 'coon.' You now have power over the name. When next you hear that song, say to yourself, 'the coon can'" (145). These three words will conclude the novel, sending a message of defiance and affirmation in the face of ignorance and racism—much the way Hurston performs the role of Sis Cat, eating the rat and then showing her good manners, acknowledging her patrons and mentors, but in a way that underlines her subversion of the rules laid down by white folks.[40]

Before reaching the last words of Brodber's text, though, we need to hear the voices joined together, to experience transversality in visceral terms. The female characters, in particular, have acted as agents of connection, "wanting *to pull the sides of the sea together*, wanting to sew them little islands together and tack them on to New Orleans" (148, emphasis added), and Mammy has been revealed as a Garvey organizer *and* a psychic, a Black nationalist. Marcus Garvey and UNIA "gave them a framework within which to do concrete work" (153) and contributed to the empowering reclamation of identity.

In his study of Caribbean radicalism in the early twentieth century in the US, Winston James documents how "Caribbean migrants came to America with a long and distinguished tradition of resistance with few parallels in the New World. They, consequently, entered the United States with a sense of self-confidence and pride that would have predisposed at least some of them to radical activity, as the harsh racism battered their self-esteem" (76). In Brodber's fictive version, Garvey's followers in Chicago include not only Louise from Jamaica, but also Sue Ann and Silas, each of whom has engaged in lifelong battles against racism—Sue Ann most actively in organized rebellion in the South.[41] It seems not far-fetched to see Anna or Mammy as the US equivalent of Nanny of the Maroons, the Jamaican heroine and icon.

As Louisiana lies ill, the signature tune from the opening pages grows stronger, as does the pain she feels, and she indeed hears voices singing the same words sung for both Lowly's and Mammy's funerals. "Sheer jazz. One sound. From one body. A community song: 'It is the voice I hear, I hear them say, come unto me . . .'" (161). This culminating moment of communication with the dead is what Joseph Roach refers to as a "cultural politics of memory," further stating that "[e]choes in the bone refer not only to a history of forgetting but to a strategy of empowering the living through the performance of memory" (34). Roach identifies funeral ceremonies incorporating music as vivid examples of such performances, which Brodber illustrates in Louisiana's passing and the funeral that celebrates her life. Though it seems too fortuitous that Reuben knows Louis Armstrong, who arranges a true New Orleans funeral for Louisiana, yet the intent makes sense, another instance of pulling the sides of the sea together. Reuben says of the musicians, "I did not know that they too knew the extent to which the fusion of the music of the island men and the natives seeped over into our rehearsal room and influenced us" (165). And as he ends the manuscript, thinking of a journey home to the Congo, he envisions "an extension of the community. Isn't that exciting! The coon can" (166). The game Mammy played as Ella tried to record her on the machine becomes the larger performance of the entire text, a resistance that combines memory and survival, continual repetition with a difference, an ultimate affirmation of diasporic identities.

Brodber's opaque work defies linear narrative and easy assimilation, while relying on circles, reversals, and echoes—its own forms of creolization. *Louisiana* does "pull the sides of the sea together" to explore the nature and extent of mutual influence and shared history among the US, the West Indies, and the Caribbean Atlantic. And in modeling her protagonist on the Zora of *Mules and Men*, Brodber builds upon the foundations laid by Hurston, refusing in her own manner to perform the roles assigned by whites and then expanding upon the possibilities offered by voodoo and music, and

the unique powers of *myal*. Ultimately, both texts perform an "organized manifestation of diversity" (Glissant), by means of "an extension of community" (*Louisiana* 166) that emphasizes the nature and extent of mutual influence and shared history throughout the diaspora.

Kamau Brathwaite, discussing creolization and the evolution of Afro-Jamaican culture, states that "it is in the nature of the ex-African slave, still persisting today in the life of the contemporary 'folk,' that he can discern that the 'middle passage' is not, as it popularly assumed [*sic*], a traumatic, destructive experience separating the blacks from Africa, disconnecting their sense of history and tradition, but a pathway or channel between this tradition and what is being evolved on new soil, in the Caribbean."[42] This is not to say that the Middle Passage and slavery were not traumatic, but that in the aftermath a new syncretic culture developed, one that maintained Africanisms, just as it adapted them to European practices, resulting in distinctive belief systems such as voodoo and *myal*, and in an original form of music such as jazz. And resistance to oppression, challenges to racist attitudes and behavior, are voiced by both Zora/Sis Cat at the end of *Mules and Men* and Reuben in his final declaration: "The coon can" (166). Both texts are located in the first half of the twentieth century, primarily in the southern US, though Brodber does bring us up to the 1970s via the women's press that publishes Ella and Reuben's jointly created document. Brodber thus transposes current questions surrounding trauma, memory, and relation onto an earlier era, following Ella/Louisiana from 1936 up to the early 1950s. What happens in texts set in more contemporary moments? How do authors address trauma, memory, violence resistance, and healing? Is *myalism* possible? Tessa McWatt's works, the focus of the next chapter, offer some answers, as will the authors discussed in chapter 6.

Part Three
Unsettling Borders

Chapter 5

MAPPING THE BODY

Caribbean Migrations in Tessa McWatt's Fiction

"Home became a craving, not a place. [. . .] It wasn't gravity mixed with time that caused the body's peeling; it was prolonged homesickness. The farther we go from home, from a vital source, the more yearning we put between ourselves and our bodies" (McWatt, *Dragons Cry* 153). Tracing the desire to establish connection and to belong—to a place, to others—Tessa McWatt's narratives weave together her native Guyana, Barbados, London, and locations in Canada, most often Toronto but also Montreal. Her fiction explores family histories, ones filled with violence and loss, and the means by which a character pieces together an identity from the fragments of maps carried within traveling bodies. Each text uses a heuristic device— the moon's cycles, music, food—to structure the journeys of characters seeking to fill in the gaps created by a combination of colonialism in the Caribbean and subsequent movements of Caribbean subjects. "No study [. . .] has been made of the arts of transplanted peoples in order to assess a kind of seismic quality in a changing culture, an epicenter that releases a suddenly fissured crack, a suddenly penetrated wall or door" (Harris, *The Womb of Space* 119). Through her mapping of Caribbean migrations, Tessa McWatt explores the intersections of family and geography, of bodies and memory, of Caribbean relations and locations of the self.

In his discussion of literary cartographies, Graham Huggan argues that the map can act as an agent of change: "it may provide a medium for the visualization of new, unforeseen opportunities: opportunities for both personal and social/cultural growth" (28). Using the example of Guyanese writer Wilson Harris, Huggan suggests that the map fosters new forms of kinship; he concludes his study with the concept of "productive dissimilarity" (152), as a cartography of

exile metamorphoses into a cartography of difference (147–48, 150).[1] As Harris himself writes, "The voice of authentic self is complex muse of otherness" (*The Womb of Space* 137). McWatt's fiction engages in literary cartography that maps the body and moves towards a vision of invention and transformation, genealogies that ground kinship in reconceived difference.

In *Out of My Skin* (1998), the protagonist Daphne negotiates multiple paths of Relation, as she searches for her biological family in contemporary Canada, reads the journal of her maternal grandfather who went insane in Guyana, and becomes tangentially involved in events surrounding the 1990 standoff at Oka between Indigenous peoples and the Canadian government.[2] *Dragons Cry* (2000) traces relation across and between bodies in Guyana, Barbados, and Canada, with gestures towards both the US and England. And *This Body* (2004) connects a present-moment London with both Toronto and Guyana in the protagonist's past, as borders blur and spaces bleed into one another. In all three texts, the characters concern themselves with issues surrounding Relation—violent loss, suicide, childlessness, adoption—their bodies carrying traces of Caribbean history both personal and communal. These novels form a triptych, building upon and resonating with each other, the body a constant focus in migrations and border negotiations. As in the texts discussed throughout this study, Relation takes on central significance in confronting and exposing the legacies of colonialism in the Caribbean. The paths that McWatt maps move from excavation and burial of that past, to personal mourning and forgiveness, to both a return home and an outward movement in the creation of new relations and an acceptance of "this body" as the key site of identity and healing. Lines from Derek Walcott's "The Castaway" serving as epigraph to *Out of My Skin* point toward the value that McWatt places on self-invention: "We end in earth, from earth began. / In our own entrails, genesis."

I.

The protagonist of McWatt's first novel does not know her mother's-land Guyana, though both the missing mother and the unknown Caribbean structure her inchoate desires. Adopted in Montreal and growing up in an all-white neighborhood in Toronto, Daphne Baird has always faced the question of who she is: "the question *what are you* nudging [the crack] wider each time she asked it of herself. So she began to invent answers, and even events conspired to confirm them" (17). Her brown skin sets her apart from her Scottish adoptive parents and marks her as different from her peers at school, a displacement that those around her exacerbate rather than alleviate. Adoptee of Canada, orphan of Guyana, Daphne might play the role of "nowarian" in the game imagined by

the protagonist of Ramabai Espinet's *The Swinging Bridge*, an invented persona who seeks a room for the night: "I is a traveler. A nowarian" (Espinet 152). The "No/Where" signifying lack of roots will shift over the course of the narrative to a "Know/Where" as she discovers answers to her origins, and then to a "Now/Here" as she creates and locates her self. Though she is thirty years old, Daphne often appears and acts much younger, suffering an arrested development that offers a perverse comfort—a *kumbla* of sorts.[3] The trope of birds, migratory beings, provides both a structure for Daphne's own seeking and a means to understand her dilemma: an obsessive birdwatcher, she finds satisfaction in identifying each unfamiliar one in her Audubon book, much as she seeks a classification of her own, an answer to the "*what are you*" that has shadowed her life.

As seen in other narratives of Caribbeanness, the desire to trace a family tree and to know one's "roots" can lead to obsessive quests to discover ancestors and origins.[4] Seeking her biological parents through the adoption agency, Daphne comes face to face with incomplete lines in her genealogy: she learns her birth date, her mother's name, and the fact that no father is listed on her birth certificate. Her mother was from "British Guiana, now Guyana," she is told by the agency (14), information that complicates her self-image: "The pounds were leaving. Checking her buttocks, she rubbed them as she had her belly, reluctantly beginning to relinquish her descendance from a Greek goddess. Her real mother had probably been part Chinese, part White, and part Black. She touched her cheek and drifted in and out of the ingredient colours of her mother's skin: yellow, white, black" (15). As she embarks on this journey, she hears a voice speaking to her with a West Indian accent, using words and phrases unfamiliar to her—a voice that comes to be identified with the unknown mother, though one of Daphne's own invention. "For the last few weeks the voice had accused and admonished in motherly tones" (8). The text traces the development of Daphne's selfhood as a process of self-mothering and self-birthing: neither the woman who physically gave birth to her nor the one who adopted and raised her stands behind the voice that guides this quest. An Indigenous woman, Surefoot, who is the closest to a surrogate mother for Daphne, tells her that "belonging is what you give yourself" (98), a philosophy that will challenge and then displace the patriarchal concept of roots as well as its contorted reflection in the colonized mind. Initiating the process of invention by seeking knowledge of her parentage, Daphne also conjures the maternal voice that will speak to her throughout the journey.

Using the information provided by the adoption agency, she then hears the voice of her mother's sister in Montreal, first on the phone and then in person—a meeting she goes to with the "excitement of coming home" from travels (76). This woman shows her niece a photo album and makes the abrupt announcement that Daphne's mother, Muriel Eyre, had committed suicide by

drowning. The patronymic makes an obvious reference to both Brontë and Rhys, twinned stories with madness and suicide at their heart (and Daphne will read *Jane Eyre* in the public library, in a reflexive moment of self-seeking). The aunt gives Daphne two large diaries written by the grandfather, Gerald Eyre; reading these notebooks, Daphne embarks on a mapping of her own body, the traces it bears of both colonizer and colonized. "In its [one notebook's] raging sentences, she sensed the littered narrative of the time before she was born, a past that had sat in her lap with those photographs just a few hours before. [. . .] Her face was burning with a rush of blood that felt shared for the first time in her life" (84). Throughout Daphne's process of relational cartography, the city itself serves as both territory of exploration and reflection of the "I" that she gradually constructs: site of multiple migrations and of self-inscription.[5]

In Daphne's increasingly agitated quest to discover her origins, we observe another instance of the power of Relation—the irresistible desire to locate and identify parents and ancestors, to place oneself on the branch of a family tree. That journey becomes a descent into the brutality of colonized spaces and the potential madness of a colonized mind (similar to Brodber's protagonists). Not having a history of her own, Daphne first appears in the narrative haunting the nighttime streets of Montreal as voyeur, standing in the dark outside the lit windows of homes where she observes familial existence, epitomized in photographs on a wall or a young boy playing under the watchful eyes of an elderly woman. At such times, she experiences that crack in the world and her feeling of "falling between cracks, of stepping and missing. [. . .] A gaping hole in reality" (2). This sensation of stepping into a gap or fissure offers an example of the in-between or interstitial predicated by Homi Bhabha: "It is in the emergence of the interstices—the overlap and displacement of domains of difference—that the intersubjective and collective experiences of nationness, community interest, or cultural value are negotiated. How are subjects formed 'in-between,' or in excess of, the sum of the 'parts of difference,'"[6] he asks. McWatt's Daphne provides an illustration of the individual experiencing and then using the "in-between" spaces from which to shape an identity.

She keenly observes her own body and physiognomy, seeking signs of ancestral history and a line of descent, observing her large nose, her frizzy hair, her full lips, brown skin, and "bouncing, high-rumped gait. A trace of Africa" (5). She attempts to erase the evidence of her own sexuality, while at the same time entranced by the feel of her skin. Thus, she plucks out each pubic hair, frequently strokes her belly, pinches a breast, or masturbates. Urban space, specifically the North American metropolis, is both site and catalyst for what we might describe as a civil war inside her body. That is, the city is a sexualized space, one that encourages Daphne to explore her desires. On the other hand, she experiences her body as alien and threatening, to both others and to herself.

Her behavior resembles that of the survivor of sexual abuse or trauma, seeking to reverse time, repress the memory, return the body to a state of innocence. *Out of My Skin* might be read as a survivor narrative not of the original victim, however, but of the descendant (as well as the product) of that cataclysm. Her mapping of the body becomes a process of (self-) reclamation, an exploration and seizing of embodied space that has been labeled "empty," even "mad." As Huggan notes, "If displacement is regarded as a prerequisite for new, formerly suppressed or disallowed projections of self, women can be seen in this sense both as *mapbreakers* engaged in the dismantling of a patriarchal system of representation and as *mapmakers* involved in the plotting of new coordinates for the articulation of (female) knowledge and experience" (13, original italics). As the diaries will make evident, Daphne must contend with a history of violent, traumatic familial relation and put that legacy to rest in order to heal from its abuses. Her journey resonates with those depicted in texts discussed in the previous four chapters, including the excavation of bones by Philip, Brand, and John, or the ways that Ezili encourages the women in Hopkinson's novel to unblock the cancerous Salt Roads.

For Daphne, the present situation in Montreal, where a group of Mohawks have taken over a bridge in solidarity with those participating in the standoff at Oka, mirrors the violent legacies of British colonialism that she will confront in the diaries. The narrative underscores this parallel throughout, from the moment in the adoption agency when Daphne encounters the Indigenous woman Surefoot (also seeking to identify her parents), whose body bears horrific scars, testimony to the brutality she suffered at the hands of nuns throughout her years in foster care. As Maureen Moynagh argues (in her discussion of a verse drama by George Elliott Clarke), "The promise, then, of articulating cultural memory with gender and race is the contestation of hegemonic narratives of nation, a splitting open of the historical sutures that close out stories of racial terror and sexual injustice, relegating them to a space beyond the body of the nation" (97).[7] Montreal is at the nexus of histories that erupt in explosive ways during the hot summer when McWatt's novel takes place. "The city was draped in veils. Behind the first, the languages of two empires were still fighting a colonial war. Her life seemed to be developing behind the second veil, where there was a calm, free space, as in the eye of a tornado, which asked for nothing except her imagination for survival" (65). Referred to by a coworker as an "ethnic" and lumped by this same woman into "people who look like you," that is, nonwhite, Daphne thinks of herself as the "foreign body" (142).

Daphne's body itself resembles territory, bearing traces of history that she pieces together, while also learning to script her own identity. And the diaries that she carries as precious baggage provide the outline of a story of madness and transgression that created her body. "She would continue to excavate them

for meaning, for the cause of the brutality that had produced her. They were all she had, so she clung to them as to an amulet" (186). During this period, her apartment in Montreal serves in the capacity of *kumbla*, a space to which she retreats but which does not lend itself to healing—in fact, the reverse occurs, when she consumes so much alcohol one night in her desire for amnesia that she almost annihilates herself. Montreal is thus the "cocoon" (156) from which she will of necessity emerge if she is to complete the process of self-invention.

In texts by many contemporary women writers from the Caribbean, as discussed throughout this study, women's bodies are the targets of violence rooted in systems established by European colonizers. Whether present antagonisms sunder the mother-daughter relationship, or women suffer from physical and emotional abuse from their partners, or live with the trauma of rape, female bodies and women's psyches testify to the dangers of home. As Surefoot's marked skin reveals the savagery of Christian missionaries, so does Daphne's bear witness to the traumas of history in the Americas, a body mapped by colonialism and migrations.[8] When Daphne looks into the mirror during a weekend trip to a lake, she sees herself with new eyes:

> Generations of submission and rebellion still battled for position there. Were hers the eyes of the victors or of the vanquished? The ears of slaves or of masters? Her hair was born of a cruel passion that sprang up kinky and horny in the moist heat. And her nose was a sculpture: a monument to the history of bones pounding other bones, mixing up dry marrow to unveil the post-historic shape that was displayed like a museum piece in the center of her face. (186)

Her body shifts and resists borders, such that the map is both "broken" and "reconstituted": "The easy ethnocentric distinction between 'our' territory and 'theirs' is consequently blurred, indicating a faultline between the neat rhetorical divisions inherent in conventional (Western) cartographic discourse" (Huggan 19). What Daphne discovers in the diaries is tortured handwriting that narrates a series of violent assaults, from the damaging education that young Gerald received from the British, to the coercions of heteronormativity, to the madness induced by racialized categories of identification, and his incestuous relations with his younger daughter—Daphne's mother. This familial history has awaited Daphne in the lines of the notebooks, never stated directly but limned in phrases that provide enough clues for her to piece together the violent transgression that produced her.[9]

The question "what are you" that drives her quest is only superficially answered by her aunt, who tells Daphne that she now knows her "hyphenation," that is, "West Indian-Canadian" (81). Instead of memory or passed-down

stories of ancestors, she struggles with a mixture of amnesia and invention, and then with the incomplete text of alienation and insanity bequeathed her by her unknown kin. "She had been walking around in the mind of a related stranger" (97), she thinks to herself in the middle of reading the notebooks: "Like the amnesia of her own birth that had landed her a stranger in someone else's family. None of it was hers. Step, miss. Invention was no longer possible. She retreated once again under the covers" (171). The diaries seep into this *kumbla*-like cocoon, forcing the "no/where" to become Daphne's "know/where." Guyana, though her homeland through blood and also her mother's-land, is a site of British colonialism and its aftereffects that ultimately destroyed her grand/father. Writing the diaries on the eve of independence, in the asylum to which he has been condemned following his breakdown and abuse of his daughter, Gerald contemplates the patriarchal role played by England: "*Today they're all talking about politics and independence* [. . .]. *In the fables of buck hunters, the son who rejects the authority of his father will blister and swell in the sun like a rotting carcass; that will be this country without Britain*" (126, original italics). Invested in what he considers "civilization," which equates Britishness and whiteness, Gerald has spent his life imitating that model.[10] Obedient to authority, committed to his job, he has been betrayed by coworkers who accuse him of the theft they themselves have perpetrated: he recognizes that they have used him, writing in his diary that "*the colored man must pay for the curse of his birth*" (120, original italics). Gerald then has turned his self-loathing and his impotence in the public sphere against his younger daughter, whom he impregnated before being sent to the hospital. We do not have access to that young woman's trauma, only the traces of it in her suicide by water and the fresh marks it leaves on her daughter as Daphne discovers her bloodline.

This text makes the argument that the body (including the skin) bears memory, and as we follow Daphne's movements through the novel, she understands that despite her amnesia she also has the ability to recall. During her night of nonstop drinking when she realizes that she is about to cross a deadly line, she "entered a sleep close to annihilation, a relief from thought, but with her memory mercifully intact. For memory, she sensed, was what made her life" (174). Ironically, and tragically, Gerald was subjected to medical attempts to erase his memory, indeed to cause amnesia, via electric shock treatment that "*turns my skull into a <u>map</u> of minefields*," he recorded in the notebook (127, original italics, emphasis added). The narrative intertwines memory and amnesia in the larger context of colonialism and its legacies of pain, abuse, and ongoing "cracks" in the Caribbean subject. In Gerald's damaged mind, the empire's orderly map of the world becomes instead an explosive cartography of danger and destruction: a first step in mapbreaking, to be taken further by his grand/daughter.

In her quest to know her genealogy, Daphne has torn the web woven by adoption (163), proving its fragility, just as the narrative exposes the myth of the nation as monoracial biological family.[11] Daphne herself is displaced, without clear lodging in the family tree: "Where was she meant to perch? Parallel, cornered, or off to the side? [...] There seemed no spot she could claim for herself, no offshoot to which she could be grafted, to close the gaping hole in her reality once and for all. So many disrupted nests. *Sing cuckoo*" (196, original italics). Of her adoptive parents, she thinks, "Born of brutality—she would have to thank them for rescuing her from that. Thank them for their attempt to revise history" (196). These attempts resemble the ECT administered to Gerald Eyre, which produces amnesias of varying length and aims to "normalize" the psyche in an invasive, colonizing procedure. But that history cannot be revised, must not be forgotten, and indeed Daphne's quest throughout the narrative is to resurrect it from the diaries and piece it together.

That project of re-membering parallels her personal journey of self-invention, both processes informed by (re)iteration. Her paternity complicates the family tree, requiring a taboo repetition—Gerald as grand/father, a double exposure as he occupies two branches at once. Daphne's job at Copie Copie, the shop's name itself an iterative, reflects her attempts to model herself on received narratives as she resists the specificities of her own body.[12] Thus, for instance, her obsession with figures from Greek mythology, such as the one whose name she shares. In reality, however, Daphne is a copy of no-body and of multiple bodies at once, as her ruminations on her biological mother have illustrated—the several ethnic backgrounds embodied in her physical features.[13] The bond of maternal surrogacy that she develops with Surefoot, formed in their shared search to know a genealogy, takes on layers of meaning as the narrative proceeds. Watching in disgust as Surefoot peels off a scab, Daphne also perceives what connects them: "Each fragment of old skin was tossed onto the pavement of the bridge. [...] Then she recognized the unnamed something she had sensed, the thing they shared that kept them adrift from others, seeming laden and ridiculous. They were creatures that made sense only in the imagination, that had to be invented like the improbable animals formed by clouds in a childhood game" (149). Daphne's own process of such invention is interrupted by the knowledge, from her aunt, that Gerald raped his other daughter and thus became Daphne's father as well as grandfather.

Traumatized by this information, Daphne experiences the in-between or interstitial: "Step, miss, step, miss, again and again. [...] Amnesia: everything in the present, all accessible; no distance, no cause, no effect, no responsibility" (171). Though this revelation sends her into the temporary, alcohol-induced annihilation of memory, Daphne emerges from the *kumbla* to perform an ironic, self-reflexive act of invention when she xeroxes the word "chameleon" from Gerald's diary, then enlarges it to the actual size of the reptile and tapes

it to her arm as a tattoo. As Gerald haunts the narrative, his diaries occupying the heart of the text, his ghostly hand scripts a word onto Daphne's skin: both express the longing to erase colonial history and the madness induced by heteropatriarchy.[14] The chameleon can shift shape and shed skins, but such transformations are temporary, like the paper on which the word is written and onto which it is copied. McWatt's text posits that the transitory can find a seed of rootedness in the body itself.

Throughout the novel, the trope of the moon passing through its multiple phases serves as a marker of Daphne's journey. Each chapter title is one of those phases: Crescent, Quarter, Half, Gibbous (1, 2, and 3), Full (1 and 2), Last Gibbous (1 and 2), Last Half, Last Quarter, Last Crescent, New 1, New 2, Crescent. The natural cycle of the moon thus reflects Daphne's progression from a childlike thirty-year-old seeking her mother and attempting to halt the maturation of her own body, to a woman who watches "her own body become rounder" while the gibbous moon also swells like a pregnant belly (60), to the adult woman she will (self-) birth at the end. Her growth toward selfhood is a reverse reflection of Gerald's increasing lunacy and descent, and his eventual death from what can be described as self-mutilation (when he cuts off his own leg to stop gangrene). McWatt employs the moon in a dual movement, to underscore both the mortal infection or cancer wrought by colonialism in the Caribbean and also the potential to bring that disease to the skin's surface, acknowledge the scar tissue, and initiate a healing in the body's present time and space.

Significantly, Daphne exits the city and from the distance of a lake in the hills completes first the reconstruction, then the symbolic and ritualistic burial of that catastrophic history. "She now felt she would enter nature like an alien, wearing skin that stretched out over unfamiliar blood" (176). She gradually severs herself from the Copie Copie coworkers with whom she is spending this long weekend, and guards the diaries—placing them under bed covers, hiding them under a towel—with "a fierce maternal instinct to protect the words that were now hers" (195). Floating in the lake—an amniotic return, as well as a gesture towards Caribbean waters and even the Middle Passage—she mentally confronts her biological parents:

> [S]he considered Gerald and what he'd heard in the back of his head. She started to hear it and to feel the fear of being swallowed up by a foreign element so powerful it feels innate. Her mother had loved too deeply, without borders that would stop violations [. . .]. Her father had been a coloured man who died believing he was white, yet finding a way to believe he had outsmarted them. But his own cells had revolted, backed up on him, and stopped reproducing. (192)

Gerald represents a dead end. Ultimately marked by impotence and lack, his body degenerated due to the dis-ease of his colonized mind.

Daphne needs to reach this blockage—similar to the bridge that is under siege in the background to her narrative—in order to pass through and then beyond it. Just as she has repeatedly sought sanctuary in the park in Montreal when her small apartment closes in on her—the dangerous envelopment of the *kumbla*—at the lake Daphne finds a counterbalance to the city in the watery surroundings and uninhabited vegetation. The diaries serving as her companions, she ventures into unknown territory and spends a night alone in the forest. Physically stripped due to the effects of sun exposure and covered in mossy earth to ward off mosquitoes, she decides to bury the notebooks: "A bow to memory. *To let the snow and rain work on them* until they became a place in which her own body could eventually be laid to rest. To have the paper petrify and fill the cleft between vegetable and rock, the words silent and grinning into the earth" (202, emphasis added). Having entombed the pages, she imagines a seed of forgiveness sprouting from this rough monument, and emerges from the wilderness dirty, scraped, bleeding, but also "closing the cracks of time" (206).

While Daphne performs this ritual solo and the entire scene resembles a rite of passage in liminal space, the text itself draws attention to Surefoot's role in the birthing process. At the barricades, when a police officer refuses to let Surefoot hand Daphne a cup of tea, the Indigenous woman challenges the laws he enforces: "You know, if you take all the laws, lay them out under the sun, and *let the snow and rain work on them* for awhile, there'll be nothing left of them but the earth they've become" (149, emphasis added).[15] That Daphne incorporates this image of disintegration into her burial of the diaries indicates how Surefoot serves as midwife to this birthing process. In the aftermath of the traumatic discovery of her origins, Daphne has sought out Surefoot, who refuses to offer sympathy and tells her that she can select her own birth, that the story of Gerald and Muriel Eyre need not determine her identity: "It's only a seed; you don't have to plant it. Animals make tracks. You choose the ones you want to follow" (173). Lost in the woods near the lake, Daphne sees the "thin curved sliver of the crescent moon" (205), and follows tracks of something "enormous, a wide human figure—many forms in one," an apparition that is "taking her home" (206). Having buried the pages marked by Gerald's hand, Daphne finds a different set of tracks—a script for her to read, a linguistic marking on the territory that shows the way "home." Her passage leaves its own tracks, a border-crossing or a step across the crack, into her own skin.

What does it mean to be out of one's skin? On one level, the title is linked to Gerald Eyre's twisted belief in the superiority of whiteness and in his

own proximity to it. The "violent ward" in the mental hospital results from colonialism and heteropatriarchy: "*Violence has a special category in the world. Like love, but there is no love ward, no place to go if you have forgotten it or if you have never had it.* [... in the violent ward] *there are cages, metal bars, and small tombs for those who can't be controlled*" (103, original italics). In one entry, he has written after ECT that he is "*dancing out of my skin*" (150), and in another he states that the doctors want him to "*be a coloured man*" (154, original italics). In another sense, however, the title can refer to what emerges "out of my skin," in a birthing of self such as Daphne finally performs when she emerges from the forest and hitchhikes back to Montreal. She thus extends beyond the reiterative image of snakes in Gerald's diary: "*This is the snake pit*," he wrote, "*and we are flailing, one on top of the other, crawling in and out of our skins*" (126, original italics). Her destination conflates the city with Michel, a farmer and amateur photographer she has met in her nocturnal excursions in search of familial *tableaux*; her identity now clarified and (re)claimed, its brutal origins also ceremonially laid to rest, she can embark on different paths, mapping her body in new migrations of the soul, perhaps.[16] "She was closing the cracks of time. She pranced on the soul of the world as if it were her own shadow" (206). She replaces the "what" of who she is with a "where." Arriving at the central market where Michel runs the family business in tomatoes, she locates herself in space as she tells him simply, "I'm here" (208). No reference is made to a journey "home" to Guyana; indeed, the text refuses any sense of exile or nostalgia for the "lost homeland," where Daphne was conceived in spaces of violence.[17]

Instead, Daphne solidly locates herself in the North American city that has provided the territory where she could pursue a different version of homecoming. In this act of self-location, presentness replaces the crack or fissure that repeatedly tripped her: "She had never actually passed over the first crack; it was the same one over and over that she kept falling into. A crack in time that had continued to shift everything like a great divide" (200). The experience in the forest and her return to Montreal mark Daphne's emergence into the "here" that has previously evaded her.[18] The novel's conclusion suggests that such self-placement requires connection with others, however, that one cannot achieve such presentness alone. Earlier, Daphne has grasped at the urban environment as a protection against the madness inside the diaries, claiming the streets, the here and now: "*This is mine*" (112, original italics). Nevertheless, as her journey illustrates, she needs creative (not biological) Relation, which she has found with Surefoot to an extent and may find in Michel, the person to whom she announces her presence, "I'm here" (208).

II.

In the larger configuration of what I describe as the triptych of McWatt's first three novels, however, genealogical branches and roots continue to exercise a powerful pull on the characters. While Guyana is visited only in flashbacks throughout *Dragons Cry*, as is Barbados where two of the central characters grew up, the text is permeated by loss and elegy, as the epigraph underscores:

> Until this day, nobody has seen the trekking birds take their way toward such warmer spheres as do not exist, or the rivers break their course through rocks and plains to run into an ocean which is not to be found. For God does not create a longing or a hope without having a fulfilling reality ready for them. But our longing is our pledge, and *blessed are the homesick, for they shall come home*. (Isak Dinesen, *Anecdotes of Destiny*, emphasis added)

While Gerald becomes a missing presence in Daphne's mapping of her identity and his diaries provide a scaffolding for the entire narrative, *Dragons Cry* is haunted by the absent David, who has committed suicide. The novel takes place during a few hours following his funeral in Toronto, though the narrative weaves together many times and places through memory and polyphony—primarily via the consciousnesses of Simon, David's younger brother, and his wife Faye. This couple is estranged, due to Faye's having slept with David and become pregnant (after having tried obsessively and unsuccessfully to have a child with both her former boyfriend and with Simon), though she later suffered a miscarriage. As Faye thinks, "David has left his body, but not hers. He's churning up his own story, and tonight they're tossing in its wake" (145). The last time Simon saw his brother alive, David gave him a gift—an antique compass etched with the four directions, N.S.E.W., "all possible paths" (183). Now, as Faye and Simon awkwardly inhabit the shared space of their apartment and take turns selecting music to fill the emptiness, the "compass points Simon back to the cemetery, to David's coffin" (188). This narrative exhumes the past, a counter move to the ritual burial of the diaries performed by Daphne in the previous novel; in that process of excavation, *Dragons Cry* moves closer to the Caribbean, though refusing to return to those roots in present time, making that journey only in Simon's memories of Guyana and (especially) Barbados.

If David's dead body serves as the focal point for the charting of these migrations, the scar on his face marks the center of that map. That he received the wound in Guyana, and that it became the catalyst for the family's relocation to Barbados, signals the complicated role of "home" in McWatt's vision of the Caribbean. In a Guyana "toddling toward independence" (25),

Edwin, the family patriarch, was district supervisor of agriculture, involved primarily in the breeding of cattle:

> Heterogeneity was the agenda of living systems: life was fed by all available energies. [. . . Edwin was a] participant in a great experiment of mongrelization. The infiltration of exotic breeds increased the likelihood of agricultural success; Guyana would become the force of the continent, he assured his clients. Edwin was a chef, scrambling up gametes, mixing blood, and concocting food for his country, with all the hope and anguish of a proud father. (25–26)

This "mongrelization" serves as a symbol not only of the cattle Edwin helps to breed through artificial insemination, but also of the mixedness of Guyanese—and Caribbean—identity. Just as Daphne's face is a composition in "white, yellow, and black," so are Edwin's children an image of the multiplicity of features that resulted from the "catastrophe" of colonialism and enslavement.[19] As the family's servant MacKenzie observes, the children have "[f]aces of chaos, not one of them resembling the other," their hair, skin, noses, and eyes seeming the product of more than two parents. "Like a box of assorted sweets, the multiformity was dazzling" (2). The descriptions of both cattle and children—Edwin's two sets of creations, in a sense—recall Glissant's exploration of Caribbeanness: "Linearity gets lost. The longed-for history and its nonfulfilment are knotted up in an inextricable tangle of relationships, alliances and progeny, whose principle is one of dizzying repetition" (*CD* 80).

While such a "pattern of fragmented Diversity" (*CD* 97) lends itself to creativity and challenges colonial ideologies, Glissant continually reminds us of the initial violence of Caribbean history, what Kamau Brathwaite refers to as the "catastrophe" at its heart.[20] That chaos resurfaces repeatedly in ensuing periods of both colonialism and independence. In *Dragons Cry*, Edwin's optimistic vision of "mongrelization" falls apart in the face of class divisions, racial rivalries, and political violence, evidenced in the government's appropriation of land from impoverished farmers, as well as in the opposition of Black and Indian embodied in the leading political parties. Witnessing the death of a man who apparently jumped in front of a truck, the young Simon understood that "the man had lost everything, had nothing to live for if he didn't have his land, and that deterioration was hobbling toward their country like the twisted leg of slavery" (29). The legacy of that system is the antagonism symbolized in broom and cup, one for a Black state, the other for an Indian one, and Edwin's family inevitably was drawn into the maelstrom caused by that internal division postindependence. Caught in traffic during a parade, the children joined the crowd around the demonstrators; as one man wielded a broom in a symbolic sweeping in of the Black party, one

of its straws wounded David so that "[his] cheek split open like a ripe peach" (31). This moment served as the catalyst sending the Carter family from home in Guyana to the island of Barbados; the scar formed on David's face thus locates him at the center of a catastrophic history. The scar also links him to Africa: "The China scar on his brother's cheek reminded Simon of the ritual symmetrical cuts on the faces of African men he had seen in the subway. Dark and round against the coffin-white satin, David's face was an incomplete mask, the echo of a lonely darkness. A sacrificial face" (32). The narrative strives to remove that mask, to see behind the (now dead) face born from and marked by Caribbeanness, and to cure homesickness through creative mappings of the body. The blood-soaked straw that Edwin preserved becomes a signpost in that process of cartography, "the straw that had driven [the father] out of his native country" (68).

Guyana in the aftermath of independence represents the abandoned site of radical experimentation and thwarted hopes, but from the opening paragraphs, Barbados more closely symbolizes the lost home. It is an imperfect homesite, made manifest in a scene Simon recalls as he watches David's burial, a moment when he accidentally broke a vase while practicing cricket: "Placed [at the entrance to the house] four years earlier in an unribboned moment of welcome to the island by his mother's cousins, the vase and its future as heirloom were shattered. Mackenzie picked up a slice of the porcelain on which a fair, dainty woman in bonnet and flowing dress dipped her ruffled turquoise parasol as she stepped up to a waiting carriage" (1). Illustrating the racialized and gendered aspects of colonialism, as well as its class stratifications, this ironic welcome loses its anticipated value in the further irony of Simon's wielding of the cricket bat.[21] The cracked vase that cannot serve as familial treasure becomes a symbol instead of disinheritance, just as the family itself does not reflect the supposed Britishness of Barbados but rather manifests the complicated genealogies of the Caribbean.

Nevertheless, this island became home, in particular to the younger generation. For David, music stands in clear contrast to the porcelain of both the broken vase and the female figure painted on its surface.

> Music had immigrated to Barbados in the same way as had the Carter family. Calypso from Trinidad, reggae from Jamaica, and soul music from Motown. Simon's family, via David, consumed it all. The music they listened to was "black"—black people's music. David would bring home albums and style himself after the men shown on the covers, wearing an unwilling Afro and calling himself "black" even before everyone else was told they weren't "colored" anymore. (16)

Failing his exams and thus shattering his father's expectations that he would journey to England to receive an education, David instead left for New York to

become a professional musician. "Music would set him free and he would reciprocate—composing, arranging, and recording a hybrid of Motown, rhythm and blues, reggae, and calypso. Only now does Simon understand the ingenuity of these ideas and how David was decades ahead of his time" (60). The syncretism inherent in David's music echoes the promise held out initially in Guyana, of a novel experiment, its potential rooted in heterogeneity. Driven from the homespace by the violence of divisions originating in the plantation system and slavery, David's body becomes the traveling sign of repeated attempts to shape a unique, syncretic identity. Rejecting an education that would replicate British colonialism, imagining New York as the place that would free his creative energy, David left Barbados with his father's parting gift of the straw stained with his blood and a note saying *"Some journeys are like anchors, inviting you to sink"* (68, original italics).

Significantly, David is the darkest of the four Carter children, and the one to have first claimed "blackness" in both his music and his self-styling.[22] While his mixedness has in a sense offered him an anchor in the Caribbean, that grounding may shift into imprisonment if he does not overcome the "inferiority complex bred in the bone" that he has tried to escape (181). In the US, he will encounter the unexpected binary of the color line: "Arriving in America had felt like arriving at an accident, he said to Simon. It was like happening upon a tragedy of life, not knowing what had caused it or how anything would ever be the same again" (181). How could he maintain his island self and the music he was creating, in the face of that sharp border between white and Black that left no room for his brownness? Significantly, the only aspect of Barbados that David did not find too "small" in his desire for freedom was the ocean surrounding the island. Ultimately, for reasons that the text suggests but does not directly state, David proves unable to navigate the waters where the Middle Passage and subsequent migrations have traced paths of trauma and loss. His failure suggests that, as Rinaldo Walcott argues, we need to develop strategies that place "blackness outside of national boundaries and [. . .] theorize blackness as an interstitial space" (31). David has not found ways to implement broader notions of Blackness, in the face of cultural patterns that enforce not only racial but also national boundaries. The younger Simon, in contrast, takes on the responsibility of charting these complex territories, mapping the body and exploring the nature of relation formed in salt and water.

While McWatt employs music as a heuristic device to guide the narrative, characterize the protagonists, and track their shifting relationships, she also structures the novel with chapters that alternate between "Salt" and "Water," concluding with a final section titled "Tears." An elegiac note echoes throughout Simon's interior monologues, especially as he considers the qualities of salt: *"The concentration of salt in a tear is higher than in the ocean. The stain is*

deeper" (4, original italics); "*Water dissolves an old form either to create a new form or annihilate it. Salt is an unknown and invisible body, like a spirit that sustains the thing which it permeates*" (50, original italics). Fascinated by the properties of salt, as well as by its history, production, and commodification, Simon pursued that interest in his study of geology at university in Canada.[23] He has become the geographer who works with maps, the compass thus a fitting gift from his now-deceased brother.

David both literally and symbolically lost his way, his final employment as prison guard suggesting the psychic and emotional shackles that became the weight sinking him. Simon, on the other hand, has found a rootedness in change, as expressed in his work as cartographer: "Simon's job involves cross-referencing new maps with their immediate predecessor, the careful monitoring of changing topography. [. . .] Simon finds the process prismatic, with each frame of change on a map refracting whole ways of living we can no longer imagine" (9). This approach to change is salutary, McWatt suggests, working counter to the inclination to cling to a familiar map or to hold to rigid categories. As Simon further observes, "Flat representations of the earth's surface with landscape features described by symbols, all maps are generalizations. A map cannot portray reality: detail is lost at the reduced scale. *I long for release from simplification, smoothing, displacement, and classification*" (73, original italics). The relations bodied forth in Simon and his siblings contest categorization or identity dictated by simple binarisms.[24] And the mapping of bodies in *Dragons Cry* resists nostalgia for home as it dismantles fantasies of a preserved homeland and sheltering past. Instead, there is the ever-present "gene for shipwreckedness found only in those surrounded entirely by water," both hopeful and forlorn (141).

Heredity and genetics permeate this narrative, and ceaselessly circle back to a center—the island in the sea. Simon has made that return migration both physically to Barbados and now in his memories of that lost home, symbolized most vividly in the pelicans he observed on numerous occasions, their numbers gradually dwindling into complete absence. The text encourages a recognition that nostalgia is blinding and that one must make a home in the body itself. "During the months Simon spent on Barbados trying to imagine a place for himself there, he starts to feel himself slipping *out of his skin*, as though the space between bone and flesh had widened with nothing to fill it up. Home had become a hollow, echoing word. He went back one last time to Ragged Point to look for the pelicans, but still nothing" (152, emphasis added). Then, bathing in Atlantic waters near Pico Tenerife, he "looked out to sea, lost himself in the surf whose only previous land obstacle had been Africa. His skin felt tighter: salt and belonging" (153). This passage emphasizes the complicated relationship between body and place, the ocean of salt water itself offering perhaps the most solid

location and most permanent space of belonging. With that center to fill his skin, Simon is also able to create new Relation, as well as to remember and to forgive.

In its final pages, the text returns to its multiple beginnings, in the straw, in the suicide, and in the fractured love between Faye and Simon. As hinted at in the conclusion to *Out of My Skin*, when Daphne arrives at the market seeking Michel, relation between individuals may repair the damages of a history rooted in catastrophe. Excavating the past—of family, of nation, and of the Caribbean—is salutary, but is not the end in itself. Rather, the concluding scene stresses the need for forgiveness and for connection in the present. Faye has taken custody of David's suicide note to Simon and opens it to find the straw, "fat reed from a broom," and a note that reads,

> A journey is possible
> only if you remember what you've left.
> Forgive me.
> I love you,
> David. (192)

As Daphne's narrative concludes with her arrival at the market reaching for Michel, *Dragons Cry* ends with Simon and Faye extending hands towards each other instead of for the bloody straw, taking tentative steps of reconciliation. In the background, "Mercy, mercy me" plays on the stereo and Faye silently thinks "*A child*" (195, original italics) as she moves closer to Simon's touch. The text offers the hope of a child but stops short of making that desire material. Rather, in its evocation of the violence surrounding independence in Guyana, in the losses suffered by the characters in migration, and in the gaps between the central couple at the end, *Dragons Cry* would seem to negate the vision of presentness as healing offered in the previous novel. Some wounds may not heal, as some relations may not suffice to counter the catastrophic effects of Caribbean history.

III.

McWatt's subsequent novel, *This Body*, also follows migrations, explores Relation, and negotiates multiple borders—of age, nationality, ethnicity, language, culture, geographical location, as well as of narrative form (myth, folk tale, computer games, websites, letters). This text completes the triptych, as McWatt continues to navigate between the Caribbean and Canada, while adding England and Africa to the cartography: multiple sites of displacement, relocation, and embodiment. In this novel, for the first time in her fiction, characters journey back to the Caribbean, including to Guyana, not only in memory but

also in present time. Both Simon and Daphne seem poised at the conclusion of their respective stories to deepen relation instead of longing endlessly for reconnection to missing (genetic) family. Though McWatt does not underscore racial difference, both Michel and Faye can be identified as "white" or Euro-Canadian, so that both narratives suggest the possibility of relation that contributes to mixedness. In *This Body*, both Victoria and her young nephew Derek gradually come to terms with violent loss, to shape a concept of self and relation based not in genealogy but in "this body" and its shifting locations, its unexpected opportunities for engagement with others. As in the previous novels, the dead also haunt this text: Victoria's lover Kola, shot to death in London; her sister Gwen (Derek's mother) and their mother, killed in a car accident in Guyana. There is a movement, however, from the violence and madness wrought by colonialism, to an awareness that diasporic identities open up new possibilities and allow one to imagine and invent, as well as requiring a solid grounding in the body itself—and in the capacity to love.

Choice informs this narrative in ways that the two previous ones precluded, specifically in the decision to emigrate from Guyana. Victoria's flight signals an interconnection between nation and Relation, between public and private systems born of colonialism and heteronormativity. The trope of tomatoes comes to signify her father's illicit sexual liaisons that resulted in a series of half-siblings. Eroticism and secrecy were thus intertwined in a discomfiting stew as Victoria grew up and watched the women her father slept with bear "wild boys" and her mother deny their paternity.

> When Victoria left, she wanted only the truth, or at least something bald-faced and blunt, not the amorphous deceit shrouding her family. The government was no better than her relations at truth, so Guyana was a place for leaving. [. . .] Politics created a society of two warring factions—Indian and black; her mixed family *fell between the cracks*. Public Guyana went on around them, while its more intimate dramas took place right in their garden. As soon as she was old enough, Victoria joined countless others in the slow haemorrhage of the once most prosperous British colony of the Caribbean. (21, emphasis added)

Victoria rejects versions of relation that she finds confusing, deceitful, and destructive, and seeks to locate herself in a space that allows for and respects her mixedness. Guyana comes to represent the ways that borders and divisions—the classifications that Simon aims to erase from his maps—lead to violence and ruin. The challenge is to shape a creative and peaceful union from a heterogeneous population: "the country had been created, ruled, and then set free by the British, leaving behind an ethnic soup of people, trying

to find common ground upon which to be governed. [...] As she told these stories, Victoria would see herself as a doll inside a doll inside a doll of all the people in her family and where they came from, where they went" (31). Guyana thus stands at the center of multiple diasporas, which Victoria carries with her as she journeys to Barbados, to Toronto, to London, and in reverse passages back to the Caribbean to confront ghosts and arrive at "this body."

The absent again form a substantial presence in this narrative, most forcefully for the young boy who has lost his mother and grandmother in a car crash, has been sent from Guyana to live with his aunt in London, and has no knowledge of his father. Derek was conceived through artificial insemination (one of the many procedures undergone unsuccessfully by Faye in *Dragons Cry*), and for a while he seeks to identify the sperm that contributed to his genealogy. Victoria ponders his unknown roots: "Where on earth did he come from? [...] How could a mere collision of gametes be enough to thicken a bloodline and have it burst like an artery—a child from nowhere, no one's family, no one's sad copulation?" (20). He also misses his dead mother and re-members her in the tales of King Arthur and Guinevere that he finds on a "Camelot" website. Derek is a child of invention, not only in his origins but also in his creative imagination throughout the novel. He devours tales of wizards and magic, then begins to write his own narratives and to incorporate into them multiple versions of his parentage. This process offers alternatives to an obsessive quest for roots and genealogy, instead emphasizing the power of invention to shape Relation and to birth versions of the self. McWatt explores ways to move beyond the conventional image of the family tree and to offer new concepts of Relation while keeping the Caribbean at the center of those visions.

The (re)construction of Derek's lineage forms the core of his imaginative explorations in England—a place he fittingly calls "Inkland" (though most of his scripting takes place not with pen and paper but on a computer screen). He employs not only the virtual texts he finds on sites such as "Camelot" but also Guyanese tales his aunt tells of the mysterious spirits called Kanaima and stories his mother told him of a hero-revolutionary father: "She built a father for him the way a writer builds a character, borrowing fragments of fact from the lives of everyone she'd ever known, entwined with fancy and longing" (60).[25] Further, he secretly reads letters Victoria has stored in a trunk, missives from her dead lover Kola, as well as from her mother and sister. From this mixture of narratives, Derek attempts to fashion a paternity that can give him a history and an identity: unlike Daphne, he thus has a freedom to choose, the ability to select and to retell differently. The most striking moment in this process arises out of a history lesson about the kings and queens of England:

> Trace one's lineage back far enough and it will, inevitably, merge with all the others.
>
> Derek is fascinated by this fact, imagining that everyone in his class is on a branch of the same huge tree—did Mr. Shaw call it a *peditree*?—which links all ancestors: William the Conqueror, Tutankhamen, Confucius. The whole western world is somehow linked to the Emperor Nero, and couldn't it be possible then that if King Arthur did exist [. . .] that Derek is his heir? (101, original italics)

In this version of bloodlines—the sprawling "peditree" that Derek envisions—lineage essentially becomes irrelevant as all merge eventually in the past and anyone he chooses could be his father.

Though he will be sidetracked by a friend into seeking information online about sperm banks and longing to locate the specific one in Miami that furnished the "seed" that led to his conception, Derek ultimately understands that he has much more power in his own hands: "He wishes his mother had told him the secret, but without knowing it he's growing resigned to the fact that *loss is the father of his imagination*. Everything changes. To keep changing: that's perfection" (303, emphasis added). In such lines, we hear a version of the "tidalectics" formulated by Kamau Brathwaite as a means to understanding Caribbeanness.[26] Derek's embrace of loss as the means to self-creation, and of change as continuity and "perfection," resembles the shifting movements of tides on the shore and takes him beyond a dialectics of presence/absence synthesized into self-sameness. In Guyana, where Victoria takes Derek when she realizes how deeply he desires to know his origins, she explains to him the way that humans make things up: stories nurture belief and ease fears. "Maybe we're made up of all the water in the place we're born," she tells him, "like somewhere to go" (302). Then in Barbados, the last stop before their return to London, Derek floats in the sea and contemplates water and maps:

> He likes Kola's idea [from one of the letters to Victoria] of putting countries where you'd prefer them rather than where they appear on a map. He would put Guyana and England side by side, somewhere near this island of Barbados, so that he could have all three. *And have this sea.* He's not sure where he'd put Miami, but it's not far from here, so he might just keep that connection across the water. [. . .] Fathers matter for their secrets. (306–7, emphasis added)

This mapping of the body allows for multiple locations as well as self-invention, and echoes Simon's desire to create new maps that resist classification and rigidity: cartographies of disidentification, perhaps. Genetics matter far less,

McWatt suggests, than what one does with this body in the spaces that it presently occupies and the relations that it selects and pursues.

While Derek represents the self in early stages of such discoveries, Victoria in her sixties has mapped journeys across islands and continents and has accumulated memories that deeply mark both body and psyche. For her, embodiment means death and grief, as well as the need for both food and sex. Her work as chef provides a leitmotif that illuminates these truths of the body—eroticism, nourishment, love, loss, and death. The huge outdoor Dalston Market in London serves as a key location in this geography (as markets also figure in *Out of My Skin* and *Dragons Cry*), not only source of the panoply of goods that become meals for her and her new (British) lover Alexander, but also site of a sudden bombing that she and Derek witness. The market is described in terms that echo the vision of Guyana as an "ethnic stew" and Victoria's family (like Simon's) as a vision of mixedness: "Here humanity is as mixed up as stew," she thinks (107). As it did in Stabroek Market in Georgetown where the broom straw scarred David's face, violence erupts in this London market over clashing ideologies. Victoria's thoughts redefine the phrase "flesh and blood," from kinship with biological family to the concrete specificity of "this body": "Flesh and blood. Of all the feelings that have stayed with her since the explosion in Dalston Market, it has been this one, of the simultaneous fragility and certainty of flesh and blood" (138). The borders born of hierarchical categories of "difference" (the Human/other dichotomy as theorized by Sylvia Wynter) would cut across and through that body and leave it in fragments, much as the bomb blows apart the market and leaves behind wounded bodies and twisted wreckage. In this explosion, we see an instance of what Huggan terms "mapbreaking" and then of "the reconstitutive activity of mapmaking" (19). Combined with Derek's pressing desire to find his father, the bomb provides the catalyst that sends Victoria home to Guyana—the step not taken by either Daphne or Simon, the movement that helps to complete McWatt's triptych mapping the diasporic Caribbean body.

Placement plays as large a role as does displacement in each of McWatt's narratives; while clearly rooting characters in the legacies of colonialism and enslavement, her novels also offer an argument for locating the self in present time and space, as well as for claiming a mixed identity and finding multiple home-spaces. In that process, the presumed "center" itself becomes dislocated and borderlines bleed into the spaces around them. *This Body* begins with Victoria Layne contemplating the Albert Memorial in London, supposedly a monument to grief. As she superimposes the loss of her African lover Kola onto this image of royal pain and sorrow, Victoria realizes that the memorial is actually a depiction of Queen Victoria's empire and of the physical desire between her and her prince consort: "Lower down, guarding

each of the four corners of the prince's coquettish boudoir, are symbols of his lady's empire, depictions in marble of all that desire can conquer. [. . .] Sculpted before her are fragments of the entire world captured in lust. [. . .] No, this has nothing to do with grief. This is a monument to sex" (4). Recognizing the personal elements embedded in a monument to imperialism does not, however, erase the damaging effects of that hegemonic system. As Guyana-born Victoria replaces the queen whose name she shares, Albert fades into the shadows, displaced in the narrative by "the Bluebird of Piccadilly," "a big, black Caribbean lady, like Victoria's great-grandmother" (9). The Caribbean and Africa thus permeate the London that Victoria inhabits, rendering monuments and empire two-dimensional, shifting the boundaries and resisting familiar cartographies.

Throughout *This Body*, Guyana, Barbados, and Toronto seep into the present-moment experiences of Victoria in London. The migrations she traces are thus firmly located in specific sites, yet also have a quality of aquacity: "Maps are useless where you are going, because the territory ahead is constantly shifting. You might as well try to map flowing water" (226). One recalls Simon's desire for maps that are not bound by categories and classifications, as well as Daphne's claiming of all the parts of her heritage—beyond hybridity to a more complex understanding of Relation and identity. For Victoria, Barbados stands in memory as the place where she has felt most alive: "a moment in Barbados, after she'd left home, when she climbed the cliff at Pico Tenerife and stood staring out over the Atlantic. The pounding of the waves on rock was persistent and almost measured, like a pulse. This was not silence, which implies absence; it was its opposite. The peace she felt came from the sense that nothing was missing" (79). And she still has that country mapped in memory almost forty-five years after she arrived there the first time, fleeing Guyana and the corrupt kinship that it represented to her. The image of her father with multiple women "in the tomatoes" that haunted her childhood and adolescence presented relation as that to be escaped. "What did fathers bring? Children. More and more children, through women's splayed-open legs" (284). The cliff site in Barbados stands as a counterpoint to the bonds of home, while also affording a centering of the self in the sea.

Nevertheless, Victoria makes the journey back to Guyana, a necessary homecoming in this third narrative of the triptych. "Here she would gather herself the way she might the stretched-out waistline of a garment—by drawing a string that would ruffle and pucker delicately. She needs to fit herself again" (283). That process involves a return to the now-decaying house in which she grew up, where she performs a ritual cleansing, sweeping and dusting, and clearing the overgrown garden. Victoria also comes face to face with the women who stayed behind and their offspring, such as Gerty's daughter, who may be related to her.

Gerty's daughter bears a vague resemblance to the Bluebird of Piccadilly. What's more, it could easily have been Victoria here, in Gerty's daughter's place, still in Guyana with a brood of children to look after and not a lone traveler on a quest for fairness in London. So, here they all are. These women, like an opening, peeling, double-helix strand in replication. All of them born with the fury, the searching, and the awe in the presence of tiny moments that erupt like a sprout. These belong to the look of no one woman in particular. Perhaps this is as related as one gets. (298)

Through her return to Guyana, Victoria finds a model of kinship that replaces paternity with relationships among women—not an idealized vision of female connectedness and bonding, but instead the image of replicating DNA shared by women of different classes and colors who bear little else in common.

Landscape reflects embodiment in the final stage of Victoria's migrations, back in Barbados before the return flight to London. To reach the center of peace that Pico Tenerife represents, Victoria and Derek cross a hybrid site, a field that recalls England even as it is marked a Caribbean space:

> The pasture is distinctly literary, as though written into the island by an early visitor longing for something to resemble home in this strange territory. [...] Victoria doesn't remember this landscape at all, and feels she could be back in the English countryside with its traces of Roman wall running like a hot spring under a new civilization. She realizes that the walls are remnants of dwellings that were likely slave huts or shelters for freed slaves waiting here on the windy cost for boats to take them ... back. But there are also traces of a low wall marking a farmer's pasture. (312)

This scene offers a double interpretation of the landscape-as-text, gesturing towards both Africa and England, reading layers of several civilizations in the traces of walls, reminding us again of the interconnectedness of those origins as it blurs borders between them.[27] After she has slipped while climbing the peak and Derek has gone for help, Victoria sits alone high above the Atlantic: "She knows, deep down, that this is as much as we have: this body, this air" (319). Her thoughts echo those of Simon as he stood on the nearby coast of Barbados, looking outward: "As her eyes scan the horizon, she realizes that from here there is no landmass until Africa" (319). She also knows that this is not Africa, however.

The text, like McWatt's previous two novels, does not express a nostalgic longing for a lost homeland before the catastrophe of modern history. Instead, Victoria embraces what resides in "this body" in the present moment. As she

waits patiently, her body becomes a "connecting sparkle, creating the whole picture for an observer lying on his back, pointing up, drawing out meaning between Georgetown, Toronto, London, and this rock. [...] There's still time yet for this body, she thinks. Before it calcifies with the wash of salt air" (320–21). Like the narrative itself, she represents diasporic experience that is less about exile than about finding a center—in the Caribbean as in "this body"—to connect the multiple identities and (re)shape a self to contain them.[28] The novel concludes with a projection into the future for both Victoria and her nephew, ending with Derek at the edge of the Thames shortly before he will begin university in London: "he is infused with an inkling he will carry with him his whole life: an itching, sparking, igniting sensation that being born means I have this body, and that dying means, simply, that I leave this body, and there's more" (325).

CODA: *THERE'S NO PLACE LIKE . . .*

In the same year that she published *This Body*, Tessa McWatt also published a book for young adults, a narrative loosely based on *The Wizard of Oz*, which follows the global travels of a young woman named Beatrice. Unlike the characters in the first three novels, Bea has not migrated but instead commences her journey from her home in Georgetown, Guyana, and sends letters, postcards, and email messages to family and friends there. In *There's No Place Like . . .* , the ellipsis of the title allows for multiple sites to become "home" to the young Beatrice—in a text that McWatt wrote partly as the narrative to which she did not have access growing up.[29] The fantasy-like journey of the protagonist serves to explore "roots" and claim her mixed heritage, indeed her Caribbeanness, and to embrace all facets of her self—Scottish, Chinese, Indian, African. Each of the characters whom she meets in these locations is male, a gender twist suggesting that none is a mirror reflection but instead part of a larger vision of Relation. The "lessons" of each chapter have a didactic note and the text's final message sounds a utopian chord; nevertheless, this narrative extends the author's developing ethos of self and other as connected and related. It thus serves as a fitting coda to the triptych, in the movement from "nowarian" to "Know/Where" and "NowHere."

The young protagonist performs the answers to a question Michel asks Daphne during one of their first meetings: not where is she from, but *where has she been*? While Daphne can only reply "here," as she has never left Canada, Beatrice will have been to sites around the globe, in her travels to Miami, Mexico City, London, Scotland, Paris, Cannes, Beijing, Nanjing, Shanghai, Hong Kong, Delhi, Gujarat, Kerala, Nairobi, and Accra, ending at the airport in Kenya where she commences her journey home to Guyana.

This vision is informed by a central paradox, in that Bea seeks the different, while finding herself at home in each new location: "She wanted a place so different from Guyana she would have no choice but to experience something fantastic" (47); "She knew that what she had learned on this trip was that she was at home everywhere. Everywhere she had been people had recognized her in some way" (121). This "cartography of difference" (to borrow Huggan's term) structures the story, for instance in Mexico, one of her first stops: "Some days I feel like I am in a carnival or circus, with halls of mirrors, tricks and shows going on around me. But I realize that perhaps I am being shown a giant collage of one big human family" (24). Bea experiences no "step, miss" or fissure as does Daphne, nor a rupture as do the characters in *Dragons Cry* and *This Body*, several of them torn from Guyana as children. Beatrice has enjoyed a childhood in Guyana marked neither by violence nor by death; in contrast to Daphne, her family's immediate past includes no displacement, no dislocation, no madness. On one level, *There's No Place Like* . . . thus functions as a fairy tale to counter the historical realities of the Middle Passage, colonialism, and enslavement, the trauma or wound at the center of the Atlantic World.

Yet Beatrice struggles with questions similar to those that preoccupy Daphne and McWatt's other protagonists: "Did blood have any real significance at all?" (57); "But Diary, who am I?" (60). Even as she feels a familial connection with those she encounters, experiences a sense of recognition, and on one hand asserts that backgrounds are superficial, she also discovers elements of her own ancestry that are invisible yet undeniable (such as the Scottish of her last name "Douglas"), and is confronted with virulent racism in the form of the familiar "what are you?" and "third world" slurs (88). In her journeys she meets both colonized and colonizers, and must recognize each as part of her heritage. Bea also learns that all began in Africa, and on the coast of Ghana she absorbs images of the slave trade: "One of the slaves who survived the crossing was related to me somehow. I'm not sure how, and I will never know. But I know that he or she was treated brutally. There is so much brutality in the way we've all treated each other, African and European alike. Everywhere" (125). Once again, McWatt employs the space of the outdoor market as a double signifier, both a complex and gorgeous stew, and a dangerous, volatile mixture. In the Belleville section of Paris, Bea is addressed as "daughter" by a woman who resembles those in Guyana: "It was odd to be recognized by someone from an entirely different culture. [. . .] What did it mean to look like you were something you weren't? Is that what being an actress would be like?" (51–52). Into this communal space, however, violence erupts as it did in Georgetown and also in London: "Suddenly a scuffle at the far end of the market was followed by gunshots. Then

a small explosion. [. . .] The cultural tension in the quarter had increased random violence, just as in Ireland. Each incident escalated the possibility of another" (57). McWatt thus complicates the utopian vision of harmony and peaceful mixedness with an acknowledgment of the explosive potential of difference—the market a logical site, where cultures become commodities, with class and ethnicity creating boundaries and inequities.

McWatt also interrogates the concept of hybridity, at least to an extent, specifically in the character Cynthia Buckley, an obnoxious, loud-mouthed American whom Bea encounters at nearly every stop along her journey. Cynthia is the character who personifies racism, as when she says to Bea (who wears red shoes acquired early in her travels), "And what are you, young lady?" and terms her "exotic" (70). The "wicked witch" of this tale of Oz, Cynthia is involved in bioengineering, working for a corporation that develops hybrid crops; she travels the globe in search of animals on which to experiment, even as she claims to be bringing prosperity to the "Third World." "No longer will there be hunger, because we are changing nature," she tells an audience of villagers in India (99). And in China, Cynthia invites Bea and her companions to dinner at a "special" restaurant that serves only "engineered" plants and animals. "I never was so disgusted in my life," Bea relates. "I felt like I was in Frankenstein's workshop. This was not just genetic modification, this was a whole darker side of what Cynthia and her company thought they could achieve to make money" (75). Clearly a form of neocolonialism, this kind of "mixing" McWatt directly condemns as "evil," an artificial hybridity developed for purposes of profit and control. Cynthia has inherited this corruption from her father, who was investigated "in a scandal with pollution some years back," Bea is told, and it "seems his company was responsible for a terrible disaster" (100). Just as the imperial maps designated some space as empty and some as "mad" (Huggan 5), Cynthia imprisons Beatrice and her companions when they challenge her authority, setting free the hybrid creature that was to be the "salvation" of a starving "Third World." McWatt's critique of artificial hybridity and its implications in neocolonialism is illustrated most obviously in Cynthia's violent death, killed by the lion she had been hunting.

Nevertheless, the human mixing that has produced Beatrice is embraced in this text, as in McWatt's three previous novels. "When she thought of her own background and the long lineage of hybrid genes, she felt a bit of mix-up couldn't be all bad" (100). Bea will never know the African ancestor who made the Atlantic crossing in a slave ship, but she does meet Joash, a young African who (along with his mother, a village wisewoman) offers the authorial words that may guide Bea's future journeys. Some of his comments underscore the deleterious effects of colonialism as well as demythologizing

or deromanticizing simplistic concepts of relation: "He said that Africa could have been the most prosperous, most productive place on the planet if it hadn't been for the other countries that changed it, and for all the snags that come with kinship. Kinship, he said, meant that tribes kept to themselves and battled other tribes. Whoever you belonged to by blood you were bound to forever" (112). In this formulation of family, blood causes deadly strife and imprisoning bonds; kinship creates difference, which Joash's pronouncement syntactically parallels to the divisions and hierarchies that came with colonialism. To those divisive forces, his philosophy juxtaposes the individual like Beatrice who embodies links across bloodlines or kinship groups, and also across national boundaries. Thus, he tells Bea, "You are lucky. You belong everywhere" (112). This statement forms one of the core messages of this book: that one does not have to identify with a single ethnic, racial, or national group in order to belong.

The book asserts that love starts with the self, and that mixedness is to be embraced.[30] Beatrice has origins on all sides of the sea, with Africa at the core, Guyana as home. The text concludes with an email to her parents, in which performance in multiple media promises to connect the layers of time and place informing her identity: "I want to study art and filmmaking, and to one day make a film about Guyana that will tell my story. And not only that, I want to work with others to set up a place for other young people like me to meet and create stories and to learn to use cameras and equipment to make movies. I want all of our stories to be told" (132). That vision of creativity and aesthetic self-performance offers a syncretism beyond hybridity—a mapping of bodies in a shared and simultaneous manner that challenges divisions, bloodlines, kinship, and the legacies of the "catastrophe" of the Atlantic World. Harris states: "The paradox of cultural heterogeneity, or cross-cultural capacity, lies in the evolutionary thrust it restores to orders of the imagination, the ceaseless dialogue it inserts between hardened conventions and eclipsed or half-eclipsed otherness, within an intuitive self that moves endlessly into flexible patterns, arcs or bridges of community" (*The Womb of Space* xviii).[31] The self that emerges in McWatt's fiction resonates with Dionne Brand's evocation of "another place" in *No Language Is Neutral*: "In another place, not here, a woman might touch something between beauty and nowhere, back there and here" (34).

Beatrice's future filmmaking recalls the encounter Daphne had at the age of eight, when she escaped the Bairds' house late at night and found herself in the dark city park. There, she meets a destitute man stinking of urine, who tells her a story in an accent that her adoptive mother later identifies as most likely West Indian. The narrative about 'Nansi clearly originates in the Anancy stories of African oral culture, which migrated to the Americas

with the enslaved and form a core of Caribbean folk tales.[32] This man thus introduces Daphne to part of her cultural roots, just as his voice plants a seed of invention that will contribute to the maternal voice she hears during the present-time of the novel.[33] In the fantasy-utopian vision of *There's No Place Like . . .* , Beatrice imagines a future space in which young people in the Caribbean will have access to the stories and the accents, as well as to the means to make real their visions and to pass on the tales. Like the tricky spider Anancy, they hold the potential to fashion stories that resist the contours of colonial cartography.

This vision resonates with the ways that both Daphne and Victoria have mapped their bodies by the end of their respective narratives, and also echoes the words that Surefoot offers to Daphne in her odyssey of self-invention. McWatt's narratives participate in the "resiting" that Huggan observes in contemporary Canadian and Australian literary mapping: "In this resiting, the map no longer features as a visual paradigm for the ontological anxiety arising from frustrated attempts to define a national culture. The map operates instead as a locus of 'productive dissimilarity': productive in the sense that the provisional connections of cartography enact a process of perceptual transformation" (152). Joash's mother, Wambui, contributes her own wisdom, which he translates for Daphne as follows: "The road you take to yourself has no beginning, no end, and no map has ever been made for it. But it is the only road to take" (130). This advice also resonates with Daphne's trek through the forest after she performs the burial ceremony for the diaries: "She headed in one direction, then instinct told her that it wasn't right. So she turned another way, circling back around the red spruce. Again, not right. Then, on the other side of the mound of dirt, she spotted what appeared to be a soft print outlined in the moss, leading into the next grove. Her own she thought" (205). That road takes Daphne out of the woods, back to Montreal, and to Michel at the Marché Jean Talon. For Beatrice, the road she travels leads both to her self and to Guyana, to a creative claiming of identity.

McWatt offers her own exploration of the question "what are you?" in her recent anatomy-of-self, *Shame on Me: An Anatomy of Race and Belonging* (2019), a story of her body as crossing. This text provides a counterpoint to the novels, circling back to the question that Daphne confronts in *Out of My Skin* and answering it via an in-depth discussion of ancestors, colonialism, bone and blood, skin and hair, capitalism and racialized identities, all written on the body. She imagines the plantation where her multiple ancestors crossed paths: the Chinese woman, the Indian woman transported through the *kala pani*, the Arawak woman indigenous to what became Guyana, the Portuguese woman who migrated to the colony, the French ancestor who most likely was Jewish, the African great-great grandmother, the Scottish great-great-great grandmother.

Invoking the words of Lorde, Baldwin, Brand, and others who inform this study of Caribbean women writers, McWatt arrives at a vision of how to dismantle plantation logic: "Race is the story of the self told by a stranger, with 'white' as the primordial narrator. If we disable that narrator, new stories based on true identity rather than identification become possible. But what is a true identity? The plantation divides by its very nature. To resist that division is to maintain hope in discovering a true self" (219). She connects the women she imagines working the plantation's soil with poets who have inspired and guided her. Rejecting the feeling of not-belonging embedded in and by the question "what are you?" and seeking a place beyond the plantation, she states: "I desire a new language of belonging. A *who-are-you* space to gather in with others, rather than the biological 'what' am I" (233). Seeking to be part of a "sea change" (230), McWatt pulls the sides of the sea together, shifting the geographies shaped and maintained by plantation logic, imagining Relation as revolutionary.

Chapter 6

CARIBBEAN BOUNDARY CROSSINGS

Undoing the Violence of Borders in Santos-Febres and Lara

I.

Mayra Santos-Febres and Ana-Maurine Lara explore the Caribbean Atlantic in narratives that both illustrate and challenge the violence born of borders, whether those of nation, of race/ethnicity, of class, of gender and sexuality, of faith, of language. In *Sirena Selena* and *Erzulie's Skirt*, respectively, Santos-Febres and Lara employ the figures of La Sirena, La Mar, and Erzulie to invoke multiple passages across the waters, beginning with the Middle Passage and continuing through contemporary travel into, out of, and especially within the geographical and cultural spaces termed "Caribbean." As they follow the paths traced by traveling subjects, the texts also engage with questions of citizenship and challenge what Walter Mignolo terms the "myth of global citizenship": "Citizens, foreigners, and passports are part of the short history of the same package that constructed an imperial idea of the 'human' and traced the frontiers with 'the less human' and the 'non-humans.' [. . .] 'Citizens' is the frame that allowed for the definition of the 'foreign,' which was the translation, in secular terms, of Christianity's 'Pagans' and 'Gentiles.'" (314). Exposing and disrupting binarisms, both texts demonstrate the damage wrought by adherence to prescribed boundaries, illustrate the subversive potential of nonnormative identities, and suggest the healing that such affiliations can initiate in a queer undoing of borders. Nevertheless, the ways in which the two texts engage these questions differ, as does their incorporation (or lack thereof) of

historical context, traces of Africa, issues of race, and the presence of the sea itself. A further, crucial difference is that while Santos-Febres explores the lives of transgender and transsexual characters who begin life as male, Lara's protagonists are two women who become life partners. The challenges the two sets of characters face and concomitantly pose within and to borders in their respective contexts raise questions that this chapter explores. How fluid is gender in each text? In what ways do transgressive sexualities meaningfully disrupt the norms? To what extent do queer identities undo boundaries informed by colonization and reinforced by neocolonial systems?

This chapter revisits the hauntologies of oceanic ossuaries and of the Middle Passage, analyzing texts from the Hispanophone Caribbean that invite different readings of concepts of tidalectics (Brathwaite), repeating islands (Benítez-Rojo), and Relation (Glissant).[1] In a discussion of "hauntologies of form," Vilashini Cooppan argues that "[l]ike capital, genre and race are shown to be 'spectral,' in Jacques Derrida's sense of entities that resist straightforward narratives of progression and presence" (71). Weaving race and genre into world literary history, Cooppan concludes as follows: "The past ghosts the present, the invisible ghosts the visible, the unknown ghosts the known, what is to come ghosts what is and what has already been" (82).[2] Cooppan explains Derrida's theory of hauntology as "the trace discourse of the temporal that 'belongs to the structure of every hegemony,' simultaneously preceding, succeeding, and exceeding each point in which power finds its *telos*" (74). In this study, I continually return to the depths of the sea, to the history that "ghosts" the present even as it has shaped the world systems operative in both Santos-Febres's and Lara's novels. As Elizabeth DeLoughrey reminds us, "while water may ebb and flow, or connote borderlessness, it is still patrolled by economic and military powers that claim their own type of territorialization" ("Routes and Roots" 164). That patrolling by neoimperialist forces compounds the challenges faced by the *travestis* in *Sirena Selena* and Miriam and Micaela in *Erzulie's Skirt*. As DeLoughrey concludes: "An engagement with the roots of routes, a 'tidal dialectic,' is necessary in order to understand the process by which 'peoples of the sea' navigate cultural and national sovereignty" (173). In tracing paths taken by those who embrace transgressive sexualities in the spaces of and between the Dominican Republic, Puerto Rico, and the US, we can delve once again into the "roots of routes" and explore the possibilities for resistance to violence and domination.

Édouard Glissant continues to inspire and guide engagement with Caribbean history, literature, and culture. Both his concept of Relation and the metaphor of the spiral inform this study, as does his focus on the sea, the submarine, and "intermixing" (Corio 924). In a discussion of the biopolitics of literature in Glissant's poetics, Alessandro Corio states: "Contrary to Western historicism—from which Glissant often distanced himself—the entry of the peoples of

the African diaspora into history is a violent irruption, followed by an equally violent oblivion that has rendered any attempt at a return to origins fleeting" (919). What Glissant theorizes as the Abyss, starting in *Caribbean Discourse* and continuing throughout his oeuvre, expresses this combination of irruption and oblivion centered in the Caribbean Atlantic. Relation emerges from this abyss (as discussed in chapters 1 and 2), as does Glissant's concept of opacity.

The latter is especially relevant in examining the borders of gender and sexuality that Selena, Miriam, Micaela, and other characters in these two novels encounter and attempt to cross or even erase. As Corio explains, "Glissant contrasts the metaphor of the *darkness* of falsity and ignorance [. . .] with the fertility of *opacity*—which is what allows us to enter into relation, to mutually change and exchange with one another. What is usually represented as an obstacle in the classical gnoseological path [. . .] becomes a freedom to choose *not* to conform to a norm or a pre-established hierarchy of values and criteria of truth" (924, original emphasis). Corio cites Glissant's essay "Rien n'est vrai, tout est vivant": "'Opacity benefits us when we are brought to a halt by darkness. We grow in opacity: it is the freedom of the living." He continues: "Opacity, together with detour, is also a tactic of escape from the devices—not only discursive—that facilitate the grip of biopower on bodies and lives, thus both concepts contribute to the poetic and political production of an 'affirmative biopolitics'" (924). *Sirena Selena* and *Erzulie's Skirt* engage with forms of opacity, for instance in Selena's performances or in ceremonies in which Lara's characters are "mounted" by the *luases* or gods. Bodies that are oppressed and exploited may find freedom through opacity as the subjects choose nonconformity *and* Relation. A persistent question concerns the efficacy and lasting success of such passages.

In a similar vein, Beatriz Llenín-Figueroa posits questions raised by Glissant, as follows: "*How do we mobilize the Caribbean Sea's historical and metaphorical trace as a means to freedom in a present in which the ships that populate our ports are either cruise ships or cargo ships, yachts of the rich and famous, or yolas of the poor and infamous?*" (93, original italics). Her assessment signals the continuing necessity of Glissant's poetics and theorizing: "Glissant's work provides a compelling, urgent answer-challenge to this question and the earlier question of how the coast is experienced from within. Because we have not met this challenge in our Caribbean archipelagic societies, we have yet to inhabit a post-Glissant moment" (93). The coastal experience is one of frontiers and tidalectics. Glissant conceives of frontiers "becoming places of agreement and exchange. The world is inextricably interconnected, but we are learning more and more how to live with this and conceptualize it" ("In Praise of the Different" 858). The Abyss has not disappeared, nor has a gap been filled in. Rather, "Relation recognizes no frontier, in either space or time, and yet we need frontiers. *But Relation is the fundamental frontier, which is open passage*" (858, emphasis added). As Gloria

Anzaldúa envisions a border that expands into a space of borderlands, of differences in relation in a shared space, the Caribbean Sea (or the Caribbean Atlantic in my formulation) provides a potential site of transformation.

> At some point, on our way to a new consciousness, we will have to leave the opposite bank, the split between the two mortal combatants somehow healed so that we are on both shores at once and, at once, see through serpent and eagle eyes. Or perhaps we will decide to disengage from the dominant culture, write it off as a lost cause, and cross the border into a wholly new and separate territory. (Anzaldúa 100–101)

Brathwaite's image of the archipelagic offers a comparable vision: "the frenetic convulsions of Brathwaite's archipelago are not constraining. They do not favor frozen or self-sufficient units or islands of meanings. Instead, these images facilitate the abolition of boundaries and redistribute meaning in terms of new conjunctions and oppositions" (Dash 193). Through their boundary-crossing characters, Santos-Febres and Lara suggest ways to mobilize the "trace," to inhabit and embrace the frontier, and to seek freedom within and between the spaces traversed by contemporary Caribbean subjects.

One might argue, though, that archipelagic thinking may run the risk of eliding important differences, for example between Anglophone, Francophone, and Spanish-speaking locations in the Caribbean, their histories inflected by specific colonizing nations, their status varying from independent nations, to "departments" or "protectorates," as well as their individual positions vis-à-vis the US as neocolonial power in the region. Salient distinctions between the Dominican Republic, Puerto Rico, and Haiti, for instance, as well as interrelations between them, and the long-term presence of the US in each, do affect the narratives and also may invite caution when applying a Barbadian or a Martinican poet/critic's theories to the texts.

Nevertheless, the concerns remain shared, as does the history: the Caribbean traces, Walcott's "the sea is history," the Middle Passage, slavery, the plantation, and various forms of globalization that arose during the Atlantic slave trade. In developing a theory of the "Caribbean essay," Florencia Bonfiglio turns to the triad of Glissant, Brathwaite, and Benítez-Rojo, citing relation and geography as guiding elements of the genre. Amalia Boyer coins the term "geoaesthetics" to characterize Glissant's poetics.[3] And in an analysis of Santos-Febres's novel, Jossianna Arroyo argues for a "transcaribeño," "ya que rompe con las definiciones tradicionales fijas de la nación 'puertorriqheña' o 'dominicana.'" She continues, discussing "fronteras porosas," "en las que coexisten contradicciones y exclusiones raciales, sexuales, de genero y de clase" (41). These "porous frontiers" create a culture of displacement that

is "*two-ways*" or circular (41, original italics). That both Santos-Febres and Lara evoke continual *movement* in their novels as well as invoking figures who arise from and embody the waters (La Sirena/La Sirène, Erzulie) opens the way for an analysis that draws upon Glissant and Brathwaite to explore boundary crossing and frontiers in the Hispanophone Caribbean. Furthermore, we can connect these texts to the others that "pull the sides of the sea together" in an exploration of the Caribbean Atlantic. Santos-Febres and Lara participate in this Caribbean Atlantic chorus of voices:

> The water continues to gaze calmly, as it has always enjoyed doing, at the light-speckled shorelines suddenly retreating beneath dusk's quiet step. Quite soon the moon, lumbering up over those hills in the east, will have something to say about all this. But for now, over all that glistening water and beneath it, gathered voices are rising. Rising as they call *Now*, as they call *Here*. As they utter, so softly, *Listen*. (Thomas Glave, Introduction to *Our Caribbean* 10, original italics)

II.

Santos-Febres's *Sirena Selena vestida de pena* (2000) explores the lives of transvestites, gay men, transsexuals, and transgender individuals who test the boundaries of conventional categories of masculine and feminine. The central characters travel between Puerto Rico and the Dominican Republic, dreaming of New York City as magical destination and imagining an elsewhere unconfined by national borders. As Gloria Anzaldúa argues:

> Borders are set up to define the places that are safe and unsafe, to distinguish us from them. A borderland is a dividing line, a narrow strip along a steep edge. A borderland is a vague and undetermined place created by *the emotional residue of an unnatural boundary*. It is *in a constant state of transition*. The prohibited and forbidden are its inhabitants. *Los atravesados* live here: the squint-eyed, the perverse, the queer, the troublesome, the half-breed, the half-dead; in short, those who cross over, pass over, or go through the confines of the "normal." (25, emphasis added)

Anzaldúa's description of this borderland resembles the urban spaces inhabited by Sirena Selena in San Juan, Puerto Rico, as well as the sites Selena and her mentor Martha Divine visit in Santo Domingo, capital of the Dominican Republic.[4] A question the text raises is whether the border crossing—between

nations, between genders and sexualities—effects a real change or has a lasting impact on the neocolonial norms in each location.

The fifteen-year-old protagonist of Santos-Febres's novel subsists in a borderland in Puerto Rico's capital, homeless and destitute after his grandmother's passing and then the death of his surrogate mother, the transsexual prostitute Valentina. His only possessions, as an impoverished youth of color, are his astonishing singing voice and his beautiful body with an oversized penis. When solicited for sex by a wealthy white man, this young boy experiences violent assault and rape, a traumatizing attack that reminds him of his vulnerability and lack of power. In the aftermath, he is found and saved by Valentina, returns to the street, and demonstrates symptoms of PTSD: "When the car doors [of clients] closed, he didn't even see faces, he didn't want to know when the *señores* finished their business. He was far away, as if buried in a fog on the other side of something that had happened somewhere off in the distance" (69). His psychological state is one of disassociation and splitting, in the face of trauma. His goal is to survive and to make the money he needs to do so. His voice, as he sings boleros learned from his grandmother, becomes his defense against the pain and shame of selling his body: "His *abuela*, her trembling voice, her inert body carried off in the ambulance, she was bringing all the boleros to his breast, word for word, the perfect memory of their melodies" (69). Those songs—their haunting—become a different kind of capital: "He didn't even count the bills to make sure the amount was correct. His *abuela*'s boleros were all the wealth he needed to protect himself from nights on the street forever" (70). Nevertheless, he becomes an easy target—or object of attention—for the older Martha, who sees in his talent her own opportunity to profit and be able to complete her transition from male to female. She will ignite his desire to "cross over," to metamorphose into a beautiful young woman with the assistance of hidden bandages, feminine attire, makeup, and hairstyling.

The "siren" or Sirena appears in the epigraph to the narrative: "Coconut shell, melancholy and restless, from the gods you came, sweet Selena, succulent siren of the glistening beaches; confess, beneath the spotlight, *lunática*. You know the desires unleashed by urban nights." An ocean deity is both invoked and commodified, as well as sexualized, in the vision of Selena as a modern-day Venus on the half-shell, and a version of Erzulie or La Sirène. A number of critics, as well as Santos-Febres herself, have discussed the role of consumer culture and capitalism in the protagonist's construction and performances as a *travesti* or transvestite. Equally important to note is the difference between the original passage in Spanish and the English translation. The latter concludes the epigraph as follows: "You are who you are, Sirena Selena . . . and you emerge from your paper moon to sing the old songs of Lucy Favery, Sylvia Rexach, la Lupe, sybarite, dressed and adored by those who worship your face. . . ." (ellipsis

in original).⁵ In Spanish, the epigraph concludes: "vestida y adorada por los seguidores de tu rasto," which translates as "dressed and adored by those who follow your track/trail/scent, trace/sign" (my translation). In particular, the word *rasto* offers ways to read both Sirena Selena's haunting presence/absence throughout the novel and the ending in which she vanishes from the narrative.

Before that ambiguous disappearance, the protagonist journeys between Caribbean capitols, along the routes of capital and consumption. Above the Caribbean Sea, in an airplane flying from Puerto Rico to the Dominican Republic, the transsexual performer Martha and her new "son," Selena, experience a liminal safety: "hanging up there suspended in the sky didn't make her the least bit uncomfortable. [. . .] [B]ut takeoffs and landings always provoked anxiety in her. And there was no anxiety in this world that didn't prompt Martha to think about her body" (10). Several elements of this passage illuminate the paradoxical status of the two characters. Unlike the two women in Lara's novel (discussed later in this chapter), Martha and Selena can afford to travel by air instead of taking a precarious journey by *yola* and thus risking a likely death by drowning or sharks. Puerto Rico and the Dominican Republic are both similar and different: though Selena has barely survived on the streets of San Juan, yet she is mobile, able to cross borders and profit from the business opportunities available in Santo Domingo. "They were traveling on business, he and Martha. It's his first time flying in an airplane, his first *puddle jump*. The second will be to New York, he imagines. To try his luck there as who he really is" (3, emphasis added). Especially significant in the larger scope of this study is the fact that air travel avoids contact with the water: there is no mention of the Caribbean Sea and no evocation of the Atlantic that permeates Lara's narrative. That Serena considers the flight a "puddle jump" diminishes the history of those waters and suggests a position of privilege in comparison to Miriam and Micaela's experiences crossing the Mona Strait. And in a version of hauntology, the histories evoked by the texts discussed in Part One of this study are largely erased, silenced, made invisible in the plane flight between islands.⁶

On the other hand, as Martha's anxieties make evident, this ability to change location, to enter a different country, is itself precarious, fraught with the threat of having "the secret" revealed. Martha imagines her body being exposed as "not a woman," being tossed off the plane, her suitcases bursting open, "suddenly spewing high heels, gauze and tape, depilatory creams, and thousands of other cosmetic items, lending themselves, the bitches, as evidence." She would thus lose "the right to enjoy the comfort, the airborne luxury, the dream of traveling to other shores" (9‑10). And the main impetus for the journey is that Selena is too young to perform legally in Puerto Rico, so travel is necessary in order to profit from her body and voice. In contrast to flight, landing subjects Martha and Selena to the threats posed by passports, taxes, customs,

barriers, and the bodily assault and violence that enforce those national borders. Nevertheless, suitcases containing dresses, wigs, and makeup that do manage to pass through those containment mechanisms allow for a potential queer undoing of boundaries: "they paid the arrival tax, showed their birth certificates, exchanged some dollars into local currency. Nothing to declare. [. . .] Definitely, some unseen power was guiding them" (13). The ability to pay, in US dollars, as well as the birth certificates that identify them as citizens, allow for this safe crossing. Thus, the *travesti* is supported and protected by a combination of capitalism and neocolonialism.[7]

The text subtly underscores the ways that the present is haunted and shaped by the past of the Atlantic Slave Trade and also by traces of Africa, both in the references to Selena as "mulatto" and to the gods of the African Diaspora. The epigraph (quoted above) begins with "Cáscara de coco," which as Rita De Maeseneer explains is an "instrumento de adivinación en muchas religiones de origen africano" (536). De Maeseneer also quotes an interview with Santos-Febres, in which the author states that "por debajo está la figura de la sirena que es Sirena Selena, que es Ochún. En el vodú haitiano Erzili es Ochún, la sagrada Caridad del Cobre representada por una sirena" (536).[8] Such an identification highlights the role of the sea, a connection that Lara relies on centrally throughout *Erzulie's Skirt*, but that is muted in *Sirena Selena*. More saliently, Selena prays to María Piedra de Imán during the plane flight, asking for her protection and blessing: "Lend me your beneficent magic. I want you to lend me your talisman, I want to have power and dominion to conquer my enemies" (7). In an interview with Elba D. Birmingham-Pokorny, the author herself makes what might be taken as contradictory statements about being of African descent and about Blackness in the Caribbean. Santos-Febres states that in comparison to other Puerto Rican writers, what sets her apart is that, "I am Black. My take on race as a literary theme goes beyond its use as a trope or a symbol of nationhood" (453). And indeed she is often referred to as Afro-Puerto Rican, which distinguishes her from most contemporary authors from her island. Yet, in the same conversation, she also states that to be a Black woman in the Spanish-speaking Caribbean "feels as if you exist in virtual reality, as a symbol of 'our shared African heritage,' as if you passed out of an episode of Roots and started roaming around the island without any connection whatsoever to the transformations that you see unraveling in front of your eyes. You are the past" (455). She continues, saying that in those nations, neither the present nor the future is Black, seeing instead a performance and a spectacle that "theatricalise" origins. The crucial element in her comments is the rhetoric of nation, which "domesticates" race. Elsewhere, she argues for the "translocal," a concept she developed in her doctoral dissertation at Cornell. This idea resonates with other theories of Caribbean identity and experience, such as Brathwaite's tidalectics and Glissant's Relation.

Indeed, Santos-Febres cites Glissant's *Poetics of Relation* when explaining how she understands the Caribbean: "*¿Entender del Caribe? la mezcla, lo fluido . . . Esto de la globalización, nosotros lo vivimos desde hace tiempo. Aquí hay libaneses, chinos, africanos de dos mil países, europeos de dos mil países más, todo el mundo mezclado tratando de ver qué hacemos. Así que estas cosas de la hibridez y de las subjetividad fragmentada*" (qtd. in Celis, "Appendice" 265, original italics). This statement about mixing, fluidity, and a history of globalization resonates with Santos-Febres's concept of the translocal: "the continuous displacement and continuity within Puerto Rican literature both on the island and in the United States" (Rodríguez 215). In an article on "queer Caribbean localities," Juana María Rodríguez cites from Santos-Febres's dissertation:

> [T]ranslocality is a tool that defines the social and discursive practices of writers that reflect upon conditions of circular migration. It differs from hybridity or oppositional consciousness in that it focuses on the problems of location and displacement within multinational contexts. Translocality directly applies to texts that respond to multiple discursive fields of racial, class, national, gender and sexual identities. It sets them in motion and pays attention to textual practices that uncover and thus criticize conditions of multiple oppressions. (Santos-Febres, "Translocal," qtd. in Rodríguez 215–16)

The tension between Blackness or African heritage and a vision of "translocality" that emphasizes multiple identities and a constant circulation of people (and/as goods) is reflected in the narrative of Sirena Selena and the various "trans" characters through whose spaces and lives she is in transit. The text exposes the workings of dominance and oppression, as it also suggests paths of resistance. The dynamics between Martha and Serena, as well as their interactions with those who wield economic and cultural power, navigate a tightrope that promises a crossing both thrilling and tenuous.

Spatial arrangements matter in this narrative of trans-Caribbean geographies. The two *travestis* arrive at the Hotel Conquistador, in front of which stands "a majestic fountain spraying streams of water over a statue of a woman playing a flute shaped like a seashell" (14). Yet these traces are subsumed into the luxurious surroundings in which commodity culture reigns and the sea disappears, only a simulacrum adorning the hotel's entrance. The view from their room on the eleventh floor resembles that of the colonizer, the conquistador: "From where she [Martha] stood she could see all of Santo Domingo—the cathedral, the streets of the colonial district, the alleys of shops, the houses lost in the distance beyond other hillside hotels" (15). The description reminds readers of the role of the Catholic Church in colonization, and the architecture

reflects colonial power, consumption, and contemporary neocolonialism in the tourism economy. The queer performances, the "real" identities of these *transformistas*, form the financial base that supports Martha's (desired) lifestyle. The text repeatedly raises the question of whether borders are indeed dismantled, boundaries erased, or whether the necessary participation in negotiations that echo colonial hierarchies instead undoes the potential of successful transgression. How effective are these challenges to systems still guided by norms established through colonization and enslavement? Further, what relations are formed in these potential borderlands?

In these characters' "wanton Caribbean" (12), we do encounter a dizzying slippage of nouns, names, and pronouns, watching the fluid performances of these *transformistas*. Creating and nurturing their transgender and transsexual identities, the Caribbean *locas* inhabit their desire to be something else: "to invent a new past, dress ourselves up to the hilt, head out, and be something new, among the spotlights and the dry ice, mirrors and strings of lights, to start out fresh, newly born" (20–21). Martha also expresses the desire not to live on a border between genders, a split self, but to "finally be able to rest in a single body" (11). Rosamond King discusses this novel (along with Michelle Cliff's *No Telephone to Heaven* and Shani Mootoo's *Cereus Blooms at Night*) in her pathbreaking article on "Trans Deliverance" in Caribbean fiction.[9] She states that the novel "swings between portraying trans characters [. . .] as individuals struggling to live the lives they want and as stereotypically mythical beings who deliver others by revealing their deepest desires" ("Re/Presenting" 589). I see the latter characterization in the original epigraph in which, as noted earlier, Serena is a "trace," a "track," a "sign," rather than the more individual "face" of the English translation. King does argue that Santos-Febres is the only one of the three authors she discusses who "places well-developed trans characters at the center of a novel" (590), while also pinpointing the possible double readings of Martha's desire to be a "real" woman. King states: "This notion of 'real' can simultaneously be read as the narrator's embrace of trans identities and genders as true and not approximations and as the specific embrace of trans people who can pass and therefore support conventional genders and existing hierarchies. This tension highlights the problematics of gender authenticity" (590). King further argues that these texts, *Sirena Selena* included, may depict trans characters but they do so "*without challenging the system of binary gender*" (594, original emphasis).[10] The extensive body of scholarship on this text, especially in terms of gender and sexuality, the many permutations and interpretations of "trans" in articles by Luis Felipe Díaz, Jossianna Arroyo, Efraín Barradas, Daniel Torres, Iker González-Allende, Mary Ann Gossero-Esquilín, and others, demonstrates that Santos-Febres does engage in a challenge to binary norms even as the characters also seem to shore up those dichotomies. I will

return to this question when discussing Leocadio dancing with Migueles at the end of the novel. For now, I am highlighting the ambiguity and uncertainty surrounding the possible effects or outcomes of the multiple permutations of gender identities displayed by the central characters. This ambivalence echoes the depictions of racialized identity in the text and the author's statements on Blackness and African heritage. Again, the haunting and the trace embodied in Sirena Selena trouble the waters.

In Santos-Febres's text, the gender crossing and queering of identity are presented in part as theatrical invention and expose the process through which the young boy "becomes" an enchanting siren. In the face of danger, loss, rape, and other traumas, La Sirena pursues these *transformista* desires, though one might ask *whose* desires are being enacted. We watch as Martha painstakingly works to turn the young man into a woman:

> She was the living image of a goddess. Each step, carefully considered, evinced the aura of a consummate *bolerista*. She was seductive, serene, with her head crowned with perfect black curls and her face framed by two curls that fell to the middle of her cheeks. [. . .] Her slender form was sheathed in sparkling mother-of-pearl, from which a tanned, perfectly sculpted leg emerged with each step, as if from the sea at sunset. (34–35)

Selena is a spectacle and an aesthetic product who both embraces and is discomfited by her appearance in the mirror as she takes on the form of a mythical sea-born figure. Her mixed reaction parallels the ways the text has been read, as a "refusal of myth" (Den Tandt 201) and as a reinforcement of the mythic figure of trans deliverance (King, "Re/Presenting" 590). Given the emphasis the narrative places on the financial motivations, as well as the necessity of economic success for survival, I argue that the mythic is debased and parodied rather than taken seriously by either the characters or their audience and clients.[11]

The characters repeatedly underscore the economics of this endeavor and embrace their abilities as businesswomen. The enterprise is profit-driven and the performers are candid about taking advantage of wealthy tourists. As Santos-Febres states in an interview: "Yo no creo que ni Solange, ni Serena, ni Martha estaban haciendo otra cosa que *negociar con los deseos de los poderosos*, tratar de hacer lo que se puede para no sucumbir" (Peña-Jordán 121, emphasis added). She goes on to say that Martha is "la *master negotiator*" (121, original emphasis). The text itself emphasizes the business aspects of the three characters' self-invention and negotiations with those (male) who hold power. In the opening paragraph, Martha thinks to herself in the airplane: "He was a businessman, my husband. And since I have a

businesswoman's blood, I learned from him how to keep books and sneaked as much as I could to set up my own little business" (2). Both Martha and Sirena Selena see the trip to the Dominican Republic in monetary terms: "they were going on business, to see if they could sell his show to a hotel. They both had the blood of businesswomen running through their veins" (4). And when Sirena runs off to Graubel's home, thinking she will profit on her own from her performance, she leaves Martha a note: "I got a fabulous offer to do a private show at the residence of the gentleman Contraras [owner of the Hotel Conquistador] introduced us to. If I don't act now, the opportunity will be lost. [. . .] You keep working on Contreras, while I work this other one from my end. We are going to be rich!!!" (49). Selena has mimicked her mentor and also taken possession of her own body—or at least of the mechanisms for profiting from her performance.

The description of one of the many *travestis* Martha has known underscores the ways they also manipulate tourists' desires:

> "What Milton liked to do was go to the bars for the tourists who came to this island in search of the mythical Latin lover who would jump their bones in a night of glorious passion under a palm tree. That's what Milton liked, the gringo bars. She only went out with blue-eyed blonds who had a lot of Ben Franklins in their wallets. And she plucked them like hens." (21)

We can return to DeLoughrey's analysis of the roots of routes to examine these forms of "negociar con los deseos de los poderosos" (as Santos-Febres says of her characters). The trans-Caribbean crossings reflect and refract the Caribbean Atlantic passages beginning in the 1400s, rooted in imperialism and capitalism. In seducing and profiting from the desires of the powerful, those who belong to the Caribbean and the "gringos" who come with romantic visions of sexual exploits, Milton, Martha, Selena, and other trans subjects both engage in systems formed by those routes, while also offering a potential challenge to the prevailing norms.

In turn, the men who pay to watch and hear her perform participate in this queer undoing of boundaries: "In continuous debut your featured star, Sirena Selena, would be the ideal personification of what they came here to find. Lust, mystery, temptation, the whole package wrapped in an amorous bolero and in the sparkling body of an adolescent *travesti*" (94). When Martha and Selena first meet Señor Contreras for the audition, he is accompanied by his friend Hugo Graubel. Together, these men represent the interlocking networks of power in this Caribbean nation: "they saw a circumspect gentleman approach with another man, dressed impeccably in a white linen suit and wearing a thin

wedding band of brilliant gold. You could smell his position and class from a distance" (35). Furthermore, men like the Dominican millionaire Graubel, who wants to hire Selena to perform at a private party, belong to the central economic and political systems that run the country—the vast plantations of sugar cane worked by Haitians, for instance. In this particular case, Graubel and his family are "friends of army generals, advisers to the Ministry of Commerce, intimates of the vice president of the republic" (84). Santos-Febres inserts Dominican history into the background through Selena's paucity of knowledge about the country, for instance her not having realized that such wealth existed: "On the news they only talked about Dominicans fleeing in boats—encrusted with salt, or gnawed at by sharks and floating belly up in the Mona Passage" (84). Such will be precisely the journey that Lara's protagonists take by *yola*, as well as the only way that Leocadio and Migueles can imagine leaving Santo Domingo. Selena, however, has plans to reach New York in the same way she arrived in the Dominican Republic.

The passage continues to list the ways that she lacks knowledge of the economic and racial relations, the structures of power and oppression, from which Graubel's family has profited:

> [Selena] didn't know about the acres and acres of sugarcane that had paid for her host's estate. She didn't know about the Haitians toiling over pots to ensure that the sugarcane syrup achieved the perfect consistency; she didn't know about the peasant leaders chopped up by sugarcane plantation owners in San Pedro de Macorís, fertilizing the red earth stolen from the sea [. . .]. At home, the little wife was planning her debut as a poet at the National Library. (84)

These lines sketch the history of violence at the border and the exploitation of Haitians in the Dominican Republic, while the narrative voice stresses Selena's ignorance of that history, perhaps in order to make the reader pause and consider her own grasp of those facts. The family not only benefits from systems rooted in enslavement, but also is connected to the major institutions of power, from the military, to economics, to politics, to the official channels of cultural production. Arroyo comments on this passage as employing an omniscient narrative voice to show the hierarchies operative between these three Caribbean locations and identities, also noting that it illustrates the contrast between the violent history of the Caribbean and the atmosphere of the hotels and tourist center of Santo Domingo. However, the passage underscores the continuity of that history as it infiltrates and shapes the dynamics of a Hotel Conquistador, a Hotel Quinto Centenario, or the neighborhood in Juan Dolio where Graubel resides.[12] The rapidity with which Selena agrees to the bargain made on the beach demonstrates the

ability of a millionaire like Graubel to manipulate and control her movements, drawing her into his space with the power to keep her captive. She realizes this danger, that "this game of seduction could turn against her, set back her plans, and leave her trapped in the wrong situation" (83). The text repeatedly plays with these power dynamics, teasing the reader with the possibility that the *travesti* can conquer the powerful, shifting or even undermining the existing biopolitics.

Selena does exert a reciprocal power over these men, whose obsession for the figure of Sirena Selena suggests that the borders are permeable, that even concerted vigilance may not prevent a queer "contagion" and undoing of norms, most obviously when Graubel invites her into his palatial home. The negotiations that draw her into this space begin on Bocachica beach, where Selena has gone because "the hotels in this country were situated along a sea without a beach, along a *malécon* full of cars, beggars, and conmen trying to get as much as they could from the tourists" (42). Selena calculates the dollar equivalent of the sum she is offered to perform a private show and considers it "her opportunity to go to New York to try her luck" (42). Graubel has observed her from his car: "Amid puddles of urine and shit floating on the waves, Selena walked along the edge of the ocean. Her hairless body seminude, in a tiny bikini, made her look like a tomboy trying to be an *hombrecito* on the beach, but showing her femme side [. . .] the temptress in the sand" (43). The passage stands out as one of the few times the narrative describes the shore and water in more detail than vague references to "the sea." The hotels with their names signaling roots in colonialism turn away from the sea, even as their main commerce continues the patterns of global exchange and the circulation of capital begun in the Triangle Trade. The repeated images of filth—Graubel's wife Solange complains about the "dirty disgusting beach," for instance—further invoke the rot at the core of these "negotiations," people bought and sold, the bones that form oceanic ossuaries, and the trauma of the Middle Passage. These traces, like Selena herself, perform a version of tidalectics, in this case the past, washing ashore as waste.[13]

Raphael Dalleo says of both Brathwaite's concept and Glissant's image of beach and ocean's interplay that the "image of movement based on ebb and flow emphasizes the circular and repetitive, rather than the progressive and teleological" (6). According to Dalleo, the significance of movement to both theories involves relation and fragmentation, the avoidance of a fixed identity: "In this context, identity can no longer be seen only as inheritance; it is something always becoming, created through contact with Others" (5). The space where sea meets sand, site of both Brathwaite's and Glissant's vision, is both debased and mythical, and also a space of encounter and potential relation. Graubel wonders "how to cross the abyss that separated him from Sirena Selena, that being of fantasy," and he will do so "no matter the cost" (45).[14] That Solange is

audience to her husband's visible longing for Selena and determination to "buy" her makes the wife complicit in the desire to possess the *travesti*.

That complicity also operates as a doubling when Selena enters their home and we witness Solange's own performances of femininity and the scaffolding on which the marriage tenuously balances.[15] Delivered to their home in Juan Dolio, an area that is "part of a tourist consortium" near the Talanquera Hotel, Selena sees this step as a means to an end: money to get her to New York City. The location participates in neocolonial relations: "Juan Dolio rose above the reefs, with its villas and beachfront houses, its village of sugarcane workers and fishermen now transformed into hotel employees, its red earth and coral rock now used for the construction of souvenir shops, Italian restaurants, and golf shops for European tourists" (50). The queer infiltrates the space of the "normal," in what Gayatri Gopinath terms a "radical reworking" of home space: "The queer diasporic body is the medium through which home is remapped and its various narratives are displaced, uprooted, and infused with alternative forms of desire" (5). Such a displacement occurs when Graubel is overcome by his desire for Selena right in his own home space.

A central question the text raises is whether this displacement, a potential deterritorialization, makes a difference in the end. Developing a genealogy of sexual citizenship across the trans-Caribbean, Mimi Sheller explores the possibility of "a theory of embodied freedom in the context of postcolonial, transnational and what some would call a neo-imperial restructuring process" (345). Can such an "embodied freedom" of the "queer diasporic body" result from the exchange between Graubel and Sirena Selena? Sheller focuses on Black agents, primarily heterosexual women, while arriving at a conclusion that does gesture towards the possibility of "erotic agency as a practice of resistance to the constrained heteronormative sexualization and hierarchical racialization of citizenship" (364). One of Sheller's statements resonates for Selena's complicated, contradictory presence in Graubel's mansion: "Thus everyday 'personal' relations between bodies in both public and private spaces *underwrite forms of unequal freedom*, while also affording opportunities for social change by allowing *for occasional performative destabilization or revision* of conventional interplay between bodies, spaces, and racial, gender, and sexual norms" (348, emphasis added). That Graubel is Dominican makes the relations both intra- and trans-Caribbean, and the ways that their bodies are marked racially—Selena described as "mulatto" or "Creole" and Hugo appearing in a flashback as "that feeble white boy who looked like a girl" (103)—suggest the possibility for a "performative destabilization" of the norms that structure citizenship in the Dominican Republic.

Graubel is thus both similar to and yet different from the foreigners, those who come from elsewhere in the Caribbean and also from North America and

Europe. In a chapter that is entirely in English in the original (the only one in the novel), an anonymous gay traveler talks about the Hotel Colón:

> And where can you get that [a beach full of "pretty boys"] at a reasonable price? Only in the Caribbean! [. . .] The only problem is the infrastructure. [. . .] Stan, the owner [. . . is] from Sweden or some other Scandinavian country. [. . .] Put ads for the Hotel Colón in the *Village Voice* [. . .] all the right places. The hotel is very neat, very well kept, and the boys he finds! Let me tell you, they are unbelievable! Pretty chocolate skin, incredible bodies [. . .]. (151)

The chapter continues in that vein, the voice of neoimperialism and sex tourism assessing a site whose name invokes Columbus and "discovery," as he also speaks of the "boys" who work there as if they were consumable products like the chocolate produced on Caribbean plantations. These attitudes mirror those of men Martha encountered when she worked in New York City, who also participated in a trans-Atlantic and global circuit of exchange: "who only on business trips allowed themselves the luxury of letting go, of being free and feeding on the desires they kept under lock and key back in their respective republics. At home in their countries they reproduced, inherited, buried grandparents, rode horses on their haciendas, and acted like the future fathers of their countries" (92). The North American gay man whose voice speaks in English for all of chapter 34 may be more open and "real" about his sexuality and identity, while the heterosexual businessmen hide their desires.

Nevertheless, in all of these instances the clandestine border-crossing may appear to challenge the heteropatriarchal and genealogical dictates of nation and family, but as the second passage in particular makes clear, they in fact reassert and shore up the boundaries that exclude the "abnormal" and "perverse." And the gay voice also speaks dismissively of the country he is visiting, even as he takes advantage of the opportunity to stay in a hotel that caters to sex tourists, when "[i]t's so difficult for us to travel abroad, especially to the Caribbean," and refers to himself as "sort of 'normal'" in comparison to drag queens and street boys (150). Hugo Graubel illustrates a Dominican version of these biopolitics, referred to by Selena as the "Real Client," as she is driven to his home. I will return to Hugo's eventual fate in relation to Sirena Selena, which is left ambivalent in the narrative's denouement.

At the core of the *travesti* (and travesty) that is "Sirena Selena" is the singing voice that transgresses borders and suggests a potential healing through resistance. He has inherited the voice from his mother and been given the name by his grandmother, a genealogy that itself undermines a more masculine, patriarchal line of descent. Raised by his *abuela*, he assisted her in cleaning the homes

of the wealthy and listened to her tales and boleros. As his grandmother told him, "You have a beautiful voice, [and] [y]ou sing just like a sirena. If you were a girl, that's what I'd call you, Sirena" (28). Thus, his grandmother names him, initiating the transformation into the *travesti* he will become under Martha's tutelage and management. Labor and performance intertwine in these roots of what becomes his public identity as he crosses borders with his new "mother." Significantly, what Sirena excels at is singing boleros, which as José Quiroga argues are a form that "signals the beginning of a new voice that reappears from the past in order to seduce readers again into a transnational (and even a meta-Caribbean) space" (151).[16] Quiroga also states: "Boleros are all about erasure. What other musical genre can be so invested in its own sense of disappearance that it seeks to proclaim absence by belting out songs claiming that the only thing that remains is disappearance itself?" (152). In light of Selena's eventual flight—from Graubel, from Martha, from the text—this observation about the bolero helps to elucidate the inherent contradictions embedded in the *travesti* that structures the novel.

Quiroga also comments on the erasure performed by the bolero: "its geographical referents are a mental constellation of tropics that can be invented at will. These emblematic spaces can exist only by erasing other tropics, those where poverty is the norm and not the exception, where the panache and romance of the nightclub are available only to a few" (152). Such is the case when Martha negotiates with Contreras so that Sirena Selena can perform boleros for a wealthy crowd of tourists and when Selena sings privately for Graubel and his circle. While these moments are located in Santo Domingo, it is not the city in which young Leocadio has struggled to survive, nor does it resemble the streets of San Juan where Selena sold his body, was raped, became a drug addict, and otherwise lived an urban experience far different from the "panache and romance" of the Hotel Conquistador or the Hotel Talanquera (in the well-off seaside neighborhood Juan Dolio), in which Graubel is "a stock holder and partner," and where he vacations (49). The latter hotel's name means "parapet," a form of security and defense, suggesting a space protected by wealth and privilege that performs its own forms of erasure and exclusion. These spaces serve as doubles or reflections, and within them Selena stands in front of mirrors as she prepares for each performance as *travesti*.[17]

Santos-Febres devotes a whole chapter to Selena's performance at the Graubel mansion, mapping the performer's journey down a grand staircase and charting the effects on her audience, as well as incorporating the words of the bolero itself. The passage frequently relies on metaphors of the sea and the siren: "She leaves her shimmering tail by the sea there on the shore," as the guests watch the "thin, smooth legs of a sylph emerging from the deepest waters" (161). Those images, along with several of "sea foam," mix with others

more mercantile, such as her eyes, "as black as the jewels in the windows of department stores" (163). Selena is both mythical creature and consumable commodity, a simulacra that may be empty at its core. "Lost somewhere deep inside they only look at the reflection of her image," a line that refers to La Sirena's awareness of her self as multiply refracted through the gaze of her "witnesses," as they consume her performance through screens of their own lost and imagined longings. The scene is inflected with nostalgia and lost desire, which Quiroga identifies as central to the bolero. He connects the popularity of this form to the global economy:

> At the end of the twentieth century the globalized ideology masks the rigid positionalities of center and periphery; the new flexibilized economy does not change the rigid polarities between rich and poor, and the present democratic openings in Latin America are constantly undermined by the authoritarian infrastructure that sustains them. This is why boleros are genuinely popular in the marketing apparatus of nostalgia: they give a fairly accurate account of what is happening at the base. In this case, the neocapitalist context produces its own marketing of the past as an act of resistance that it sees as ultimately useless. (158)

This "marketing of the past" indicates a cynical attitude towards the possibility of resistance that would succeed in changing the status quo, shifting or erasing borders, challenging the norms in terms of gender, sexuality, economy, and exchange. That leads one to question the efficacy of the border crossings performed by the *travesti* in Santos-Febres's text. The sea provides a backdrop, but it is more a staged presence, one of mythical images, than a site of transformation and Relation.

The actual shore does provide a meeting space for Selena and one of his doubles, Leocadio, the young Dominican boy who mirrors and repeats Selena, with a difference. The doubling of these two characters caused confusion for some readers and critics, who assumed that Sirena Selena and Leocadio were the same person or otherwise missed the distinctions between them. Leocadio first appears early in the text, on the beach at Bocachica with his mother and sister: "Leocadio, don't stray too far from the shore, *mijo*, the sea is very rough and you don't know how to swim" (38). Introduced abruptly, following a chapter delineating the artifice that constructs La Sirena, Leocadio's relationships with his biological mother and then his adoptive mother Adelina echo those between La Sirena and her grandmother, as well as with Valentina and the other *travestis* who become mother figures to her. Santos-Febres chooses to have these two characters cross paths once, in this scene on the shore at Bocachica beach. As Leocadio walks at the edge of the water, he feels "a heavy gaze on his shoulder," from a man who is not the first to demonstrate a perverse desire for the young

boy. Turning his own gaze away, Leocadio then sees a boy older than himself, whom we recognize as Selena. "The boy stretched slowly and walked to the edge of the sea, glaring catlike as he tried to step around the trash washed up by the waves. The boy gingerly lifted his delicate legs to avoid the plastic cups and candy wrappers. [. . .] the being approached the sea seeking relief from the heat and rowdiness of a day at Bocachica beach" (41). At first Selena gives Leocadio a hostile look, but then smiles and the younger boy smiles back. This moment on the shore, a direct encounter with the sea and between the two characters, creates a bridge across the gap and establishes Relation in and of the Abyss. As Arroyo points out in her discussion of "sujetos transcaribeños" in the novel, Puerto Rico and the Dominican Republic share similar histories yet differ in significant ways.[18] Through the connections the text establishes between these two characters as well as the differences between their situations at the conclusion of the narrative, we can assess the potential resistance enacted in various border crossings.

Throughout the novel, the chapters have woven a complex network of relations as the narrative also reveals the process of constructing a *travesti*, inviting the reader to watch the performance from multiple angles, and then like a bolero taking apart the vision. Do the economics and the structures of power that shape and drive this market short-circuit potential resistance? After Sirena's appearance as the mythical diva, Graubel's desire leads him to contemplate suicide, while Solange sees the "imposter as a thief disrupting her own constructed identity as a *dama* in high society. Hugo imagines possessing La Sirena in an act that will kill him, which suggests the potential deconstructing of this center of power. Solange sees her husband take Sirena's arm and "leave [her] abandoned, not knowing where to go" (173). Their home, symbol of the heteronormative and neocolonial forces that control the capital and the nation, appears ready to split and crack open, as if the transgressive subject has driven a wedge into the center. Yet the following scenes between Hugo and Sirena raise more questions, about gender and sexuality, about desire, and about subversion.

The Hotel Talanquera's gardens are the backdrop for an encounter between the two after the bolero scene, when Hugo slowly disrobes her and reveals first the bindings, then the teenager's skinny frame, and finally his penis. The narrative maintains suspense by withholding the outcome for several chapters, returning to Sirena two days later, again by the ocean. But her dream of success and possibly romance has been interrupted by nightmares of the brutal rape he experienced in San Juan. Material objects and financial security seduce, but trauma trumps those desires. The final scene between the two is one of penetration that slowly erases La Sirena. To hear Hugo use the masculine "Sirenito" to speak to her takes Sirena back to the consciousness of the young boy who was viciously attacked. Her trauma, the wound that evokes the deeper roots of the Abyss, renders her voiceless: "But to speak she would have to let go of who she

really is, who it took her so much work to become. And if she goes out there and doesn't come back? Who would she be then" (206)? Her penetration of Graubel is narrated from the latter's perspective, as Sirena recedes like the tide.[19] We see her disappearance through Hugo's eyes, when he wakes to find her gone, along with his expensive watch, his wallet, and the closetful of clothes that he bought her. She has left "nothing" for him except the keys to the hotel room.

Instead of a challenge to or disruption of the status quo, aside from stealing a few replaceable possessions, Sirena has indeed left the keys to the structure in the hands of the owner and has asserted his own male power rather than be penetrated in a repetition of rape. The scene empties of desire and of transgression or resistance, and La Sirena dissolves like the sea foam that metaphorically surrounded her performance. In her analysis of "trans deliverance," King states: "The failure to portray full trans lives keeps them marginal—reinscribing conventional heteronormative gender—and avoids exploring how the presence and acceptance of trans individuals could challenge Caribbean gender hierarchies" ("Re/Presenting" 598). And while others assume that Sirena has journeyed to the US, specifically to New York City, to pursue her quest for money and fame, we do not witness any evidence that she in fact makes that passage.[20] I return to Quiroga's discussion of the bolero: "Boleros are all about erasure. What other musical genre can be so invested in its own sense of disappearance that it seeks to proclaim its absence by belting out songs claiming that the only thing that remains is disappearance itself" (152). While La Sirena disappears from the narrative as she abandons Martha and embarks on her own trans-Caribbean journey, the text leaves us with the possibilities of undoing the violence of borders and suggests an ongoing legacy or passing it on.

We are left in the Dominican Republic, not in New York City, not back in Puerto Rico. Throughout La Sirena's story, we have also followed that of her double Leocadio, who works in the Hotel Colón and is mentored by an older boy, Migueles. In one conversation, these two discuss the possibility of leaving Santo Domingo and traveling to Puerto Rico. The islands share their colonial past as they also stand in relations of neocolonial dependency on the United States, but they also differ. While La Martha and Sirena have passports, travel by air, and cross borders with relative ease, the two Dominicans can only envision leaving by *yola*, a dangerous passage across the Mona Strait. Migueles repeatedly instructs Leocadio on how to be *un hombre*, which means making money and taking care of women, especially mothers. Migueles sees Puerto Rico as the place to succeed, because the people there "are used to being gringos" and do not work, so the opportunities will be endless (157). Leocadio's difference and queerness, expressed in his growing affection for the older Migueles, emerge more fully in the scene of the two of them dancing together in an empty hotel bar. Migueles instructs Leocadio on how to lead and how to follow, and on

the respective genders aligned with those roles, yet his words underscore the fluidity and mutability of the norms. Leocadio contemplates the potential permutations: "There are many ways to rule, many things required to be *un hombre* or to be *una mujer*, for each person can decide for himself. Sometimes you can even be both. Without having to choose one or the other" (208).[21] Leocadio steps onto the dance floor with Migueles, forming a new relation.

III.

In *Erzulie's Skirt* (2006), Ana-Maurine Lara interweaves the narrative of a long-term relationship between Miriam, who is of Haitian descent, and her Dominican lover Micaela, with dream sequences linking their lives in the contemporary Caribbean back to Africa, the Middle Passage, and enslavement. This haunting directly connects their present-day lives in the Dominican Republic and their boat journey to the Door of No Return as invoked by Dionne Brand: "In the Diaspora, as in bad dreams, you are constantly overwhelmed by the persistence of the spectre of captivity. The door of dreams" (*A Map to the Door of No Return* 29). The novel opens on a "sleepy morning in the Atlantic Ocean," with a conversation between Agwe, great spirit of the ocean, and Erzulie/La Sirène, goddess of the waters and the waves, as the latter tells Agwe the story of Miriam and Micaela. Their narrative is born of and permeated by the ocean, the realm through which Erzulie transports those whose passing returns them to Guinée, space and home of the African ancestors.[22] Agwe says to Erzulie, "You should try being down here, in this cold with this many spirits walking through you," and she replies, "I have to hold them all the way down. That tires me out sometimes" (xiv). The novel's title refers to Erzulie's role as protector, her skirt a shelter for those she embraces in the journey home. Micaela's father, a *brujo* who deals with spirits, tells her: "One day, when you are ready, your soul will return to Guinée. You will traverse the waters where our ancestors lie on their return journey and Erzulie, great Erzulie, will guide you home" (81). The story begins with that final passage, as Micaela and her lover Miriam have just died. Dawn Stinchcomb comments that the two characters "are lovers that make the passage together in the physical as well as the spiritual worlds. Their relationship is analogous to that of Yemayá and Ochún, who are said to have once been lovers. The stories of these two orishas of Yoruban culture intertwine and represent Erzulie of the Dahomey, who has come to accompany Miriam throughout her life" (7). Lara's Erzulie in the opening pages is also called "sirène" by Agwe and later blends into La Mar as the two protagonists begin their journey in a small *yola*. In her pathbreaking article "Black Atlantic, Queer Atlantic," Omise'eke Natasha Tinsley focuses on

the goddess La Mar and this contemporary (middle) passage across the Mona Strait.[23] That Erzulie in one of her incarnations is the goddess of love, as well as of the ocean, and that she welcomes the two female lovers into her space also serves as a queering of the Caribbean Atlantic in ways that deepen and complicate the real and imagined crossings in *Sirena Selena*.

Throughout the text, we witness the violence born of borders, including that of the Massacre River dividing Haiti and the Dominican Republic. Miriam's family is Haitian, relocated to the Dominican Republic for employment, and scarred physically and psychically by the vicious 1937 massacre of Haitians by order of Trujillo. Miriam's mother Chavel lost six children in that horrific event, and her friends recall losing multiple family members. Lara illustrates that the contemporary moment is not "post-plantation" as the text follows the childhood and adolescence of Miriam and then Micaela. Miriam's father explains the hostility towards Haitians on the plantation where their family labors in the cane fields: "You were born in this country, but you are Haitian. You will always be Haitian. Our people are treated poorly because we are free; we know when something is wrong. [. . .] That is why they hate us. [. . .] Because they think that silence will protect them. But we are a free people, and we know that we are right" (22). In *Erzulie's Skirt*, life in the Dominican Republic demonstrates the "hauntology of race" or what Cooppan calls "the spectral modality of reading race in(to) the novel. Disclosing to sight an invisible structure within a visible one is part of what it means to place race in literary history" (79). Lara explicitly reminds us of that invisible structure as she weaves in the history of the island named Saint-Domingue, Hispaniola, or Quisqueya, of the dictatorship of Trujillo that exploited the constructions of race in the Dominican Republic, and of the ways that the "ghosts" of that past haunt the present for her characters.[24]

This depiction of diaspora, beginning in the oceanic conversation between the gods, relies on a doubling as well as a network of relation rooted in the sea and in Africa. Avtar Brah defines diaspora space as follows:

> [D]iaspora space as a conceptual category is "inhabited," not only by those who have migrated and their descendents, but equally by those who are constructed and represented as indigenous. In other words, the concept of diaspora space (as opposed to that of diaspora) includes the entanglement, the intertwining of the genealogies of dispersion with those of "staying put." The diaspora space is the site where the native is as much a diasporan as the diasporan is the native. (qtd. in Gopinath 144)

This definition applies to the intertwined relations in the Dominican Republic and Haiti, to the ways that those relations shape the identities of the characters

in Lara's novel who are Dominican, Haitian, *and* African, and to the queer relationship between Miriam and Micaela that forms the narrative's core. "The queer diasporic body is the medium through which home is remapped and its various narratives are displaced, uprooted, and infused with alternative forms of desire" (Gopinath 165). Queer relation thus challenges not only heteropatriarchal norms but also the division between Haitians and Dominicans that is rooted in racialization and colonialism, perpetuating both racism and class differences in the Dominican Republic.

That challenge resonates with Glissant's philosophy of Relation, as developed in one of his late works: "Today's humanities call out to the unexpected (wild) dialectics of multiplicity" (*Philosophie de la relation*, qtd. in Wiedorn 911). Michael Wiedorn explicates this concept as follows:

> Once again, latent in this turn to multiplicity is a sense of oneness, and Glissant's use of the term "bifidities" is key here [. . .] a bipartite entity that was originally a whole; it is a whole that has been split in two. Dialectical opposites, therefore, are no more that the remains of a divided whole. Here as elsewhere in Glissant's essays, binary oppositions fade into and out of unification: they partake of multiplicities. (911–12)

The parallel narratives of Miriam's and Micaela's lives, from birth until their individual arrivals in Santo Domingo, and then their shared life from their meeting until their simultaneous deaths, illustrate this idea of "bifidities." Even their names mirror each other, with a difference based in the languages of Haiti and the Dominican Republic. Like the island itself, they are two parts of a whole who "partake of multiplicities" as they come together and establish a queer relationship.

In one exchange, Micaela and Miriam talk about children's lack of awareness of the "difference" and the ways that adults make distinctions. Miriam argues that all are of African descent: "They [Dominicans] don't see how we are all living in small shacks, and that we all go hungry from time to time. They don't see how our skins and faces can't hide the truth of where we come from. We are all from Africa" (119). Micaela tells her that Erzulie will guide everyone "home through her waters," but for now, they honor her as Erzulie Freda, "the sensual full-bodied woman, [. . .] the queen of lovers and the metresa of female flirtations" (120). Erzulie connects them to the Caribbean Atlantic and also queers that space as she validates their desire. This form of Relation challenges the border lines between the two nations and their citizens. Gopinath argues that "[q]ueer diasporic cultural forms and practices point to submerged histories of racist and colonialist violence that continue to resonate in the present and that make themselves felt through bodily desire. It is through the queer diasporic

body that these histories are brought into the present; it is also through the queer diasporic body that their legacies are imaginatively contested and transformed" (4). Miriam and Micaela embody that process of transformation in their journeys throughout the narrative.²⁵

Those individual paths have taken each of them to the capital, Miriam with her husband Jérémie and baby Antonio, Micaela alone after her mother blames for her young brother Fernandito's drowning and she is cast out of the family. The dynamics of the plantation are repeated in the capital, a different urban space than that depicted by Santos-Febres. Rather than the hotels, gay clubs, and wealthy enclaves like Juan Dolio, Miriam and Micaela inhabit shacks in an impoverished neighborhood and find work on the streets or in the market. Abandoned by her husband when he cannot find a job, Miriam and her young son are never safe from the violence directed at Haitians: "There was nowhere to hide. [...] The men were entering peoples' houses. She could hear the sound of boots against the tin doorways. She could hear people screaming as the Dominican boys they used as guides pointed guns to peoples' heads, or shouted out to the police officers the places where they could find the Haitians" (131). That racialized violence surfaces constantly, as do other forms of hostility and oppression.

Despite the pervasive violence, the urban environment is also suffused with the presence of the *luases* and the spiritual practices associated with those deities. Erzulie and Changó inspire and mediate the desire between Miriam and Micaela. When she mentions Erzulie Freda, "[Micaela] felt their bodies stir, getting hotter at the mention of Erzulie Freda's infamous character" (120). Leaving a gap in time, the narrative moves to the next morning, after a night of drums and visits from the gods. In that communal gathering, Miriam became Changó's "horse," Anaísa entered Micaela's body, and the two then "loved each other" (122). Lara continues, "Together they formed the rain that feeds the earth. Anaísa a mirror of Changó's thunderous sound, the brilliant white paths of lightning like the veins of sweet water in the forests. Anaísa fed Changó's thirsty skin with water, watched as Changó split open, pouring rain in the rosy light of dawn. Oyá, Changó's dearest lover, blew in through the loose boards surrounding them. Micaela and Miriam trembled" (122). The passage does not specifically refer to body parts or sex yet the description of the two gods, watched over by a third, Oyá, pulses with eroticism and passion. This scene is the sole time that Lara depicts the two women having sex, a very different way of incorporating transgressive sexuality than the scenes in *Sirena Selena*. Nevertheless, both texts use queerness to disrupt norms and to challenge dominant systems. Gopinath's comments on "queer diasporic cultural forms" helps to elucidate what happens in both of these novels: "What emerges within this alternative cartography are subjects, communities, and practices that bear little resemblance to the universalized

'gay' identity imagined within a Eurocentric gay imaginary" (12). Through the incorporation of the African orishas or *luases* into the sexual relationship between Miriam and Micaela, Lara shapes such a cartography, one that encompasses Santo Domingo, as well as Haiti, the Dominican Republic, the Mona Strait, and Puerto Rico. We witness another version of the *transcaribeña* subject, who might resist the plantation and invent new modes of Relation.

In the capital, where labor is a necessary part of survival, Micaela has more "opportunities" because she is recognized as Dominican and thus gets a job cleaning house for a wealthy woman in the hills (similar to the work performed by Sirena's grandmother and Leocadio's mother and sister). But as the two women and Antonio form a new family, race and class determine their socioeconomic position at the bottom of the hierarchy. Katherine McKittrick discusses the "plantation logic" that still informs the Atlantic World, using George Beckford's "plantation economy thesis," which "suggests that the plantations of transatlantic slavery underpinned a global economy; that this plantation history not only generated North Atlantic metropolitan wealth and exacerbated dispossession among the unfree and indentured, it also instituted an incongruous racialized economy that lingered long after emancipation and independence movements in the Americas; and that the protracted colonial logic of the plantation came to define many aspects of postslave life" ("Plantation Futures" 3).

Though Miriam and Micaela have each left the bateys and fields where their respective families lived and labored, Santo Domingo's economy is structured in much the same way as is the plantation. The beach cluttered with hotels for tourists is the site of Miriam's labor, using the hair-braiding skills learned from her mother as a means to earn money: "Young men and women dressed in fuzzy hotel uniforms ran around the beach picking things up and putting things down. [...] Miriam looked out at the water and followed the currents to shore with her eyes. The gentle water formed foamy blankets along the water's edge" (128). She notes the ways white female tourists sunbathe with their breasts exposed and are "swarmed" by the young men who are willing to exchange sex for money. Working on a French woman's hair, she thinks: "These women were all so rich. They simply arrived on the beach for a week, sometimes two or three, and sat reading or drinking rum. [...] She had never seen a hungry european or north american. [...] It would be different once she was over there. In Nueva York, she knew she would never be hungry" (149). Both poverty and trauma weigh upon Miriam, who constantly fears for her son's safety and dreams of flight to New York and "a real home of my own" (136).

This image of New York as safety and freedom is as insubstantial as the souvenir Micaela dusts in the home of a wealthy Dominican family: "a small porcelain keepsake of New York City. It was outlined in gold, with tiny blue lettering. New York. She polished the small relief of tall buildings and the

Statue of Liberty" (146). Her dream of New York has been fueled by an aunt who returned from the US for a visit and conveyed the promise of the city. Like Sirena, Leocadio, and Migueles, Lara's protagonists envision New York as the space in which they will succeed and thrive. In Santos-Febres's novel, only Martha has actually been to New York, while Sirena vanishes without a trace (or evidence of arriving in the US), and Leocadio and Migueles know that the furthest they may reach is Puerto Rico (in a journey they might not survive). In all of these cases (including Lara's characters), the dream of New York as site of financial success and sexual freedom is short-circuited or refused. Transgressive sexualities may be a determining factor in these varying trajectories.[26]

The dream is fragile and commodified (like the miniature cityscape), seemingly available for purchase but actually a mirage and a nightmare. In *Erzulie's Skirt*, the fantasy of an elsewhere free of the racism and heterosexism rooted in colonialism, of a place unmarked by the violence born of that history, sends Miriam and Micaela to the American consulate for visas, then to La Gata, a woman who sells them passage on a boat. They will enact the voyage that Migueles describes to Leocadio, transit by flimsy *yola* across the treacherous waters of the Mona Strait. Lara frames the novel with an epigraph that points to the many lives lost in this attempted passage: "No es posible contar los muertos de una manera confiable, aunque se cuentan por lo menos en centenares todos los años" (n.p.). Desperation and longing for a better life make Miriam and Micaela determined to leave Santo Domingo, despite the fact that Miriam's identity as "Haitian" prevents her from having official papers and being able to get a visa. As noted above, the city resembles the plantation, its economy structured on the systems inherited from colonialism and slavery, including the racist attitudes towards Haitians and the rigid rules enforced by the American consulate.[27] Sirena and Martha, as Puerto Ricans, hold US passports and carry US dollars, while Miriam and Micaela have a different relation to the Caribbean Atlantic. Their experiences illustrate "the mobility of cheap labor migrating between Caribbean islands and towards the United States in *yolas* or *balsas*" (Llenín-Figueroa 90). We meet Martha and her "son" airborne over the sea and passing through customs without incident, a very different experience from that of Lara's characters in the Caribbean Sea. Their journey becomes a modern Middle Passage, which echoes the one appearing to Micaela in dream fragments inserted at the beginning of many of the chapters.

Throughout the text, Lara weaves in these sequences evoking the violence of colonization perpetrated by "ghosts," the capture of Africans, and the horrors of the Middle Passage: "rough white men pushing and pulling them up the thin boards, dragging the resistant after a hard blow to the back. [. . .] With the hilt of their guns, the ghost men struck her head and Ifé crumpled into a pile of bones and dirt-stained flesh amidst the chains" (174). These short segments

introduce the chapters and link the experiences of the two women in the present moment with those of two female ancestors forced to cross the ocean into captivity and enslavement. This inscription of a second pair of women, another doubling, queers the roots of the diaspora as it also contributes to a vision of the queer Black Caribbean Atlantic. In her landmark study, Tinsley focuses on the journey of Miriam and Micaela, but I argue that Lara further develops such a concept in her re-membering of the rooted routes from Africa, through the Door of No Return, to the plantation and enslavement in the Americas.

The two women, She and Ifé, embody an Africa that is both female and woman-loving, invoked in their names—a female pronoun and the word for the heart of Africa. "Ifé held Her hand in the darkness of the night. Ifé's grasp shook Her body; it sent tremors to her feet. With those tremors Ifé said: remember. She held her breath, remembering the taste of laughter" (99). Through their story, we witness the violent disruption wrought by Europeans, the catastrophe of the Middle Passage, and the necropolitics of the slave ship and then the auction block.[28] The segments form a wound that speaks, the originary trauma of the Atlantic World: "She floated over rows and rows of bodies, dead or suffering in the fungal darkness of the ship's keep. [. . .] As She made her way back to the corner where her body lay covered with pustules and fleas, She imagined finding Ifé" (173). These short sections perform a hauntology, demonstrating how the past permeates the present—the first time Micaela dreams of the two African women is titled "Now," for instance.

The "ghosts" sever the enslaved from home and turn them into commodities: "She was displayed as if she was flesh hung out to dry" (199). Yet the haunting also creates Relation in a vast network that shapes the Caribbean Atlantic. This female ancestor, She, arrives on an island and looks to those who preceded her into the Americas, whom she perceives as "masks" in the hills above, and she "[sings] to them so that they might recognize her" (199). Borders of time and space are tested and blurred, as the African woman enters the violent arena of the Caribbean. That space is also one of Relation, as Glissant repeatedly demonstrates. "Like the sea, which both 'limits and opens,' like Brathwaite's tidalectics [. . .] Relation names an understanding of the centuries-old encounters in the Caribbean archipelagos on the basis of a never-ending spiral with neither definitive, rooted origins nor definitive, rooted endings. [. . . Glissant] suggests that the slave trade both inaugurates and is the necessary, urgent touchstone of the poetics of Relation" (Llenín-Figueroa 98). In its insistent inclusion of this history, Lara's text differs significantly from *Sirena Selena*. In the latter, we find scant vestiges of history, a near-amnesia about routes into the Caribbean Atlantic, and a lack of attention to the parallels between the Atlantic Slave Trade and the exploitation of the impoverished and abandoned like Sirena Selana and Leocadio. Sirena flies high above the sea and

has no memory of the enslaved, while Micaela's dreams are vivid sequences from She's journey. As the latter stands on the auction block (and the lines remind one of Philip's "Dis Place"), "She looked toward the mountains behind the city. The same mountains where the masks now appeared. They steadily gazed at the city and She watched, asking them what medicine they brought to cure Her of this nightmare" (199). In *Erzulie's Skirt*, the masks that She sees in the hills of the island where the slave ship arrives may represent both those who came before her through the Middle Passage and the belief system that they brought with them. Those "medicines" will sustain the contemporary women in their own nightmare journey in the sea.

We witness another middle passage when the women and Miriam's young son board the *yola* and find themselves in a contemporary version of the slave ships. This short section resonates with the depictions of the Middle Passage discussed in chapter 1 of this study, the "oceanic ossuaries" of chapter 2, the experiences and memories of Agnant's Emma, and other literary evocations of this central wounding. At the edge of the water, Micaela thinks of the sea: "La Mar had always been there. She knew from dreams that it was from there that she had arisen. That somehow long ago she had entered her waters and emerged on this side, whole and broken. That somewhere in her depths was the key to her death and to her living" (159–60). Tinsley's "Black Atlantic, Queer Atlantic" analyzes this brief chapter at the center of *Erzulie's Skirt* to argue for the presence of a Black Queer Atlantic that begins in the Middle Passage and is illustrated in the contemporary crossing of the Mona Strait. The connections across time that Lara has established through the short segments about She and Ifé offer another example of haunting or ghosting. In discussing queer temporality, Carolyn Dinshaw examines "the possibility of touching across time, collapsing time through affective contact between marginalized people now and then" ("Theorizing Queer Temporalities" 178).[29] The words of La Mar, who sings to Micaela, perform this collapsing of time: "La Mar told her of a place where two people lay with irons on their ankles. They gazed at each other across the darkness, despite the darkness [. . .]" and speak of love and passion (160). The passage draws the past into the present, as She and Ifé blend with the foreshadowing of what awaits Miriam and Micaela in Puerto Rico. The women thus gesture towards what Dinshaw further suggests, "that with such queer historical touches we could form communities across time" (178). This contemporary passage will participate in networks of trauma as well as Relation, with the spirits or *luases* serving as the connective force or tissue that holds queer bodies together.

The journey is prefaced by multiple reminders of the past, of the roots of capital's routes, and of the consequences for Black bodies: La Mar/Erzulie/La Sirène appears to Micaela, "to reclaim her tortured children, to soothe their

skin torn and mangled by the irons of slavery." And Micaela steps into "Her waters warmed by the day's sun and the countless souls resting in Her depths" (160). We enter the submarine depths of which Brathwaite says, "one is haunted that there is more there. Underground and under the water there are larger forms which have deeper resonance and we haven't yet reached them" (qtd. in Dash 193–94). Lara's narrative (like others discussed in previous chapters of this study) explores this haunted space and brings those forms closer to the surface. Speaking silently to Erzulie and La Sirena, Micaela imagines the journey into freedom, but the two women see instead what seems "a trail of lost spirits" as they watch those boarding the *yola* ahead of them (161). As Tinsley observes, "Water that defies abstract, passively feminized figuration, the shark-infested Mona passage is an active seismic area rocked by enormous waves that tens of thousands of immigrants confront each year in small wooden boats" ("Black Atlantic" 199). The spectral vision offered by La Mar is realized not long after, as the boat drifts and two men leap rather than die on board. Micaela hears them call to Erzulie and sees the spirit gather them under her skirt, into death. Though Micaela equates La Mar and Erzulie with La Sirena (161), and one might hear a resonance with Santos-Febres, in Lara's novel the orishas are active, physical presences who "mount" the characters and otherwise guide and permeate the narrative. In contrast, *Sirena Selena* presents only faint traces of the orishas, in keeping with the fabricated aspects of Sirena's persona. Though Santos-Febres does include the horrific assault and other violent aspects of life for Selena on the streets of San Juan, that text rarely connects the contemporary moment to the submarine past or to enslavement, instead focusing on the performative and ultimately, the ephemeral.

In *Erzulie's Skirt*, the two women find themselves sold into the hell of sex-trafficking in Puerto Rico, and Miriam's son dead, probably thrown overboard still alive by the traffickers. The text details the violence of this new captivity and the brutal, repeated rape perpetrated on the women, who are treated as commodities in this modern-day manifestation of enslavement. The locked room in which they are imprisoned differs from Sirena's home spaces in Santurce and the gay "ambiente" where she performs in both Puerto Rico and the Dominican Republic. Lara has said of her characters, "Dominican women are the third most trafficked population in the world after Brazilian and Thai women, and Erzulie is the tie that binds us all" (qtd. in Stinchcomb 7). And as Tinsley observes, "This survival of twentieth-century captivity is framed and given meaning by its connection to a history of transoceanic slavers. Lara imagines the choppy surface of the Mona Strait as a window through which the 'other side of the water'—the liminal space where ancestors and spirits reside in Vodoun cosmology—touches the realm of the living" ("Black Atlantic" 200). The section of the text that tells of Miriam and Micaela's nightmare in

Puerto Rico begins with a segment of the dream in which She is surrounded by bodies on a slave ship and demonstrates symptoms of PTSD, such as disassociation. Micaela does the same in the bed where sheets feel like chains and she prepares for a journey into death. But neither her ancestors nor the gods will allow that surrender to contemporary manifestations of capitalism and the trade in human beings.

Erzulie, La Mar, and La Sirène, *luases* of the sea, counter the trauma of this present-day captivity and offer spiritual power to survive the extended violence of sex slavery. This deep spiritual belief shared by Miriam and Micaela is missing in Sirena Selena, who does not often call on the orishas and seems to have little protection when she enters the spaces of neocolonial capitalism inhabited by those such as Hugo Graubel. The power of commodity culture and a seeming investment in neocolonialism drive her desires and her actions. For Lara's characters, the spirits support an act of subversion and resistance, when Micaela uses her powers first to obtain beads and candles from one of the male "customers," and then performs rites and prayers that open the door and allow the women to escape. Their escape is left in the realm of the magical or miraculous, as they find the locked door open and dollars strewn in the courtyard outside the room. They run through streets no different from those in Santo Domingo, indicating the repetition involved in these experiences of the colonized island: "Outside, the road they thought was gold was a searing, tar black. The houses were like the old city of the Dominican capital. They ran down the crowded streets, past the cruel stares and the pastel buildings of the old city. They stopped only once, to ask in which direction they could find the ocean" (192).[30] Reaching the sea, "Micaela called out Erzulie's name, begging for a safe journey home" (193). That voyage is elided in the text, as the women are already back in the Dominican Republic at the start of the next chapter, which begins with the final segment of She's story, the sight of the masks waiting for Her in the hills. Lara does not conclude with romanticized visions of homecoming, however, and points to the fact that the violence born of borders shaped by colonialism may belie such notions of safe return and healing.

Nevertheless, the masks in a sense undo the geography of colonial nations as they cross borders and set up home in the Americas. As Gopinath argues, "The queer diasporic body is the medium through which home is remapped and its various narratives are displaced, uprooted, and infused with alternative forms of desire" (165). The queer desire of the two *brujas*, so perceived by their neighbors when they purchase land and resettle in the Dominican Republic, challenges the brutal impulses to impose normative boundaries and to force relation into rigid categories—as well as to turn bodies into commodities. The idea of two women as life-partners, buying property, building a house, and establishing a business, is not sanctioned by the mandates of heteropatriarchal

systems and the discourses governing them. Those dictates erupt in a destructive attack on Miriam and Micaela's colmado and garden, intended to prevent their "corrupting" the community and to reject their "satanic wares" (206). As M. Jacqui Alexander explains, women have been expected to bond against violence directed at the nation but not to form same-sex intimate relationships in the process. "Women were to fiercely defend the nation by protecting their honour, by guarding the nuclear, conjugal family, 'the fundamental institution of the society,' by guarding 'culture' defined as the transmission of a fixed set of proper values to the children of the nation" ("'Not Just'" 13). As border outlaws, Miriam and Micaela face "a somber, hopeful mass yet to awaken from the deceit of life on the plantations" (214), a group who in a night of madness and fury have destroyed what the two women have created.

The queer desire evidenced in their relationship—desire that crosses boundaries of nation, even as it transgresses gender norms and threatens the stability of lines demarcating masculine and feminine behavior—leads to attacks on the very property that they have claimed. The frenzied crowd would reassert the foundations of the plantation and the colony, even as they themselves yearn for freedom from that history of chains and forced labor. This kind of resistance is not shown as directly in Santos-Febres, because the locations are primarily in queer space in both San Juan and Santo Domingo—as discussed by Santos-Febres herself as well as critics such as Kristian Van Haesendonck.[31] Those neighborhoods are both bordered—La Ambiente—and protected, such as Hugo's house and the Hotel Talanquera where he "keeps" Sirena, and to a degree transgressive. Instead, Miriam and Micaela's transgression infiltrates the space of the plantation itself. Can their queerness shift and change that system and its dictates? Can they establish a new form of Relation? Celia Britton states: "Glissant also emphasizes the paradoxical fact that the present-day societies of the Caribbean were created by the gigantic and brutal *change* that was transportation into slavery, which, he claims, had the advantage of delegitimizing any essentialist notion of a historically continuous collective identity and thereby opened up the possibility of the people's entry into Relation" (170, original emphasis).[32] As Miriam and Micaela perform a different kind of negotiation than that of the "business women" in *Sirena Selena*, engaging with neighbors, healing and then mentoring a young girl, Yealidad, they "open up a possibility" of Relation in the space of the plantation.

In the invocations to Erzulie and La Sirène, and in the transmission of wisdom and healing powers to the young girl Yealidad, even as the two older women pass into death they leave a legacy that challenges borders and offers a vision for the future. McKittrick wonders how to give the plantation a different future, how to disrupt the geographies born of that space. She posits that "our future modes of being might hinge on a decolonial poetics that reads

black dispossession as a 'question mark'—punctuating postslavery violences and posed to our present mode of being—thus providing a critique of the very historical process that brought the Manichean working of the plantation" (3). Drawing upon Sylvia Wynter, McKittrick says that a plantation logic can "put forth a knowledge system, *produced outside the realms of normalcy, thus rejecting the very rules of the system that profits from racial violence, and in this envisions not a purely oppositional narrative but rather a future where a corelated human species perspective is honored*" (11, original italics). Lara's characters offer a vision of such a future. Miriam and Micaela initiate Yealidad into their healing arts: "The world is yours now," they tell her, leaving her with keys to their store and their female-centered connection to the seas, so that "her body filled with a new sense of belonging" (242). Like the young Leocadio at the end of Santos-Febres's novel, Yealidad represents a generation who may continue the twinned process of transgression and healing, who have the potential to offer a vision of queer diasporas and the undoing of borders that replicate the patterns of normative identification born of colonialism, reiterated by neocolonialism, enforced by centuries of violence.

Conclusion

BEYOND THE DOOR

Journeys to the Free

In *The Salt Roads*, Nalo Hopkinson invokes the oceanic depths and the watery pathways that shaped the Atlantic World. The voices of Ezili and the other female figures at the center of that narrative strive to unblock the Salt Roads and to set free the flows of aether: the souls of the African Diaspora. Contemporary works by Caribbean women writers continue that practice, in what I am identifying as four streams or narrative strategies. Commenting on the trickster figure Anancy, Janelle Rodriques states: "Diaspora culture is migration culture, and it makes sense that a being without a home—or one that exists at the threshold(s) between worlds (or rooms)—would come to emblematise this culture. It is the Caribbean's diasporic discontinuity—Anancy's trickery—that fosters creativity, and that creates culture from scattered fragments" ("'Threads Thin'" 15). In this conclusion, I briefly explore the ways that authors locate their narratives on those thresholds as they also pull the sides of the sea together, performing an archipelagic assembly: in realist fiction focused on mother-daughter relations and Black queer identities (Nicole Dennis-Benn); in speculative fiction located in Caribbean cosmology (Erna Brodber); in a novel set in Haiti that centers ecocritical and geopolitical approaches (Myriam J. A. Chancy); in poetic prose poems that develop an *ars poetica* (Dionne Brand). In a sense, all of these texts fit Kelly Baker Josephs's description of Afrofuturist narratives, works that "imagine a past for the New World present" and that create a "counterhistory of the present" (123).[1]

I.

While the characters in *Sirena Selena* and *Erzulie's Skirt* only dream of New York City, in many contemporary novels by Caribbean women writers, the protagonists do cross the sea, leaving an island home for the metropole and remembering that home from urban spaces in Canada, Britain, or the US. In these narratives, Toronto, Montreal, London, Chicago, Miami, and New York City serve as sites of complex and contradictory meanings for the female subject. Works by Jamaica Kincaid, Edwidge Danticat, Loída Maritza Pérez, and Nicole Dennis-Benn (among many others) join the "flows" of the African Diaspora as envisioned by Nalo Hopkinson: "The aether world streams. Many flows, combining, separating, all stories of African people" (*The Salt Roads* 193).[2] In doing so, they question meanings of home for the Caribbean female subject and complicate traditional notions of mother-daughter relationships. The mother herself can become equated with both the nation of origin and the imperial "motherland" that imposed colonial structures and institutions, as in Kincaid's *Lucy*. For daughters who flee that repetition of heteropatriarchal norms, New York City often serves as site of tension but also of potential agency and self-possession. Dennis-Benn takes that narrative in a new direction, as she also queers the more familiar story of generational conflict and gendered geography.

In her discussion of home, Carole Boyce Davies states: "Writing home means communicating with home. But it also means finding ways to express the conflicted meanings of home in the experience of the formerly colonized. It also demands a continual rewriting of the boundaries of what constitutes home" (129). That process of rewriting unfolds throughout Nicole Dennis-Benn's second novel, *Patsy* (2019), which follows the eponymous protagonist from Jamaica to New York City, as an undocumented immigrant who envisions reuniting with her childhood friend Cicely. The sexual desire the two girls felt and expressed led to male violence, as well as to each one's attempts to perform heteronormativity via partnership with a man. The novel's epigraph, quoting the contemporary poet Warsan Shire, testifies to the elusiveness of the "home" that Patsy seeks: "Maybe home is somewhere I'm going and have never been before." That imagined site psychologically counters the constricted spaces in which Patsy lives with her mother and interacts with her young daughter's married father. Mama G's religious fervor and Roy's job as a member of the police force together imprison Patsy in rules and expectations for women, including the stricture against abortion that meant Patsy had a child by Roy despite her antipathy for motherhood. As Patsy tries repeatedly to acquire a passport and travel to the US, both Mama G and Roy insist that she must stay, that she cannot leave her daughter Tru, because, "A girl-pickney need har mother. How else she g'wan learn fi be a woman?" (50). Nevertheless, Patsy does manage to get a

passport and travel to New York, where she imagines Cicely waiting to welcome her and start a life together. *Patsy* challenges institutions rooted in colonialism and inscribes queerness into the geographies of home on both sides of the sea.

Patsy has faced heteronormative violence in the domestic spaces she occupies in Jamaica, first as a girl when she experienced both rape and the aggressive policing of female sexuality, and later as a woman whose mother and male partner seek to keep her contained by ideologies born of colonialism. She also confronts an immigration system that militates against mobility and subsequently endures the multiple challenges of life as an undocumented immigrant—Black, female, poor—in the US. The dedication of the novel reads: "In memory of the unsung stories of undocumented immigrants in search of trees with branches." Patsy's home and family in Jamaica having proved inhospitable to the roots that she might choose to set down, she holds out hope that New York City will offer spaces of belonging and Relation. In the novel's opening paragraph, Patsy stands in line at the US Embassy in Kingston, holding all her important papers in an envelope that "carries her dream, a dream every Jamaican of a certain social ranking shares: boarding an airplane to America. For the destination and for the ability to fly" (15). That desire is reflected in Roy's nickname for her, Birdie. But her dream is based on hidden passion and mistaken assumptions, stowed away in letters from Cicely that seem to promise a shared life in America.

Heteronormativity has claimed Cicely's life in Brooklyn, a space of superficial safety that she refuses to relinquish, even when Patsy arrives prepared to commit herself to a life together, even in the face of the physical and emotional abuse Cicely suffers from her husband Marcus. Gradually, the narrative reveals the trauma that left each of them scarred both literally and psychologically: their secret space for sexual intimacy violently invaded by a stranger. "They had no place for this desire besides the old abandoned house, hidden by posts of blue mahoe and palm trees and a fence of weeds [. . .]. Concealed and secured by the lushness and decay around them, on top of a beach towel spread on the ground, the girls attained the fullest freedom" (147). Forming a kind of utopia or nowhere space removed from community and family, the secret location cannot support a public relationship. A man breaks through the fragile shelter and attacks them, in the process shattering an old mirror that wounds and scars them. That piercing of their haven demonstrates the precarious and vulnerable state of same-sex desire, perceived as "evil" and taboo in their community. Years later, Cicely has been trained to accept the rules that condemn queer love and assert heteropatriarchal norms, despite her husband's violence that leaves her visibly bruised. When Patsy sees the facial scar that Cicely attempts to conceal, she remembers "bloodstained shards of broken glass—hundreds of them that reflected bits and pieces of their girlhood that crashed down with the mirror that fell on them in the old, burned-down house" (80). As Patsy comes to realize,

Cicely will remain in the prison she herself has constructed through her adherence to gender norms and inability to give up the material trappings of success.

Set next to Patsy's struggles as she grapples with the shattered expectations that have brought her to the US. are those of her daughter Tru, left behind in Jamaica, deeply missing her mother and herself attracted to girls. As she comes into an awareness of her sexuality, Tru begins to encounter the homophobia that did violence to her mother's body and spirit. Transgressive sexualities are explored in *Patsy* through the interlinked chapters that follow Tru's life as she grows up without her mother, rejects standards of femininity, and gradually embraces her ambiguous identity. Looking more like a boy than a girl, Tru makes other females uncomfortable: "She doesn't apologize or explain. She simply stares back at anyone who stares –an act that incites people to loudly suck their teeth and cuss her under their breath. *'Ah wha dat?'*—it's a question that rarely offends Tru. She likes this ambiguity, feels secretly affirmed by it" (277). Each of these two main characters occupies an outsider position, each seeking both freedom and connection: the longing to belong. The narrative is structured in a complex weave of past and present, as well as the double perspectives of mother and daughter, so that Dennis-Benn captures the interlocking challenges encountered in the search for safe spaces, particularly by Black lesbian girls and women, not only in Jamaica but also in New York City.

During her first decade in the city, Patsy remains an outsider, living in borrowed space and working the kinds of jobs available to undocumented immigrants. Dennis-Benn shows both the living spaces and work conditions that cause stress and illness, a nexus of limited options that lead Patsy to consider America a coffin: "Patsy's visa status has draped itself like a thin gauze throughout the years and she is caught in its mesh" (244). She knows that she is never going back to Jamaica (249) and sees herself as an eternal outsider, "a landless wanderer" (259). While we witness Tru cutting herself in response to having to wear a dress from her grandmother, we also observe Patsy's PTSD surface from even deeper inside: her memory of being raped and impregnated by her "uncle" Curtis, which led to a still-birth when she was only twelve years old. The juxtapositions explain Patsy's inability to mother and Tru's insatiable desire for maternal love and attention.[3] A potential healing necessitates the release of trauma, a testimony expressed in Patsy's scream as she relives the childhood violation: "Her castaway innocence has long been drowned by the sea, and Patsy weeps for the girl who died with it" (302). In the process of expelling that grief, Patsy begins to pry open the bars of normative thinking that continue to trap her. Nevertheless, she fails to see that her ingrained concepts do damage to her daughter's own sense of self.

The "barrel of love" that Patsy works to fill with girls' clothing and feminine accoutrements for Tru becomes not only a mistaken gesture but also a

potentially fatal one. The dresses, skirts, and "a bag full of girlie accessories" (401), material items sent as replacement for the love and care she has not been able to offer the girl, convey a message that reinforces gender norms and illustrates the damage they inflict. While the term "Barrel of Love" is accurate in that it brings together Patsy and the woman who will become her lover (Claudette), ultimately it proves ironic in that the gesture underscores Patsy's ignorance surrounding her daughter. As already noted, Tru grows up challenging gender binaries, in her devotion to playing soccer with the boys, her choice of a short haircut, her binding of breasts to hide her womanhood, and her unapologetic embrace of who she is. The missing piece in her life is her mother, so when the barrel representing Patsy arrives containing such a blatant lack of awareness of Tru, the effect is cataclysmic. In an act that resonates with the scene of trauma for Patsy and Cicely, Tru breaks a mirror with her fist and attempts suicide with one of the shards. As Roy says to Patsy when he calls with the news that Tru is hospitalized, "A stupid barrel. Dat's all it was to you. A selfish guilt trip. A Band-Aid fah di deep wound yuh cause" (403). The attempt at self-annihilation, after the act of breaking her mirrored image, provides the catalyst for Tru's passage through despair to selfhood and freedom. She begins to understand the forces in Jamaica that her mother was fleeing, ones that she also confronts. And she reads a letter from Patsy that confesses and explains her inability to take on the role of mother, as well as expressing her love for her daughter.

Nevertheless, the text refuses narrative closure that would reunite mother and daughter, affirm that form of female bonding, or otherwise simplify Patsy's struggle to claim her own identity and plant new roots. In a sense, it mirrors in reverse the fraught mother-daughter relationship at the center of Jamaica Kincaid's *Lucy*, in which the daughter escapes the colonizing force of both her mother and her motherland (Antigua). *Patsy* also denies the kind of reconciliation performed at the end of Edwidge Danticat's *Breath, Eyes, Memory*, in which Sophie takes her mother's body home to Haiti after Martine's suicide in New York. Patsy resists a return to the home/mother land, forcing Tru to find her own path. While the mother becomes a transplanted tree in New York City, the daughter claims her queer identity on home soil. The final chapter, "What Is True," focuses solely on Tru, who remains firmly in Jamaica, going steady with a girl: "Tru doesn't like the idea of pinning things down, defining them. She relishes this ambiguity of liking who she likes" (421). The narrative concludes with her leading her soccer team and scoring goals as a recruiter from Cambridge University watches. Her public performance indicates her degree of comfort with claiming same-sex desire within the home country, claiming what Michelle Cliff called "an identity they taught me to despise" ("Identity"). *Patsy* thus undoes familiar tropes and envisions homes designed with new blueprints and constructed with new tools.

II.

"I gazed outside into the sea which touches our past and the Future, the sea of odd, interesting things" (Brodber, *The Rainmaker's Mistake* 134). As a coda to chapter 1, which analyzed Hopkinson's *The Salt Roads* as an Afrofuturistic imagining of the Middle Passage and enslavement (as well as the diaspora that resulted from those traumas), I turn to Erna Brodber's novel *The Rainmaker's Mistake* (2007). Janelle Rodriques states: "Modern Caribbean existence has always already been speculative, as 1492 indeed bore witness to a supernatural cataclysm whose aftereffects continue to be suffered globally" (4). The Caribbean lies at the center of that traumatic upheaval, the site of disaster and of unprecedented change, which Brodber excavates and imagines in her fourth novel. Brodber herself explains the impetus behind her creative endeavors:

> My sociological effort and therefore the fiction that serves it, unlike mainstream sociology, has activist intentions: it is about studying the behavior of and transmitting these findings to the children of the people who were put on ships on the African beaches and woke up from this nightmare to find themselves on the shores of the New World. It is my hope that this information will be a tool with which the blacks and particularly those of the diaspora will forge a closer unity and, thus fused, be able to face the rest of the world more confidently. ("Fiction in the Scientific Procedure" 164)

In *The Rainmaker's Mistake*, Brodber reimagines both the plantation and the diaspora, melding past and future into a potential present of freedom. Positing enslavement as the perpetuation of a vegetative state based in labor that produces without procreation, growth, or maturation, the text then buries the "master" and begins to disrupt the status quo. Mr. Charlie's project of growing his own yams, or an enslaved labor force, starts to collapse as the people question what they have been told, move beyond fixed boundaries, and walk, swim, or fly into the future.[4]

Embodiment presents both problem and answer in this retelling of Caribbean—and Diasporic—history. One character, Queenie, pursues an MD so that she can understand biology and find an explanation for her people's stunted development. She also studies archeology in order to excavate and comprehend both the past and death itself. In the past lies the future: "—Something was done to make us forget that we were ever at any other stage than the one in which we entered work," Queenie tells Abdul (130). He replies, "If we know one theory and the technology by which we were changed, we should be able to direct our forward change" (131). The plantation, their

existence as Mr. Charlie's yams, involved indoctrination into a state of shame, humiliation, and "robot-hood" (142). That training has rendered them "retarded people, kept at your particular task for eternity," mindlessly working cane (143). The crucial step is to understand the past and to act on that knowledge, to move toward and into freedom.

That shift also entails a new relation to the sea.[5] On an island, one can fall into stasis, gazing at the surrounding waters:

> The dominating sound is that of the sea and it is having a somnambulistic effect on me, lulling me to sleep with its splash here and splash there, in rhythm. [. . .] I've taken the seaway back to the past to help take the dirt here; I've taken the seaway to the Future quite often. Apparently travelling on the sea is one thing and looking into the sea and watching the past and the Future merge is quite another. (120–21)

To travel the seas takes one out of stasis and zombification, into spaces that bridge past and future, waves going in every direction (122). The novel begins with Mr. Charlie addressing the "yams," telling them that the year is 1834, they are under six years old, and now free (10). At the beginning, they see him as "Our Father, Our Maker, Our Preserver," and do not comprehend what he says, even more so when he almost immediately states that the year is 1838 (11). The narrative zigzags through time, landing in the 1990s, but also erasing clear temporal markers. Spatial signposts also shift and transform, as the characters migrate to another island, fly airplanes, and seek to establish their own community. Centuries after the Middle Passage and decades after emancipation, the destination is true freedom.

The narrative questions the meaning of "free" and circles around and through possible ways to grasp it, one of which is "naturalness" (146). The characters gradually understand themselves now as human—and mortal—with the power to form relation. They can "grow ourselves into a nation. Right here. Not off into the Pluperfect with Jupiter. No Future, no past. Here and now" (149). The power to relate and to create together offers hope at the end of the novel. The "Master," Mr. Charlie, is a dried-up carcass in a cave, buried, disempowered, to be forgotten. The people who start to see themselves as emancipated, on the other hand, hold potential: "It is naturalness twinned to mortality, accompanied by hope, and duly tempered by responsibility. [. . .] See you there. In the free" (150). These concluding lines of *The Rainmaker's Mistake* underscore the power of a Caribbean, diasporic vision of the present that renders the past a catastrophe of exploitation, a nightmare from which to awaken, a soporific acceptance of the sea that must be transformed into active engagement with the present. Brodber presents an Afrofuturist re-vision, or

a "counter history of the present" (Josephs 123).⁶ The novel offers a Caribbean cosmology, as theorized by Brathwaite, a version of tidalectics that refuses dialectical thinking, challenges linear temporality, undoes European mapmaking, and envisions a new space: the free.

III.

Another stream in contemporary Caribbean texts explores the epicenter of the African Diaspora, Haiti, through spiritual, environmental, and geopolitical lenses. Myriam J. A. Chancy's recent novel *What Storm, What Thunder* (2021) provides a multiperspectival narrative of the catastrophes that continue to strike the first independent Black nation in the Western hemisphere, focusing on the massive earthquake of January 12, 2010, that devastated the nation. In placing Haiti at the heart of the African Diaspora and reminding readers of its deep connections to both Africa and the Americas, as well as the unceasing interference it suffers from the US and other nations, Chancy demonstrates both the precarity that continues in the twenty-first century and also the endurance of Haiti as a site of revolution. Centering the experiences of women and children, Chancy employs the ecological and social disaster of the 2010 earthquake to explore questions about madness and insight, violence and trauma, the exploitation of natural resources such as water and land, and possible forms of reparation and healing.

Both the *lwas* of vodou and an icon of Black history frame the text; epigraphs juxtapose the traditional invocation to Legba, god of the crossroads and of communication, with the words of Frederick Douglass (1852) that provide the novel's title: "For it is not the light that is needed, but fire; it is not the gentle shower, but thunder. We need the storm, the whirlwind, and the earthquake." Douglass's voice resonates with the rage that Brand's author expresses and the adamant refusal of Brodber's characters to remain mute and obedient. The cataclysmic earthquake referred to as "Douz" (the date it occurred) offers a window into contemporary Haiti and the centuries-long anti-Blackness that has blocked its path to freedom and independence. On one level, the novel is an indictment not only of European (especially French) involvement in Haiti but also of the role of the US in perpetuating economic exploitation and intractable immiseration.

The text is framed by the figure of Ma Lou, a market woman who connects the other nine characters whose stories form the narrative. Ma Lou's first section opens with an invocation to Ezili, in which the speaker says, "I have no bones" (3). The novel excavates ossuaries both literal and symbolic, particularly the stories untold and the people lost to violence and disasters. Ma Lou listens to others, gathers those voices, and weaves the text:

> Like a sponge, I absorb and grow fat and round. The weight of their words like leaves imprinted into my flesh, hanging heavy from my frail bones, rooting myself to the ground because it is the only thing that I can be sure of, then, now. Who's to say that the red of the earth of this island isn't drawn from the blood of women like me, sitting in the markets, pooling? (12)

Ma Lou contains the lives of multitudes, particularly impoverished women, who form the soil and foundation of the country. The polyphonic form of the novel constructs a complex depiction of the earthquake and its immediate aftermath, as well as of Haitian identities, social relations, power dynamics based in both gender and color, and belief systems rooted in Africa and the diaspora—Brathwaite's African Atlantic.

In a conversation with Nicole Dennis-Benn (hosted by the Center for Fiction in Brooklyn), Chancy noted that the character Jonas, a young boy, came to her first, saying that she wanted in part to explore the experiences of children during and after the earthquake. In his section of the novel, Jonas explains what the word "Douz" means to him. He was only eleven when it shook his world, leaving him with an amputated leg and the understanding that he would never again play soccer. In mathematical formulations of hours, days, weeks, Jonas narrates the loss not only of his limb, but of his two sisters killed instantly by falling debris, his father who abandoned the family, his mother gone mad, and his own death. Trauma informs his narration, both disassociation and splitting or doubling, as a child's delight in marbles, marketplace, and sports weaves through his impressions of the catastrophe and his own excruciating experience. His words connect the characters who have already offered their stories, so that his narration also provides a capsule version of "Douz." The horror grows more explicit as he describes the sight of his younger sisters disappearing under one of the walls of their home, the crude method of amputating his crushed leg, the infection that invaded his body, and his death.

> Times infinity: the number of microbes that multiply and spread tentacles from the sutures holding together the seams of my missing leg, crawling through tissue, to blood, to my heart, and settling there, like displaced people needing to set up camp on land not their own, like us. Me, looking on my body upon the mattress, and Mama moving slowly around the bed where it lies. [. . .] I am flying in the air, laughing, not a care in the world. I can see my little sisters, too, playing hide-and-seek inside and around the tent. (293)

Jonas's narration viscerally illustrates the physical and mental damage suffered by children in a disaster, emphasizing the effects of such trauma as they ripple through an individual, a family, and a community. As Haiti has been repeatedly occupied and exploited by other nations, including the US as neocolonial power, and as Haitians have been displaced within their own country, so Jonas describes his body invaded by a toxic infection and eventually succumbing to death. His passages are replete with insights and awareness, logic and poetry, even as what he describes includes forms of madness.

His mother, Sara, does go mad in the aftermath of the earthquake, as she suffers the loss of her two daughters, abandonment by her husband, then her son's death, as well as the destruction of their home and any semblance of stability or belonging. In a camp for displaced persons in front of the collapsed cathedral in Port-au-Prince, she remembers a childhood filled with love and laughter despite extreme poverty: "Being born in scarcity—in a shack by the ocean on a stretch of beach an hour out from the big city, a stretch that had since been privatized for the wealthy, and for the tourists who were given run of the place—had been preparation for a life of gratitude" (13). As she follows a thread of memory through her life with Didier and their three children, she is driven mad by grief and haunted by a menacing presence, coming to occupy a liminal space not only physically but also spiritually: "She had crossed over. That was what it was. She had crossed into an in-between world in which the ghosts could see her, but she could not see or touch their shimmering contours" (24). In her borrowed space under a tent, she creates a nighttime ritual to tame and quiet the spirits tormenting her. She prepares for night by setting bowls of water around her mattress, three of salt water for the "malevolent ghosts," three of fresh water for the spirits of her children. The tent catches fire from the candles she burns, and in her madness, Sara does not comprehend the danger, "transfixed by the blaze eating through the logo: 'A gift from the American people'" (32). The flimsy protection, not fireproofed, mirrors the deeper systemic flaws in neocolonial power relations. As a character states later in the novel, "[p]hilanthropy is a form of necrophilia" (242). In multiple instances, the central characters encounter danger and violence, not support and safety, some like Jonas dying, others choosing to take their own lives.

One critical form of violence exacerbated by the aftermath of the earthquake is that directed at girls and women—experienced by young Tafia, who witnesses the immediate destruction and then suffers multiple traumas in the following days and weeks. As corpses pile up and she helps to excavate more bodies, she also observes the swift formation of male gangs that will draw in not only the boys in her devasted neighborhood but also her beloved brother, Paul. The narrative performs an avoidance, replicating PTSD, as Tafia spins into memories

beginning with her birth and gradually moving towards the present moment of April 2010. Mentally mapping the tent city, learning to navigate it especially at night, she still cannot avoid the threat of sexual violence that permeates the dark: "At night we heard screams and all of us knew what they meant. They weren't screams of despair any longer but something else, like when dogs are kicked, or worse" (153). A young man, Junior, who had threatened Tafia before the earthquake, becomes infinitely more dangerous in the present, leading to the "night it happened, something worse for me even than Douz, that would mark and change me even further, forever " (163). Viciously assaulted by the male gang, Tafia becomes pregnant. Her trauma and PTSD take the form of a pair of scissors, two sides, before and after, joined, with no way to forget: "The feeling uniting dream and pain lasts eternally, but you yearn for the return to a blank space, the in-between suspension between the two before they came to be jointed. You yearn for the sweet, open-eyed innocence, the comforting warmth of the blankness, to never become aware of the jointing itself, of then having to live in the after, always, remembering the before" (170). The second-person pronoun also serves the function of disassociation, severing Tafia from the gang rape and its consequences, even as her life has been irreparably riven into two. Perhaps fittingly, after the tent fire, Sara is brought to live with Tafia and her remaining family, each haunted by the past and alienated from the present, their traumatized states challenging any hope for healing.

As the narrative unfolds and each character's voice adds new dimensions to the cataclysm, the text also becomes a condemnation of the causes of Haiti's precarious state, linking past to present, indicting the US in particular. Once rich in resources, the country has been laid waste by exploitation of water and land, by the ravages of capitalism, and by the decades-long imposition of an insurmountable debt. The gestures of aid do more harm than good, intensifying the damage and contributing to the cycles of poverty and violence. Port-au-Prince, the capital, embodies those patterns: "The city was like a raw, exposed nerve delivered up to the winds and the dust swirling through the devastated and broken streets. [. . .] Concrete was cheap, had replaced wood since foreign powers had deforested the land. [. . .] Beyond the physical collapse, one could feel a heaviness in the air. Let me say it: one could feel the dead" (266). Pledges of money from around the world are not what the country needs, because those funds do not go directly to the people: "Imagine if every single Haitian who lost someone could get their hands on some of that money, decide what they needed for themselves, their family? You could create a healthy middle-class and still, there would be millions amassing in a treasure trove behind them. But of course, they won't let that happen" (230). "They" refers primarily to the US, the primary neocolonial power preventing Haiti from achieving necessary forms of autonomy and self-determination. Clothing factories in the capital

and other parts of the country epitomize this ongoing exploitation: "By March 2010, the American government could give a fuck about butthole Haiti and its abject masses as long as they provide their 'competitive advantage' to the world economy: pittance labor" (232). These thoughts come from Olivier, who represents those who are part of the land and oppose forms of exploitation like selling a natural resource—water. His section ends when he runs in front of a truck, committing suicide. Ironically, another apparent suicide is Richard, who has profited by selling bottled water. A counter or foil to Oliver, Richard turns to the sea, walking into the waves off the beach of an old plantation converted into a 1960s resort: "Then, all there was, everywhere, was water: water, on all sides of me" (95). Neither Olivier nor Richard sees a way to address the past and chart a different future for Haiti, so that their suicides, along with the deaths of other characters in the chaos of the earthquake, would suggest a pessimistic outlook on Haiti's prospects for change going forward.

Ultimately, however, the text does propose a way to combat the violence and ongoing anti-Blackness, as the narrative returns to the perspective of Ma Lou. A truth bearer and the voice of wisdom, she represents the market-women like Chancy's great-grandmother, those who (according to the author) know what is happening, both locally and globally, including in economic terms. They hold society together, through their practical knowledge as well as their belief in the ancestors and the *lwas*. A further irony is that Richard is Ma Lou's son. He learned entrepreneurship from her, but profited from corrupt forms through his capitalist venture of selling a natural resource that belongs to all. The novel comes full circle, back to Ma Lou and to her opening invocation to bones. Ma Lou states: "We are particles in motion. That is why the gods can descend into us. My mother's gods. Lou's [her husband's] gods. The ancestral gods. Our gods. We must find our way back to them. No more rosaries and earthenware statues, no more churches that fall down around our ears. [The *lwas*] allow us to see into things beyond us. Because everything has always been moving, falling. *Se konsa*" (299). She has argued with a judge not to move a cemetery, when she was arrested trying to save the bones. They carry energy in their marrow, she argues: "I feel the chill, the sadness. I feel some of the spirits lingering there, at the crossroads" (301), which is Legba's realm.

Her path leads out of Port-au-Prince, away from death and destruction, to her other home. Sacred waterfalls along the way will provide relief and purification: "Our bones, too, need a cleansing, to be released from all that they have seen and absorbed these last years of sorrow and grief. Grief resides in the marrow. [...] It's what weighs us down and pains us as we grow old: the grief in the marrow" (304). The bones she has carried home are buried in her village in the final scene, but she also acknowledges and mourns those who died in the earthquake whose bones have not been rescued:

> I think of all those bones with no one to claim them, all the bodies that were thrown into a pit somewhere on the outskirts of the capital, beneath the cleaned-up city, disintegrating, becoming foundation. I realize, then, that those who died may have been unclaimed, their remains abandoned of necessity, but never, never, were they unloved. For all of them, for us, with Anne's [her daughter's] palm against my mouth, I weep. (307)

Ma Lou, the female elder who weaves the text together, is a repository of the multiple, on-going traumas, an archive of the individual and collective narratives, and has survived "Douz" along with the preceding disasters and the harrowing effects of neocolonialism.

IV.

"Our origins seemed to be in the sea" (Brand, *Map* 12). Perhaps more than any other living author, Dionne Brand has pondered the African Diaspora from multiple, complex angles in fiction, essay, memoir, poetry, and variations on each of those genres. In *The Blue Clerk* (2018), she offers prose poems that explore the written and the unwritten, as well as fragments and drafts, shaping an *ars poetica* that arises from the depths of the ocean and stretches outward across the globe. *The Blue Clerk* presents a dialogue between the "author" (who resembles Brand in references to works like *Inventory*, *Thirsty*, and *Moon*) and the "clerk," a textual performance of creating, producing, receiving, responding, connecting, and archiving. The reams of paper that the clerk endlessly sifts through and sorts recall the children of Bola in Brand's novel *At the Full and Change of the Moon*, a line of descendants linked to Bola's enslaved mother Marie-Ursule, tortured and murdered for her role in an insurrection and spread outward from a bay in Trinidad to create a fictional version of the diaspora. This aesthetics embodies the streams of the African Diaspora, as the clerk stands on shore surrounded by bales of paper, awaiting ships that carry texts, not captured Africans. The pages proliferate and pile up on the sand, resembling the tidalectics movement theorized by Brathwaite or the mangrove posited by Glissant to illustrate Caribbean Relation. *The Blue Clerk* resonates also with Glissant's words in his volume *Black Salt*, lines in an invocation to the sea: "*There—on the delta—is a river where the words pile up—the poem—and where salt is purified*" (61, original italics). Brand's clerk of (the) blue engages with a vast repository and ever-growing archive of fragments and files, performing an *ars poetica* informed by the experiences of colonized subjects and methods of resisting the Man/other dichotomy.

The sea is a primary archive, and the symbolic ship traversing it has rotted for four hundred years, the centuries marked by the African slave trade, plantation logic, enslavement, and the toxic institutions that perpetuate those ideologies. On the shore, the clerk sees waves as liquid pages: a library that reminds the author of one in Trinidad. Together, clerk and author perform a transformation or transmogrification of the diaspora, a sea change.

> There are bales of paper on a wharf somewhere; at a port, somewhere. There is a clerk inspecting and abating them. She is the blue clerk. She is dressed in a blue ink coat, her right hand is dry, her left hand is dripping; she is expecting a ship. She is preparing. Though she is afraid that by the time the ship arrives the stowage will have overtaken the wharf. [. . .] The clerk looks out sometimes over the roiling sea or over the calm sea, finding the horizon, seeking the transfiguration of a ship. (4)

She begins to compile a new manifest, not of bodies and commodities, but rather of women's stories, experiences, and methods of creation. The endeavor remains always in progress, always challenging received ideas and official history. This *ars poetica* places women at the center and illuminates their movements, like the flows of aether through the Salt Roads.

This text meanders, travels, remembers, and invents, becoming an archive of the writer's life and creative vision, her cartographies of the spirit. The clerk also writes, offering a succinct statement about the colonizing impetus of empire: "*The empires*, she fumes, *the empires called culture and religion only have one province left—women*. Her notebook is sleepless" (27, original italics). With the author, we travel to Elmina (one of the "slave castles"), where this modern history began, focusing on woman as alien, without nation: "the dirt floor, the damp room of the women's cells, nation loses all vocabulary. Loses its whole alphabet. [. . .] Of course the earth is beneath your feet and so there must be place or the feeling of place or gravity. But which nation ever said of a woman she is human? So what allegiances do you have? Temporary and provisional, wherever" (40). The clerk asks the author, "weren't you always an outsider?" (40). That alienation leads to insanity: "But then it struck me later that the mad woman's moment of lucidity was the entranceway to women's madness on earth" (41). The real madness lies in the colonizer's mind and actions, such as Columbus capturing Taino from Hispaniola, an othering that led to European "zoos" of human beings. Such forms of imprisonment and grotesque display are directly linked to contemporary life, to the ways that the colonized are trained to perform as if captive in a zoo.

That captivity occurs in language, such that the author cannot express resistance when using the colonizer's tongue. The concept of transgression

assumes the law is legitimate, natural, normal. Rather, the text argues, the slave castle leads directly to the human zoo, and language (English, in this case) keeps the colonized captive in the same way: "Even the language that we used to combat the more awful ailments, even that can be turned inward on itself. To *transgress* to *rebel*. They capitulate to the existence of a law, a *truth*. So you are dying in their etymology. And these words are, at the core, a construction of the zoo" (82, original italics). The author's job, she says, is to stay uncomfortable and unsettled, as she excavates the bones at the core of empire, her material gathered from across the globe. For her, all of life is an "emergency," specifically for women and female embodiment: "the death of a certain set of narratives, the death of the aesthetic of imperialism. It is an aesthetic that contains narratives of the body, bodies that the poet suggests were dead anyway" (92). The effects of colonization continue to manifest in the present as forms of captivity, corporeal, mental, spiritual: "Well, I can only give you a glimpse of these bits and pieces of a body that has been deconstructed as itself, and reconstructed as a set of practices in un-freedom" (93). Yet, the author continues to imagine and create, as the clerk continues to sort the endless bales of paper.

As in Brand's other works, homesickness permeates this text, the longing to belong. She states in *Map*: "I am interested in exploring this creation place—the Door of No Return, a place emptied of beginnings—as a site of belonging or unbelonging" (6). Where is home in diaspora? Can it lie in the bales of paper, perhaps change them from ships' manifests to the author/poet's charting of the diaspora? Yet, both futility and madness inflect many passages in *The Blue Clerk*, particularly those delivered in the voice of "the author." Perhaps home resides in the spirit, whose cartographies Brand has mapped for decades. In a late verso, we return to Elmina (unnamed) and the passage out into the diaspora: "When I finally arrived at the door of no return, there was an official there, a guide who was a man in his ordinary life, or a dissembler. [. . .] Our gods were in the holding cells. [. . .] They stood when we entered, happy to see us. [. . .] They felt happy for us, we were still alive" (223). She continues: "We were pilgrims, they were gods. They said with wonder and admiration, you are still alive, like hydrogen, like oxygen" (224). That connection and that recognition, the affirmation of life, counter the state of un-freedom and may unlock the gates of the zoo.

The final verso underscores the role of an *ars poetica*, the power of the written word, as it offers a "reading regimen," instructions of what to read when writing poetry, when writing fiction, ending with the single word, "Almanacs" (232). Brand writes elsewhere of living in the African Diaspora as inhabiting a fiction, "a creation of empires, and also self-creation" (*Map* 18). She continues: "So I am scouring maps of all kinds, the way that some fictions do,

discursively, elliptically, trying to locate their own transferred selves" (19). Brand's pages serve as maps, guiding clerk, author, and reader on journeys both real and imagined, preserved and lost, through the seas that birthed the African Diaspora. The words both remember and refuse the ideologies that imprison colonized and colonizer. Words chart the diaspora as they also offer a key to self-invention that can unlock centuries-old cells, or in Hopkinson's vision, unblock the cancerous Salt Roads.

NOTES

INTRODUCTION: THE CARIBBEAN ATLANTIC: TRAUMA, RELATION, RESISTANCE

1. The ending of Brand's novel *At the Full and Change of the Moon* is one example of that combination of grief and embrace, its elegiac note sounding throughout her oeuvre (as I have discussed elsewhere).

2. Brathwaite develops the concept of tidalectics beginning in the mid-1990s, particularly in his collection *Barabajan Poems*. See Savory: "Tidalectics can be expressed (or as Brathwaite would put it, xpressed) as the ways in which ideas flow together and separate like the edges of waves on a coral beach. They weave together, reshape, separate, flow back, and come forward again. This is more accurate as an image of Caribbean intellectual traditions than are such Euro-American oppositional models as dialectics" (190). See also Savory 192. Tidalectics is part of Brathwaite's concept of "nation language," which forms a core of his poetics and his poetry.

3. See Llenín-Figueroa on Glissant: "the submarine connections substantiating the status of Caribbean literature as Relation's 'archive.' This is the case because in Caribbean literature, we find an affirmative reconceptualization of the archipelagos' 'smallness' against the imperial '*grandote*,' a register of the submarine histories that we share versus the territorial History that alienates us, and an affirmation of the archipelagic multiple versus the Western regime's continental One" (89).

4. Michelle Stephens discusses contemporary Caribbean art in terms of islands, archipelago, and sea, noting that

> the word *archipelago* derives etymologically from the Greek *arkhi*, meaning "chief," and *pélagos*, meaning "sea." In the original meaning of *archipelago*, which now denotes an island-system or chain, the island itself does not appear. Rather, the archipelago was the name of a sea, the Aegean Sea, [. . .]. It [the term] retains the sense of islands as liminal spaces somewhere between land and water, defined by the relation *between* the territorial and the oceanic rather than by either alone. (10)

5. See also Walcott, "The Antilles: Fragments of an Epic Memory," in his *What the Twilight Says*.

6. See also Bonfiglio, who references Brathwaite's use of the term "African Atlantic": "'utterly involved with African Atlantic: its engines, energies, exhilarations, its memories & whispers & rumours of Atlantis on my face, my history, my body, facing the sea . . . '" (Bonfiglio 161).

7. To re-member is both to remember and to put back into embodied experience, a re-embodying. It includes putting back together the fragmented bodies and lost souls.

8. See Sharpe, *In the Wake*.

9. While Benítez-Rojo's work lays a groundwork for thinking about the plantation system, I turn instead to Caribbean women writers themselves for theoretical approaches, most specifically Wynter (and McKittrick's work that expands on Wynter's thought) and Philip.

10. While the term "routes and roots" comes from James Clifford's pathbreaking study, many scholars have since employed the phrase; most useful for my discussion is DeLoughrey's "Routes and Roots."

11. See Bonfiglio's discussion of the Caribbean essay, in which she examines Glissant, Brathwaite, and Benítez-Rojo from an archipelagic perspective: "If water, and especially the sea, according to Bachelard's phenomenology of imagination, is a melancholic element *par excellence* which incites memory and remembrance, recalling in the Caribbean can in turn lead to *re-membering* (re-assembling) the archipelagic fragments" (166). As I have discussed elsewhere, re-membering can also invoke the traces of those who lost their lives in the Middle Passage as well as in enslavement on the plantations.

12. See also Roach, who studies performances in circum-Atlantic "Cities of the Dead" such as New Orleans and London.

13. See also Mbembe, "Necropolitics."

14. See, for example, Wynter's discussion of the sociogenic principle (which she adapts and expands from Fanon), her essay "1492," and "Unsettling the Coloniality," which I discuss below.

15. See especially McKittrick, *Demonic Grounds*, which is informed by Wynter's theories; see also Philip, especially "Dis Place"; see also Weheliye.

16 On Gilroy, see Helmreich 245; DeLoughrey, "Gendering the Voyage." See also Dayan.

17. See also McKittrick, "'Who Do You Talk To'" (on the work of Philip).

18. See, for example, King, *Island Bodies*; the essays collected in *Our Caribbean*, edited by Thomas Glave; Tinsley's *Thiefin' Sugar* (on women's same-sex love in Caribbean poetry); Sheller's *Citizenship from Below*.

19. Sheller cites Thomas Glave, Makeda Silvera, and others in making this claim.

20. Other Caribbean women writers who explore "queer livity" in their fiction include Michelle Cliff, Dionne Brand, Oonya Kempadoo, Myriam Chancy, and Nicole Dennis-Benn.

21. See also Sheller, "Work That Body"; Outar; King, "One Sustained Moment"; Thomas Glave.

22. See also Boyer's analysis of what she terms *archipelia*, based in Glissant's theories: "Los archipiélagos no son ni islas ni continentes, y en ello consiste todo su interés" (17). As Boyer's title tells us, she sees the archipelago as "the place for the Relation between (geo)aesthetics and poetics." "La importancia del mar Caribe radica entonces en que trae consigo la diversidad" (20). See also Dash's discussion of the "submarine" in Glissant and Brathwaite: "this pattern of archipelagic thought leads away from ethnocentrisms and legitimizing genealogies" (199).

CHAPTER 1: WATERY WEBS WEAVE STORIES:
UNBLOCKING THE SALT ROADS IN MARSHALL, CLIFF, AND HOPKINSON

1. Gikandi comments that "although the middle passage represents the temporal moment when the slaves are dislocated from Africa, it is also a challenge to them to reassemble their cultural fragments, fuse their multiple identities, and appropriate imprisoned social spaces" (14). See also Nielson (though he focuses primarily on the significance of the Middle Passage for the US): "we cannot truly tell ourselves a free story till we tell ourselves that we are truly the children of the Middle Passage. It is a story that brings to bear upon our daily lives the full indebtedness of our identities" (171).

2. Equiano's origins have been questioned, based on evidence that he was born not in Africa but in the southern US and that his narrative of the Middle Passage is a fictive reconstruction, not an autobiographical account. See especially Carretta. Nielson states: "The Middle Passage may be the great repressed signifier of American historical consciousness" (101). He also argues that "the Middle Passage is everywhere inscribed within the archives of our thought," and it "irrevocably hinges African and American cultural experience" (103).

3. On Hayden's poem, see Smith, especially 69–78.

4. All passages spoken in this voice appear in bold print in the original text.

5. In her discussion of contemporary revisionist representations of the Middle Passage, Mayer comments that all of them, "different as they are, concentrate on the fantasy space in-between and nowhere at all, spaces that present themselves as mixed-up, ambivalent, floating. The most obvious of these in-between spaces is, of course, the sea, this paradigmatic space of openness and indeterminacy which gains so radically contradictory connotations once it becomes the setting for abduction, violation, enslavement, and revolt" (556).

6. Nielson comments on Marshall's novel *Praisesong for the Widow*, in which African American Avey Johnson flees a cruise ship in the Caribbean and discovers her "roots" in the small island of Carriacou, that the text "does not return to a continental home in Africa but seeks its salvific renewal in the syncretic cauldron of the Caribbean, in the Antillean heart where Africa and America meet" (135).

7. The term "re-membering," which also invokes Toni Morrison's "rememory" from *Beloved*, is one that I developed in the essay that began this chapter's discussion of the Middle Passage. See Garvey, "Passages to Identity."

8. Gikandi notes that "narrative, and the act of narration, have immense powers to counter the colonial vision; against the stasis of imperialism, narrative introduces the disruptive power of temporality" (28).

9. See also Jonathan Smith's discussion of Hayden's poem: "Black history reaches back across the Atlantic to Africa, but black home never quite outspans the ocean. The mocking ships on the horizon are thus mournful symbols of the mythic and impossible return (in a sense, back through blackness) to Africa—an Africa which, because of the trade, no longer exists as the captives remember it" (75).

10. On this positioning, see Coser 3; Rahming 79, 86; DeLamotte 227–28, 234. See also Keizer, who comments on a view the character Saul expresses: "This view of Bournehills—as testimony to and memorial of the Atlantic slave trade and plantation slave labor as well as rebellions against slavery—is not merely Saul's partial view, it is the novel's perspective, the

revelation to which the entire work directs its readers. [. . .] Bournehills is the receptacle of these histories for the Americas as a whole, not simply for Bourne Island or the Caribbean" (89).

11. Coser explores the interconnection of time, place, and peoples offered by this choice: see her chapter 2. See also Christian 113.

12. On Hopkinson's fiction as "fabulist" and "speculative," see especially Batty; Houlden; Nelson; Sorensen.

13. In commenting on Marshall's protagonist Merle, Rahming points to a movement that characterizes all of the works under discussion in this chapter: "Since, like Caribbean society, Merle is herself the repository of a cultural diversity, her impulse toward a unified consciousness can be seen as reflecting the sociopolitical impulse of the Caribbean toward the coherence of its disparate parts, the meshing of its varied cultural influences into a distinctly Caribbean cultural identity" (81). These authors also display a *diasporan* cultural identity, as theorized by Gilroy in *Small Acts*, among others.

14. In *Small Acts*, Gilroy comments:

> The value of the term "diaspora" increases as its essentially symbolic character is understood. It points emphatically to the fact that there can be no pure, uncontaminated or essential blackness anchored in an unsullied originary moment. It suggests that a myth of shared origins is neither a talisman which can suspend political antagonisms nor a deity invoked to cement a pastoral view of black life that can answer the multiple pathologies of contemporary racism. (99)

For an extended discussion of Black aesthetics and diaspora, see Edmondson, "Race, Privilege, and the Construction" 109–20; Edmondson, "Race, Privilege, and the Politics" 180–91. See also Coser 22–24; Dance 14; Willis 57.

15. See, for instance, chapter 7 of Hartman's *Lose Your Mother*. See also her "Venus in Two Acts." I explore more of this approach in chapter 2, particularly in the discussion of Philip's *Zong!*

16. On race and class, especially the role of labor and of capital, see Keizer: "In *The Chosen Place*, Marshall represents diaspora as a continuing process, not as a fixed reality. The original African Diaspora, the scattering of Africans through the Atlantic slave trade, is repeated again and again through the operations of multinational capital and the still-powerful forces of the European imperialist powers" (84).

17. See Beckert; Baptiste; Baucom. I discuss this set of issues in more depth in chapter 2, particularly in connection with the *Zong*.

18. Merle's name contains the word "mer," which circulates among the names of Hopkinson's characters and draws attention to both the ocean and to maternal relation.

19. See Wynter, "Beyond" 363, 365. See also Pettis, "'Talk'" 109–17, for a discussion of the links between diasporic experience, identity, and speech.

20. On homophobia in the Caribbean, see Alexander, *Pedagogies* and "Not Just (Any)." Critics such as Rosamond King have challenged the assumption that the Caribbean is a deeply homophobic space. See, for instance, King and Nixon, eds. See also King's *Island Bodies*, especially chapter 3 (on women who desire women). On eroticism between women

in Caribbean literature, see Tinsley, "Black Atlantic," *Thiefing Sugar*, and *Ezili's Mirrors*. On homophobia in Barbados, see Murray. I discuss this topic in the next two sections of this chapter, especially on Hopkinson, and in more depth in chapter 6.

21. On homophobia in Marshall's novel, see Spillers in *Conjuring*. See also Spillers, "Black, White, and in Color" (especially footnote 1), which Keizer addresses in her discussion of *The Chosen Place*.

22. On romanticizing Africa instead of using history and memory to re-member, see Gerima 90–114. Schenk discusses the text as being at odds with itself and Merle's position at the end (50). Also see Dayan's critique of Gilroy's *The Black Atlantic*: "Although Gilroy argues against 'Africentrism' and its cult of Africa [. . .] in Gilroy's story, the slave ship, the Middle Passage, and finally slavery itself become frozen, things that can be referred to and looked back upon, but always wrenched out of an historically specific continuum. What is missing is the continuity of the Middle Passage in today's world of less obvious, but no less pernicious enslavement" ("Paul Gilroy's Slaves" 7).

23. See Edmondson on "Re-Writing History" ("Race, Privilege, and the Politics" 187). Cliff notes that she started out doing graduate studies in history: "I've always been struck by the misrepresentation of history and have tried to correct received versions of history, especially the history of resistance. It seems to me that if one does not know that one's people have resisted, then it makes resistance difficult" (Adisa 280).

24. Saidiya Hartman's *Lose Your Mother* brilliantly explores the desire to "return" and to visit The Door, as well as the ramifications of that journey.

25. See Shea, for Cliff's explanation of the choice of Pleasant. See also Raiskin 665; Adisa 279–80. See also Tinsley, *Ezili's Mirrors*, chapter 3 ("Riding the Red"), in which she weaves together an analysis of Hopkinson's *The Salt Roads* with her version of Pleasant's story.

26. On the *gens inconnus* and the connections between Annie Christmas and Clare Savage in Cliff's first novel, *Abeng*, see Bost, especially 684.

27. Cliff also refers to this infamous incident in her earlier novel *Abeng*. Martin Delany's serial novel *Blake; or the Huts of America* (1859, 1861–62) illustrates a similar event: see Gilroy, *The Black Atlantic*, for a discussion of Delany, especially 19–29. For background on Turner's painting and a discussion of its significance in diasporic experience, see Gilroy, *Small Acts* 81–84. Rice discusses not only Turner's painting but works by the contemporary artist Lubaina Himid: see especially 69–74. Rice comments on Himid's *Memorial to Zong*: "the memorial is not just a mourning but a call to action. Himid's work seeks to put back together the dismembered bodies of Turner's ultrarealistic portrayal of the black Atlantic and to show an African culture surviving the middle-passage nightmare" (74). I discuss the *Zong* at length in chapter 2, analyzing M. NourbeSe Philip's book-length poem about this incident and the legal case that ensued.

28. See Drabinsky's analysis of Glissant's references to Turner: "Birth is marked with this time as an absence more absent than loss and its traces" (300).

29. See Baptist; Beckert; Baucom.

30. On storytelling in *Free Enterprise*, see Chancy, "Exiles." At the end of *Citizen: An American Lyric*, Claudia Rankine includes the painting and a detail from it—the depths of the Atlantic Ocean where body parts bleed and chains begin to turn green.

31. See Deren, who discusses the pain and weeping of this *lwa*: "The wound of Erzulie is perpetual: she is the dream impaled eternally upon the cosmic cross-roads where the world of men and the world of divinity meet" (145). See also Dayan, *Haiti*, especially 54–65, who says that Ezili

> subverts the roles she affects. In her many aspects, Ezili reveals a sexual ambiguity and a convertibility of class so pronounced that the study of this goddess and her relations with other spirits and mortals—as well as her use in literary representations—would help articulate a phenomenology of eros in Haiti. [. . .] She possesses men as well as women: both sexes take on her attributes and accede to her mystique of femininity. Ezili also chooses women as well as men in "mystic marriage." The customary gendered relations between men and women do not matter. She is no fertility goddess, and except for a song about her lost child Ursule (product of her union with Ogou Badagri), who disappeared under the waters of the Caribbean Sea, she is not a mother. (63)

See also Tinsley: "Ezili is the lwa who exemplifies imagination. And the work of imagination is, as other scholars have already beautifully stated, a central practice of black feminism—indeed, it remains a black feminist necessity to explicate, develop, and dwell in the demonic grounds of realities other than the secular Western empiricisms that deny black women's importance in knowing, making, and transforming the world" (*Ezili's Mirrors* 17).

32. See Drabinsky, on Glissant: "Thinking after trauma, toward the future, must confront transparency and universality, not because it is a remnant of an Old World order, hopelessly square or even quaint, but because of the conditions of thinking in a Caribbean context. [. . .] The future must be mapped and unmapped across a *geos* that puts salt in wounds" (305, original italics).

33. See Rutledge; Batty; Diane Glave; Wolff; Watson-Aifah.

34. See Mustakeem, who incorporates female experience throughout her study of the Middle Passage.

35. See Shields on the ways that *The Salt Roads* incorporates the figure of Sycorax, particularly in the character Mer (chapter 4, "Signs of Sycorax").

36. See also Jackson, *Becoming Human*, chapter 4, "Organs of War," on Audre Lorde and artist Wangechi Mutu, and "Coda: Toward a Somatic Theory of Necropower."

37. In his discussion of Hayden's "Middle Passage," Jonathan Smith points to two "unpleasant" realizations about the role of the Middle Passage in constructing "blackness":

> [First] that vast body of Africans who underwent Middle Passage trauma, and their descendants are forced to interrogate themselves almost incessantly about *self*-identity in relation to the slave masters, and subsequently to all members of the race that comprised the majority of New World slaveholders. [. . .] [And second] the recognition that this process, of all things, was procreative; that the crossing itself, although constantly under revision, was indeed progenitive—patriarchal, yes, but progenitive nonetheless. (76–77, original emphasis).

Hopkinson makes it both progenitive and *female-centered* in that procreation.

38. See Jackson, especially her "Coda: Toward a Somatic Theory of Necropower," which engages with Mbembe in powerful ways.

39. On the historical Makandal, see Mintz and Trouillot, who note that François Makandal was probably of "Guinea" origin, perhaps a Muslim, and enslaved at the age of twelve. In Saint-Domingue, he was sold to Lenormand de Mézy, a plantation owner in the north. He escaped and became a maroon leader; eloquent and intelligent, he gained many followers; he made poisons and developed a plot to poison white planters. He was captured and burned at the stake in 1758 (Mintz and Trouillot 136). See also Dayan, *Haiti* 252.

40. Clover, based on the historical Clover (Hooper) Adams (wife of Henry), keeps a bat named Atthis, reads Sappho, and expresses a latent attraction to her cousin, Alice Hooper.

41. See also Shields on this fight between Mer and Makandal (137).

42. See also McKittrick, *Demonic Grounds*.

43. See Mustakeem: "One cannot make sense of the behaviors widespread throughout Atlantic slave societies—reproductive agency, maroonage, resistance to familial separation, suicide, violent rebellions, or even poisoning—without examining how these insubordinate patterns took shape through early manifestation at sea" (7).

CHAPTER 2: OCEANIC OSSUARIES: CARIBBEAN WOMEN READING THE BONES

1. A number of scholars have discussed Philip's poem in the context of this historical event, which took place in 1781, the trial in 1783. For a brief overview, see Khan 8–9; see also Fehskens. See especially Walvin, *Black Ivory* and *The Zong*, for a study of the case; see also Baucom. For the larger context of the *Zong*, see Krikler. See also Naimou, especially the Introduction, in which she discusses "salvage work" and the "debris of legal personhood" that a text like *Zong!* explores through both voices and silences.

2. I am approaching these texts through a circum-Atlantic lens, centered on the ocean. See Boelhower, "The Rise" 88–92. He states: "The Ocean Sea is also the Atlantic world's unconscious, its most significant archive, and its Braudelian *long duree* [*sic*]. . . . Much of Atlantic history—that concerning the African diaspora in particular—has to be written exactly because the documents are missing. But it is in the very absence of documentation that these drowned have fashioned the archives of the Atlantic world" (94). See also 97. For a reading of "submarine poetics" in *Zong!* that aligns with Brathwaite's theories, see Siklosi. For a reading of *Zong!* and epic catalogues, see Fehskens.

3. On the sea and water, see Lambert, who discusses the "ocean as the site of reconstitution and repair" (112).

4. On Boateng, see Pinnix 439–42. Pinnix also cites an interview of Philip by Jordan Scott.

5. On "Zorg," see Philip, "Notanda" 208. See also Baucom. On "Song," see Philip, "Notanda" 207, and interview with Saunders, "Defending" 79. See also Philip, "Earth and Sand": "I have chosen to 'mine' a language—both in the sense of making it mine, as well as plumbing its depths and, if necessary, exploding it; I have chosen to excavate painstakingly the layered deposits of memory; to stalk a history busy with larger events; to lay waste the citadels of lies to find that place" (180).

6. See also Philip, "Whose Idea Was It Anyway?," especially 187.

7. Baucom applies Derrida's theory of "hauntology" to discuss "a trajectory from a largely obscure eighteenth-century atrocity to a present in which the capital and phenomenological protocols which are that atrocity's conditions of possibility have not waned but intensified,

a present in which the 'past' survives not as a sediment or attenuated residue but in which the emergent logics of this past find themselves enthroned as the dominant protocols of *our* 'nonsynchronous' contemporaneity" (23–24, original emphasis). See also Baucom 243. In her "Notanda," Philip directly invokes Derrida's *Specters of Marx* and the concept of "hauntology"—see 202. She also mentions Baucom's book in the "Notanda."

8. Philip herself might not agree with this linking of her approach to Walcott's. In an earlier interview, Philip distinguishes between Walcott, whom she places in the European tradition, and Brathwaite, who see the presence of Africa in the Caribbean. Philip here aligns herself with Brathwaite. See Mahlis 696–97.

9. On the court case see also Walvin, *Black Ivory*, chapter 2, especially 14–20. See also Rediker, 240–41 (though he deals with the *Zong* only tangentially). See also Leong on the "ecology of thirst" in *Zong!* and its relevance to contemporary injustices.

10. On Walcott's *Omeros*, see Ramazani.

11. See Mahlis 683–84; see also Saunders, *Trying Tongues*, for Philip's comments on her brief career in law. In the "Notanda," she discusses her use of the law: see 193, on what she does to the text of the case; see also 199. She refers to the case as a "mystery of evil" (190), which suggests that the poet performs the work of a detective. She explains that she turned from a novel about the event to the legal document as a way to open up the *Zong*: "certain, objective, and predictable, it would cut through the emotions like a laser to seal off vessels oozing sadness, anger, and despair. I yield to a simple but profound curiosity [*sic*]—about the sea, a captain, the sailors, and a ship. About a 'cargo.' And that story that must tell itself" ("Notanda" 191). On biopolitics and writing the Middle Passage, see Corio. On the legal aspects of the *Zong*, see especially Ruprecht, "'Very Uncommon,'" on ways it was appropriated by abolitionists; see also Ruprecht, "'Limited Sort,'" on trauma, memory, and reparations.

12. See also Boelhower, "'I'll Teach You,'" on the *ship* as "a semiotic operator in producing Atlantic space" (33). He connects the ship and the map as generating the Atlantic World.

13. This concept of Relation is similar to Said's idea of the affiliative method or unity-in-multiplicity. See Boelhower, "'I'll Teach You,'" 41, 46.

14. Baugh discusses theories of Caribbeanness, such as Brathwaite's "tidalectics" and Benítez-Rojo's "repeating island," as means to use the scattering and fragmentation as part of the process of healing from the wounds/trauma. On the ethical representation of the trauma of the *Zong*, see Austen.

15. See also Ramazani, on Walcott's *Omeros*: "Repudiating a separatist aesthetic of affliction, Walcott turns the wound into a resonant site of interethnic connection within *Omeros*, vivifying the black Caribbean inheritance of colonial injury and at the same time deconstructing the uniqueness of suffering" (405). Ramazani also states: "In fashioning a mirror relation between injury and remedy, Walcott represents within *Omeros* the poem's homeopathic relation to the traumatic history of the West Indies" (413). A similar relation is at work in Philip's *Zong!*

16. Again, see Ramazani on the potential for healing: "*Trauma* is, of course, Greek for wound, and Walcott's *Omeros* could be said—extending a psychological analogy endorsed by Glissant—to remember, repeat, and work through the trauma of African Caribbean history. But this ameliorative work should not be confused with a definitive healing" (414).

17. Ruth's name appears in the Manifest at the end of Philip's poem, among the "Women Who Wait," referring to those in England. On Ruth, see Khan; see also Dowling 49–52; see

also Walters. I disagree with the argument presented by Gervasio, who claims that "ruth" is one of the enslaved African women on the *Zong* (3).

18. Baucom analyzes Walcott's epic poem *Omeros* in terms that resonate with what I argue is *Zong!*'s contribution to circum-Atlantic literature. Citing a passage in which Achille sees an image of bone and contemplates "the nameless bones of all his brothers / drowned in the crossing," Baucom argues that the inheritance understood within Walcott's text is "the persistence of what death has wrought and the enduring resolution to live on within the very territory of the abyss, to assume some property in its fatal waters, and to make of a time that has not passed but filled the present with its overwhelming, accumulated weight, a modern way of being in the world" (326).

19. See Glissant, *Caribbean Discourse* 66–67, 139–41. While Pinnix makes an original argument for replacing Glissant's metaphor of the rhizome (which follows from Deleuze and Guattari) with *sargassum* or seaweed as an image of Caribbean and Atlantic relation, I continue to employ the concept of the rhizomatic, in particular the mangrove.

20. In a further rendering of rhizomatic Caribbean identities, Iris lived with a Lebanese family, a means by which John inscribes part of her own heritage within the narrative. On social life in Dominica, which developed from both French and English influences, see Paravisini-Gebert. See also Down.

21. On slavery and law, see Khan. See also Robinson on gender and the law.

22. See Wynter, "1492," for example. See also her "Unsettling the Coloniality" essay. McKittrick applies Wynter's theories specifically to Black women in her *Demonic Grounds*. See also Jackson.

23. Matilda thus embodies "Caliban's Woman," as theorized by Wynter.

24. On the Caribs, see Hulme.

25. This description resembles the dragon in Carnival as depicted by Earl Lovelace in *The Dragon Can't Dance*. One is also reminded of the centrality of performance to re-membering the Middle Passage in Marshall's *The Chosen Place, The Timeless People* (as discussed in chapter 1).

26. On obeah and colonial laws and practices, see Paton, who argues that "colonial law-making and law-enforcing practices have made a crucial contribution [. . .] to producing obeah as a singular, unitary phenomenon. As a result, any intervention that seeks to transform contemporary understandings of obeah needs to address the history of colonial constructions of obeah" (1–2).

27. "Necropower" was coined by Mbembe and is further deployed by Jackson in her *Becoming Human*. See Jackson, especially "Coda: Toward a Somatic Theory of Necropower."

28. In that recuperation, John's narrative performs a fictional parallel to the poetic reparation Philip accomplishes in dis-membering the archive. See Lambert on Philip's text as a form of reparation.

29. See also Hartman's "Venus in Two Acts," as well as her narrative of a girl who jumps from a slave ship in *Lose Your Mother*. Imagining that leap, "the one soaring and on her way home," Hartman writes: "If the story ended there, I could feel a small measure of comfort. I could hold onto this instant of possibility. [. . .] then I could wade into the Atlantic and not think of the *dead book*" (152–53, original emphasis). In this section of the book, Hartman also references the *Zong*.

30. See John's website for a Q&A on the novel. See also Down.

31. See Jackson's discussion of Audre Lorde in the context of racialized and sexualized disease. She cites Lorde's argument in *The Cancer Journals*, "that carcinogenesis is a feedback loop encompassing biological, psychological, environmental, and cultural efficacies. Therefore it is neither a matter of individualized disease nor inferior biology but rather a somaticization of politics" (Jackson 165).

32. On Baartman, see Holmes.

33. On Baartman's eventual return to South Africa, see Holmes 169–83. Baartman's remains were returned to South Africa two centuries after she was stolen from her home; she was given a state funeral on August 9, 2002.

34. See also Agamben on the witness, who can be either *testis*, a third party in a trial, or *superstes*, a person who has lived through and can give witness to something. Agamben states: "[L]aw is not directed toward the establishment of justice. Nor is it directed toward the verification of truth. Law is solely directed toward judgment, independent of truth and justice" (18). That is, law is trial and judgment. In the three texts under discussion, trial and judgment are undone, and instead, each offers witnessing, similar to Agamben's definition of the witness as *superstes*.

35. See chapter 1 for ways that Brand explores the African Diaspora in *A Map to the Door of No Return*. She states: "Having no name to call on was having no past; having no past pointed to the fissure between the past and the present. That fissure is represented in the Door of No Return [. . .]. In some desolate sense it was the creation place of Blacks in the New World Diaspora at the same time that it signified the end of traceable beginnings" (5). She further states: "To have one's belonging lodged in a metaphor is voluptuous intrigue; to inhabit a trope; to be a kind of fiction. To live in the Black Diaspora is I think to live as a fiction—a creation of empires, and also self-creation" (18).

36. See MacDonald, who discusses the bones as "toxic," containing "a resistant power as a poisonous reminder of the price, and the legacy, of modernity" (96).

37. Of cities, Brand says in *Map*: "Origins. A city is not a place of origins. It is a place of transmigrations and transmogrifications. Cities collect people, stray and lost and deliberate arrivants. Origins are rehabilitated and rebuilt here" (62).

38. See Quéma's discussion of "necropolitics" and violence in this text. On Afropessimism, see especially Wilderson. See Jackson on the ramifications of anti-Blackness and necropower.

39. One is also reminded of Toni Morrison's Paul D in *Beloved*, who similarly followed the flowering trees once he fled the chain gang in Georgia.

40. "[Poetry is] a philosophical mode for thinking through how one lives in the world and ones [*sic*] *relation* to other human beings in the world" (Brand, interview with Nolan, n.p., emphasis added).

CHAPTER 3: WORDS TO HEAL THE WOUNDS: AMNESIA, MADNESS, AND SILENCE AS TESTIMONY IN HAITIAN WOMEN'S FICTION

1. "Madness is a crying out of resistance and the upheaval created by the weight of the past, of memory, and of the ways it resonates in the present" (my translation).

2. On Haitian women and silence, see especially Chancy, *Framing Silence*. See also the volume edited by Boucher and Spear, *Paroles et silences chez Marie-Célie Agnant*, especially the chapters by Lucienne J. Serrano and by Heather A. West.

3. Agnant; Boucher.

4. See Chancy, "No Giraffes" 309.

5. On where the hospital is located, see Proulx, "Bearing Witness," who says it is not specified; see also Barreiro, who states it is Montreal (as do Ziethen, Siemerling, and others).

6. On the taboo of slavery and on the act of "telling" Haiti, see Jurney 388. On the color blue and the ocean, see Schuchardt.

7. On Flore, see Adamowicz-Hariasz; Jurney; Proulx, "Bearing Witness"; Siemerling.

8. On Kilima's mutisme, see Adamowicz-Hariasz.

9. On Nickolas, see Ndiaye 57; Proulx, "Breaking the Silence" 55; Tervonen.

10. See also Saidiya Hartman, *Lost Your Mother*.

11. On this return of the memory, see Agnant, "Marge." See also Adamowicz-Hariasz.

12. On violence against women in Haiti, from the beginnings to the present day, see Chancy, "No Giraffes."

13. On the process of testimony, see Boucher 203.

14. On the role of French and Creole in Emma's narration, see Ziethen, especially 115–16.

15. On the Duvalier era, see Agnant, " . . . vide." See also Barreira.

16. See Culbertson 191.

17. On Emma as maroon, see Agnant, " . . . vide." See also Barreira; Branach-Kallas 161–63.

18. See also Siemerling, on breaking silence in the conclusion of Emma's story, especially 856–57.

19. On *Retour*, see Jurney 389. On Flore and Nickolas at the conclusion, see Ndiaye 59–60; Barreira 371–72.

20. Adjarian, *Allegories*, discusses the mother and daughter flight from the Duvaliers; she also focuses on the concept of occupation, both historical and psychological. On the Duvalier era, see François. See also Chancy, *Framing Silence* 92.

21. See Chancy, *Framing Silence*.

22. On the scene of rape, see Chancy, *Framing Silence* 101. She also interprets the act as both mental and physical, and identifies the rapist as the character Patrick.

23. On the city, see François 297, who also quotes Dominique. See also Sourieau 700.

24. On the name Maya, see Sourieau 699.

25. On this pseudonym Lili adopts and the scenario with the father's assistant, see François 295.

26. See Dominque's interview with François, 297, on the oral tradition, and on the storyteller and leader as the two voices throughout the text.

27. Bailey notes the role of spiritual tradition, linking *The Serpent's Claw* to decolonial approaches to trauma, as analyzed by Visser, Rothberg, Andermahr, Balaev, and others.

28. On the intersections between individual and collective trauma in this novel, see Bailey, especially 51–54.

29. On healing, see Bailey 58.

30. See Mehta, on Mami Céleste as an incarnation of Sycorax.

31. In *Framing Silence*, Chancy mentions that Chancy herself is the descendent of the sister of Toussaint, a woman named Affiba, whose name she has given to Désirée's lover.

CHAPTER 4: "I HEAR THE VOICE":
PERFORMING THE AFRICAN DIASPORA IN BRODBER AND HURSTON

1. In the same article, Brodber also discusses writing and silence, both the content of the words and the method of producing them: "with the computer rather than the typewriter, the writer operates in relative silence" (124). See also Saunders, who states that the construction of *Louisiana* with its stress on translation "is in an effort to understand silence as a strategic positionality capable of signifying epistemological and ontological presence" ("The Project of Becoming" 142).

2. On the concept of diaspora, from an angle that includes gender and transethnic relations, see Anthias.

3. Saunders links Brodber's fiction to Glissant's theory of opacity or opaqueness, "whereby that which is hidden can be made transparent through focusing on contradictions and obscurities" (Saunders, "The Project of Becoming" 143).

4. A number of scholars have addressed the connections between Brodber's novel *Louisiana* and Hurston's ethnographical works including *Mules and Men* and *Tell My Horse*, as well as linking Brodber's protagonist Ella to the "Zora" of Hurston's texts. See Roberts, who dedicates full chapters to the comparisons and offers a long list of similarities. See also Pinto, who looks at the role of "possession," as well as diasporic feminist politics, the role of Marcus Garvey, and theories of modernity. Toland-Dix compares the two through the lens of "spirit possession." In "Me and My Head-Hurting Fiction," Brodber says that she learned about Hurston's field work and use of a tape recorder, implying that this knowledge came after she had written *Louisiana* (125), though the many parallels are salient and several scholars assume that Brodber was consciously working with those connections as she created her character Ella/Louisiana.

5. Throughout this chapter, when referring to Hurston's explorations of vodou, I use the term that she (and many scholars of her work) employs, "voodoo." If referring to the Haitian practice, I use "vodou" or "vodun." I also use "hoodoo" if quoting Hurston directly.

6. Philip has given many performances of *Zong!*, including one I attended at Fairfield University.

7. See also Toland-Dix; Roberts.

8. See Jenny Sharpe, "When Spirits Talk," on "anthropology of the dead," especially 93–94. See also Jenny Sharpe, *Immaterial Archives*, chapter 3.

9. See Forbes, who discusses spiritualism and community in *Louisiana*, arguing that Brodber "centralize[s] community without fixing it to geography or the hegemony of nationalist discourse" and "excavate[s] submerged cross-connections without making of the cross a teleology or a line" (17).

10. See also Domina's overview of the range of opinions (208).

11. On the insider-outsider question, see also Gambrell's chapter on Hurston. On Hurston as ethnographer in the Caribbean, see Meehan, who argues that in *Tell My Horse*, she performs a "decolonizing ethnography" that centers women. He states: "Hurston, though, brings

gender dynamics to the fore and clears a space for women in the representation of popular agency. In *Tell My Horse*, then, Hurston transforms the sexual politics of African American and Caribbean solidarity and makes the decolonizing contact zone more universally liberating" (*People Get Ready* 77). Meehan does not address *Mules and Men* in this context.

12. Lauden offers an intriguing twist in showing how at least one tale that the Zora of *Mules and Men* claims was told to her is, in actuality, one that Hurston herself wrote and published as fiction. See especially Lauden 47.

13. See Walters 344, 356–63.

14. On background for the journey, see Mikell.

15. Theater was part of Hurston's life from her early job traveling with and assisting a stage actress, to the writing of plays, some jointly with Langston Hughes, to performances including dance and song in support of the WPA/FWR in the late thirties: see Bordelon 36–37. She also had a job teaching drama at North Carolina College (Bordelon 46).

16. On the mating game, see Sánchez-Eppler 478–80.

17. On performance and the performative in *Mules and Men*, see Hill; Gordon; Hale; Dorst. See also Lawrence, who argues that "these performative representations are the most valuable part of the entire book because they represent the performer in context, in the act of performing for an audience which expects him or her to be competent enough to showcase verbal skills which are satisfactorily executed" (125). See also Jordan 125–28. Dolby-Stahl offers this useful assessment: "It is precisely because [Hurston] was a skilled observer that she was able to draw upon the unspoken 'rules' of performance ('the ethnography of speaking') when constructing her realistic dialogues. She taught herself the rules and the 'stuff' of performance and incorporated them into her book" (50).

18. See also Hurston's recently published *Barracoon: The Story of the Last "Black Cargo,"* based on her conversations with a survivor of the last slave ship known to have crossed the Middle Passage (the *Clotilda*).

19. On folklore as resistance in *Mules and Men*, see Nicholls, especially 472–75. He also comments on Hurston's role progressing from the initial "clumsy, obtrusive 'I'" to the insider status that "allows her to transcribe the 'hidden transcript' of everyday resistance in the camp," and sees her setting the stage for each performance via the frame story of the working day (476).

20. On Sis Cat, see also Taylor, who argues that

> Hurston's tone in the parable about Sis Cat identifies her with the tellers of Part I, who comment on their tales' relation to their own experience, connect personal and storied contexts, and presume rough analogies among the tales about those with power [. . .] and those with resistant cunning [. . .]. Only with the Sis Cat parable does she take up her role as teller of a tale [. . .]. The spiritual intimacies of Vodou supplant anthropology, and the folklorist turned participant tells a tale about social positioning. (180)

See also Harrison, especially 46; Baker, especially 95–97.

21. Baker discusses the situation in Polk County as "a community in disorder—a world undone by philandering males and women in competition" (87). He further argues that Zora's flight to New Orleans provides the antidote to such chaos: "In the capital city of conjure Hurston takes up the mysterious and magical work that can harmonize and renew a disrupted community" (88). On Ella Wall, see Cheryl Wall 60–61.

22. In his discussion of Esu-Elegba in *Their Eyes Were Watching God*, Pavlić comments briefly on this scene in *Mules and Men*, as follows: "Showing the diasporic structure of her ethnographic research in *Mules and Men*, Luke Turner's initiation of Hurston into connection with the spirits of hoodoo connects the rituals of New Orleans to the *loa* or òrìsà of Haiti and West Africa," and further notes that "Hurston was well aware of Esu-Elegba's role in the connection between people as well as between the *loa*" (81). I argue that we can also connect Ella/Louisiana in Brodber's text with the figure of Esu-Elegba.

23. On the textual history of the "Hoodoo" section's inclusion in *Mules and Men*, see Dutton 136–37.

24. See all of chapter 13 in *Tell My Horse*. On the drug, see especially 195–96. See Pinto for an extended discussion of "possession" and "modernity" in Hurston's ethnography of Jamaica and Haiti. Pinto states that "Hurston thinks of Haiti as a Glissantian 'point of entanglement,' a complex site of New World cultural identity and history" (112). Dayan comments on the zombi as follows: "born out of the experience of slavery and the sea passage from Africa to the New World, the zombi tells the story of colonization: the reduction of human into thing for the ends of capital" ("Vodoun" 54). See also Taylor: "Tellingly, Hurston's fascination with zombies links the terror of a living death to a tragic loss of agency" (191). Taylor also states: "From positions of power and western rationalization—even in its religious forms—the zombie appears as 'the other of the Other,' a case where those imagined without agency themselves imagine the horror of one without agency" (192).

25. On "voodoo," see Rowe 290. See Brathwaite, *Roots*, on obeah and *myal*. See also Trefzer, who argues that "voodoo in Hurston's work emerges as a subversive, international political gesture that helps to produce a global trans-Caribbean space. Hurston's focus on voodoo is indeed political, for in the figuration of 'possession' we find the connection between the material and spiritual history of trans-Caribbean cultures" (299). Dutton comments that "[voodoo] remains the unnamed inspiration behind much of Hurston's writing in this period [the 1930s], the most productive time of her life" (146), and notes that a main aspect of Hurston's study of voodoo is her emphasis on female deities such as Erzuli (147). See also Meehan, who argues that "*Tell My Horse* stands out in the history of critiques of colonial discourse by offering harshly critical narratives about the limits of decolonization for women in the Caribbean" (246). He also says of this text that it "derives its perspective and rhetorical strategy from a dissident tradition of African diasporan travel and cultural production radiating outward from the Caribbean in all directions" (246).

26. Baker sees the space of conjure as "most fully defined by women" (94) and offers a somewhat different reading of Zora's practice of "hoodoo" and her association with the conjure woman Kitty Brown:

> A storyteller and a uniter of lovers, a woman who has syncretized Western religion and African cultural traditions to ensure powers of retribution, redress, reward, and renewal, she [Kitty] provides a model of conjuring that the entire text of *Mules and Men* prepares us for. She is the intimate *home*, the imagistic habitation or poetic space of the spirit in which works of mythomanic transmission can take place. [. . .] Zora, in effect, inhabits Kitty's *conjure woman* as spiritual space. (92, original emphasis)

See Gourdine on "Carnival-Conjure" in Brodber's novel, including the scenes with Madame Marie.

27. As in Hurston's work—and I would argue building directly on Hurston's texts—in Brodber's novels voodoo/vodun and *myal* as well as ethnography (in *Louisiana* specifically) are cast in terms of performance. See Anderson for background on voodoo as performance. See also Trefzer on the performance of voodoo in Hurston, which also resonates for *Louisiana*: "Possession then is a particular kind of performance for a community of believers who witness the power of the spirit in and through the body of a human being" (306). Toland-Dix discusses the performative aspects of *Mules and Men* (see, e.g., 194) and the representation of spiritual states in ethnographic fiction.

28. See the rest of Brodber's "Fiction in the Scientific Process" for the development of Brodber's ideas for the novel that became *Louisiana*. An example of Brodber's sociological work on Caribbean women is her study of stereotypes (*Perceptions of Caribbean Women*), based on fieldwork and research in Jamaica. See also Brodber, "Me and My Head-Hurting Fiction." For an overview of Brodber's life work, see Catherine John. See also Khokher, who discusses the ways that characters move across borders in *Louisiana*, which he argues, "creates a discursive space that positions the African diaspora along a fluid and rich continuum of shared traditions and experiences" (38).

29. On Nellie and the kumbla, see Cooper, "'Something Ancestral'" 74–75; Cooper, "Afro-Jamaican" 284–86. Narain does not address the kumbla and dwells on the negative depictions of female sexuality and embodiment in *Jane and Louisa*. See also Wilentz: "It is both a protective device and a metaphor for suffocating social dis-ease" (38); "The kumbla, initially used to protect, becomes a symbol of deformed cultural identity" (45). For a discussion of related depictions of madness in Caribbean women's writing, see O'Callaghan, who touches on *Jane and Louisa*. See also Brown.

30. On *myal* in this novel involving an emphasis on hybridity, see Puri, especially 103–9. See also Nelson-McDermott: "*Myal* thus creates a space in which the community is strong enough to rewrite the colonizer, one way or another" (60). See also Cooper, "'Something Ancestral.'"

31. See Puri 110; Narain 101. See also Tiffin, on colonial systems and resistance, in the context of voice: "But at the same time that such rituals of imperial obedience [as recitation] were being sponsored by both English and local educational systems which contained British traditions, their ironic doubling yet reversal was being enacted in Caribbean communities through Afro-Caribbean oral performance and Indo-Caribbean dramatic and poetic traditions" (914).

32. On Hurston with a tape recorder for the FWP, in Florida, see Bordelon 37–41, 45–46. In *Dust Tracks on a Road*, Hurston mentions the game of "coon-can" in the context of interactions between herself, Big Sweet, and Lucy (190).

33. Simone Drake makes an argument about what she terms Ella's "barrenness," in the context of Black women who devote themselves to their work (120–23), but this view elides the communal qualities of Ella/Louisiana's diasporic spirituality. See Jenny Sharpe ("When Spirits Talk" and *Immaterial Archives*), in particular, for an analysis of Ella as the conduit who is "hole" and "whole."

34. We can understand the new role Ella takes on as Louisiana in terms of "the spirit," as discussed by Joseph Murphy:

Whoever is empowered to manifest the spirit does so for the benefit of the community to allow others to share in the consciousness, either in dialogue or in identity with their own. In each tradition this path to shared consciousness is grounded in rhythm. [...] To be mounted, crowned, or converted by the spirit is to die to a former life and be reborn into a new one "in the spirit." (185)

35. On New Orleans in Hurston's essay "Hoodoo in America," see Estes, who discusses this city in the context of Hurston's "map of the diaspora" (73). He also comments: "The Crescent City becomes a New World center of the ancient mysteries of creative, spiritual power. Thus it is the urban mother of all African American culture, a sacred place where myth becomes a potent force in history" (75). He also sees New Orleans in *Mules and Men* as "a place for empowerment of and through women" (77).

36. Page discusses *Louisiana* as a "community text" in the context of her argument about "remitting the text," the interrelations among communities throughout the Caribbean Diaspora. See her chapter 3, "'Two Places Can Make Children?': Metaphysics, Authorship and the Borders of Diaspora."

37. See Meriwether, on the "blues matrix" in *Louisiana*.

38. For more background on *myal*, see Maximin, especially 52.

39. Cited in Dayan, "Caribbean Cannibals" 53.

40. The defiance also recalls the battles between Zulu and Rex in Mardi Gras parades in New Orleans: see Roach 18–25. It is interesting to note that Reuben regularly participates as a Zulu.

41. On Garvey's role, see especially Pinto; see also Roberts, especially chapter 12. On a Garveyite, Mother Audley Moore, who is a possible model for Sue Ann/Mammy Grant King, see Blain. See also Sharpe, *Immaterial Archives*. Brodber mentions her intention to include Garvey in *Louisiana* (Abraham 31); see also the chapter on Garvey in Brodber's *The Continent of Black Consciousness*.

42. Cited by Cooper, "Afro-Jamaican" 280–81.

CHAPTER 5: MAPPING THE BODY: CARIBBEAN MIGRATIONS IN TESSA MCWATT'S FICTION

1. In his discussion of Harris, Huggan further states: "If the map is perceived as a vehicle of imaginative reconciliation rather than as a mirror of cultural prejudice, it can serve as a metaphorical device for the unification of disparate, or warring, cultures" (28). He continues: "[the map] may provide a medium for the visualization of new, unforeseen opportunities: opportunities for both personal and social/cultural growth. Far from confirming the authority of the dominant culture, the map allows for the possibility of a new kinship both between and within cultures: a kinship that satisfies the need for communication and cultural exchange rather than yielding to the strident demands of personal ambition" (28–29). In Harris's work, Huggan argues, "the map is ironized on the one hand as a visual analogue for the inflexibility of colonial attitudes and celebrated on the other as an agent of cultural transformation and a medium for the imaginative 'revisioning' of post-colonial cultural history" (151–52).

2. On the ways that McWatt incorporates "Oka" into the novel, see especially Moyes. On Daphne's lack of direct engagement with the Oka events, see also Lacombe. See also Simpson and Ladner, eds.

3. On the *kumbla*, see Brodber, *Jane and Louisa Will Soon Come Home*. See also Cobham; Dance, "Go Eena Kumbla"; O'Callaghan, *Woman Version*.

4. Maryse Condé's Marie-Noëlle (in *Desirada*) and her Spero (in *The Last of the African Kings*) offer perhaps the most striking examples of such longing, as I have discussed elsewhere.

5. On Montreal as "glocal" city in this novel, see Lacombe, who builds on the work of Diana Brydon.

6. See Bhabha, *The Location of Culture*, "Introduction" and 217, 230.

7. See also Lacombe, who discusses the problematic depiction of Surefoot, particularly in Daphne's responses to this character (especially 40–42, 46–50).

8. Moyes notes that "Daphne and Surefoot bear the marks of colonial violence," and lists the ways that history manifests in Daphne's behavior: "dissociating at moments of crisis, resisting adulthood, living on caffeine and chips, binge drinking, resisting intimacy, peeping and eavesdropping" (104). She discusses Daphne in the context of settler identity in Canada, which does not take into account the layers of traumatic history embodied in McWatt's protagonist.

9. Moynagh's analysis of George Elliott Clarke's Beatrice Chancy offers a pertinent argument about memory, incest, and national narratives: "In staging a drama about incest [the rape by a white slaveowner of his mulatta daughter in Nova Scotia], Clarke impresses on his audience the extent to which cultural memory work that redresses sexual and racial violence is necessarily about 'everyone's citizenship.' [. . .] Clarke interrupts the national imaginary, disrupting its coherence with a drama that lays bare the nation's intimacy with racial and sexual violence" (98–99).

10. In this sense, as in his sexual abuse of his daughter, Gerald resembles Chandin Mohanty in Shani Mootoo's *Cereus Blooms at Night*, which I have discussed elsewhere.

11. Rinaldo Walcott addresses this myth, discussing the complexity of migrations to Canada; he lists the many ethnic groups, and states that all except for Native peoples "migrated at different points in time, and have found themselves placed differently in the narratives of the nation, in ways which complicate the fiction that the modern nation-state is constituted from a 'natural' sameness. [. . .] [E]ach successive migrant group represented a rupture in the myth of the nation as constituted from sameness. What the European groups demonstrate, as well, is that sameness is constituted in the process of forgetfulness, coercion and various forms of privilege and subordination" (75).

12. Huggan discusses the representative claims of maps, drawing upon an essay by J. B. Harley: "The hidden rules of cartography contribute to the map's status as a symbol of political authority. By de-emphasizing or excluding minority interests, maps reveal themselves as 'preeminently a language of power, not of protest'"; he further notes that "maps are ultimately neither copies nor semblances of reality but modes of discourse which reflect and articulate the ideologies of their makers" (Huggan 11). On imperialism and mapmaking, see also Goldman: "According to G. N. G. Clarke, 'the map exists as a text of *possession*: a reconstruction of a culture's way with the world.' What emerges in this study is an awareness that the imperialist practices of map-making supported, and continue to support, the construction of gendered as well as colonized identities" (13, original emphasis).

13. See Rinaldo Walcott on the copy and the original: "In writing the black diaspora, exodus is performed as an incitement to dialogue because the writing concerns itself with mimesis and alterity. The tensions of the copy or sameness, and difference or otherness, are mapped into diasporic works as the very basis of their logic" (96). See also his discussion of

Black language, which he argues "moves us far beyond notions of original, copy, and imitation to recognize black realities and 'new origins'" (106).

14. Gerald's diaries also reveal his early same-sex attraction to a young Black boy, which has contributed to his internalized shame and investment in normative roles and behavior.

15. The barricades serve as a boundary, one both excluding the Native woman and one that provides space where she can challenge (patriarchal) law: "Boundaries may be perceived as means of exclusion, symbolic devices for the marginalization of women in patriarchal culture, or as means of territorial delimitation which allow women to define their own space and to give shape to their own experience" (Huggan 15).

16. Lacombe offers an extended discussion of Michel and argues that a relationship with him would signal Daphne's embrace of "a safer, neo-liberal version of multiculturalism at the expense of recognizing Indigenous land rights and the Indigenous right of passage in the city" (53). This reading gives too much significance to Michel and not enough weight to the lasting impact that Surefoot has had on Daphne's development.

17. In this character, McWatt addresses what Rinaldo Walcott identifies as a challenge "to move beyond the discourse of nostalgia for an elsewhere and toward addressing the politics of its [contemporary Black Canadian art's] present location. [. . .] What I am trying to suggest," he continues, "is that 'immigrant writing' and in this case 'Caribbean (black) immigrant writing,' is often shrouded in a nostalgia for a past that is neglectful of the politics of the present location" (39). McWatt herself—and her characters—move beyond the identification "black," claiming mixedness that includes India and China, as well as African and European ancestry. Nevertheless, I think that Walcott would include McWatt (and her Caribbean-identified characters) under his term "black Canadian."

18. Goldman notes that "where is here?" is a question that has preoccupied Canadian writers, and cites David Staines, who "speculates that the question may hark back to 'the possible origin of the very word *Canada*, which may well come from the Portuguese word meaning "Nobody here"'" (Goldman 10, original italics).

19. See Pauline Melville's fiction, especially her short story collection *Shape-Shifter*, on the mixedness of Guyanese identity. See also Welsh's essay on Melville's fiction.

20. Brathwaite invoked this concept in his plenary address at the Caribbean Migrations: Negotiating Borders international conference, Toronto, July 18, 2005. See also Rinaldo Walcott's discussion of M. NourbeSe Philip's *She Tries Her Tongue*: "Clearly, it is at the interstices of dislocation, havoc and destruction that something new occurs" (105).

21. See C. L. R. James's *Beyond a Boundary*, on the role of cricket in colonization.

22. See Rinaldo Walcott, who focuses on music in particular in his discussion of blackness: "Those who are descendants of Africans (New World Blacks) dispersed by TransAtlantic slavery continue to engage in a complex process of cultural exchange, invention and (re)invention, and the result is cultural creolization. [. . .] I argue that these works [music and other imaginative works] often offer complex analyses of black performativity and therefore of black political identifications" (xii).

23. McWatt develops the motif of salt in ways that resonate with Nalo Hopkinson's use of this image in *The Salt Roads*, as I discuss in chapter 1.

24. Huggan states that "[Wilson] Harris distinguishes between the map as a paradigm of conquest and as a medium of perceptual transformation. In the first instance, maps are limited,

even monolithic structures which are made to represent the one-sided views and self-serving ambitions of conquistadorial cultures; in the second, they are perceived as multidimensional, providing the means by which different, apparently incompatible cultures may be cross-fertilized " (28). Through Simon, McWatt offers a vision similar to that of Harris, "[who] does not simply reject the map as a metaphor but insists that, with perceptual adjustment, it may be considered as an agent of change rather than as a safeguard of existing authority" (Huggan 29).

25. Pauline Melville draws upon Guyanese tales of the Kanaima in her novel *The Ventriloquist's Tale*. In his introduction to *The Carnival Trilogy*, Wilson Harris describes "the revenge apparition or fury or god called Canaima," a figure "who is indeed a formidable legend associated with the enactment of revenge upon wrongdoers. The pathology of revenge in him becomes a form of evil" (xv).

26. See Brathwaite, *History of the Voice* (especially section 8). See also Rinaldo Walcott: we should not "retain the idea of 'unicultural' performance—identity as a tidy package of originary inheritances which reveal a specific core of familial bonds. Space and time, however, always reveal other traces. Edward Kamau Brathwaite's notion of the tidal reveals that cultural practices, like waves, give, take and reshape, leaving new sediment behind in new forms. The arena of the political also suggests these complexities" (102).

27. Huggan makes the following distinction between landscapes and maps in literature: "whereas the symbolic representation of landscapes in literature is primarily directed towards the question of how the land is *perceived*, the metaphoric function of maps in literature is addressed first and foremost to the issue of how the land is *controlled*. Like maps, landscapes are culturally determined and susceptible to political manipulations; maps, however, draw more immediate attention to their status, function, and implication as power structures" (31, original italics). In this scene in Barbados, McWatt uses landscape not only as symbolic representation but also in the metaphoric function of maps, to indicate how Caribbean land has been controlled.

28. Rinaldo Walcott argues that "black cultural practices have always treated bodies as a canvas upon which historical and contemporary social relations may be signified, inscribed and rewritten. The body, therefore, is not only used as a biological mechanism, it also works as a site for the contestation of social relations as those relations relate to acts and actions of power on and through the body" (64).

29. Interview with author, July 20, 2005, Toronto.

30. This vision resembles that described by Rinaldo Walcott in his discussion of authors like Dionne Brand and others: what they "suggest about black migratory politics/histories and experiences is a continual (re)negotiation and (re)articulation of what nation, home and family mean. All these artists produce work that can only be accurately described as ambivalent and ambiguous in its relation to the nation-state" (83).

31. See also Harris, "An Autobiographical Essay," where he expresses his desire for "the creation of an understanding of cross-cultural parallels and the deep bearing these have in overcoming implacable opposition and divides within a tormented world" (xxxi).

32. The figure's name varies. "Anansi" and "Ananse" are African spellings sometimes used in the Caribbean; the British spelling "Anancy" is used in the Aglophone Caribbean, along with "'Nansi" or "Anansi."

33. For an incisive discussion of language, the mother's voice, and the role of this West Indian man in McWatt's novel, see Waisvisz.

CHAPTER 6: CARIBBEAN BOUNDARY CROSSINGS: UNDOING THE VIOLENCE OF BORDERS IN SANTOS-FEBRES AND LARA

1. See Brathwaite, especially *Barabajan Poems* and *History of the Voice*; Benítez-Rojo; Glissant. See also Introduction, note 2.

2. Cooppan further states: "So the logic that ties together genre, race, and capital in novelistic form at the juncture point of slavery and its abolition will resurface in the logics operating within the novel, not to mention other literary genres, at other epochal reorganizations of the world system such as empire, apartheid, and postcolonial globalization" (83).

3. See Bonfiglio, who summarizes Boyer's argument: "For Boyer, it is necessary to replace transcendental reason for a geographic one which implies assuming a geopolitical point of view as a result of the impact of the 'spatial turn' on [*sic*] the humanities—even though Caribbean, as other 'peripheral' theoretical systems of thoughts formed under conditions of dependence, has been marked by a strong spatial and geopolitical conscience since its very beginnings" (162–63).

4. On urban spaces in the novel, see Van Haesendonck, especially on transgressive spaces.

5. The names refer to actual bolero singers. See especially Quiroga, chapter 6.

6. On the absence of Caribbean histories and Santos-Febres breaking with tradition—i.e., not offering a project for social and economic change by locating the narrative within Puerto Rican history—see Den Tandt 203.

7. See Rivera on the cooptation involved: "la utilización de figures potencialmente disruptivas como el travesti, la diva transexual, y el homosexual atraviesa una fina línea imaginaria que juega entre la democratización de la cultura y una dinámica despolitizada de la administración del mercado transnational y de su capitalismo. En cierta maniera, de acuerdo a esta propuesta de lectura, el potencial revolucionario del subalterno queda coaptado o subsumido a una lógica de reproducción capitalista" (100). Rivera also comments on the dangers of becoming consumable commodities: "A pesar de las potencialidades transgresivas de la figura del travesti, las identidades puestas en escena en *Sirena Selena* corren el peligro de corresponder a los intereses y posibilidades que tienen de ser mercadeadas en forma de espectáculo para ser consumidas" (102). See also Gossero-Esquilín, who examines "el consumo intra-caribeño": "Los personajes de la novela representan varios aspectos de esta economía basada en el consumo de simulacros ya que ellos viajan de diferentes puntos geográficos y pertenecen a diferentes clases sociales, económicas, raciales y politicas, además de ofrecer variantes de sexualidades masculinas" (42). On the desire for economic independence (Sirena Selena and Leocadio), see González-Allende (n.p.).

8. De Maeseneer also discusses Oshun as an icon of homosexuals (*sic*) and notes the fluidity of gender in Santos-Febres's central characters.

9. I have discussed each of these novels in terms of gender and sexuality in Garvey, "A Dream Deferred?" and "Complicating Categories."

10. See also King's recent book, *Island Bodies*, which includes a chapter on depictions of trans characters and individuals in the contemporary Caribbean.

11. In response to an interviewer's question about whether the characters find liberation, Santos-Febres herself says of Martha and Sirena that they negotiate more than they truly transform or change the systems of power. She says that she herself "[n]o pienso tanto en la resistencia; me interesan más las negociaciones, porque, si piensas en una membraba resistente, ya la impermeabilizas y entonces la conviertes en una mortaja . . ."; the interviewer inserts, " . . . que recrea otra vez las misma lógicas de exclusion . . ." and Santos-Febres concludes the statement: " . . . y en la gente buscando la pureza, la coherencia y todas esas vainas . . . A mí me interesa mucho más meterme por los poros, por todos lados, infectar" (Peña-Jordán 125, ellipses in original). Also see King, "Trans Deliverance": "On the surface trans expressions of gender may seem to highlight that which they are not—'authentic' or conventionally-gendered men and women. But in fact trans individuals, set up by others as myths, ironically reveal 'true' and 'real' genders as profound myths—even for conventionally-gendered women and men. This revelation then opens a space for the recognition of other genders" (595). A larger question I am addressing in this chapter is whether that recognition in itself provides a path to transform Relation into a shared space of difference.

12. See Arroyo 46. She does, however, deepen that analysis when examining the two Dominicans Leocadio and Migueles (46–47).

13. On waste and the Atlantic, see DeLoughrey, "Heavy Waters," in which she draws on Caribbean writers such as Lorna Goodison, Brathwaite, and Edwidge Danticat to examine "waste and Atlantic modernity." The concepts also apply to what I am terming the Caribbean Atlantic.

14. On this passage on the beach, see also Gossero-Esquilín, especially 49.

15. On Solange as Sirena Selena's double, see Arroyo.

16. See Morell for a brief history of the genre and its adaptation by writers such as Guillermo Cabrera Infante, Manuel Ramos Otero, and others. She also discusses *Sirena Selena*, a commentary that I address later in this section.

17. Arroyo discusses the bolero as a hybrid genre (building on the work of Iris Zavala): "la confluencia de Europa, África, América es el lugar de la agudeza, la síncopa y la parodia, que parte, de forma única, del deseo por el Otro" (43).

18. Arroyo states: "En *Sirena Selena*, los personajes principales se organizan a partir de la técnica del 'doble' o *doppelanger* [sic], siendo ese doble siempre un dominicano" (43). One pairing is "Junior" who becomes Selena and Leocadio; another is Selena and Graubel's wife, Solange. Space does not permit a full discussion of Solange Graubel as the other main "double" for La Sirena. For an analysis of this character and her role as mirror, see Arroyo, especially 43. One of the ways that Leocadio and Selena are both similar and different, as are the histories of Puerto Rico and the Dominican Republic, concerns racialized identities, for instance.

19. On the penetration of Graubel by Sirena, see Torres, who sees the scene as a disruption and dismantling of stereotypes, as agency for the queer subject. See also Sandoval-Sánchez 18–20.

20. I disagree with Morell, who argues for a contrasting scenario: "Unable to sustain the passive drag queen role, she reverts back to his bugarrón self" (22). The ending is much more elusive and ambiguous, which contributes to the uneasiness demonstrated in the scholarly analyses of the text. See also Sandoval-Sánchez, who poses a series of questions that the ending leaves unanswered: "Will Sirena Selena remain caught in the trap of colonial

dependency? What does her/his migration to New York City truly imply and signify? Will s/he achieve economic independence and sexual liberation? [and more]" (17).

21. See King on this scene: "This exchange takes place near the end of the novel, and reveals that binary gender is not nearly as rigid as it is generally portrayed" ("Re/Presenting" 596).

22. On the Caribbean writer as shaman or prophet, mythically engaged, see Wiedorn, footnote 3, where he cites Antoinette Tidjani Alou. These writers, and I would argue that Lara may be included among them, "seem to set themselves the task of rediscovering origin, exploring chthonic realms, of reconstructing the deleted past, inventing foundations myths and ancestors. [. . .] [T]hey invent meaningful symbols meant to heal the traumatized . . . to lead the lost home" (Wiedorn 914).

23. Tinsley comments on Micaela's vision of La Mar as the two women wait to board the *yola*:

La mar's queerness churns silverly in her *overflow*, in the sea-like capacity to desire beyond the brutality of history, nationality, enslavement, and immigration that she models for drowned shipmates and endangered *yola*-mates. Neither disembodied metaphor nor oozing wound, her fluid desire becomes a resistant creative praxis [. . .]. No matter what devastation she traverses La Mar keeps desiring, and this is the queer feeling that metaphorically and materially connects her to African diaspora immigrants past and present. ("Black Atlantic" 201–2, original emphasis)

24. See also Cooppan 74.

25. See also Eng: "the conceptual category of queer diasporas—outside the boundaries of territorial sovereignty and in excess of sanctioned social arrangements—brings together dissonant desires with the political" (1483). Eng also cites Brian Massumi: "'For the in-between, as such, is not a middling being but rather the being *of* the middle—the being of a relation. A positioned being, central, middling, or marginal, is a *term* of relation'" (Eng 1492). These ideas meet in the work of Deleuze and of Glissant.

26. On this refusal in Lara, see Decena: "Refusing New York City is also about rerouting the couple's desire away from New York and its overdetermination as a site for alternative sexualities and cultures. [. . .] [A]lso, turning away from New York City disrupts the narrative of *progreso* that routes *dominicanidad* through departure from Dominican shores" (185). See also Hoffnung-Garskof, especially chapters 1 and 2, on the connections between Santo Domingo and New York City, in a narrative of "progress" via migration and transnational cultures.

27. See Hoffnung-Garskof for an in-depth study of the intersections of capitalism, migration, and race in the history of Santo Domingo and New York City.

28. On "necropolitics," see Mbembe.

29. See also Carla Freccero in the same *GLQ* roundtable, who "proposes queer spectrality as a phantasmic relation to historicity that could account for the affective force of the past on the present in the form of an ethical imperative" ("Theorizing Queer Temporalities" 184).

30. On colonial architecture, which repeats throughout the Spanish Caribbean (perhaps a version of repeating islands), see Buscaglia-Salgado, especially chapters 2 and 4.

31. See Santos-Febres, interviews with Silva and with Celis Salgado. See also Celis Salgado, "Heterotopías," especially 133–35. See also Díaz.

32. See also Llenín-Figueroa 97, on Glissant's Relation as "an archipelagic" poetics that invites change, a "movement inspired by the waves," and thus similar to Brathwaite's tidalectics. This kind of movement is illustrated in the ways that Miriam and Micaela's relationship shifts and changes the dynamics on the plantation. See also Corio: "This continuous *espacement*, which is opened by the poetic languages of the 'archipelago-world,' begins to conceptualize an affirmative planetary biopolitics. It becomes imperative to make room for forms-of-life able to free themselves from the deadly grip of power and to 'be born into the world,' in a reciprocal openness and constituent relationship" (925).

CONCLUSION: BEYOND THE DOOR: JOURNEYS TO THE FREE

1. Josephs is discussing Erna Brodber's novel *The Rainmaker's Mistake*, to which I turn in the second section of this conclusion.

2. Other novels include Danticat's *The Dew Breaker*, Esmeralda Santiago's *América's Dream*, Achy Obejas's *Memory Mambo*, Cristina García's *Dreaming in Cuban*, and Angie Cruz's *Soledad, Dominicana*, and *Let it Rain Coffee*.

3. Rodriques discusses *Patsy* in terms of what she calls "mandatory motherhood," analyzing Patsy's migration to the US as a rejection of "motherhood on someone else's terms" ("'Promises'" 279).

4. DeLoughrey analyzes this text through the lenses of allegory and theories of the Anthropocene, examining the ways that Brodber foregrounds soil and yam (and drawing on Wynter's theories of plot and plantation, as well as Glissant's discussion of Caribbean history in *Caribbean Discourse*): "the violence of plantation societies ruptured continuous human relationships to place and thus to earth (soil) and Earth (planet)" (*Allegories* 37). On the yam, see especially DeLoughrey, *Allegories* 41–47. See also Niblett, who focuses on Brodber's use of yams "to envision emancipatory food futures" (303). Like DeLoughrey, he draws on Wynter's discussion of plantation and provision ground. See Wynter, "Novel and History, Plot and Plantation."

5. The sea both defines islands and serves as the main means of transportation between them as well as to the Caribbean in the centuries of the Atlantic Slave Trade. In reimagining the island, its soil and its roots, as Brodber does in this speculative fiction, the re-membering also needs to take the sea into account and reclaim it, refashion it, and understand the histories buried there.

6. On Afrofuturist artists, Mayer states that "all of them focus one way or another on the intersecting imageries of pastness and future in black culture, setting out not so much to rewrite the history of the African diaspora, but to systematically deconstruct it, rendering Africa as an 'alien future' [to cite Kodwo Eshun . . .]. The aliens and monsters haunting Afrofuturist narratives explode the confines of historiography and realism, collapsing established patterns of signification and identification, and put forth undecipherable codes and fractured images" (564).

WORKS CITED

Abraham, Keshia. "Interview with Erna Brodber." *BOMB*, no. 86, winter 2003/2004, pp. 28–33.
Adamowicz-Hariasz, Maria. "Le trauma et le témoignage dans *Le Livre d'Emma* de Marie-Célie Agnant." *Symposium*, vol. 64, no. 3, 2010, pp. 149–68.
Adisa, Opal Palmer. "Journey into Speech—A Writer between Two Worlds: An Interview with Michelle Cliff." *African American Review*, vol. 28, no. 2, 1994, pp. 273–81.
Adjarian, Maude M. *Allergories of Desire: Body, Nation, and Empire in Modern Caribbean Literature by Women*. Praeger, 2004.
Adjarian, Maude M. "A Passion for Literature: An Interview with Jan J. Dominique." *Journal of Haitian Studies*, vol. 11, no. 2, fall 2005, pp. 76–93.
Adler, Joyce Sparer, editor. *Exploring the Palace of the Peacock: Essays on Wilson Harris*. U of the West Indies P, 2003.
Agamben, Giorgio. *Remnants of Auschwitz: The Witness and the Archive*. Translated by Daniel Heller-Roazen, Zone Books, 1999.
Agnant, Marie-Célie. *The Book of Emma*. Translated by Zilpha Ellis, Insomniac Press, 2006.
Agnant, Marie-Célie. "Écrire en marge de la marge." *Reconfigurations: Canadian Literatures and Postcolonial Identities*, edited by Marc Maufort et Franca Bellarsi, Peter Lang, 2002, pp. 15–19.
Agnant, Marie-Célie. "Écrire pour tuer le vide du silence." *Canadian Woman Studies*, vol. 23, no. 2, winter 2004, pp. 86–91.
Agnant, Marie-Célie. *Le Livre d'Emma*. 2001. Les Éditions du remue-montage, 2008.
Alexander, M. Jacqui. "Not Just (Any) *Body* Can Be a Citizen: The Politics of Law, Sexuality, and Postcoloniality in Trinidad and Tobago and the Bahamas." *Feminist Review*, no. 48, 1994, pp. 5–23.
Alexander, M. Jacqui. *Pedagogies of Crossing: Meditations on Feminism, Sexual Politics, Memory, and the Sacred*. Duke UP, 2005.
Andermahr, Sonya. Introduction. *Decolonizing Trauma Studies: Trauma and Postcolonialism*, special issue of *Humanities*, vol. 4, no. 2, 2015, pp. 500–505.
Anderson, Michelle. "Authentic Voodoo Is Syncretic." *The Drama Review*, vol. 26, no. 2, summer 1982, pp. 89–110.
Anthias, Floya. "Evaluating 'Diaspora': Beyond Ethnicity?" *Sociology*, vol. 32, no. 3, Aug. 1998, pp. 557–80.
Anzaldúa, Gloria. *Borderlands/La Frontera: The New Mestiza*. 2nd ed., Aunt Lute, 1999.
Arroyo, Jossianna. "Sirena canta boleros: travestismo y sujetos transcaribeños en *Sirena Selena vestida de pena*." *Centro Journal*, vol. 15, no. 2, 2003, pp. 38–51.

Austen, Veronica J. "*Zong!*'s 'Should we?': Questioning the Ethical Representation of Trauma." *English Studies in Canada*, vol. 37, nos. 3–4, Sept./Dec. 2011, pp. 61–81.

Bailey, Carol. "Trauma, Memory and Recovery in Myriam Chancy's *The Scorpion's Claw*." *Journal of West Indian Literature*, vol. 24, no. 1, Apr. 2016, pp. 46–61.

Baker, Houston A., Jr. "Workings of the Spirit: Conjure and the Space of Black Women's Creativity." *Workings of the Spirit: The Poetics of Afro-American Women's Writing*, by Baker, Chicago UP, 1991, pp. 69–101.

Balaev, Michelle. "Literary Trauma Reconsidered." *Contemporary Approaches in Literary Trauma Theory*, by Balaev, Palgrave Macmillan, 2014, pp. 1–14.

Baptiste, Edward E. *The Half Has Never Been Told: Slavery and the Making of American Capitalism*. Basic Books, 2014.

Batty, Nancy. "'Caught by a . . . Genre': An Interview with Nalo Hopkinson." *ARIEL*, vol. 33, no. 1, Jan. 2002, pp. 175–201.

Baucom, Ian. *Specters of the Atlantic: Finance, Capital, Slavery, and the Philosophy of History*. Duke UP, 2005.

Baugh, Eddie. "Literary Theory and the Caribbean: Theory, Belief and Desire, or Designing Theory." *Journal of West Indian Literature*, vol. 15, nos. 1–2, Nov. 2006, pp. 3–14.

Beckert, Sven. *Empire of Cotton: A Global History*. Vintage Books, 2014.

Bell, Beverly. *Walking on Fire: Haitian Women's Stories of Survival and Resistance*. Cornell UP, 2001.

Benítez-Rojo, Antonio. *The Repeating Island: The Caribbean and the Postmodern Perspective*. Translated by James E. Maraniss, Duke UP, 1992.

Bernabé, Franca. "Transatlantic Poetics of Haunting." *Atlantic Studies*, vol. 8, no. 4, Dec. 2011, pp. 485–506.

Bhabha, Homi. *The Location of Culture*. Routledge, 1994.

Birmingham-Pokorny, Elba. "'The Page on Which Life Writes Itself': A Conversation with Mayra Santos Febres." (sic) *Daughters of the Diaspora: Afra-Hispanic Writers*, edited by Miriam DeCosta-Willis, Ian Randle Publishers, 2003, pp. 451–61.

Boelhower, William Q. "'I'll Teach You How to Flow': On Figuring Out Atlantic Studies." *Atlantic Studies*, vol. 1, no. 1, 2004, pp. 28–48.

Boelhower, William Q. "The Rise of the New Atlantic Studies Matrix." *American Literary History*, vol. 20, nos. 1–2, spring/summer 2008, pp. 83–101.

Bonfiglio, Florencia. "Notes on the Caribbean Essay from an Archipelagic Perspective (Kamau Brathwaite, Édouard Glissant and Antonio Benítez Rojo)." *Caribbean Studies*, vol. 43, no. 1, Jan.–June 2015, pp. 147–73.

Bordelon, Pamela, editor. *Go Gator and Muddy the Water: Writings by Zora Neale Hurston from the Federal Writers' Project*. W. W. Norton, 1999.

Bost, Suzanne. "Fluidity without Postmodernism: Michelle Cliff and the 'Tragic Mulatta' Tradition." *African American Review*, vol. 32, no. 4, winter 1998, pp. 673–89.

Boucher, Colette. "Québec-Haïti: Littérature transculturelle et soufflé d'oralité. Une entrevue avec Marie-Célie Agnant." *Ethnologies*, vol. 27, no. 1, 2005, pp. 195–221.

Boucher, Colette, and Thomas C. Spear, editors. *Paroles et silences chez Marie-Célie Agnant: L'oublieuse mémoire d'Haïti*. Éditions Karthala, 2013.

Boxwell, D. A. "'Sis Cat' as Ethnographer: Self-Representation and Self-Inscription in Zora Neale Hurston's *Mules and Men*." *African American Review*, vol. 26, no 4, winter 1992, pp. 605–17.

Boyer, Amalia. "Archipelia: Lugar de la Relación Entre (Geo)Estética y Poética." *Nomadas*, 31, Octubre de 2009, pp. 13–25.

Branach-Kallas, Anne. "Maroon Mothers, Motherless Daughters: *At the Full and Change of the Moon* by Dionne Brand, *Le Livre d'Emma* by Marie-Célie Agnant, and *Drawing Down a Daughter* by Claire Harris." *Migrance Comparée. Les Littératures de Canada et du Québec*. [*Comparing Migration: The Literatures of Canada and Quebec*], edited byMarie Carrière et Catherine Khorduc, Peter Lang, 2008, pp. 153–69.

Brand, Dionne. *The Blue Clerk: Ars Poetica in 59 Versos*. Duke UP, 2018.

Brand, Dionne. *Land to Light On*. McClelland and Stewart, 1997.

Brand, Dionne. *A Map to the Door of No Return: Notes to Belonging*. Vintage Canada, 2002.

Brand, Dionne. *No Language Is Neutral*. Coach House Press, 1990.

Brand, Dionne. *Ossuaries*. McClelland and Stewart, 2010.

Brathwaite, Kamau. *Barabajan Poems: 1492–1992*. Savacou North, 1994.

Brathwaite, Kamau. *History of the Voice: The Development of Nation Language in Anglophone Caribbean Poetry*. New Beacon Books, 1984.

Brathwaite, Kamau. *Roots*. U of Michigan P, 1993.

Britton, Celia. "Identity and Change in the Work of Édouard Glissant." *Small Axe*, vol. 21, no. 1, (no. 52), Mar. 2017, pp. 169–79.

Brodber, Erna. *The Continent of Black Consciousness: The History of the African Diaspora from Slavery to the Present Day*. New Beacon Books, 2003.

Brodber, Erna. "Fiction in the Scientific Procedure." Cudjoe, pp. 164–68.

Brodber, Erna. *Jane and Louisa Will Soon Come Home*. New Beacon Books, 1980.

Brodber, Erna. *Louisiana*. New Beacon Books, 1994.

Brodber, Erna. "Me and My Head-Hurting Fiction." *Small Axe*, vol. 16, no. 3, (no. 39), Nov. 2012, pp. 119–25.

Brodber, Erna. *Myal*. New Beacon Books, 1988.

Brodber, Erna. "Oral Sources and the Creation of a Social History of the Caribbean." *Jamaica Journal*, vol. 16, no. 4, 1983, pp. 2–11.

Brodber, Erna. *Perceptions of Caribbean Women: Towards a Documentation of Stereotypes*. U of the West Indies P, 1982.

Brodber, Erna. *The Rainmaker's Mistake*. New Beacon Books, 2007.

Brown, Caroline A. "Magic, Madness, and the Ruses of the Trickster: Healing Rituals and Alternative Spiritualities in Gloria Naylor's *Mama Day*, Erna Brodber's *Jane and Louisa Will Soon Come Home*, and Nalo Hopkinson's *Brown Girl in the Ring*." *Madness in Black Women's Diasporic Fictions: Aesthetics of Resistance*, edited by Caroline A. Brown and Johanna X. K. Garvey, Palgrave Macmillan, 2017, pp. 225–65.

Buscaglia-Salgado, José F. *Undoing Empire: Race and Nation in the Mulatto Caribbean*. U of Minnesota P, 2003.

Carr, Brian, and Tova Cooper. "Zora Neale Hurston and Modernism at the Critical Limit." *Modern Fiction Studies*, vol. 48, no. 2, summer 2002, pp. 285–313.

Carretta, Vincent. *Equiano, the African: Biography of a Self-Made Man*. U of Georgia P, 2005.

Caruth, Cathy. *Unclaimed Experience: Trauma, Narrative, and History*. The Johns Hopkins UP, 1996.

Celis Salgado, Nadia. "Appendice: 'Mayra Santos Febres: El Lenguaje de los Cuerpos Caribeños' Conversación con Nadia V. Celis." *Lección errante: Mayra Santos Febres y el*

Caribe contemporaneo, edited by N. V. Celis and J. P. Rivera, Isla Negra Editores, 2011, pp. 247–65.

Celis Salgado, Nadia. "Heterotopías des Deseo: Sexualidad y Poder en el Caribe de Mayra Santos Febres." Celis and Rivera, pp. 132–52.

Chancy, Myriam J. A. "Ayiti çé ter glissé: l'occupation américaine en Haïti et l'émergence de voix féminines en littérature haïtienne." *Elles écrivent des Antilles (Haïti, Guadeloupe, Martinique)*, edited by Susanne Rinne et Joelle Vitiello, L'Harmattan, 1997, pp. 17–36.

Chancy, Myriam J. A. "Exiles and Resistance: Retelling History as a Revolutionary Act in the Writings of Michelle Cliff and Marie Chauvet." *Journal of Caribbean Studies*, vol. 9, no. 3, winter 1993/spring 1994, pp. 266–92.

Chancy, Myriam J. A. *Framing Silence: Revolutionary Novels by Haitian Women*. Rutgers UP, 1997.

Chancy, Myriam J. A. *The Loneliness of Angels*. Peepal Tree Press, 2010.

Chancy, Myriam J. A. "No Giraffes in Haiti: Haitian Women and State Terror." *Écrire en pays assiégé. Haïti. Writing Under Siege*, edited by Marie-Agnès Sourieau et Kathleen M. Balutansky, Rodopi, 2004, pp. 303–21.

Chancy, Myriam J. A. *The Scorpion's Claw*. Peepal Tree Press, 2005.

Chancy, Myriam J. A. *What Storm, What Thunder*. Tin House, 2021.

Charles, Carolle. "Gender and Politics in Contemporary Haiti: The Duvalierist State, Transnationalism, and the Emergence of a New Feminism (1980–1990)." *Feminist Studies*, vol. 21, no. 1, spring 1995, pp. 135–64.

Childs, Dennis. "'You Ain't Seen Nothin' Yet': *Beloved*, the American Chain Gang, and the Middle Passage Remix." *American Quarterly*, vol. 61, no. 2, June 2009, pp. 271–97.

Cliff, Michelle. *Abeng*. 1984. Penguin, 1991.

Cliff, Michelle. "Claiming an Identity They Taught Me to Despise." *Claiming an Identity They Taught Me to Despise*, by Cliff, Persephone, 1980, pp. 43–51.

Cliff, Michelle. "Clare Savage as a Crossroads Character." Cudjoe, pp. 263–68.

Cliff, Michelle. *Free Enterprise*. Penguin/Dutton, 1993.

Clifford, James. *Routes: Travel and Translation in the Late Twentieth Century*. Harvard UP, 1997.

Clifton, Lucille. *Blessing the Boats: New and Selected Poems 1988-2000*. BOA Editions, 2000.

Cobham, Rhonda. "Revisioning Our Kumblas: Transforming Feminist and Nationalist Agendas in Three Caribbean Women's Texts." *Callaloo*, vol. 16, no. 1, winter 1996, pp. 44–64.

Condé, Mary, and Thorunn Lonsdale, editors. *Caribbean Women Writers: Fiction in English*. St. Martin's Press, 1999.

Connell, Lisa. "Ce corps qui écrit: L'Écriture et la corporalité dans *Le Livre d'Emma* de Marie-Célie Agnant." *Nouvelles Études Francophones*, vol. 31, no. 2, automne 2016, pp. 29–43.

Cooppan, Vilashini. "Hauntologies of Form: Race, Genre, and the Literary World System." *Gramma: Journal of Theory and Criticism*, vol. 13, 2005, pp. 71–86.

Cooper, Carolyn. "Afro-Jamaican Folk Elements in Brodber's *Jane and Louisa Will Soon Come Home*." Davies and Fido, pp. 279–88.

Cooper, Carolyn. "'Something Ancestral Recaptures': Spirit Possession as Trope in Selected Feminist Fictions of the African Diaspora." *Motherlands: Black Women's Writing from Africa, the Caribbean, and South Asia*, edited by Susheila Nasta, Rutgers UP, 1992, pp. 64–87.

Corio, Alessandro. "Anagrams of Annihilation: The (Im)Possible Writing of the Middle Passage in NourbeSe Philip and Édouard Glissant." *International Journal of Francophone Studies*, vol. 17, nos. 3-4, 2014, pp. 327–48.

Corio, Alessandro. "The Living and the Poetic Intention: Glissant's Biopolitics of Literature." *Callaloo*, vol. 36, no. 4, fall 2013, pp. 916–31.

Coser, Stelamaris. *Bridging the Americas: The Literature of Paule Marshall, Toni Morrison, and Gayl Jones*. Temple UP, 1994.

Crichlow, Wesley E. A. "History, (Re)Memory, Testimony, and Biomythography: Charting a Buller Man's Trinidadian Past." T. Glave, pp. 101–31.

Cudjoe, Selwyn, editor. *Caribbean Women Writers: Essays from the First International Conference*. Calaloux Publications, 1990.

Culbertson, Roberta. "Embodied Memory, Transcendence, and Telling: Recounting Trauma, Reestablishing the Self." *New Literary History*, vol. 26, no. 1, 1995, pp. 169–95.

Dalleo, Raphael. "Another 'Our America': Rooting a Caribbean Aesthetic in the Work of José Martí, Kamau Brathwaite and Édouard Glissant." *Anthurium: A Caribbean Studies Journal*, vol. 2, no. 2, Dec. 2004, article 1. http://scholarlyrepository.maimi.edu'anthrurium/vol2/iss2/1.

Dance, Daryl Cumber. "An Interview with Paule Marshall." *Southern Review*, vol. 28, no. 1, winter 1992, pp. 1–20.

Dance, Daryl Cumber. "Go Eena Kumbla: A Comparison of Erna Brodber's *Jane and Louisa Will Soon Come Home* and Toni Cade Bambara's *The Salt Eaters*." Cudjoe, pp. 169–84.

Dash, J. Michael. "Libre Sous la Mer—Submarine Identities in the Work of Kamau Brathwaite and Édouard Glissant." *For the Geography of a Soul: Emerging Perspectives on Kamau Brathwaite*, edited by Timothy J. Reiss, Africa World Press, 2001, pp. 191–200.

Davies, Carole Boyce. *Black Women, Writing and Identity: Migrations of the Subject*. Routledge, 1994.

Davies, Carole Boyce. "Carnavalised Caribbean Female Bodies: Taking Space/Making Place. *Thamyris*, vol. 5, no. 2, autumn 1998, pp. 333–46.

Davies, Carole Boyce, and Elaine Savory Fido, editors. *Out of the Kumbla: Caribbean Women and Literature*. Africa World Press, 1990.

Dayan, Joan. "Caribbean Cannibals and Whores." *Raritan*, vol. 9, no. 2, fall 1989, pp. 45–67.

Dayan, Joan. *Haiti, History, and the Gods*. U of California P, 1995.

Dayan, Joan. "Paul Gilroy's Slaves, Ships, and Routes: The Middle Passage as Metaphor." *Research in African Literatures*, vol. 27, no. 4, winter 1996, pp. 7–14.

Dayan, Joan. "Vodoun, or the Voice of the Gods." *Raritan*, vol. 10, no. 3, winter 1991, pp. 32–57.

De Maeseneer, Rita. "Los caminos torcidos en *Sirena Selena vestida de pena* de Mayra Santos-Febres." *Revista de Estudios Hispanicos*, vol. 38, no. 3, 2004, pp. 533–53.

Decena, Carlos Ulises. "Multiplying Archives." *Small Axe*, vol. 20, no. 3, (no. 51), Nov. 2016, pp. 179–88.

DeLamotte, Eugenia. "Women, Silence, and History in *The Chosen Place, the Timeless People*." *Callaloo*, vol. 16, no. 1, 1993, pp. 227–42.

DeLoughrey, Elizabeth. *Allegories of the Anthropocene*. Duke UP, 2019.

DeLoughrey, Elizabeth. "Gendering the Voyage: Trespassing the (Black) Atlantic and Caribbean." *Thamyris*, vol. 5, no. 2, 1998, pp. 205–31.

DeLoughrey, Elizabeth. "Routes and Roots: Tidalectics in Caribbean Literature." *Caribbean Culture: Soundings on Kamau Brathwaite (Second Conference on Caribbean Culture, 2002)*, edited by Annie Paul, U of the West Indies P, 2007, pp. 163–75.

Den Tandt, Catherine. "Sirena Wears Her Sadness Like a Beautiful Dress: Literature and Globalization in Latin America." *Relocating Identities in Latin American Cultures*, edited by Elizabeth Montes Garcés, U of Calgary P, 2007, pp. 191–215.

Dennis-Benn, Nicole. *Patsy*. Liveright Publishing, 2019.
Deren, Maya. *Divine Horsemen: The Living Gods of Haiti*. 1953. McPherson, 1983.
DeSouza, Pascale. "Folie de l'écriture, écriture de la folie dans la littérature feminine des Antilles françaises." *Présence Francophone*, vol. 63, no. 1, 2004, pp. 130–44.
Díaz, Luis Felipe. "La narrativa de Mayra Santos y el travestismo cultural." *Centro Journal*, vol. 15, no. 2, fall 2003, pp. 25–36.
Dolby-Stahl, Sandra. "Literary *Objective*: Hurston's Use of Personal Narrative in *Mules and Men*." *Critical Essays on Zora Neale Hurston*, edited by Gloria L. Cronin, G. K. Hall, 1998, pp. 43–52.
Domina, Lynn. "'Protection in My Mouf': Self, Voice, and Community in Zora Neale Hurston's *Dust Tracks on a Road* and *Mules and Men*." *African American Review*, vol. 31, no. 2, summer 1997, pp. 197–209.
Dominique, Jan J. *Memoir of an Amnesiac*. Translated by Irline François, Caribbean Studies Press, 2008.
Dominique, Jan J. *Mémoire d'une amnésique*. 1984. Les Éditions du remue-montage, 2004.
Dorst, John. "Rereading *Mules and Men*: Toward the Death of the Ethnographer." *Cultural Anthropology*, vol. 2, 1987, pp. 305–18.
Dowling, Sarah. "Persons and Voices: Sounding Impossible Bodies in M. NourbeSe Philip's *Zong!*" *Canadian Literature*, 210/211, autumn/winter 2011, pp. 43–58.
Down, Lorna. "'Flying inna Massa Face': Woman, Nature, and Sacred Rites/Rights in Marie-Elena John's *Unburnable*." *Experiences of Freedom in Postcolonial Literatures and Cultures*, edited by Annalisa Oboe and Shaul Bassi, Routledge, 2011, pp. 231–41.
Drabinsky, John E. "What Is Trauma to the Future? On Glissant's Poetics." *Qui Parle*, vol. 18, no. 2, spring/summer 2010, pp. 291–307.
Drake, Simone. "Gendering Diasporic Migration in Erna Brodber's *Louisiana*." *MaComère*, vol. 8, 2006, pp. 112–35.
Dubois, Laurent. *Avengers of the New World: The Story of the Haitian Revolution*. Harvard UP, 2004.
Dubois, Laurent. *Haiti: The Aftershocks of History*. Henry Holt, 2012.
Dumas, Reginald. *An Encounter with Haiti: Notes of a Special Advisor*. Medianet, 2008.
Dutton, Wendy. "The Problem of Invisibility: Voodoo and Zora Neale Hurston." *Frontiers*, vol. 13, no. 2, 1992, pp. 131–52.
Edmondson, Belinda. "Race, Privilege, and the Politics of (Re)Writing History: An Analysis of the Novels of Michelle Cliff." *Callaloo*, vol. 16, no. 1, 1993, pp. 180–91.
Edmondson, Belinda. "Race, Privilege, and the Construction of the Caribbean Aesthetic." *New Literary History*, vol. 25, no. 1, winter 1994, pp. 109–20.
Eng, David L. "The End(s) of Race." *PMLA*, vol. 123, no. 5, 2008, pp. 1479–1493.
Espinet, Ramabai. *The Swinging Bridge*. HarperPerennial, 2003.
Estes, David C. "The Neo-African Vatican: Zora Neale Hurston's New Orleans." *Literary New Orleans in the Modern World*, edited by Richard S. Kennedy, Louisiana State UP, 1998, pp. 66–82.
Farmer, Paul. *Haiti: After the Earthquake*. Edited by Abbey Gardner and Cassia Van Der Hoof Holstein, Public Affairs, 2011.
Farmer, Paul. *The Uses of Haiti*. Common Courage Press, 2006.
Faucheux, Amadine H. "Race and Sexuality in Nalo Hopkinson's Oeuvre, or, Queer Afrofuturism." *Science Fiction Studies*, vol. 44, no. 3, 2017, pp. 563–80.

Fehskens, Erin M. "Accounts Unpaid, Accounts Untold: M. NourbeSe Philip's *Zong!* and the Catalogue." *Callaloo*, vol. 35, no. 2, spring 2012, pp. 407–24.
Feracho, Lesley. "Engaging Hybridity: Race, Gender, Nation and the 'Difficult Diasporas' of Nalo Hopkinson's *Salt Roads* and Helen Oyeyemi's *The Opposite House*." *South Asian Review*, vol. 82, no. 4, winter 2017, pp. 31–52.
Forbes, Crudella. "Redeeming the Word: Religious Experience as Liberation in Erna Brodber's Fiction." *Postcolonial Text*, vol. 3, no. 1, 2007, pp. 1–19.
François, Irline. "From Continents to Freedom: Jan J. [Gigi] Dominique's *Mémoire d'une amnésique*." *Écrire en pays assiégé. Haïti. Writing Under Siege*, edited by Marie-Agnès Sourieau and Kathleen M. Balutansky, Rodopi, 2004, pp. 285–301.
Frisch, Andrea. "The Ethics Testimony: A Genealogical Perspective." *Discourse*, vol. 25, nos. 1–2, winter and spring 2004, pp. 36–54.
Gambrell, Alice. *Women Intellectuals, Modernism, and Difference: Transatlantic Culture, 1919–1945*. Cambridge UP, 1997.
Garvey, Johanna. "Complicating Categories: 'Race' and Sexuality in Caribbean Women's Fiction." *Queer Studies*, special issue of *The Journal of Commonwealth and Postcolonial Literature*, vol. 10, no. 1, spring 2003, pp. 94–120.
Garvey, Johanna. "A Dream Deferred?: Spaces and Languages of Resistance in Caribbean Women's Fiction." *Black Liberation in the Americas*, edited by Christopher Mulvey and Fritz Gysin, Forecaast/Lit Verlag, 2001, pp. 153–71.
Garvey, Johanna. "Passages to Identity: Re-Membering the Diaspora in Marshall, Phillips, and Cliff." *Black Imagination and the Middle Passage*, edited by Maria Diedrich, Carl Pederson, and Henry Louis Gates, Jr. Oxford UP, 1999, pp. 255–70.
Gervasio, Nicole. "The Ruth in (T)ruth: Redactive Reading and Feminist Provocations to History in M. NourbeSe Philip's *Zong!*" *differences*, vol. 30, no. 2, 2019, pp. 1–29.
Ghinelli, Paola. "Marie-Célie Agnant: Entretien du 20 janvier 2005." *Archipels Littéraires*, Mémoires d'encrier, 2005, pp. 141–49.
Gikandi, Paul. *Writing in Limbo: Modernism and Caribbean Literature*. Cornell UP, 1992.
Gillis, John. *Islands of the Mind: How the Human Imagination Created the Atlantic World*. Palgrave Macmillan, 2004.
Gilroy, Paul. *Against Race*. Harvard UP, 2000.
Gilroy, Paul. *The Black Atlantic: Modernity and Double Consciousness*. Harvard UP, 1993.
Gilroy, Paul. *Small Acts: Thoughts on the Politics of Black Culture*. Serpent's Tail, 1993.
Girard, Philippe. *Haiti: The Tumultuous History—From Pearl of the Caribbean to Broken Nation*. Palgrave Macmillan, 2010.
Glave, Diane. "An Interview with Nalo Hopkinson." *Callaloo*, vol. 26, no. 1, winter 2003, pp. 146–59.
Glave, Thomas. *Our Caribbean: A Gathering of Lesbian and Gay Writing from the Antilles*. Duke UP, 2008.
Glissant, Édouard. *Caribbean Discourse: Selected Essays*. Translated by J. Michael Dash, UP of Virginia, 1989.
Glissant, Édouard. *Philosophie de la Relation*. Gallimard, 2009.
Glissant, Édouard. *Poetics of Relation*. Translated by Betsy Wing, U of Michigan P, 1997.
Glissant, Édouard. *Tout-Monde*. Gallimard, 1993.
Goldman, Marlene. *Paths of Desire: Images of Exploration and Mapping in Canadian Women's Writing*. U of Toronto P, 1997.

González-Allende, Iker. "De la pasividad al poder sexual y económico: El sujeto activo en *Sirena Selena*." *Chasqui: Revista de Literatura Latinoamericana*, vol. 34, no. 1, May 2005, pp. 51–64.

Gopinath, Gayatri. *Impossible Desires: Queer Diasporas and South Asian Public Cultures*. Duke UP, 2006.

Gordon, Deborah. "The Politics of Ethnographic Authority: Race and Writing in the Ethnography of Margaret Mead and Zora Neal Hurston." *Modernist Anthropology: From Fieldwork to Text*, edited by Marc Manganaro, Princeton UP, 1990, pp. 146–62.

Gossero-Esquilín, Mary Ann. "El consume del cuerpo travesti en *Sirena Selena vestida de pena* de Mayra Santos-Febres." *Publication of the Afro-Latin/American Research Association: PALARA*, vol. 14, 2010, pp. 42–53.

Gourdine, Angeletta K. M. "Carnival-Conjure, Louisiana, History and the Power of Women's Ethnographic Narrative." *ARIEL*, vol. 35, nos. 3–4, July–Oct. 2004, pp. 139–58.

Hale, Anthony R. "Framing the Folk: Zora Neale Hurston, John Millington Synge, and the Politics of Aesthetic Ethnography." *The Comparatist*, vol. 20, 1996, pp. 50–61.

Hantel, Max. "Rhizomes and the Space of Translation: On Edouard Glissant's Spiral Retelling." *Small Axe*, vol. 17, no. 3, (no. 42), Nov. 2013, pp. 100–112.

Harris, Wilson. "An Autobiographical Essay." Adler, pp. viii–xxxiv.

Harris, Wilson. *The Carnival Trilogy*. Faber and Faber, 1993.

Harris, Wilson. *The Womb of Space: The Cross-Cultural Imagination*. Greenwood Press, 1983.

Harrison, Elizabeth Jane. "Zora Neale Hurston and Mary Hunter Austin's Ethnographic Fiction: New Modernist Narratives." *Unmanning Modernism: Gendered Re-Readings*, edited by Elizabeth Jane Harrison and Shirley Peterson, U of Tennessee P, 1997, pp. 44–58.

Hartman, Saidiya. *Lose Your Mother: A Journey along the Atlantic Slave Route*. Farrar, Straus and Giroux, 2007.

Hartman, Saidiya. "Venus in Two Acts." *Small Axe*, vol. 12, no. 2, (no. 26), June 2008, pp. 1–14.

Helmreich, Stephan. "Kinship, Nation, and Paul Gilroy's Concept of Diaspora." *Diaspora* vol. 2, no. 2, 1992, pp. 243–49.

Hemenway, Robert E. *Zora Neale Hurston: A Literary Biography*. U of Illinois P, 1977.

Hernández, Graciela. "Multiple Subjectivities and Strategic Positionality: Zora Neale Hurston's Experimental Ethnographies." *Women Writing Culture*, edited by Ruth Behar and Deborah A. Gordon, U of California P, 1995, pp. 148–65.

Hill, Lynda Marion. *Social Rituals and the Verbal Art of Zora Neale Hurston*. Howard UP, 1996.

Hoffnung-Garskof, Jesse. *A Tale of Two Cities: Santo Domingo and New York after 1950*. Princeton UP, 2008.

Holmes, Rachel. *The Hottentot Venus: The Life and Death of Saartjie Baartman, Born 1789–Buried 2002*. Bloomsbury, 2007.

Hopkinson, Nalo. *The Salt Roads*. Warner Books, 2003.

Houlden, Kate. "Writing the Impossible: Racial, Sexual and Stylistic Expansivity in Nalo Hopkinson's *The Salt Roads*." *Journal of Postcolonial Writing*, vol. 51, no. 4, 2015, pp. 462–75.

Huggan, Graham. "Decolonizing the Map: Post-Colonialism, Post-Structuralism and the Cartographic Connection." *Ariel*, vol. 20, Oct. 1989, pp. 115–31.

Huggan, Graham. *Territorial Disputes: Maps and Mapping Strategies in Contemporary Canadian and Australian Fiction*. U of Toronto P, 1994.

Hulme, Peter. *Remnants of Conquest: The Island Caribs and Their Visitors, 1877–1998*. Oxford UP, 2000.

Hurston, Zora Neale. *Dust Tracks on a Road*. 1942. Harper Perennial, 1991.

Hurston, Zora Neale. *Mules and Men*. 1935. Harper Perennial 1990.
Hurston, Zora Neale. *Tell My Horse: Voodoo and Life in Haiti and Jamaica*. 1938. Harper and Row, 1990.
Jackson, Zakiyyah Iman. *Becoming Human: Matter and Meaning in an Antiblack World*. New York UP, 2020.
James, C. L. R. *Beyond a Boundary*. Duke UP, 1993.
James, C. L. R. *The Black Jacobins: Toussaint L'Ouverture and the San Domingo Revolution*. 2nd ed., rev., Vintage, 1989.
James, Winston. *Holding Aloft the Banner of Ethiopia: Caribbean Radicalism in Early Twentieth-Century America*. Verso, 1998.
John, Catherine. "Caribbean Organic Intellectual: The Legacy and Challenge of Erna Brodber's Life." *Small Axe*, vol. 16, no. 3, (no. 39), Nov. 2012, pp. 72-88.
John, Marie-Elena. *Unburnable*. Amistad/Harper Collins, 2006.
Jordan, Rosan Augusta. "Not into Cold Space: Zora Neale Hurston and J. Frank Dobie as Holistic Folklorists." *Southern Folklore*, vol. 49, no. 2, 1992, 109-31.
Josephs, Kelly Baker. "Beyond Geography, Past Time: Afrofuturism, *The Rainmaker's Mistake*, and Caribbean Studies." *Small Axe*, vol. 17, no. 2, (no. 41), July 2013, pp. 123-35.
Jurney, F. Ramond. "Entretien avec Marie-Célie Agnant." *The French Review*, vol. 79, no. 2, 2005, pp. 384-94.
Kawash, Samira. *Dislocating the Color Line: Identity, Hybridity, and Singularity in African-American Narrative*. Stanford UP, 1997.
Keeling, Kara. *Queer Times, Black Futures*. New York UP, 2019.
Keizer, Arlene R. *Black Subjects: Identity Formation in the Contemporary Narrative of Slavery*. Cornell UP, 2004.
Khan, Almas. "Poetic Justice: Slavery, Law, and the (Anti-)Elegiac Form in M. NourbeSe Philip's *Zong!*" *Cambridge Journal of Postcolonial Literary Inquiry*, vol. 2, no. 1, Mar. 2015, pp. 5-32.
Khokher, Reginald. "Dialoguing Borders: The African Diasporic Consciousness in Erna Brodber's *Louisiana*." *Canadian Woman Studies/Les Cahiers de la Femme*, vol. 23, no. 2, 2004, pp. 38-42.
King, Rosamond S. *Island Bodies: Transgressive Sexualities in the Caribbean Imagination*. UP of Florida, 2014.
King, Rosamond S. "Re/Presenting Self and Other: Trans Deliverance in Caribbean Texts." *Callaloo*, vol. 31, no. 2, 2008, pp. 581-99.
King, Rosamond S. "One Sustained Moment: The Constant Re-creation of Caribbean Sexualities." *Small Axe*, vol. 21, no. 1, (no. 52), Mar. 2017, pp. 250-59.
King, Rosamond S., and Angelique V. Nixon, editors. *Theorizing Homophobia in the Caribbean's Complexities of Place, Desire, and Belonging*. Digital Multimedia Collection, 2012, http://www.caribbenhomophobias.org.
Krikler, Jeremy. "A Chain of Murder in the Slave Trade: A Wider Context of the *Zong* Massacre." *International Review of Social History*, vol. 57, no. 4, Dec. 2012, pp. 393-415.
Lacombe, Michèle. "Embodying the Glocal: Immigrant and Indigenous Ideas of Home in Tessa McWatt's Montreal." *Literature and the Glocal City: Reshaping the English Canadian Imaginary*, edited by Ana Maria Fraile-Marcos, Routledge, 2014, pp. 39-54.
Lambert, Laurie R. "Poetics of Reparation in M. NourbeSe Philip's *Zong!*" *The Global South*, vol. 10, no. 1, spring 2016, pp. 107-29.
Lara, Ana-Maurine. *Erzulie's Skirt*. Redbone Press, 2006.

Lauden, John. "Reading Hurston Writing." *African American Review*, vol. 38, no. 1, spring 2004, pp. 45–60.

Lawrence, David Todd. "Folkloric Representation and Extended Context in the Experimental Ethnography of Zora Neale Hurston." *Southern Folklore*, vol. 57, no. 2, 2000, pp. 119–34.

Lee-Keller, Hellen. "Madness and the Mulâtre-Aristocrate: Haiti, Decolonization, and Women in Marie-Chauvet's *Amour*." *Callaloo*, vol. 32, no. 4, winter 2009, pp. 1293–1311.

Leong, Diana. "The Salt Bones: *Zong!* And an Ecology of Thirst." *ISLE: Interdisciplinary Studies in Literature and Environment*, vol. 23, no. 4, autumn 2016, pp. 798–820.

Llenín-Figueroa, Beatriz. "'I Believe in the Future of "Small Countries'": Édouard Glissant's Archipelagic Scale in Dialogue with Other Caribbean Writers." *Discourse*, vol. 36, no. 1, winter 2014, pp. 87–111.

MacDonald, Tanis. "'Rhetorical Metatarsals': Bone Memory in Dionne Brand's *Ossuaries*." *The Memory Effect: The Remediation of Memory in Literature and Film*, edited by Russell J. A. Kilbourn and Eleanor Ty, Wilfred Laurier UP, 2013, pp. 93–106.

Mahlis, Kristen. "M. NourbeSe Philip: Language, Place, and Exile." *Journal of West Indian Literature*, vol. 14, nos. 1–2, Nov. 2005, pp. 166–203.

Mancke, Elizabeth. "Early Modern Expansion and the Politicization of Oceanic Space." *Geographical Review*, vol. 89, no. 2, Apr. 1999, pp. 225–36.

Mardorossian, Carine M. "'Poetics of Landscape': Édouard Glissant's Creolized Ecologies." *Callaloo*, vol. 36, no. 4, fall 2013, pp. 983–94.

Marinkova, Milena. "Revolutionizing Pleasure in Writing: Subversive Desire and Micropolitical Affects in Nalo Hopkinson's *The Salt Roads*." *Postcolonial Literatures and Deleuze: Colonial Pasts, Differential Futures*, edited by Lina Burns and Birgit M. Kaiser, Palgrave Macmillan, 2012, pp. 181–98.

Marshall, Paule. *The Chosen Place, the Timeless People*. 1969. Vintage, 1984.

Mata Barreiro, Carmen. "Le Moi femme/le Nous histoire: Voix et vies dans l'oeuvre de Marie-Célie Agnant." *Revue des Lettres et de Traduction*, 7, 2001, 361–74.

Maximin, Colette. "Distinction and Dialogism in Jamaica: *Myal* by Erna Brodber." *Commonwealth Essays and Studies*, vol. 21, no. 2, spring 1999, 49–62.

Mayer, Ruth. "'Africa As an Alien Future': The Middle Passage, Afrofuturism, and Postcolonial Waterworlds." *Amerikastudien*, vol. 45, no. 4, 2000, pp. 555–66.

Mbembe, Achille. "Necropolitics." Translated by Libby Meintjes. *Public Culture*, vol. 15, no. 1, winter 2003, pp. 11–40.

McKittrick, Katherine. *Demonic Grounds: Black Women and the Cartographies of Struggle*. U of Minnesota P, 2006.

McKittrick, Katherine. "Plantation Futures." *Small Axe*, vol. 17, no. 3, (no. 42), Nov. 2013, pp. 1–15

McKittrick, Katherine. "'Who Do You Talk To, When a Body's in Trouble?': M. Nourbese Philip's (Un)Silencing of Black Bodies in Diaspora." *Social and Cultural Geography*, vol. 1, no. 2, 2000, pp. 223–36.

McKittrick, Katherine, editor. *Sylvia Wynter: On Being Human as Praxis*. Duke UP, 2015.

McWatt, Tessa. *Dragons Cry*. Riverbank Press, 2000.

McWatt, Tessa. *Out of My Skin*. Riverbank Press, 1998.

McWatt, Tessa. *Shame on Me: An Anatomy of Race and Belonging*. Scribe, 2019.

McWatt, Tessa *There's No Place Like.* . . . Macmillan, 2004.

McWatt, Tessa. *This Body*. HarperCollins, 2004.
Meehan, Kevin. "Decolonizing Ethnography: Zora Neal Hurston in the Caribbean." *Women at Sea: Travel Writing and the Margins of Caribbean Discourse*, edited by Lizabeth Paravisini-Gebert and Ivette Romero-Cesareo, Palgrave, 2001, pp. 245–79.
Meehan, Kevin. *People Get Ready: African American and Caribbean Cultural Exchange*. UP of Mississippi, 2009.
Mehta, Brinda. *Notions of Identity, Diaspora, and Gender in Caribbean Women's Writing*. Palgrave Macmillan, 2009.
Melville, Pauline. *Shape-Shifter*. Pantheon, 1990.
Melville, Pauline. *The Ventriloquist's Tale*. Bloomsbury, 1997.
Meriwether, Rae Ann. "The Blues Matrix: Cultural Discourses and Community in Erna Brodber's *Louisiana*." *Small Axe*, vol. 16, no. 3, (no. 39), Nov. 2012, pp. 103–18.
Mikell, Gwendolyn. "The Anthropological Imagination of Zora Neale Hurston." *The Western Journal of Black Studies*, vol. 7, no. 1, 1983, pp. 27–35.
Miller, Christopher L. *The French Atlantic: Literature and Culture of the Slave Trade*. Duke UP, 2008.
Mintz, Sidney, and Michel-Rolph Trouillot. "The Social History of Haitian Vodou." *Sacred Arts of Haitian Vodou*, edited by Donald J. Consentino, UCLA Fowler Museum of Cultural History, 1995, pp. 123–47.
Morell, Hortensia R. "Tuning into Boleros in *Sirena Selena vestida de pena*: A Character's Flawed Defense Mechanisms." *Into the Mainstream: Essays on Spanish American and Latino Literature and Culture*, edited by Jorge Febles, Cambridge Scholars Press, 2006, pp. 15–25.
Moyes, Lianne. "Contesting Home and Native Land: Tessa McWatt's *Out of My Skin* and Drew Hayden Taylor's 'A Blurry Image on the Six O'clock News.'" *Ranam: Recherches anglaises et nord-américaines*, no. 46, 2013, pp. 99–108.
Moynagh, Maureen. "'This History's Only Good for Anger': Gender and Cultural Memory in *Beatrice Chancy*." *Signs*, vol. 28, no. 2, autumn 2002, pp. 97–124.
Mulira, Jessie Gatson. "The Case of Voodoo in New Orleans." *Africanisms in American Culture*, edited by Joseph Holloway, Indiana UP, 1990, pp. 34–68.
Munro, Martin. "Hatred Chérie: History, Silence and Animosity in Three Haitian Novels." *Echoes of the Haitian Revolution 1804–2004*, edited by Munro and Elizabeth Walcott-Hackshaw, U of the West Indies P, 2008, pp. 163–75.
Murdoch, H. Adlai. "Édouard Glissant's Creolized World Vision: From Resistance and Relation to *Opacité*." *Callaloo*, vol. 36, no. 4, fall 2013, pp. 875–90.
Murphy, Joseph M. *Working the Spirit: Ceremonies of the African Diaspora*. Beacon Press, 1994.
Murray, David A. B. *Flaming Souls: Homosexuality, Homophobia, and Social Change in Barbados*. U of Toronto P, 2012.
Mustakeem, Sowande M. *Slavery at Sea: Terror, Sex, and Sickness in the Middle Passage*. U of Illinois P, 2016.
Naimou, Angela. *Salvage Work: US and Caribbean Literatures and the Debris of Legal Personhood*. Fordham UP, 2015.
Narain, Denise deCaires. "The Body of the Woman in the Body of the Text: The Novels of Erna Brodber." Condé and Lonsdale, pp. 97–116.
Ndiaye, Christiane. "Récits des origines chez quelques écrivaines de la francophonie." *Études Françaises*, vol. 40, no. 1, 2004, pp. 43–63.

Nelson, Alondra. "Making the Impossible Possible: An Interview with Nalo Hopkinson." *Social Text*, vol. 20, no. 2, (no. 71), summer 2002, pp. 97–113.

Nelson-McDermott, Catherine. "Myal-ing Criticism: Beyond Colonizing Dialectics." *ARIEL*, vol. 24, no. 4, Oct. 1993, pp. 53–65.

Niblett, Michael. "Plotting the Future in Caribbean SF: Alimentary Imperialism and Horti(counter)culture." *Science Fiction Studies*, vol. 49, no. 2, 2022, pp. 288–303.

Nicholls, David G. "Migrant Labor, Folklore, and Resistance in Hurston's Polk County: Reframing *Mules and Men*." *African American Review*, vol. 33, no. 3, fall 1999, pp. 467–79.

Nielson, Aldon L. *Writing between the Lines: Race and Intertextuality*. U of Georgia P, 1994.

Nolan, E. Martin. "To Promote Statements That Don't Have an End: In Conversation with Dionne Brand." *Puritan Magazine*, no. 44, winter 2019.

Nora, Pierre. "Between Memory and History: *Les Lieux de Mémoire*." *Representations*, no. 26, spring 1989, pp. 7–24.

O'Callaghan, Evelyn. "Interior Schisms Dramatised: The Testament of the 'Mad' Woman in the Work of Some Female Caribbean Novelists." Davies and Fido, pp. 89–109.

O'Callaghan, Evelyn. "Play It Back a Next Way: Teaching Brodber Teaching Us." *Small Axe*, vol. 16, no. 3, (no. 39), Nov. 2012, pp. 59–71.

O'Callaghan, Evelyn. *Woman Version: Theoretical Approaches to West Indian Fiction by Women*. St. Martin's, 1993.

O'Driscoll, Sally. "Michelle Cliff and the Authority of Identity." *Journal of the Midwest MLA*, vol. 28, no. 1, spring 1995, pp. 56–70.

Outar, Lisa. "Indigenous Sexualities: Rosamond S. King's *Island Bodies* and the Radical Politics of Scholarship." *Small Axe*, vol. 21, no. 1, (no. 52), Mar. 2017, pp. 241–49.

Page, Kezia. *Transnational Negotiations in Caribbean Diaspora Literature: Remitting the Text*. Routledge, 2011.

Paravisini-Gebert, Lizabeth. "'A Forgotten Outpost of Empire': Social Life in Dominica and the Creative Imagination." *Jean Rhys Review*, vol. 10, 1999, pp. 13–27.

Paton, Diana. "Obeah Acts: Producing and Policing the Boundaries of Religion in the Caribbean." *Small Axe*, vol. 13, no. 1, (no. 28), Mar. 2009, pp. 1–16.

Pavlić, Edward M. "'Papa Legba, Ouvrier Barriere Por Moi Passer': Esu in *Their Eyes* and Zora Neale Hurston's Diasporic Modernism." *African American Review*, vol. 38, no. 1, spring 2004, pp. 61–85.

Peña-Jordán, Teresa. "Romper la verja, meterse por los poros, infectar: una entrevista con Mayra Santos-Febres." *Centro Journal*, vol. 15, no. 2, fall 2003, pp. 117–25.

Pettis, Joyce. "A MELUS Interview: Paule Marshall." *MELUS*, vol. 17, no. 4, winter 1991–1992, pp. 117–29.

Pettis, Joyce. "'Talk' as Defensive Artifice: Merle Kinbona in *The Chosen Place, the Timeless People*." *African American Review*, vol. 26, no. 1, 1992, pp. 109–17.

Philip, M. NourbeSe. "Earth and Sound: The Place of Poetry." *The Word behind Bars and the Paradox of Exile*, edited by Kofi Anyidoho, Northwestern UP, 1997, pp. 169–82.

Philip, M. NourbeSe. *A Genealogy of Resistance and Other Essays*. Mercury Press, 1997.

Philip, M. NourbeSe. "In the Matter of Memory." *Fertile Ground: Memories and Visions 1996*, edited by Kalamu ya Salaam and Kysha N. Brown, Runnagate Press, 1996, pp. 21–28.

Philip, M. NourbeSe. "Interview with an Empire." *Assembling Alternatives: Reading Postmodern Poetries Transnationally*, edited by Romana Huk, Wesleyan UP, 2003, pp. 195–206.

Philip, M. NourbeSe. "Notanda." *Zong!*, by Philip, Wesleyan UP, 2008, pp. 187–209.

Philip, M. NourbeSe. *She Tries Her Tongue, Her Silence Softly Breaks*. Ragweed Press, 1989.
Philip, M. NourbeSe. "Whose Idea Was It Anyway?" *The Word behind Bars and the Paradox of Exile*, edited by Kofi Anyidoho, Northwestern UP, 1997, pp. 183–87.
Philip, M. NourbeSe. *Zong!* Wesleyan UP, 2008.
Pinnix, Aaron. "Sargassum in the Black Atlantic: Entanglement and the Abyss in Bearden, Walcott, and Philip." *Atlantic Studies*, vol. 16, no. 4, 2019, pp. 423–51.
Pinto, Samantha. *Difficult Diasporas: The Transnational Feminist Aesthetics of the Black Atlantic*. New York UP, 2013.
Piper, Adrian. "Passing for White, Passing for Black." *Transition*, no. 58, 1992, pp. 4–32.
Proulx, Patrice. "Bearing Witness and Transmitting Memory in the Works of Marie-Célie Agnant." *Québec Studies*, vol. 39, spring/summer 2005, pp. 35–53.
Proulx, Patrice. "Breaking the Silence: An Interview with Marie-Célie Agnant." *Québec Studies*, vol. 41, spring/summer 2006, pp. 45–61.
Puri, Shalini. "An 'Other' Realism: Erna Brodber's 'Myal.'" *Ariel*, vol. 24, no. 3, July 1993, pp. 95–115.
Quéma, Anne. "Dionne Brand's *Ossuaries*: Songs of Necropolitics." *Canadian Literature*, 222, autumn 2014, pp. 52–68.
Quiroga, José. *Tropics of Desire: Interventions from Queer Latino America*. NYU P, 2001.
Raiskin, Judith. *Snow on the Cane Fields: Women's Writing and Creole Subjectivity*. U of Minnesota P, 1996.
Ramazani, Jahan. "The Wound of History: Walcott's *Omeros* and the Postcolonial Poetics of Affliction." *PMLA*, vol. 112, no. 3, May 1997, pp. 405–17.
Rankine, Claudia. *Citizen: An American Lyric*. Graywolf Press, 2014.
Rediker, Marcus. *The Slave Ship: A Human History*. Penguin, 2008.
Rice, Alan. *Radical Narratives of the Black Atlantic*. Continuum, 2003.
Rivera, Angel A. "*Sirena Selena vestida de pena* de Mayra Santos-Febres. Consumidora y consumida, la nueva ciudadana del Caribe." *Bulletin of Hispanic Studies*, vol. 85, no. 1, 2008, pp. 97–109.
Roach, Joseph. *Cities of the Dead: Circum-Atlantic Performance*. Columbia UP, 1996.
Roberts, June E. *Reading Erna Brodber: Uniting the Black Diaspora through Folk Culture and Religion*. Praeger, 2006.
Robinson, Tracy S. "Fictions of Citizenship, Bodies without Sex: The Production and Effacement of Gender in Law." *Small Axe*, vol. 4, no. 1, (no. 7), Mar. 2000, pp. 1–27.
Rodríguez, Juana María. "Translating Queer Caribbean Localities in *Sirena Selena vestida de pena*." *MELUS*, vol. 34, no. 3, fall 2009, pp. 205–223.
Rodriques, Janelle. "'Promises Are Merely Sweet Lies': Mandatory Motherhood and Migration in Nicole Dennis-Benn's *Patsy*." *Caribbean Quarterly*, vol. 67, no. 3, 2021, pp. 267–82.
Rodriques, Janelle. "'Threads Thin to the Point of Invisibility, Yet Strong as Ropes': Afrofuturistic Diaspora in Paule Marshall's *Praisesong for the Widow*." *Anthurium*, vol. 14, no. 1, June 2017, article 7, https://anthurium.miami.edu/articles/abstract/10.33596/anth.331/.
Rohrbach, Augusta. "To Be Continued: Double Identity, Multiplicity and Antigenealogy as Narrative Strategies in Pauline Hopkins' Magazine Fiction." *Callaloo*, vol. 22, no. 2, spring 1999, pp. 483–98.
Rothberg, Michael. "Decolonizing Trauma Studies: A Response." *Postcolonial Trauma Novels*, special issue of *Studies in the Novel*, vol. 40, nos. 1/2, spring and summer 2008, pp. 224–34.

Rowe, John Carlos. "Opening the Gate to the Other America: The Afro-Caribbean Politics of Hurston's *Mules and Men* and *Tell My Horse*." *Literary Culture and US Imperialism: From the Revolution to World War II*, by Rowe, Oxford UP, 2000, pp. 253–91.

Rupprecht, Anita. "'A Limited Sort of Property': History, Memory and the Slave Ship *Zong*." *Slavery and Abolition*, vol. 29, no. 2, June 2008, pp. 265–77.

Rupprecht, Anita. "'A Very Uncommon Case': Representations of the *Zong* and the British Campaign to Abolish the Slave Trade." *The Journal of Legal History*, vol. 28, no. 3, Dec. 2007, pp. 329–46.

Rutledge, Gregory E. "Speaking in Tongues: An Interview with Science Fiction Writer Nalo Hopkinson." *African American Review*, vol. 33, no. 4, winter 1999, pp. 589–601.

Sánchez-Eppler, Benigno. "Telling Anthropology: Zora Neale Hurston and Gilberto Freyre Disciplined in Their Field-Home-Work." *American Literary History*, vol. 4, no. 3, fall 1992, pp. 464–88.

Sandoval-Sánchez, Alberto. "*Sirena Selena vestida de pena*: A Novel for the New Millenium and for New Critical Practices in Puerto Rican Literary and Cultural Studies." *Centro Journal*, vol. 15, no. 2, fall 2003, pp. 5–23.

Santos-Febres, Mayra. *Sirena Selena*. Translated by Stephen Lytle, Picador, 2000.

Santos Perez, Craig. "Guam and Archipelagic Black Global Imaginary." *Archipelagic American Studies*, edited by Brian Russell Roberts and Michelle Ann Stephens, Duke UP, 2017, pp. 97–112.

Saunders, Patricia. "Defending the Dead, Confronting the Archive: A Conversation with M. NourbeSe Philip." *Small Axe*, vol. 12, no. 2, (no. 26), June 2008, pp. 63–79.

Saunders, Patricia. "The Project of Becoming for Marlene Nourbese-Philip and Erna Brodber." *Bucknell Review*, vol. 44, no. 2, 2001, pp. 133–59.

Saunders, Patricia. "Trying Tongues, E-raced Identities, and the Possibilities of Be/longing: Conversations with NourbeSe Philip." *Journal of West Indian Literature*, vol. 14, nos. 1–2, Nov. 2005, pp. 202–21.

Savory, Elaine. "Wordsongs and Wordwounds/Homecoming: Kamau Brathwaite's *Barabajan Poems*." *The Critical Response to Kamau Brathwaite*, edited by Emily Allen Williams, Praeger, 2004, pp. 185–96.

Schenck, Mary Jane. "Ceremonies of Reconciliation: Paule Marshall's *The Chosen Place, the Timeless People*." *MELUS*, vol. 19, no. 4, winter 1994, pp. 48–60.

Schuchardt, Beatrice. "Deux couleurs bleus: opacité et différence dans *Le Livre d'Emma* de Marie-Célie Agnant." *Écritures transculturelles: Kulturelle Differenz und Geschlechter Differenz im Französischsprachiges Gegenwartsroman*, edited by Gisela Febel, Karen Struve, and Natascha Ueckmann, Gunter Narr, 2007, pp. 189–204.

Schwartz, Meryl E. "An Interview with Michelle Cliff." *Contemporary Literature*, vol. 34, no. 4, winter 1993, pp. 595–619.

Scott, David. "On the Question of Caribbean Studies." *Small Axe*, vol. 17, no. 2, (no. 41), July 2013, pp. 1–7.

Serrano, Lucienne J. "Transgression de l'écriture dans *Le Livre d'Emma*." Boucher and Spear, pp. 135–45.

Sharpe, Christina. *In the Wake: On Blackness and Being*. Duke UP, 2016.

Sharpe, Jenny. *Immaterial Archives: An African Diaspora Poetics of Loss*. Northwestern UP, 2020.

Sharpe, Jenny. "When Spirits Talk: Reading Erna Brodber's *Louisiana*." *Small Axe*, vol. 16, no. 3, (no. 39), Nov. 2012, pp. 90–102.

Shea, Renée Hausmann. "Interview with Michelle Cliff." *Belles Lettres*, vol. 9, no. 3, summer 1994, pp. 32–34.
Sheller, Mimi. *Citizenship from Below: Erotic Agency and Caribbean Freedom*. Duke UP, 2012.
Sheller, Mimi. "Work That Body: Sexual Citizenship and Embodied Freedom." *Constructing Vernacular Culture in the Trans-Caribbean*, edited by Holger Henke and Karl-Heinz Magestin, Lexington Books, 2007, pp. 345–76.
Shelton, Marie-Denise. *Écriture de l'histoire*, special issue of *Women in French Studies*, 2005, pp. 71–81.
Shields, Tanya. *Bodies and Bones: Feminist Rehearsal and Imagining Caribbean Belonging*. U of Virginia P, 2014.
Siemerling, Winfried. "Ethics as Re-Cognition in the Novels of Marie-Célie Agnant: Oral Knowledge, Cognitive Change, and Social Justice." *University of Toronto Quarterly*, vol. 76, no. 3, summer 2007, pp. 838–60.
Siklosi, Kate. "'the absolute / of water': The Submarine Poetic of M. NourbeSe Philip's *Zong!*" *Canadian Literature*, 228/229, spring/summer 2016, pp. 111–30.
Silva, Yamile. "Conversación con Mayra Santos-Febres." *Letras Femeninas*, vol. 41, no. 2, winter 2015, 135–41.
Simpson, Hyacinth M. "Fantastic Alternatives: Journeys into the Imagination, A Conversation with Nalo Hopkinson." *Journal of West Indian Literature*, vol. 14, nos. 1–2, Nov.2005, pp. 96–112.
Simpson, Leanne, and Kiera Ladner, editors. *This Is an Honour Song: Twenty Years since the Blockades*. Arbeiter Ring, 2010.
Smallwood, Stephanie E. *Saltwater Slavery: A Middle Passage from Africa to American Diaspora*. Harvard UP, 2007.
Smith, Faith. "Queer Livity in the Caribbean: Rosamond S. King's *Island Bodies*." *Small Axe*, vol. 21, no. 1, (no. 52), Mar. 2017, pp. 233–40.
Smith, Faith, editor. *Sex and the Citizen: Interrogating the Caribbean*. U of Virginia P, 2011.
Smith, Jonathan. "The Journey into Blackness: The Middle Passage, Floating Signifiers, and the Boundaries of Race." *Exit 9: The Rutgers Journal of American Studies*, vol. 3, nos. 3–4, autumn 1995–1996, pp. 59–90.
Sorensen, Leif. "Dubwise into the Future: Versioning Modernity in Nalo Hopkinson." *African American Review*, vol. 47, nos. 2–3, summer–fall, pp. 267–83.
Sourieau, Marie-Agnès. "Tactiques narratives dans *Mémoire d'une amnésique* de J. J. Dominique." *The French Review*, vol. 68, no. 4, Mar. 1995, pp. 694–703.
Spillers, Hortense. "Black, White, and in Color, or Learning How to Paint: Toward a Protocol of Reading." *New Historical Literary Study*, edited by Jeffrey N. Cox and Larry J. Reynolds, Princeton UP, 1993, pp. 267–91.
Spillers, Hortense, and Marjorie Pryse, editors. *Conjuring: Black Women, Fiction, and Literary Tradition*. Indiana UP, 1985.
Stephens, Michelle. "What Is an Island?: Caribbean Studies and the Contemporary Visual Artist." *Small Axe*, vol. 17, no. 2, (no. 41), July 2013, pp. 8–26.
Stinchcomb, Dawn F. "The Archetypes of the Immaterial Bodies of the African 'Supernatural': Transience, Sexual Ambiguity, and Santería in Contemporary Hispanic Caribbean Novels." *Chasqui: Revista de Literatura y Cultura Latinoamericana e Indígena*, vol. 42, no. 2, Nov. 2013, pp. 3–14.

Tal, Kali. *Worlds of Hurt: Reading the Literature of Trauma*. Cambridge UP, 1996.

Taylor, Carole Anne. "World-Traveling as Modal Skid: Hurston and Vodou." *The Tragedy and Comedy of Resistance: Reading Modernity through Black Women's Fiction*, by Taylor, U of Pennsylvania P, 2000, pp. 170–200.

Tervonen, Taina. "Transmettre par la parole, pas par le sang. Entretien avec Marie-Célie Agnant." *Africultures*, 62, janvier–mars 2005, pp. 215–18.

"Theorizing Queer Temporalities: A Roundtable Discussion." *GLQ: A Journal of Lesbian and Gay Studies*, vol. 13, nos. 2–3, 2007, pp. 177–95.

Tiffin, Helen. "Cold Hearts and (Foreign) Tongues: Recitation and the Reclamation of the Female Body in the Works of Erna Brodber and Jamaica Kincaid." *Callaloo*, vol. 16, no. 3, fall 1993, pp. 909–21.

Tinsley, Omise'eke Natasha. "Black Atlantic, Queer Atlantic: Queer Imaginings of the Middle Passage," *GLQ: A Journal of Lesbian and Gay Studies*, vol. 14, nos. 2–3, 2008, pp. 191–215.

Tinsley, Omise'eke Natasha. *Ezili's Mirrors: Imagining Black Queer Genders*. Duke UP, 2018.

Tinsley, Omise'eke Natasha. *Thiefing Sugar: Eroticism between Women in Caribbean Literature*. Duke UP, 2010.

Toland-Dix, Shirley. "'This Is the Horse. Will You Ride?': Zora Neale Hurston, Erna Brodber, and Rituals of Spirit Possession." *Just Below South: Intercultural Performance in the Caribbean and the US South*, edited by Jessica Adams, Michael P. Bibler, and Cécile Accilien, U of Virginia P, 2007, pp. 191–210.

Torres, Daniel. "La erotica de Mayra Santos-Febres." *Centro Journal*, vol. 15, no. 2, fall 2003, pp. 99–105.

Trefzer, Annette. "Possessing the Self: Caribbean Identities in Zora Neale Hurston's *Tell My Horse*." *African American Review*, vol. 34, no. 2, summer 2000, pp. 299–312.

Trezise, Thomas. "Unspeakable." *The Yale Journal of Criticism*, vol. 14, no. 1, spring 2001, pp. 39–66.

Trouillot, Michel-Rolph. *Silencing the Past: Power and the Production of History*. Beacon Press, 1995.

Van Haesendonck, Kristian. "*Sirena Selena vestida de pena* de Mayra Santos-Febres: ¿transgresiones de espacio o espacio de transgresiones?" *Centro Journal*, vol. 15, no. 2, fall 2003, pp. 79–97.

Vieux-Chauvet, Marie. *Love, Anger, Madness*. Translated by Rose-Myriam Réjois and Val Vinokur, Modern Library, 2010. Originally published in French, 1968.

Visser, Irene. "Decolonizing Trauma Studies: Retrospects and Prospects." *Decolonizing Trauma Studies: Trauma and Postcolonialism*, special issue of *Humanities*, vol. 4, no. 2, 2015, pp. 250–65.

Visweswaran, Kamala. *Fictions of Feminist Ethnography*. U of Minnesota P, 1994.

Vizenor, Gerald. *Crossbloods: Bone Courts, Bingo, and Other Reports*. 1976. U of Minnesota P, 1990.

"Voices from Hispaniola: A *Meridians* Roundtable with Edwidge Danticat, Loida Maritza Pérez, Myriam J. A. Chancy, and Nelly Rosario. *Meridians*, vol. 5, no. 1, 2004, pp. 68–91.

Waisvisz, Sarah. "Fugitive Rhythms: Re-Imagining Diasporic Caribbean-Canadian Communities in Ramabai Espinet's *The Swinging Bridge*, Tessa McWatt's *Out of My Skin*, and Dionne Brand's *What We All Long For*." 2006. McGill University, MA thesis.

Walcott, Derek. *Omeros*. Farrar, Straus and Giroux, 1990.

Walcott, Derek. "The Sea Is History." *Collected Poems: 1948–1984*, by Walcott. 1986. Farrar, Straus and Giroux, 1990, pp. 364–67.

Walcott, Derek. *What the Twilight Says: Essays*. Farrar, Straus and Giroux, 1998.

Walcott, Rinaldo. *Black Like Who? Writing Black Canada*. Insomniac Press, 1997.

Walcott-Hackshaw, Elizabeth. "Lahens's Revolution, or the Words Within." *Reinterpreting the Haitian Revolution and Its Cultural Aftershocks*, edited by Martin Munro and Walcott-Hackshaw, U of the West Indies P, 2006, pp. 38–54.

Wall, Cheryl A. "*Mules and Men* and Women: Zora Neale Hurston's Strategies of Narration and Visions of Female Empowerment." *Black American Literary Forum*, vol. 23, no. 4, winter 1989, pp. 661–79.

Walters, Keith. "'He Can Read My Writing but He Sho' Can't Read My Mind': Zora Neale Hurston's Revenge in *Mules and Men*." *Journal of American Folklore*, vol. 112, summer 1999, pp. 343–71.

Walters, Wendy W. *Archives of the Black Atlantic: Reading between Literature and History*. Taylor and Francis, 2013.

Walvin, James. *Black Ivory: Slavery in the British Empire*. 2nd ed., Blackwell, 2001.

Walvin, James. *The Zong: A Massacre, the Law, and the End of Slavery*. Yale UP, 2011.

Watson-Aifah, Jené. "A Conversation with Nalo Hopkinson." *Callaloo*, vol. 26, no. 1, winter 2003, 160–69.

Weheliye, Alexander G. *Habeas Viscus: Racializing Assemblages, Biopolitics, and Black Feminist Theories of the Human*. Duke UP, 2014.

Welsh, Sarah Lawson. "Pauline Melville's Shape-Shifting Fictions." Condé and Lonsdale, pp. 144–71.

West, Heather A. "Entre deux cultures: les contraintes de Flore dans *Le Livre d'Emma*." Boucher and Spear, pp. 171–83.

Wiedorn, Michael. *Think Like an Archipelago: Paradox in the Work of Édouard Glissant*. SUNY Press, 2018.

Wilderson, Frank B., III. *Afropessimism*. Liveright/W. W. Norton, 2020.

Wilentz, Amy. *The Rainy Season: Haiti—Then and Now*. 1989. Simon and Schuster, 2010.

Wilentz, Gay. "Reclaiming Residual Culture: African Heritage as Caribbean Curse in Erna Brodber's *Jane and Louisa Will Soon Come Home*." *Healing Narratives: Women Writers Curing Cultural Dis-ease*, by Wilentz, Rutgers UP, 2000, pp. 27–52.

Willis, Susan. "Describing Arcs of Recovery: Paule Marshall's Relationship to Afro-American Culture." *Specifying: Black Women Writing the American Experience*, by Willis, U of Wisconsin P, 1987, pp. 53–82.

Wolff, Christian. "An Interview with Nalo Hopkinson." *MaComère*, vol. 4, 2001, pp. 26–36.

Woolford, Pam. "Filming Slavery: A Conversation with Haile Gerima." *Transition*, no. 64, 1994, pp. 90–104.

Wynter, Sylvia. "1492: A New World View." *Race, Discourse, and the Origin of the Americas: A New World View*, edited by Vera Lawrence Hyatt and Rex Nettleford, Smithsonian Institution Press, 1995, pp. 5–57.

Wynter, Sylvia. "Beyond Miranda's Meanings: Un/silencing the 'Demonic Ground' of Caliban's Woman." Davies and Fido, pp. 355–72.

Wynter, Sylvia. "Novel and History, Plot and Plantation." *Savacou*, no. 5, June 1971, pp. 95–102.

Wynter, Sylvia. "The Pope Must Have Been Drunk, the King of Castile a Madman: Culture as Actuality, and the Caribbean Rethinking Modernity." *The Reordering of*

Culture: Latin America, the Caribbean and Canada in the Hood, edited by Alvina Ruprecht and Cecelia Taiana, Carleton UP, 1995, pp. 17–41.

Wynter, Sylvia. "Towards the Sociogenic Principle: Fanon, Identity, the Puzzle of Conscious Experience, and What It Is Like to Be 'Black.'" *National Identity and Sociopolitical Change: Latin America between Marginalization and Integration*, edited by Mercedes Durán-Gogan and Antonio Gómez-Moriana, Routledge, 2001, pp. 30–66.

Wynter, Sylvia. "Unsettling the Coloniality of Being/Power/Truth/Freedom: Towards the Human, after Man, Its Overrepresentation—An Argument." *CR: The New Centennial Review*, vol. 3, no. 3, fall 2003, pp. 257–337.

Ziethen, Antje. "Migration, imagination, poétique. Le paradigme transnational chez Marie-Célie Agnant." *Géographies transnationales du text africain et caribéen*, vol. 46, no. 1, hiver 2015, pp. 105–18.

Zimra, Clarisse. "Haitian Literature after Duvalier: An Interview with Yanick Lahens." *Callaloo*, vol. 16, no.1, winter 1993, pp. 77–93.

INDEX

Abeng (Cliff), 197nn26–27
Abyss, 6, 24–25, 27, 31, 33, 38, 51–54, 57, 59–60, 62–64, 68, 146, 157, 162, 201n18
Adjarian, Maude M., 203n20
Adorno, Theodor W., 61
Africa, 7, 10, 19, 24–25, 28–30, 32, 34–35, 37, 40, 52–53, 58, 61–62, 74–75, 88, 90, 94, 97–98, 102, 112, 118, 128, 130–31, 136–37, 139, 141, 145, 151, 164–66, 170, 181, 183–84, 195nn1–2, 195n6, 195n9, 197n22, 200n8, 202n33, 206n22, 206n24, 213n17, 215n6
Africans, 4, 6–8, 11, 15–16, 24, 29–31, 35–37, 40–42, 43–45, 47–54, 56–58, 60–66, 68, 73, 75, 77, 83–84, 90, 92–94, 108, 112, 128, 135, 138–40, 142, 151–52, 154, 164, 166, 169–70, 177, 188–89, 196n16, 198n37, 201n17, 210n22
Afrofuturism, 25, 32, 176, 181–82, 215n6
Against Race (Gilroy), 4
Agamben, Giorgio, 202n34
Agnant, Marie-Célie, 7, 10–11, 16, 71, 73, 82, 84, 87, 92–93, 104, 171
Alexander, M. Jacqui, 174
Allegories of Desire (Adjarian), 203n20
amnesia, 7, 52, 75, 77–82, 88, 91, 110, 120–22, 170
Amour, Colère, Folie (Vieux-Chauvet), 72
Anzaldúa, Gloria, 146–48
archipelagos, 3–6, 8, 12–13, 19, 34, 50, 53, 146–47, 170, 176, 193nn3–4, 194n11, 194n22, 215n32
Aristide, Jean-Bertrand, 85
Armstrong, Louis, 111

Arroyo, Jossianna, 147, 153, 162, 213nn17–18
Atlantic Ocean, 3, 25, 37, 49, 164, 197n30
Atlantic slave trade, 12, 37, 42, 47, 51, 53, 147, 151, 168, 170, 189, 195n10, 196n16, 199n43, 210n22, 215n5
At the Full and Change of the Moon (Brand), 188, 193n1

Baartman, Saartjie, 62–64, 202nn32–33
Bachelard, Gaston, 194n11
Bailey, Carol, 203nn27–28
Baker, Houston A., 205n21, 206n26
Baldwin, James, 143
Barbados, 7, 8, 17, 26, 115–16, 126, 128–30, 133–34, 136–37, 196n20, 211n27
Barracoon (Hurston), 205n18
Barradas, Efrain, 153
Baucom, Ian, 46, 199n7, 201n18
Baugh, Eddie, 200n14
Bauman, Zygmunt, 51
Beckford, George, 168
Becoming Human (Jackson), 201n27
Beloved (Morrison), 47, 195n7, 202n39
Benítez-Rojo, Antonio, 3, 7, 52, 145, 147, 194n9, 194n11, 200n14
Bhabha, Homi, 118
Birmingham-Pokorny, Elba D., 151
birth, 23–25, 31, 33–41, 47, 51, 54, 62–63, 72, 74, 78, 81–84, 88–89, 104–5, 107–8, 117, 121, 123–25, 133, 151, 166, 179, 186, 191, 197n28
Black Atlantic, The (Gilroy), 197n22
Blackness, 28, 37, 58, 97, 129, 151–52, 154, 183, 187, 195n9, 196n14, 198n37, 210n22

Black Salt (Glissant), 188
Blake; or the Huts of America (Delany), 197n27
"blessing the boats" (Clifton), 8
Blue Clerk, The (Brand), 188–90
bodies, 17–18, 146, 155, 158–59, 190, 194n7, 197n27, 211n28; Black, 10, 89, 171; female, 10, 36, 83, 89; queer, 171, 173
Bone Courts, 44, 46, 60–61, 63–65
Bonfiglio, Florencia, 13, 147
Book of Emma, The (Agnant), 10, 16, 71, 73–78, 83
borderlands, 147–49, 153
borders, 6, 13–14, 18–19, 67, 78, 116, 120, 123, 131–32, 135, 137, 144–48, 150–51, 153, 156, 159–63, 170, 173–75
boundaries, 12–13, 15, 19, 67, 79–80, 129, 136, 140–41, 144–45, 147–48, 151, 153, 155, 159, 173–74, 177, 181, 210n15, 214n25
Boxwell, David, 98
Boyer, Amalia, 147, 212n3
Brah, Avtar, 165
Brand, Dionne, 3–4, 7, 8, 10, 16, 24–26, 30, 42, 44, 52, 61–68, 72–73, 104, 119, 141, 143, 164, 176, 183, 188, 190–91, 193n1, 194n20, 202n35, 202n37, 211n30
Brathwaite, Kamau, 3–4, 6, 112, 134, 145, 147–48, 151, 157, 170, 172, 183–84, 188, 193n2, 194n6, 194n11, 195n22, 199n2, 200n8, 200n14, 210n20, 211n26, 215n32
Breath, Eyes, Memory (Danticat), 180
Britton, Celia, 174
Brodber, Erna, 7, 10–11, 17, 19–20, 92–108, 110–12, 118, 176, 181–83, 204n1, 204nn3–4, 204n9, 206n22, 207nn26–28, 208n41, 215n1, 215nn4–5
Brontë, Charlotte, 118

Cancer Journals, The (Lorde), 37, 202n31
capitalism, 24, 26, 28, 32–33, 49, 142, 149, 151, 155, 173, 186–87, 214n27
Caribbean Atlantic, 3–9, 12–13, 15, 20, 42, 43, 51–52, 92, 110–11, 144, 146–48, 155, 165–66, 169–70, 213n13
Caribbean Discourse (Glissant), 146, 215n4

Caribbean Sea, 5, 13, 18, 25, 66, 68, 146–47, 150, 169
Carnival Trilogy, The (Harris), 211n25
Carr, Brian, 95
cartography, 115–16, 130, 139, 142, 167–68, 189–90, 209n12
Caruth, Cathy, 9, 15
"Castaway, The" (D. Walcott), 116
Cereus Blooms at Night (Mootoo), 153, 209n10
Césaire, Aimé, 20
Chancy, Myriam A. J., 7, 16, 71–72, 75, 78, 83–85, 176, 183–84, 194n20, 204n31
chanté-mas, 53–55, 59–61
Chicago, IL, 94, 104, 111, 177
Chosen Place, the Timeless People, The (Marshall), 9, 15, 25–29, 31–32, 196n16, 197n21, 201n25
Citizen (Rankine), 197n30
citizenship, 14, 144, 151, 158
Clarke, George Elliott, 119, 209n9
Cliff, Michelle, 7, 9, 15, 24–26, 30–33, 38, 41–42, 43, 54, 153, 180, 194n20, 197n23, 197nn25–27
Clifford, James, 194n10
Clifton, Lucille, 8
colonialism, 4–8, 10–11, 13–15, 17–18, 24, 26, 28–32, 36–40, 42, 44, 53–56, 58–59, 61, 71, 73, 76, 84–85, 100–102, 108–9, 115–25, 127–29, 132, 135, 139–42, 145, 147, 152–53, 157–58, 163, 166–69, 173–75, 177–78, 180, 188–91, 195n8, 200n15, 201n26, 206nn24–25, 207nn30–31, 208n1, 209n8, 213n20, 214n30
Continent of Black Consciousness, The (Brodber), 208n41
Cooper, Carolyn, 93
Cooper, Tova, 95
Cooppan, Vilashini, 145, 165, 212n2
Corio, Alessandro, 145–46
Coser, Stelamaris, 196n11
creolization, 4, 53, 106, 110–12, 210n22
Cuba, 29, 44
Culbertson, Roberta, 76, 87–88

Dalleo, Raphael, 157
Danticat, Edwidge, 177, 180

Davies, Carole Boyce, 10, 15, 177
Dayan, Joan, 206n24
death, 3, 7, 9, 25, 33, 35–36, 39–40, 44, 51, 54–55, 57–59, 61–63, 65–66, 76, 83, 86–87, 89, 91, 99, 104–6, 108–9, 123, 127, 132, 135, 139–40, 149–50, 172–74, 181, 184–85, 187, 190, 201n18, 206n24
Decena, Carlos Ulises, 214n26
decolonization, 12–13, 29, 174, 203n27, 204n11, 206n25
Delany, Martin, 197n27
Deleuze, Gilles, 12, 201n19, 214n25
DeLoughrey, Elizabeth, 6, 145, 155, 194n10, 215n4
De Maeseneer, Rita, 151, 212n8
Demonic Grounds (McKittrick), 12, 201n22
Dennis-Benn, Nicole, 8, 176–77, 179, 184, 194n20
Deren, Maya, 34
Derrida, Jacques, 51, 145, 199–200n7
Díaz, Luis Felipe, 153
Dinshaw, Carolyn, 171
displacement, 12, 26, 93, 116–17, 119, 122, 130–31, 135–36, 139, 147, 152, 158, 166, 173, 184–85
Domina, Lynn, 95
Dominica, 7, 201n20
Dominican Republic, 8, 18–19, 145, 147–48, 150, 155–56, 158, 162–66, 168, 172–73, 213n18
Dominique, Jan J., 7, 17, 71, 75, 78–79, 83, 87
Door of No Return, 3, 8, 23–25, 30, 65–66, 164, 170, 190, 197n24, 202n35
Dorst, John, 95
Douglass, Frederick, 183
Drabinsky, John, 34
Dragon Can't Dance, The (Lovelace), 201n25
Dragons Cry (McWatt), 18, 116, 126–31, 133, 135, 139
Drake, Simon, 207n33
Du Bois, W. E. B., 107
Dust Tracks on a Road (Hurston), 207n32
Dutton, Wendy, 206n25
Duvalier, François, 72, 79, 85, 87, 89, 203n15, 203n20
Duvalier, Jean-Claude, 79, 85, 87, 203n20

education, 94, 96, 101–2, 120, 128–29, 207n31
Equiano, Olaudah, 23, 195n2
erasure, 52, 160–61, 163, 182
Erzulie's Skirt (Lara), 18–19, 144–46, 151, 164–75, 177
Espinet, Ramabai, 117
exaqua, 43, 45–46, 50–51, 61, 66, 68, 72

Fanon, Frantz, 194n14
folklore, 17, 93–94, 96, 105, 107, 131, 142, 205nn19–20
Framing Silence (Chancy), 204n31
Free Enterprise (Cliff), 15, 25, 30–33, 197n30
Frisch, Andrea, 55
frontiers, 144, 146–48

Garvey, Marcus, 110–11, 204n4, 208n41, 212n9
gay individuals, 14, 148, 159, 167–68, 172, 212nn7–8
gender, 7, 11, 14, 17, 52, 79, 90, 97–98, 100, 109, 119, 128, 138, 144–46, 149, 152–54, 158–59, 161–65, 174–75, 177–80, 184, 198n31, 198n34, 198n37, 201n21, 204n2, 205n11, 207n29, 212nn8–9, 213n11, 214n21
Genealogy of Resistance, A (Philip), 12
geographies, 4–5, 9, 12, 18–19, 24, 26, 34–35, 59, 76, 115, 130–31, 135, 143, 144, 147, 152, 160, 173–74, 177–78, 204n9, 212n3
Gerima, Haile, 74
Gervasio, Nicole, 201n17
ghosts, 12, 24, 27, 60, 64–65, 133, 145, 165, 169–70, 100, 185
Gikandi, Simon, 195n1, 195n7
Gillis, John, 53
Gilroy, Paul, 4, 11, 196nn13–14, 197n22
Glave, Thomas, 14
Glissant, Édouard, 3–6, 12–13, 17, 19, 23–24, 31, 33–34, 38, 48, 51–54, 57, 62, 64, 68, 73, 92, 94, 96, 104–5, 107, 127, 145–48, 151–52, 157, 166, 170, 174, 188, 193n3, 194n11, 194n22, 197n28, 198n32, 200n16, 201n19, 204n3, 206n24, 214n25, 215n32, 215n4
globalization, 8, 15, 46, 147, 152, 161, 212n2
Goldman, Marlene, 210n18
González-Allende, Iker, 153
Gopinath, Gayatri, 166–67, 173

Gordon, Deborah, 96
Gossero-Esquilín, Mary Ann, 153
Gregson v. Gilbert (1783), 45–46, 49, 51–52
Guattari, Félix, 12, 201n19
Guyana, 4, 7, 8, 17, 26, 57, 115–17, 121, 125–29, 131–39, 141–42

Haiti, 7, 16–17, 19, 25, 29, 33–35, 41–42, 71–74, 76–80, 82–87, 89–91, 92, 94, 99, 102, 104, 147, 151, 156, 164–69, 176, 180, 185–87, 203n6, 203n12, 206n22, 206n24; culture, 76; earthquake, 72, 183–87; history, 10, 76, 83, 85
Harley, J. B., 209n12
Harris, Wilson, 115–16, 141, 208n1, 211nn24–25
Hartman, Saidiya, 26, 197n24, 201n29
hauntologies, 46, 145, 150, 165, 170, 199n7
Hayden, Robert, 23, 195n9, 198n37
healing, 7, 9–10, 15, 18–20, 23, 29, 36, 40–42, 44, 52, 54, 64, 74, 76–78, 82–85, 87–89, 91, 94, 97–101, 106, 108–10, 112, 116, 119–20, 123, 131, 144, 147, 159, 173–75, 179, 183, 186, 200n14, 200n16, 214n22
Hernández, Graciela, 95
Himid, Lubaina, 197n27
home, 14–15, 18, 26, 30–31, 36, 38, 59–60, 62–64, 68, 73–74, 85, 87, 91, 93, 97, 102, 107–9, 111, 115–18, 120, 124–26, 128–30, 135–39, 141, 155–56, 158–59, 162, 164, 166, 168, 170, 172–73, 176–78, 180, 184–85, 187, 190, 195n6, 195n9, 206n26, 211n30
homelands, 26, 40, 79, 89, 101, 121, 125, 137
homophobia, 29, 31, 179, 196–97nn20–21
hoodoo. *See* voodoo/vodou/vodun
Hopkinson, Nalo, 7, 15, 24–29, 31, 33–39, 41–42, 43, 50, 54, 61, 65, 88, 96, 101, 119, 176–77, 181, 191, 196n12, 196n18, 197n20, 198n37, 210n23
Huggan, Graham, 11, 115, 119, 135, 139, 142, 208n1, 209n12, 210n24, 211n27
Hughes, Langston, 205n15
Hurston, Zora Neale, 8, 17, 92–99, 102–3, 105–7, 110–11, 204nn4–5, 204–5nn11–12, 205n15, 205–6nn17–22, 206nn24–25, 207n27, 207n32, 208n35
hybridity, 35, 103, 136, 140–41, 152, 207n30

immigration, 172, 177–79, 210n17, 214n23
imperialism, 6, 12, 101, 136, 140, 144–45, 155, 158–59, 177, 190, 195n8, 196n16, 209n12

Jackson, Zakiyyah Iman, 37, 201n27
Jamaica, 7–8, 17, 26, 31, 48, 93–94, 100–102, 104–5, 107–9, 111–12, 128, 177–80, 206n24, 207n28
James, Winston, 111
Jane and Louisa Will Soon Come Home (Brodber), 100, 108, 207n29
Jane Eyre (Brontë), 118
John, Marie-Elena, 7, 11, 16, 42, 44, 52–53, 59, 61, 64–65, 67, 72–73, 104, 119, 201n28
Josephs, Kelly Baker, 176, 215n1

Kawash, Samira, 95
Keizer, Arlene R., 197n21
Kempadoo, Oonya, 194n20
Kincaid, Jamaica, 177, 180
King, Rosamond, 14, 153, 163, 196n20
Kipling, Rudyard, 101
kumbla, 101, 117, 120–22, 124, 207n29, 209n3

Lacombe, Michèle, 210n16
Land to Light On (Brand), 63, 65, 67
Lara, Ana-Maurine, 8, 14, 18–19, 144–45, 147–48, 150–51, 156, 164–70, 172–73, 175, 214n26
Lauden, John, 205n12
Laveau, Marie, 99, 106
Le livre d'Emma (Agnant), 10, 16, 71, 73–78, 83
lesbian individuals, 14, 29, 38–39, 165, 179, 194n18, 197n20
lieu de mémoire, 8, 105–6
Llenín-Figueroa, Beatriz, 4, 6, 146
London, England, 17, 38, 115–16, 132–39, 177, 194n12
Loneliness of Angels, The (Chancy), 83
Lorde, Audre, 37, 143, 198n36, 202n31
Lose Your Mother (Hartman), 197n24, 201n29
Louisiana (Brodber), 7, 10, 17, 19–20, 92–95, 100, 102–7, 109, 111, 204n1, 204n4, 204n9, 207nn27–28, 208nn36–37, 208n41

Lovelace, Earl, 201n25
Lucy (Kincaid), 177, 180

madness, 10, 12, 16, 71–73, 75–78, 80–81, 83, 88, 91, 93, 102, 108, 118–20, 123, 125, 132, 139, 174, 183, 185, 189–90, 202n1, 207n29
Makandal, François, 199n39
maps, 4, 6, 8, 11–12, 17, 24, 46, 93, 105–6, 115–16, 118–21, 125–26, 128–30, 132, 134–36, 140–42, 158, 160, 166, 173, 183, 186, 190–91, 198n32, 200n12, 208n35, 208n1, 209n12, 210n24, 211n27
Map to the Door of No Return, A (Brand), 3, 8, 190, 202n35, 202n37
Mardorossian, Carine M., 5
maroons, 31, 33, 40, 53, 58, 60–61, 111, 199n39, 199n43, 203n17
Marshall, Paule, 7, 9, 15, 24–29, 31, 38, 42, 43, 54, 195n6, 196n13, 196n16, 197n21, 201n25
masks and masking, 53–55, 57–59, 82, 128, 170–71, 173
Massumi, Brian, 214n25
maternalism, 50, 117, 122–23, 142, 179, 196n18. See also mothers and motherhood
matrices, 5–6, 33–34, 37–38, 40, 51, 83, 208n37
Maximin, Colette, 102
Mayer, Ruth, 195n5, 215n6
Mbembe, Achille, 9, 198n38, 201n27
McKittrick, Katherine, 11–12, 58, 168, 174–75, 194n9, 201n22
McWatt, Tessa, 8, 10–11, 17–18, 112, 115–16, 118–19, 123, 126, 129–33, 135, 137, 138–43, 208n2, 209n8, 210n17, 210–11n23–24, 211n27, 212n33
Meehan, Kevin, 205n11
Melville, Pauline, 211n25
Mémoire d'une amnésique (Dominique), 16, 71, 79–84
Memorial to Zong (Himid), 197n27
memory, 7–9, 14–15, 16, 20, 23, 25–26, 38, 43, 46–47, 57, 65, 68, 71, 74–78, 80–88, 90–91, 93, 102, 105–8, 110–12, 115, 119–22, 124, 126, 130–31, 136, 149, 171, 179, 185, 194n6, 197n22, 199n5, 200n11, 202n1, 203n11, 209n9; collective, 104; cultural, 102, 119, 209n9

Miami, FL, 91, 134, 138, 177
Middle Passage, 5, 7–9, 13–16, 18, 23–27, 30–42, 44, 46–47, 53–54, 64–66, 68, 71–73, 79, 81–82, 93–94, 97, 110, 112, 123, 129, 139, 144–45, 147, 157, 164, 169–71, 181–82, 194n11, 195nn1–2, 195n5, 195n7, 197n22, 197n27, 198n34, 198n37, 200n11, 201n25, 205n18
"Middle Passage" (Hayden), 23, 198n37
Mignolo, Walter, 144
migration, 17, 25, 30, 94, 111, 115–17, 120, 125–26, 129–31, 136–38, 141–42, 152, 165, 169, 176, 182, 202n37, 209n11, 213n20, 214nn26–27, 215n3
Miller, Christopher, 75
miscarriage, 36, 44, 82, 126
Moïse, Jovenel, 72
Mona Strait, 150, 163, 165, 168–69, 171–72
Montréal, Canada, 17, 71–73, 79, 81–82, 115–20, 124–25, 142, 177, 203n5, 209n5
Mootoo, Shani, 153, 209n10
Morell, Hortensia R., 213n20
Morrison, Toni, 47, 195n7, 202n39
mothers and motherhood, 10, 28, 31–32, 34, 36, 43, 47, 52, 54–55, 58, 61, 72–73, 75, 77, 82, 84, 87, 89, 91, 100, 104, 107, 116–17, 120–23, 128, 132–34, 140–42, 149, 159–61, 163, 165, 167–68, 176–80, 184–85, 187–88, 198n31, 203n20, 208n35, 212n33, 215n3. See also maternalism
Moyes, Lianne, 209n8
Moynagh, Maureen, 119, 209n9
Mules and Men (Hurston), 17, 92–98, 100, 102, 105–6, 111–12, 204n4, 205nn11–12, 205n17, 205n19, 206nn22–23, 206–7nn26–27, 208n35
Mulira, Jessie, 98
Murdoch, H. Adlai, 13
Murphy, Joseph, 108, 207n34
music and song, 17, 44, 46, 54–55, 60, 64, 66, 93–94, 104, 106–12, 115, 126, 128–29, 149, 160, 163, 210n22. See also chanté-mas
Mustakeem, Sowande, 27–28, 34
Mutu, Wangechi, 198n36
myal, 20, 94, 99–102, 106, 108–9, 112, 206n25, 207n27, 207n30, 208n38

neocolonialism, 13, 17, 53, 72, 79, 140, 145, 147, 149, 151, 153, 158, 162–63, 173, 175, 185–86, 188
New Orleans, LA, 17, 20, 94, 97–100, 104, 106–8, 110–11, 194n12, 205n21, 206n22, 208n35, 208n40
New York, NY, 15, 18, 169, 177–80, 213n20, 214nn26–27
Ngugi wa Thiong'o, 103
Nielson, Aldon L., 195n6
No Language Is Neutral (Brand), 65, 141
Nora, Pierre, 8, 105
nostalgia, 85, 125, 130, 161, 210n17
"Notanda" (Philip), 200n7, 200n11
Notebook of a return to my native land (Césaire), 20
No Telephone to Heaven (Cliff), 153

obeah, 52, 54–55, 57, 59, 99–100, 201n26, 206n25
Omeros (D. Walcott), 43, 52, 200nn15–16, 201n18
ossuaries, 3, 33, 42–44, 46, 53, 59, 61–62, 64–66, 68, 72, 145, 157, 171, 183
Ossuaries (Brand), 16, 44, 61–68
Otherness, 5, 11, 52, 56, 157, 206n24, 209n13
Out of My Skin (McWatt), 10, 18, 116–25, 131, 135, 142
outsiders, 76, 94–95, 97–99, 103, 179, 189, 204n11

Page, Kezia, 208n36
patriarchy, 38, 40, 72, 79, 85, 117, 119, 121, 127, 159, 198n37, 210n15
Patsy (Dennis-Benn), 177–80, 215n3
Pavlić, Edward M., 206n22
Pérez, Loida Maritza, 177
performativity and performance, 17, 93, 96–98, 103–4, 107, 201n25, 205n17, 207n27, 210n22
Philip, M. NourbeSe, 7, 10–13, 15–16, 42, 43–52, 55, 60–61, 64–67, 72–73, 96, 104, 119, 194n9, 194n17, 196n15, 197n27, 199n1, 200nn7–8, 200n11, 200n15, 201n17, 201n28, 204n6
Philosophie de la Relation (Glissant), 13

Pinnix, Aaron, 201n19
Pinto, Samantha, 206n24
plantations, 7, 10–13, 27, 34, 37–38, 40, 66, 77–78, 129, 142–43, 147, 156, 159, 165, 167–70, 174–75, 181–82, 187, 189, 194n9, 194n11, 195n10, 199n39, 215n32, 215n4
Poetics of Relation (Glissant), 6, 33, 152
Praisesong for the Widow (Marshall), 9, 195n6
Puerto Rico, 8, 18, 145, 147–50, 162–63, 168–69, 171–73, 212n6, 213n18

queer individuals and queerness, 14, 31, 37, 40, 144, 151–53, 155, 157–58, 163, 165–67, 170–71, 173–75, 176–78, 180, 194n20, 213n19, 214n23, 214n29

racism, 10–11, 13, 28, 32, 40, 55–56, 62, 67, 100–101, 110–12, 139–40, 166, 169, 196n14
Rahming, Melvin, 196n13
Rainmaker's Mistake, The (Brodber), 181–82, 215n1
Ramazani, Jahan, 200nn15–16
Rankine, Claudia, 197n30
rape, 10, 19, 54, 58, 77, 81, 85–86, 88, 91, 120, 154, 160, 162–63, 172, 178–79, 186, 203n22, 209n9
Relation, 4–7, 10, 12–14, 16, 18–20, 25, 30, 37, 39–40, 42, 48, 52–54, 57, 60, 62–63, 65, 68, 116, 118, 125, 131–33, 136, 138, 143, 145–47, 151, 157, 161–62, 165–66, 168, 170–71, 174, 178, 188, 193n3, 194n22, 200n13, 201n19, 202n40, 213n11, 214n25, 215n32
re-membering, 7–10, 16, 23–26, 29, 35–37, 46, 54, 68, 79, 89, 91, 92, 102, 105, 122, 133, 170, 194n7, 194n11, 195n7, 197n22, 201n25, 215n5
resistance, 6–7, 11–15, 20, 28, 31, 39, 41–42, 46, 61, 63, 78, 90, 97, 99–100, 110–12, 142–43, 145, 152, 158–59, 161–63, 168, 173–74, 189, 197n23, 199n43, 202n1, 205n19, 207n31
rhizomes, 12, 201nn19–20
Rhys, Jean, 118
Rice, Alan, 197n27
Rivera, Angel A., 212n7
Roach, Joseph, 103, 105–6, 111
Rodríguez, Juana María, 152

Rodriques, Janelle, 176, 181, 215n3
Rowe, John Carlos, 94

Saint-Domingue, 15, 25, 33, 35–36, 38–39, 77, 165, 199n39
Salt Roads, 43, 45, 54, 65, 101, 119, 176, 189, 191
Salt Roads, The (Hopkinson), 15, 24–26, 31, 33–42, 88, 104, 176, 181, 198n35, 210n23
"Sankofa" (Gerima), 74
Santos-Febres, Mayra, 8, 14, 18–19, 144–45, 147–49, 151–56, 160–61, 167, 169, 172, 174–75, 212n6, 212n8, 213n11
Santos Perez, Craig, 4
Saunders, Patricia, 204n1, 204n3
Scorpion's Claw, The (Chancy), 16, 83–84, 87, 90, 203n27
sea, 3–17, 19–20, 23–26, 28–39, 41–42, 43–48, 50–54, 59, 61–62, 64–67, 73, 76, 83–84, 86–89, 93, 106–7, 109–11, 130, 134, 141, 143, 145–48, 150–52, 154, 156–57, 160–62, 171, 175, 177–79, 181–82, 187–89, 191, 193n4, 194n6, 194n11, 195n5, 199n43 (chap. 1), 199n3 (chap. 2), 200n11, 206n24, 214n23, 215n5
Sex and the Citizen (Smith), 14
sex slavery, 19, 35, 172–73
sexualization, 118, 149, 158
Shame on Me (McWatt), 142
Sharpe, Christina, 7, 9
Sheller, Mimi, 14, 158
She Tries Her Tongue, Her Silence Softly Breaks (Philip), 64–65
Shire, Warsan, 177
signifying, 30, 61, 83, 87, 97, 110, 117, 132
silence, 14, 42, 82, 84–88, 91, 95, 103, 108, 124, 136, 150, 165, 199n1, 203n2, 203n18, 204n1
Sirena Selena vestida de pena (Santos-Febres), 18–19, 144–46, 148–67, 170, 172, 174, 177
slavery, 5–12, 15–16, 19, 25–30, 32–40, 42, 44, 46–47, 51, 53–54, 60–61, 63, 66–67, 72–77, 79, 93–94, 97, 107, 120, 127, 129, 135, 137, 139–40, 142, 147, 151, 153, 156–57, 164, 168–75, 181, 189–90, 194n11, 195n1, 195n5, 195–96nn9–10, 196n16, 197n22, 198n37, 199n39, 199n43, 201n17, 201n21, 201n29,
203n6, 206n24, 210n22, 212n2, 214n23, 215n5
Slavery at Sea (Mustakeem), 28
Slave Ship, The (Turner), 15, 25, 31, 33, 197n27
Small Acts (Gilroy), 196nn13–14
Smith, Jonathan, 24, 195n9, 198n37
social class, 54, 56, 103, 127–28, 137, 140, 144, 152, 156, 166, 168, 186, 196n16, 198n31
Specters of Marx (Derrida), 200n7
Stephens, Michelle, 193n4
Stinchcomb, Dawn, 164
storytelling, 32, 42, 89, 97–98, 103, 106, 203n26, 205n20, 206n26
suicide, 10, 60, 91, 116–17, 121, 131, 162, 180, 185, 187, 199n43
Swinging Bridge, The (Espinet), 117

Tal, Kali, 10
Taylor, Carole Anne, 206n24
Tell My Horse (Hurston), 94, 99–100, 204n4, 204n11, 206nn24–25
testifying, 16, 23, 29, 53, 58, 64, 71, 76–77, 85, 90, 203n13
testimony, 15, 32, 44–47, 50–51, 55–57, 65, 71–72, 75–76, 78, 81–82, 87–88, 91, 119, 179, 195n10, 203n13
Their Eyes Were Watching God (Hurston), 206n22
There's No Place Like . . . (McWatt), 138–42
This Body (McWatt), 18, 116, 131–39
tidalectics, 4, 6, 15, 134, 145–46, 151, 157, 170, 183, 188, 193n2, 200n14, 211n26, 215n32
Tinsley, Omise'eke Natasha, 14, 37, 164, 170–72, 214n23
Toland-Dix, Shirley, 204n4, 207n27
Tontons Macoutes, 77, 79–81
Toronto, Canada, 17, 26, 115–16, 126, 133, 136, 138, 177
Torres, Daniel, 153
tourism, 153–60, 168, 185
transgender individuals, 14, 18, 145, 148, 153, 155, 163
transsexuals, 145, 148–50, 153, 155, 163, 212n7
transversality, 17, 92, 94, 104, 107, 110
trauma, 3, 5–10, 12–13, 15–16, 19–20, 23, 27, 29, 33–36, 39–42, 44, 50, 53–54, 60, 65,

73–83, 85–91, 92–93, 97, 99, 107–10, 112, 119–22, 124, 129, 139, 149, 154, 157, 162, 168, 170–71, 173, 178–81, 183–86, 188, 198n32, 198n37, 200n11, 200nn14–16, 203nn27–28, 209n8, 214n22
Trinidad and Tobago, 3, 7, 189
Trouillot, Michel-Rolph, 14
Trujillo, Rafael, 165
Turner, J. M. W., 15, 25, 31, 197nn27–28
Turner, Luke, 99

Unburnable (John), 44, 53–61, 63–64, 66, 68

Van Haesendonck, Kristian, 174
Ventriloquist's Tale, The (Melville), 211n25
Vieux-Chauvet, Marie, 72
Visweswaran, Kamala, 95
Vizenor, Gerald, 44, 46, 64
voodoo/vodou/vodun, 17, 34, 76, 88–89, 93–94, 98–100, 106, 111–12, 183, 204n5, 205n20, 206nn22–23, 206–7nn25–27

Walcott, Derek, 5, 43, 47, 50, 52, 110, 116, 147, 200n8, 200nn15–16, 201n18
Walcott, Rinaldo, 14, 129, 209n11, 209n13, 210n17, 210n22, 211n28, 211n30
Wall, Cheryl A., 98
What Storm, What Thunder (Chancy), 183–87
What the Twilight Says (D. Walcott), 50
Wiedorn, Michael, 166
witnessing, 9–11, 16, 19, 28, 35, 45–47, 51–53, 55–57, 60–61, 64–65, 68, 71–72, 74–76, 78–79, 81, 84–85, 87, 90, 120, 127, 135, 161, 181, 185, 202n34
Wizard of Oz, The (Baum), 138
wombs, 33, 51, 82, 87, 101
wounds, 5, 9–10, 13, 15, 19, 23, 29, 32, 35–36, 50, 52, 74–78, 80, 82, 84, 86–89, 91, 101, 126, 128, 131, 135, 139, 162, 170–71, 178, 180, 198nn31–32, 200nn14–16, 214n23
Wynter, Sylvia, 10–12, 28, 32, 40, 56, 135, 175, 194n9, 194nn14–15, 201nn22–23, 215n4

Zong! (Philip), 15–16, 42, 43–55, 57, 59, 63–65, 68, 73, 196n15, 197n27, 199nn1–2, 200n9, 200n15, 204n6
Zong (ship), 15, 31, 42, 45–51, 55, 60–61, 66, 96, 196n17, 197n27, 199n1, 200n9, 200n11, 200n14, 201nn17–18, 201n29

zombification, 75, 93–94, 99, 102, 109, 182, 206n24

ABOUT THE AUTHOR

JOHANNA X. K. GARVEY is associate professor of English at Fairfield University, where she was founding codirector of the Women's Studies Program, now Women, Gender, & Sexuality Studies, and founding codirector of the Program in Black Studies: Africa and the Diaspora. She is faculty in American Studies and Latin American & Caribbean Studies, as well as WGSS and Black Studies. She is coordinator of the Social Justice Signature Element in the *Magis* Core. She has published articles and book chapters on Toni Morrison, Ann Petry, Michelle Cliff, Merle Collins, Paule Marshall, Dionne Brand, Shani Mootoo, Patricia Powell, Ramabai Espinet, Maryse Condé, Shay Youngblood, Marci Blackman, Suzan-Lori Parks, Martha Southgate, and others. Her work has appeared in such publications as *Callaloo*, the *Journal of Commonwealth and Postcolonial Literature*, *Textual Practice*, *Anthurium*, *Emerging Perspectives on Maryse Condé*, *Black Imagination and the Middle Passage*, *Black Liberation in the Americas*, *Black Female Sexualities*, and elsewhere. She is coeditor, with Caroline A. Brown, of a volume titled *Madness in Black Women's Diasporic Fictions: Aesthetics of Resistance*. She teaches courses on Caribbean women writers, African American literature, the African Diaspora, Black and Indigenous voices, and women writers of color.

www.ingramcontent.com/pod-product-compliance
Lightning Source LLC
Chambersburg PA
CBHW022005220426
43663CB00007B/972